DISAPPEARING WITNESS

PUBLISHING FOR THE WORLD
125 Years
THE JOHNS HOPKINS UNIVERSITY PRESS

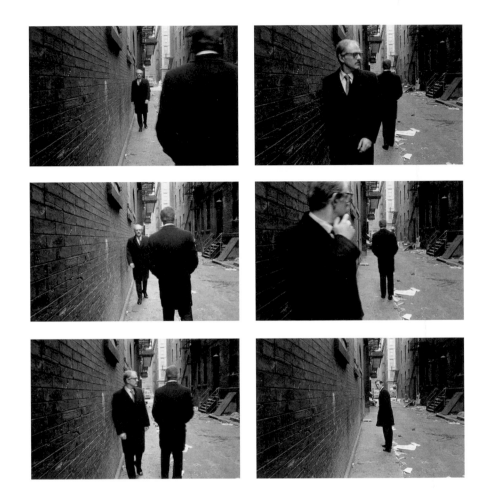

DISAPPEARING WITNESS

Change in Twentieth-Century American Photography

Gretchen Garner

THE JOHNS HOPKINS UNIVERSITY PRESS | BALTIMORE AND LONDON

The Johns Hopkins University Press

2715 North Charles Street

Baltimore, Maryland 21218-4363

www.press.jhu.edu

Library of Congress Cataloging-in-Publication Data

Garner, Gretchen.

Disappearing witness : change in twentieth-century American

photography / Gretchen Garner.

p. cm.

Includes bibliographical references and index.

ISBN 0-8018-7167-0

1. Photography—United States—History—20th century. I. Title.

TR23 .G37 2003

770'.973'0904—dc21 2002006243

A catalog record for this book is available from the British Library.

FRONTISPIECE: Duane Michals, *Chance Meeting,* 1970. Duane Michals.

CONTENTS

IN WRITING THIS BOOK I had two goals. The first was to tell the story of the enormous changes, from the 1920s up to the present, in the way photographs are made. It's a fascinating story, and I am convinced that practice in no other pictorial medium has changed more during this period. Nevertheless, despite notable changes in photography, individual viewers continue to entertain their own ideas of a "proper" or at least "typical" professional photograph, which are usually related to the time period when they began looking intensely at photographs. For an older generation it might be something caught unobtrusively in real time, on the street perhaps, with a small camera. For a younger generation it might be a fantastic creation—staged, manipulated, and often assisted by the computer—seen in a lifestyle magazine today. These two types of pictures could hardly differ more, yet both are photographs. Clearly a change has taken place. The question I set for myself as I began was, How was one type of practice taken over by the other?

The second major goal of this book was to show that the evolution has not been limited to so-called fine-art photography. Too many historical analyses of photographic style concentrate only on the relatively small world of fine-art photography, ignoring completely the photographs in popular magazines (aside from a now obligatory mention of *Life* in the thirties). Here, in contrast, I try to show how the *Zeitgeist* of practice has been shared by documentary, editorial, and fine-art photographers. This is not to say that I see no differences between them. Obviously, the first two are driven by requirements of the client or by historical impulses, and the third by the ideas of the photographer. There are also an infinite number of levels of meaning, as well as separate traditions, in the three types of practice. And yet photographers have looked at the world and used the medium in remarkably similar ways.

Inevitably, a book like this one can mention only photographers whose work exemplifies the ideas, and particularly the change in ideas, that it traces. During the

period examined in this book (1920s–1990s) there have been any number of wonderful photographers who, unfortunately, do not fit this requirement but whose work may be more moving, more beautiful, or more successful than some works included here. These photographers can be readily placed in the context of this book by the reader, but for their proper due the reader is referred to the many monographs, catalogues, and comprehensive histories that, happily, have been published in the last thirty years.

A WRITER'S EFFORT is helped immeasurably when other eyes follow the argument and give feedback during the process. I have been fortunate to have several friends and colleagues whose interest in the manuscript has been enthusiastic and whose suggestions have, for the most part, been gratefully incorporated. I thank Sam Adams, Gloria Brush, Jim Faris, Bill Jay, John Mulvany, Chris O'Connor, Mary Ross, Lynn Sloan, and Sharon Whitehill for their responses to parts of the text and Sharyn Udall for her good example and generous advice. Paula Chamlee, A. D. Coleman, Sandra Edelman, and Michael A. Smith provided invaluable responses to the whole manuscript, as did Joanne Allen, for which I am most grateful. I thank especially Norman Mauskopf, always the first reader of every chapter, who, because of his understanding of photography and keen interest in the book, was a source of both insight and encouragement. In the end, of course, any flaws in the argument or ideas are mine alone.

The early stages of the research for the book were supported by a faculty research grant from Grand Valley State University, in Allendale, Michigan, for which I am grateful. A final, special thanks goes to the photographers who have graciously allowed reproduction of their work and to the archivists who did their best to help me track down locations of pictures.

Every effort has been made to contact copyright owners for the photographs in the book, but in some cases letters were returned, addressee unknown, or requests were never answered. Any oversight that comes to light will be gladly corrected.

Unless noted otherwise, illustrations are conventional silver prints or color prints or transparencies, often printed in several sizes. Exceptions are noted in the captions.

To SPEAK ABOUT PHOTOGRAPHY in general has become almost impossible. The subject is too vast, the purposes too varied, the audiences too diverse to generalize. In its short history photography has become a virtually universally practiced means of communication, with professionals in every corner of the world. Identification photos, news photos, evidence photos, advertising photos, and portrait photos are generated nearly everywhere, and in a surprising number of places worldwide artists too have added the camera to their standard battery of equipment. Millions of amateurs record their own personal snapshots as well. How can one sort through this variety and volume? Just as one narrows the field in writing to speak about fiction, poetry, or journalism, for example, in the midst of this visual glut—in order to make the subject manageable—we usually focus on documentary, landscape, fashion, fine art, or portraiture, as particular practices among many others, in speaking of photography.

There are more than enough differences among the practices to obscure their common features. The studio photographer, for example, works so differently from the photojournalist that it seems they share only camera, film, and light. And even then the equipment varies tremendously. In the studio the photographer is likely to use a large view camera and complex artificial lighting, while the newspaper or magazine photographer is likely to use a light, 35 mm rangefinder camera and a portable flash. What is more, the slower, analytical thinking required for studio work could hardly be more different from the quick-response activity of the journalist.

Nonetheless, in this book I venture to generalize. I argue that there has been a *general* shift in the practice of American photography—many kinds of photography—over the last three decades. This shift has been away from and preceded by a remarkable period, roughly from the twenties through the sixties, when a type of photography that emphasized chance, alert presence in the real world and quick re-

sponse was dominant in almost every kind of photographic practice. I argue that this kind of photography, which I call *spontaneous witness,* was the underlying, or meta-, style uniting a surprising variety of approaches and that although it does continue in subdued fashion, this way of engaging the world photographically is no longer dominant but rather is confined now largely to journalism or documentary work. Spontaneous witness continues more strongly outside than inside the United States, but that would be the subject of another book since my focus here is on practice in the United States. Following the era of spontaneous witness, American photographers have turned to increasing control or else toward a hyperconsciousness of the syntax (and sometimes limitations) of the medium.

Alert readers will think of exceptions as we go, and certainly I emphasize some things more than others, but I ask that you follow the argument to the end before deciding whether the exceptions overwhelm the path I trace. I don't believe they do.

I discuss some European photographers and one Japanese photographer, primarily in connection with their influence on American practice or because their work became well known in this country. Although most of the material in this book is American and the argument concerns practice in the United States, my emphasis is not as narrow as it might seem because for most of the twentieth century photography flourished most strongly in the United States, and the examples cited here will be generally familiar to an international audience. In any case, the pattern revealed in this book can also be found in photography outside the United States.

It is important to understand the change photography has undergone. Unless we do, something valuable and unique may slip away without notice, and future, more cynical generations will not understand the incredibly vibrant cultural role photography played in the mid-twentieth century. It is certain that the role and practice of photography have changed; our task is to note how.

If we call the past hundred years the photographic century, few will argue. Still and motion photography have been our most important tools of gathering information—from the crime scene to the orbiting satellite—and for most twentieth-century citizens photographs were the form in which they encountered visual images. Still and motion photography have had different characteristic approaches, however. Despite cinema's documentary usefulness, early in the century the motion picture became primarily a storytelling, fictional medium, whereas still photography did not—not, that is, until the last three decades. It is clear now that still photographs can do a remarkable number of things and appear in a great number of forms: they can document events in real time and space or they can be works of

contrived arrangement, and they can also be—as physical objects—painted upon, distorted, and otherwise manipulated beyond easily identified camera-made images. A hundred years in the future, say, it may turn out that the contrived, fictional mode will be seen as the major trend of still photography, as it has been in cinema. In that case it will be all the more surprising that in our own recent history one broad style, spontaneous witness, dominated all kinds of still photography for at least half of the photographic century.

This style dominated, I believe, because it seemed the perfect medium for the kind of universal, everyman's communication that had been dreamt of by the post–World War I revolutionaries, both political and artistic. It fit, for example, the revolutionary dream of universal class solidarity: photography was accessible to most people and a communication means that did not carry, or so it was thought, any baggage of style or history. In a 1931 radio address August Sander averred, "Today with photography we can communicate our thoughts, conceptions, and realities, to all the people on earth. . . . Even the most isolated Bushman could understand a photograph of the heavens—whether it showed the sun, the moon, or the constellations."[1] Even as late as 1968 Cornell Capa, a photojournalist and founder of the International Center of Photography, could write that photography "is the most vital, effective and universal means of communication of facts and ideas between people and between nations."[2] For a long time, this seemed to be true to just about everyone.

THE HEYDAY of spontaneous witness was the period of high modernism between the two world wars and into the 1950s. Its breakdown began in the 1960s, when belief in the universal and general faith in progress began to slip. We will see below how serious photography began to turn to more private concerns, much of it becoming what the Museum of Modern Art (N.Y.) curator John Szarkowski called "mirrors" looking in instead of "windows" looking out.[3]

In addition to the claims for universal communication that were made for photography, the fast cameras that were new in the 1920s were the perfect tools for capturing the frenetic speed of a culture increasingly in motion—generally in the

[1] August Sander, "Photography as a Universal Language," reprinted in *Photography: Current Perspectives*, ed. Jerome Liebling (Rochester: Massachusetts Review / Light Impressions, 1978), 47.

[2] Cornell Capa, *The Concerned Photographer* (New York: Grossman, 1968), introduction.

[3] John Szarkowski, *Mirrors and Windows: American Photography since 1960* (New York: Museum of Modern Art/New York Graphic Society, 1978).

direction of "progress"—and increasingly glorifying the machine and the rational promises of science. As well, the new style of clear-eyed spontaneous photography made the break with pictorialist photography—those soft-focus, tonalism-derived formulas of turn-of-the-century practice that by the twenties were tired conventions—complete.

Perhaps it was not only a perfect historical fit but also the ontological genius of the medium for this type of seeing that allowed spontaneous witness to flourish. Rudolf Arnheim observed in 1974 that "the snapshot quality of photographs manifests a unique character trait of the medium. Photography does something unheard of when it catches motion in the act."[4] In other words, Arnheim argued that photography had not done anything truly new until the snapshot, or what I call spontaneous witness. Arnheim posited that there had been two phases in the development of photography by that time:

> the early period during which the image, as it were, transcended the momentary presence of the portrayed objects because of the length of exposure and the bulkiness of the equipment; and the second phase, which exploited the technical possibility of capturing motion in a fraction of time. The ambition of instantaneous photography . . . was that of preserving the spontaneity of action and avoiding any indication that the presence of the picture taker had a modifying influence on what was going on.

Nevertheless, Arnheim saw that something new was on its way:

> Characteristically enough, however, our own century has discovered a new attraction in the very artificiality of picture taking and endeavored to use it deliberately for the symbolic representation of an age that has fallen from innocence. This stylistic trend has two main aspects: the introduction of surrealist apparitions, and the frank acknowledgment of photography as an exposure.[5]

In 1974, when Arnheim spotted it, this trend had only just begun to gather speed. The "surrealistic apparitions" were meager and rather simple setups or darkroom pastiches compared with the elaborate computer concoctions of today, and the "frank acknowledgment of photography as an exposure" has since his writing generated bookshelves of postmodern theory and affected every type of practice for-

[4] Rudolf Arnheim, "On the Nature of Photography," *Critical Inquiry* 1, no. 1 (September 1974), 151.
[5] Ibid., 154.

merly dubbed "candid." While the computer culminates the trend away from the photography of witness, we will see that in an "age that has fallen from innocence" other factors had been leading away from it since the 1960s. But first we will explore the dimensions of spontaneous witness itself.

Who were the great avatars of spontaneous witness? A familiar cast of characters, they are the generally recognized masters of twentieth-century photography, such as Ansel Adams, Henri Cartier-Bresson, and Richard Avedon, among many others. These three—a great landscapist, the 35 mm master, and a brilliant fashion and portrait stylist—are not ordinarily considered in the same breath. I choose them because of what they have in common, indeed what makes them the great exemplars that they are, which is precisely this shared attitude of spontaneous witness, of being in the world, alert to time and change as it happens. I will consider below the work of many photographers of Arnheim's "second phase" and see that despite superficial differences, the great majority of them shared a deep, almost metaphysical belief that they could go to the heart of a moment in time and place without disturbing it and uncover a new kind of visual truth.

This book is concerned with *practice* more than theory, and wherever possible the ideas and the words of photographers themselves will serve as our primary documents. Since this is a historical account, all the changes in practice are situated within their times. Yet change, while necessary, cannot be predicted in its precise forms but depends on the unique visions of individuals. New paradigms in practice emerge from the creative minds of the photographers themselves, not just from historical circumstance or the ideas of critics. We must see these individuals in context; without them, context itself doesn't make change.

Because we are concerned here with change of practice in general, however, close and complete analyses of individual photographers are not offered. Fortunately, there are many excellent histories and monographs available for that, and the reader is directed elsewhere for more complete views of individuals. For my purposes, individual photographers exemplify ideas, particularly change in ideas, but in no way do I mean to diminish each one's brilliance, range, or unique contributions. Nor should lack of mention here suggest any individual's unimportance. The photographers I discuss are prime exemplars, but there are many other brilliant photographers whose work has enriched our visual culture. Indeed, many of the photographers who have given us the most pleasure won't be found here because their work has not been pivotal in the history I mean to trace.

The shape the book takes is roughly chronological—roughly, because any one

chapter may discuss works up to fifty years apart. And yet the book is chronological in the sense that Part One, "Photography of Witness," lays out the parameters of practice from early in the century up to the sixties, and Part Two, "Disappearing Witness," while similarly wide-ranging, likewise concentrates on the various factors of change in practice since the sixties.

Finally, I have written this book not just for a scholarly audience. It is also for photographers themselves and for general readers who know something about photography and have a lively interest in it as the most important visual medium of our time. This will include, I trust, picture editors, art directors, museum-goers, serious amateurs, collectors, and students in the hundreds of college-level courses in the history and practice of photography that have burgeoned in the last thirty years, the very years of change that are the focus of attention in Part Two.

PHOTOGRAPHY OF WITNESS

It must be this rhapsody or none
The rhapsody of things as they are.

—WALLACE STEVENS
The Man with the Blue Guitar

BEING THERE

Spontaneous Witness

But inside movement there is one moment at which the elements in motion are in balance. Photography must seize upon this moment and hold immobile the equilibrium of it. —HENRI CARTIER-BRESSON

I waited, focused, waited again for several minutes, then—remember, I always behaved like an amateur with little equipment—click, it was done.
—ALFRED EISENSTAEDT

IN ITS FIRST SEVENTY OR EIGHTY YEARS photography did some marvelous, astonishing things and changed the world in many ways. Before photography, portraits were for the rich; after photography, the millions had their pictures made. Not only that, but citizens of modest means could also buy images of presidents, statesmen, royalty, and all kinds of exotic subjects "taken from life." Before photography, only the rare world traveler saw the American West, the Holy Land, or India. Afterward, authentic views of these far-off lands could be seen in books or in eye-popping 3-D stereo pictures. Photographs of war or its aftermath (including medical documentation) made a grisly contribution to general knowledge after Mathew Brady's and Alexander Gardner's extensive coverage of the U.S. Civil War.

When it came to aesthetically ambitious photography, though, nineteenth-century lens artists relied on the conventions of painting and printmaking for their compositions, themes, and rendering. Photographers such as Oscar Rejlander and Henry Peach Robinson, who aimed for the status of artist in the 1850s and '60s, created multi-image extravaganzas reminiscent of Victorian genre painting and the pieties of the Pre-Raphaelites. Julia Margaret Cameron a decade later created reli-

gious or mythical studies using her friends and servants as models, and as fresh and gorgeous as these often were, their compositions and ideas were those already found in contemporary painting.

Peter Henry Emerson used a scientific theory to elevate photography to the rank of art. A passionate photographer whose great work was a documentary series, *Life and Landscape on the Norfolk Broads* (1886), Emerson developed a theory by which photography could be artistic through a softening of focus—or selective focus, an idea ultimately derived from Herman Ludwig Ferdinand von Helmholtz's theories of human vision—which was meant to render a more natural image. He put these ideas forward in 1889 under the title *Naturalistic Photography*. Convinced by the painter James McNeill Whistler that he had been confusing art with nature, however, Emerson retracted his theory the next year in a black-bordered pamphlet called *The Death of Naturalistic Photography, a Renunciation*. In it Emerson wrote that "photography was only confessing its weaknesses when it indulged in the alteration of tonal values, false emphasis to certain areas of the picture, and the use of soft focus and special effects."[1] Nevertheless, despite his own change of heart, Emerson had advanced a somewhat convincing argument and a style to go with it that was taken up by the pictorialists.

Pictorialism, the artistic photography movement just before and after the turn of the twentieth century (and I include within it Alfred Stieglitz's so-called Photo-Secession), continued the softened look of Emerson's style while also looking to the painters of the tonalist movement and turn-of-the-century aestheticism for its visual ideas. The dreamworld depicted in the languorous poses and soft renderings of the pictorialists evaporated, however, in the disillusionment of World War I.[2] It was only after the war that photography came into its own as a distinctive medium with its own aesthetic and with little relation to the older visual arts. This was when photographers perfected a unique and new philosophy of their relation to the world, a relationship that I call spontaneous witness. More than an aesthetic position, spontaneous witness is a way of being in the world, with a quality of attention all its own, that might even be termed a metaphysical path. This way of being, however, depended for its realization not just on aesthetic ideas but on technological progress as well.

Unlike other kinds of works of art, photographs have always required the photographer's presence on the scene in order to make an image of the scene. The first photographers were limited to static, painfully posed subjects, generally in a studio setting. Later the camera was brought out into the world, but even then—as in the

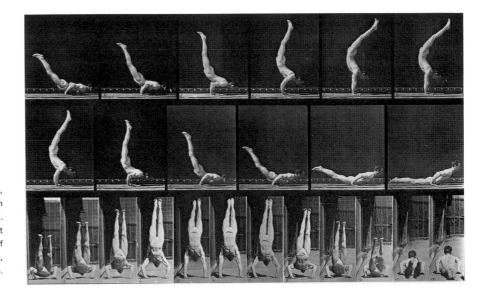

FIGURE 1.1. Eadweard Muybridge, *Acrobat, Horizontal Pressup,* from *Animal Locomotion,* 1887. University of New Mexico Art Museum, Albuquerque, gift of the Commercial Museum, Philadelphia, Pa.

documentation of the Crimean War or the U.S. Civil War—photographers were limited to static scenes after the battles or posed in camp.

The breakthroughs that allowed for action photographs were the introduction of much more light-sensitive, prepared dry-plate emulsions in 1878 and the introduction of roll film and hand cameras in the 1880s. Armed with these more sensitive materials (and freed from the darkroom), photographers could roam the world, catching life as it happened. Any number of professionals intent on photographing city streets caught people in the act of moving about, caught them sharply enough to introduce a new kind of human image. John Thomson in England, Alice Austen in New York, and Arnold Genthe in San Francisco's Chinatown, for example, caught life on the run (or walk) in images that look remarkably fresh to this day. There were many other professionals in the street, joined after 1888 by legions of amateurs with their little Kodak cameras, whose wide-angle lenses made it possible to catch and fix motion.

In addition, there were experimenters set on dissecting motion itself, men like Eadweard Muybridge and Thomas Eakins, who in the 1880s made sequenced studies of animals and humans in motion, providing a new dictionary of action that proved useful to painters. All of these developments set the stage for a new kind of visual imagery connecting figures not only to place but also to *specific moments in time.*

In this new territory it was not always professionals who led the way. As John Szarkowski has taught us, "Photography has learned about its nature not only from its great masters, but also from the simple and radical works of photographers of modest aspiration and small renown."[3] We have a delightful example of such radical, prophetic work in the photographs that a young French boy, Jacques Henri Lartigue, made in the first two decades of the century. Lartigue was a privileged young fellow who began to make photographs at the age of eight in 1902 (and would later in fact become famous for them), recording his family and friends in the air, in motion, definitely in a new century. Perhaps free from pictorial conventions because a child, he was able to realize in boyhood an almost perfect twentieth-century style. His interests in racing cars and early airplanes perfectly reflected the general fascination with speed and machines in the new century.

The final technical ingredient that allowed for the full development of spontaneous witness in photography was the development of the small camera with a "fast" lens (i.e., a wide aperture and a short focal length) in the 1920s. The Ermanox, with its fast f.2 lens, was advertised with the slogan, "What you can *see* you can *photograph*." The Leica, a small camera using 35 mm motion-picture roll film,

FIGURE 1.2. Jacques Henri Lartigue, *My Cousin Jean Haguet, Chateau de Rouzat*, 1911. J. H. Lartigue, © Ministère de la Culture, France/Association des Amis de J. H. Lartigue.

with a choice of removable lenses, was put on the market in 1925 (just after the Ermanox). The Leica allowed for virtually unlimited exploration, and with it Henri Cartier-Bresson prowled the world looking for what he was to call "decisive moments." Many others followed, and from this time spontaneous witness as a style was fully launched.

Cartier-Bresson was uniquely positioned to spread this new style not only because of his role as a foremost practitioner but also because of his connections to the advanced culture of his day, both social and artistic, and his international travel. As a young bourgeois French gentleman studying painting Cartier-Bresson had the freedom to explore the world and the intellectual currents of his day, most importantly the "primitive" and surrealism: "I was marked, not by Surrealist painting, but by the conceptions of Breton, [which] satisfied me a great deal: the role of spontaneous expression [*jaillissement*] and of intuition and, above all, the attitude of revolt."[4] "Alone," writes Peter Galassi in his book on Cartier-Bresson, "the Surrealist wanders the streets without destination but with a premeditated alertness for the unexpected detail that will release a marvelous and compelling reality just beneath the banal surface of ordinary experience."[5]

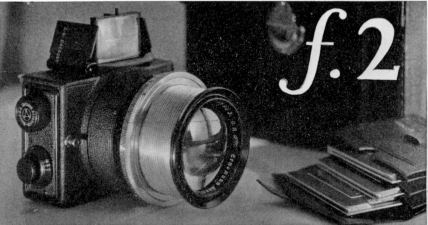

Anton Bruehl

FIGURE 1.3. Advertisement for Ermanox Camera, 1926 (photo: Anton Bruehl). Courtesy George Eastman House; Anton Bruehl Jr.

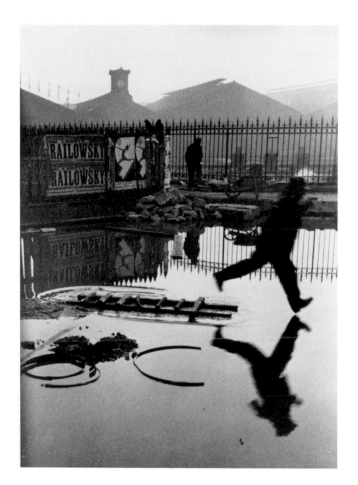

FIGURE 1.4. Henri Cartier-Bresson, *Man Jumping a Puddle, Gare St. Lazare, Paris,* 1932. © Henri Cartier-Bresson, Magnum Photos, Inc.

A 1930 trip to Africa, where Cartier-Bresson worked as a hunter, was followed by a long recuperation from blackwater fever, during which time he completely lost his taste for painting and acquired his first Leica. As he said about this time, "The adventurer in me felt obliged to testify with a quicker instrument than a brush to the scars of the world."[6]

Through connections Cartier-Bresson met some influential international cultural figures while still in France, including the art dealer Julien Levy, who featured Cartier-Bresson's photographs in his New York gallery in the fall of 1933, before he had even visited the United States. By the time Cartier-Bresson arrived there, in 1935, his work was known, and he had a *second* exhibition at Julien Levy's gallery, this time together with Walker Evans and the Mexican photographer Manuel Al-

varez Bravo. During his year in the United States Cartier-Bresson made the acquaintance of the cultural impresario Lincoln Kirstein and the young photographer Helen Levitt, among others.[7] During this time he even made some experimental (and evidently unsuccessful) fashion photographs for Carmel Snow, the editor of *Harper's Bazaar*. In this way Cartier-Bresson's work—and its new, 35 mm spontaneous style—became known on both sides of the Atlantic early in the 1930s.

To the long-accepted truth to its subject that the camera had always provided, the 35 mm camera added truth to a moment as well. From their first astonished responses in 1839, people had believed what they saw in photographs, however surprising. In the same vein, the underlying purpose in the new photography became to reveal the truth of a split second, something that was true but could be seen *only* with the aid of a camera. An essential element in the acceptance of the new photographs was a hands-off authenticity, or no fakery. This issue of authenticity had always been key to the acceptance of photographs. In the words of painter Henri Matisse, echoing a prevalent appreciation of photography, "Photographs will always be impressive because they show us nature, and all artists will find in them a world of sensations. The photographer must therefore intervene as little as possible, so as not to cause photography to lose the objective charm which it naturally possesses, notwithstanding its defects."[8] The new photographers practiced authentic witness to real moments and "intervened as little as possible." The viewer's faith was maintained.

The magic that is essentially photographic in our time has thus derived from a relationship to *place* and also to *time*, a cosmic pinpoint, a moment in which something otherwise not known is revealed. This revelation is the epiphany, or the decisive moment, and it expresses a theory of relationship to the world. It's a relationship of attention, requiring an alertness and ego-less sensitivity that turns the photographer into what Ralph Waldo Emerson in *Nature* (1836) deliciously termed a "transparent eyeball." Cartier-Bresson's photographs, interestingly enough, typically did not portray specific incidents but rather moments of ambiguity or imbalance; thus, although he referred to them as "decisive," such moments had an open-ended ambivalence and not the closure of decision. Perhaps to call this way of photography "metaphysical" seems a bit overreaching, but to call it simply "aesthetic," relating to a theory of the beautiful, does not say enough. I am writing about a belief that one can penetrate the moment and uncover a mystery.

What does it feel like to be driven by this belief? For starters, one goes out into the world knowing only vaguely what will happen. Whether shooting a landscape,

a street scene, a social occasion, or simply sunlight falling on a wall, the photographer has no plan or sketch that will be filled out in the field. Rather, one is prepared—plenty of film, equipment, research, and usually a destination—and mostly, like Galassi's surrealist, one depends on *what may happen.*

Roaming about in readiness, the photographer looks at the world in a state of high alertness and sensitivity. Something triggers a response, and the photographer is engaged—engaged, that is, in collaboration with the world in front of the camera. For example, Ansel Adams wrote about making one of his well-known landscapes, *Tenaya Creek during a Rainstorm* (1948), as follows:

> One cloudy spring day I was searching for dogwood displays, and as I was driving up the Mirror Lake Road I glimpsed an attractive possibility near Tenaya Creek. I parked the car and walked about six hundred feet toward the dogwood I saw glimmering in the forest. On reaching the creek I saw an inevitable opportunity; I returned to my car and gathered my 8 × 10 equipment.
>
> A light rain began to fall, and I considered giving up for the day, but when I came

FIGURE 1.5. Ansel Adams, *Tenaya Creek during a Rainstorm*, 1948. © Ansel Adams Publishing Rights Trust/CORBIS.

to an opening in the trees and saw this subject open up before me I banished such thoughts of defeat and set up the camera under protection of the focusing cloth. . . .

As with many of my photographs, this picture opportunity seemed to be waiting for me; the visualization was immediate and complete. . . . The photographer learns to seek the essential qualities of his environment, wherever he might be. By this I mean that he should be tuned to respond to every situation.[9]

Most times success is not known until the film has been processed. At that point there may be many discoveries. In a melodramatic way, with its accidental discovery of a murder during the printing of a roll of film, Michelangelo Antonioni's film *Blowup* (1966) was built around that stage in the process, but more often it is an effect of the light, an unnoticed expression, or an odd juxtaposition of forms that emerges like magic. Indeed, the successful photographer sometimes feels as if a miracle has been captured, as if he or she is a medium through which the magic can happen. Harry Callahan described it this way: "I sort of believe that a picture is like a prayer; you're offering a prayer to get something, and in a sense it's like a gift of God because you have practically no control."[10]

Many photographers have written or spoken about this experience. Emphasizing the importance of relating to and being in the world, Helen Levitt wrote, "All I

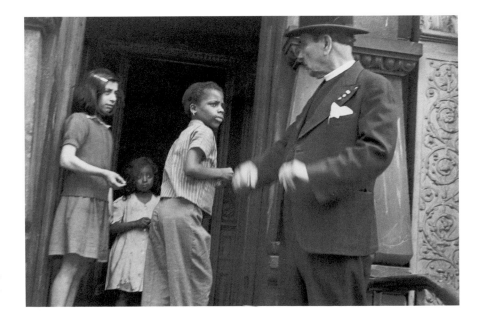

FIGURE 1.6. Helen Levitt, *New York*, ca. 1945. © Helen Levitt. Courtesy Lawrence Miller Gallery, New York.

can say about the work I try to do, is that the aesthetic is in reality itself."[11] Edward Weston described his way of working this way:

> With over twenty years of experience, I never try to plan in advance. Though I may from experience know about what I can do with a certain subject. . . . I start out with my mind as free from an image as the silver film on which I am to record, and I hope as sensitive. Then indeed putting one's head under the focussing cloth is a thrill. . . . one becomes a discoverer, seeing a new world through the lens.[12]

About making portraits Weston wrote,

> Since I never "pose" a subject but rather wait for significant moments—and they happen continually—it becomes less possible to start with preconceived ideas. The moment presents and suggests what to do, and how to do it. . . . The photographer, however, may have to effect a full integration within a few seconds.[13]

Willard Van Dyke wrote similarly about Dorothea Lange's method:

> She feels that setting out with a preconceived idea of what she wants to photograph actually minimizes her chance for success. Her method is to eradicate from her mind before she starts, all ideas which she might hold regarding the situation –her mind like an unexposed film.[14]

Even Jerry Uelsmann, that proto-digitizer, whose work from the 1960s on makes a bridge to a postwitness aesthetic, describes the same way of working: "I try to begin working with no preconceived ideas."[15]

Aaron Siskind advised photographers to

> learn to relax. . . . Move on objects with your eye straight on, to the left, around on the right. Watch them grow large as you approach, group and regroup themselves as you shift your position. Relationships gradually emerge, and sometimes assert themselves with finality. And that's your picture.[16]

Cartier-Bresson was equally concerned with composition, which "must be one of our constant preoccupations, but at the moment of shooting it can stem only from our intuition."[17]

Minor White, who through his influential teaching and editing of *Aperture* brought spiritual concepts into midcentury photography, wrote:

The state of the mind of the photographer while creating is a blank . . . a special kind of blank. It is a very active state of mind really, a very receptive state of mind, ready at an instant to grasp an image, yet with no image pre-formed in it at any time. . . . The photographer projects himself into everything he sees, identifying himself with everything in order to know it and feel it better.[18]

White described a kind of ego-erasure, a rapture of complete identification with the world, *projection* in his terms. It can be a moment of *reception* as well. Paul Caponigro described his deliberate effort to quiet his ego and prepare himself to receive a photograph as follows:

I strive to undo my reactions to civilization's syncopated demands and hope that inner peace, quiet, and lack of concern for specific results may enable a stance of gratitude and balance—a receptiveness that will allow the participation of grace.[19]

It can also be a moment of *recognition,* of finding oneself psychically in the world, or as Robert Frank wrote, it is "the instantaneous reaction to oneself that produces a photograph."[20]

Was this attitude new in the twentieth century? To be sure, some nineteenth-century photographers reveled in accident and the uncanny plenitude the camera could reveal. William Henry Fox Talbot, one of the medium's inventors and its early brilliant theorist, wrote clearly about such things as early as 1844 in *The Pencil of Nature,* but cameras were clumsy then and exposures were too long for motion or spontaneity. Also, despite advancing technology, in its images nineteenth-century photography basically repeated pictorial schemes from painting. It was not until the early twentieth century that photography was able to strike this new note.

SPEED AND THE MACHINE

To do justice to modern technology's rigid linear structure, to the lofty gridwork of cranes and bridges, to the dynamism of machines operating at one thousand horsepower—only photography is capable of that. What those who are attached to the "painterly" style regard as photography's defect, the mechanical reproduction of form—is just what makes it superior to all other means of expression. —ALBERT RENGER-PATZSCH

A T THE BEGINNING of the twenty-first century we sit at our personal computers and with the soft motion of fingers on a keyboard bring the world to our monitor screens (feeling annoyed, of course, if this takes more than a few seconds). How strange for us to imagine a world of distance, delay, and in many cases utter darkness. And yet that was the world of not so long ago.

The nineteenth was the great industrial century, and its steam-driven engines transformed manufacture and also travel. A vast network of railroads spread across the American continent, as well as throughout Europe and much of Asia and the colonized world, and great oceangoing ships circled the globe. Toward the end of the century its technical innovations began to predict the character of the twentieth century: a rapidly growing collection of inventions that fostered speed and instantaneous communication. Alexander Graham Bell invented the telephone in 1876, Thomas Edison invented the phonograph in 1877, and the first practical electric lights were devised independently by Edison and J. W. Swan in 1880.

Photographic dry plates, precoated glass plates ready for exposure, were devised in 1871 by a British physician, Richard Leach Maddox, and were perfected and marketed by 1878, allowing exposures as short as 1/25 second. The first halftone reproduction, by which a photograph was rendered as an image made up of dots of

varying sizes, was printed in the *New York Daily Graphic* on 4 March 1880. A few years later, in 1885, George Eastman manufactured coated photographic paper, and in 1888 he introduced the first of his Kodak cameras to the amateur market with the slogan "You press the button, we do the rest," bringing the taking of photographs to millions. In 1887 instantaneous flashlight powder, an improvement on the older magnesium flare, was invented in Germany by Adolf Miethe and Johannes Gaedicke. Karl Benz and Henry Ford built their first automobiles in 1893. In 1895, x-rays were discovered by William Roentgen, and in that same year Marconi invented radiotelegraphy. Utilizing the inventions of Edison and August and Louis Lumière, of France, motion-picture films were being screened regularly in the great cities of Europe and America by the end of 1896.[1]

Perhaps none of these breakthroughs rivaled the earlier mechanical inventions that had ushered in the age of steam, but they all shared the two factors that would drive the culture of the twentieth century: *speed* and *communication*. As the new century opened these factors gained momentum. In 1903 Orville and Wilbur Wright successfully flew a powered airplane. Henry Ford continued to refine his methods of automobile production and by 1915 had produced his millionth car. In that same year Bell, in New York, placed a transcontinental phone call to Thomas A. Watson in San Francisco. In 1919 Ross and Keith Smith flew from London to Australia in 135 hours, and in 1927 Charles A. Lindbergh became an international hero when he flew his monoplane *Spirit of Saint Louis* nonstop from New York to Paris in thirty-three and one-half hours. That same year, underground, New York and New Jersey were linked by the Holland Tunnel. The next year, the New York Times installed the first of its "moving" electric signs around the Times Building.[2] The world was getting smaller as information proliferated and as both communication and vehicular travel gathered speed.

An enormously important advance in the dissemination of news photographs was the Wirephoto. Professor Alfred Korn, of the University of Munich, transmitted a photograph over a telegraph wire in 1907, and the photograph was published on the cover of the 17 February 1907 *Scientific American*. Not until 1935, however, did this become a significant technology for newspapers: "The transmission of a photograph by The Associated Press over telephone wires to its twenty-four-member network on January 1, 1935, marked not only the opening of AP Wirephoto, a significant step in the history of The Associated Press, but a dramatic advance in photojournalism."[3]

AP's general manager, Kent Cooper, understood where the competition for news

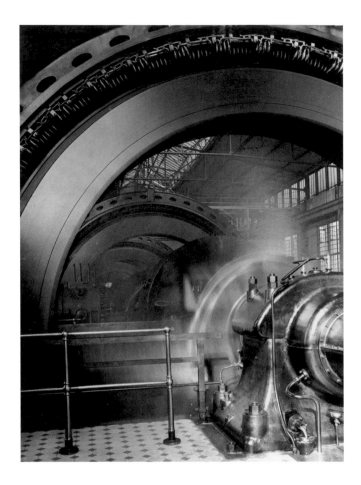

FIGURE 2.1. Albert Renger-Patzsch, *Ilsender Foundry, a Row of Generators*, 1925–1926. The J. Paul Getty Museum, Los Angeles.

pictures was headed even in 1934, and he persuaded the reluctant AP members to go forward by asking, "Why in an electrical age that has brought to other industries wide public acceptance and acclaim should The Associated Press default to its members upon an opportunity to deliver pictures by wire when they are faced with the future of live pictures by television?"[4]

Electricity was the new power driving industry, and the first two decades of the century were indeed the early electrical age, in which machines driven by electricity replaced human labor and the steam engine at a rapid rate.

The very buildings of business were changed as well. "Perhaps one of the most important elements in . . . the first two decades of the century was the increase in construction, particularly of the American skyscraper."[5] An early icon for modern

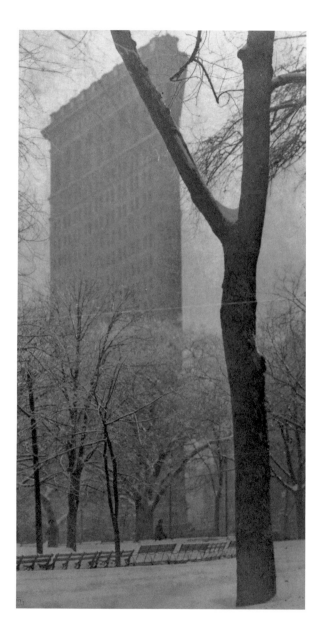

FIGURE 2.2. Alfred Stieglitz, *The Flatiron Building, New York* (photogravure), 1903. © The Art Institute of Chicago, Alfred Stieglitz Collection, all rights reserved.

photographers was the wedge-shaped Flatiron Building, described in 1903 by Alfred Stieglitz, one of its early photographers, as "not hideous, but the New America. The Flat Iron [*sic*] is to the United States what the Parthenon was to Greece."[6] Soon followed the forty-one-story Singer Building, completed in 1908, the sixty-six-story Woolworth Building, completed in 1913, and the soaring Empire State Building, completed in 1931, at eighty-five stories the tallest in the world for years to come. The urban landscape, particularly in America, had undergone a massive transformation—its buildings soaring skyward and its streets full of automobiles.

In Europe, World War I had brought the old world to an end, particularly in defeated Germany, and in the twenties progressives embraced a new aesthetic of stripped, pure form without reference to the past. The Bauhaus, with its radical rethinking of all the arts, was at the forefront of this new approach (photography's important part in Bauhaus thinking is discussed in Chapter 3). Everywhere the look of the world was changed. In his 1927 introduction to *Métal*, by the photographer Germaine Krull, Florent Fels wrote, "Steel is transforming our landscapes. Forests

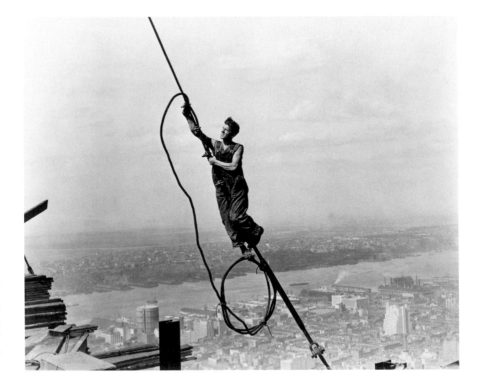

FIGURE 2.3. Lewis Hine, *Icarus, Empire State Building*, 1930. The Metropolitan Museum of Art, Ford Motor Company Collection, Gift of the Ford Motor Company and John C Waddell, 1987 (1987.1100.119).

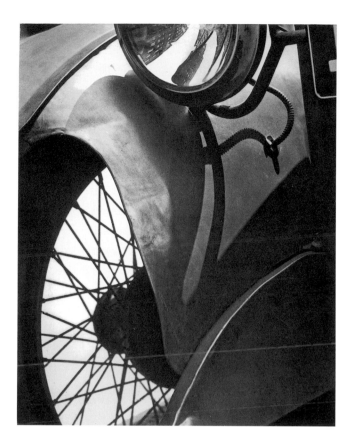

FIGURE 2.4. Paul Strand, *Wire Wheel, New York,* 1917. © 1976, Aperture Foundation, Inc., Paul Strand Archive.

of pylons replace age-old trees. Blast furnaces supplant hills. . . . The airplane, the elevator, the wheel, which sweep some few human beings up to the kingdom of the birds, have suddenly changed even our natural element."[7]

In the new Soviet Union, photography was given an important official role. A Higher Institute of Photography and Photographic Techniques was established within a year of the Soviet accession to power, and other photo-related agencies were established as well. The historian Grigory Shudakov has written that "such initiatives testified to an enormous growth of interest in photography and to the fact that, through the efforts of worker and peasant councils, photographic techniques, education and information were being developed on a national scale."[8]

The most important of these Soviet photographers was Alexander Rodchenko. His dynamic pictures of work, machines, and citizens were often taken at odd an-

gles, introducing a sense of lively urgency and motion even when there was none. Rodchenko's photographs were dedicated to political ends:

> We must seek and find, and (rest assured) we shall find, a new aesthetic, together with the enthusiasm and pathos necessary to express our new reality, the Soviet reality, through the medium of photography. For us, the photograph of a newly constructed factory is not merely a picture of a building, not merely the record of a fact, but an expression of pride and joy in the industrialization of the land of the Soviets.[9]

The buildings and mechanical structures of this new landscape became subjects for photographers in other European countries and America as well, and for other artists, like the American precisionists. The perfect geometry of machines became a lexicon of forms for painters like Fernand Léger and for dadaists like Francis Picabia, who saw machines as odd metaphors. It was the photographers, though, who celebrated machine forms in the most direct way, and little transformation was necessary to effect the look of abstraction in these photographs. The so-called cubist photographs by Paul Strand and others were in fact straightforward views, though frequently closeup fragments. As Van Deren Coke noted,

> On the one hand, the photographers used the close-up to follow contemporary artists into abstraction, and, on the other hand, details became a new short-hand visual language used to express the increasingly fast pace and fragmentation of life that has characterized our century. The photographer provided a sign, or signaled a clue, and the rest of the information was filled in as we became adept at reading fragments seen out of the windows of rapidly moving cars, buses, and airplanes.[10]

In photographic technology itself, refinement of optics and new inventions produced a radical transformation. Sound motion pictures were first demonstrated by Lee deForest in 1923, and George Eastman first exhibited color motion pictures in 1928.[11] More important for still photography, however, was the miniaturization of cameras. Dry plates, rapid printing paper, and the perfection of enlargers at the end of the nineteenth century had brought about the smaller "hand cameras," cameras that look terribly big and awkward today. Early in the 1920s, however, two innovations allowed the hand camera to become much more truly hand-sized: lenses with greatly increased light-passing power and small, compact precision cameras on which these lenses could be used to produce negatives capable of great enlargement. An example was the f.2 Ernostar lens, marketed in 1924 for the Ermanox camera, which used little glass plates or cut film. The manufacturer of the Ermanox claimed:

"This extremely fast lens opens a new era in photography, and makes accessible hitherto unknown fields with instantaneous or brief time exposures without flash light: night pictures, interiors by artificial light, theater pictures during performance, children's pictures, scientific records, etc."[12]

Even more successful was the Leica camera, invented by Oscar Barnack and put on the market in 1925, which improved upon the Ermanox by using a length of 35 mm motion-picture film instead of single sheets, allowing a sequence of photographs to be made in quick succession. The Contax camera followed in 1932, and soon lenses as fast as f1.5 were available for both cameras.[13] As noted in Chapter 1, through the work of Cartier-Bresson in particular American photographers were exposed to this new 35 mm style. Other "miniature" cameras followed, including the slightly larger Rolleiflex (1928), with its 6 × 6 cm negative, and there were hundreds of models available by midcentury. During the Korean War, Japanese optics made a huge impact on photographers covering the war, and the era of the Japanese miniature camera began in the 1950s.[14] Not all photographers used the small cameras right away; many artistic photographers continued to use large cameras, and many photojournalists stuck loyally to their 4 × 5 Speed Graphics even into the 1950s.[15] Nevertheless, with European photographers generally in the lead, the use of miniature cameras eventually became universal for documentary or news photography.

The revolution these cameras produced in photography was similar to the revolution that steel construction produced in architecture. What came before and

after were different worlds. Or as Carlo Rim wrote in jest about the speed possible in the new photography, "There is the posed photo and the snapshot, just as there is sculpture and the footrace."[16]

Of course, cameras present only possibilities—it is photographers who make a new kind of photography. It was André Kertész, Erich Salomon, and, more importantly, Henri Cartier-Bresson who created a new way of making photographs. When Cartier-Bresson began using the Leica,

> it became the extension of my eye, and I have never been separated from it since I found it. . . . I prowled the streets all day, feeling very strung-up and ready to pounce, determined to "trap" life—to preserve life in the act of living. Above all, I craved to seize the whole essence, in the confines of one single photograph, of some situation that was in the process of unrolling itself before my eyes.[17]

The thirty-six exposures available on a roll of film allowed Cartier-Bresson to shoot many exposures and then select the one, most perfect "decisive moment." These new photographs caught a cross section of motion, a moment of odd equilibrium (or disequilibrium) that became the new theme for photography—perfectly in tune with the century of speed.

In 1936 the French poet and political activist Louis Aragon summarized the gifts of the new photography at a symposium called "The Quarrel over Realism." He understood that the secret of the new photography was the insight into motion:

> How much of all that [in-motion discoveries, fugitive expressions, etc.] is to be found in classical photography up to and including Man Ray? Exactly nothing. We must look to the most recent times to find, finally, among the younger photographers a sort of renewal of their art, which was certainly based on the development of new types of cameras. In the last few years, the manufacture of cameras such as those of the newspaper photographers, the principle of which is very similar to that of cinema cameras, has brought about an absolutely new school of photography, . . . thanks to the technical perfection of the camera, photography in its turn has abandoned the studio and lost its static, academic character—its fixity. It has mixed into life; it has gone everywhere taking life by surprise: and once again it has become more revealing and more denunciatory than painting. It no longer shows us human beings posing, but men in movement. . . . The photograph . . . today stops at nothing. It is discovering the world anew.[18]

A final technological development that further allowed photography to "go everywhere taking life by surprise" was the refinement of flash. In 1925 Paul

Vierkötter patented an electric flash bulb, and bulbs were marketed by the end of the twenties that gave a brilliant, fast light. The noiseless and smokeless flash was immediately adopted by news photographers and soon used by most others, and when the multiple synchroflash technique was developed, the control and subtlety of flash was greatly improved.

Photographs taken at night constituted an interesting and important area of spontaneous witness in the thirties. Brassaï (originally from Hungary) in Paris and Bill Brandt (originally from Germany) in London both pursued the nocturnal denizens of their adopted cities. Both shot some of these pictures by available light, but both used flash as well. Both produced provocative, candid views of this dark side of life, as well as some not-so-candid arranged pictures, using friends for actors or similarly intensifying the story aspect of their pictures.

In 1931 Professor Harold Edgerton, at the Massachusetts Institute of Technology (MIT), developed an even more brilliant, electronic flash with durations as short as one microsecond (1/1,000,000 sec.), and these permanent electronic flash bulbs could be used over and over again, unlike the earlier ones, which had to be discarded after one use. Edgerton experimented with a rapidly repeating, stroboscopic electronic flash, and his remarkable photographs introduced a new way to

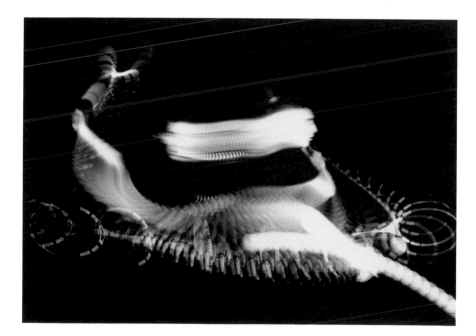

FIGURE 2.6. Harold Edgerton, *Swirls and Eddies of a Tennis Stroke*, 1939. © Harold and Esther Edgerton Foundation, 1999, courtesy of Palm Press, Inc.

analyze and picture motion. His splashing drops of milk, bullets going through apples, and multiple exposures of golf swings and tennis strokes have become delightful icons of our time.[19]

Although not at first universally accepted—for example, Cartier-Bresson said, "And no photographs taken with the aid of flashlight either, if only out of respect for the actual light—even when there isn't any of it"[20]—electronic flash, from miniature to enormous, studio-size units, is now used by almost all photographers and has extended their ability to capture motion far beyond what the eye can see. At the same time, electronic flash may be said to have compromised the spontaneity and authenticity of the photograph, making, as it does, a dramatic intervention into the moment photographed—an early sign, perhaps, of the compromise of spontaneous witness in its purest form.

FINE-ART PHOTOGRAPHY, REDEFINED

The unintelligence of present-day photographers, that is of so-called pictorial photographers, lies in the fact that they have not discovered the basic qualities of their medium. —PAUL STRAND

In today's photographic work, the first and foremost issue is to develop an integrally photographic approach that is derived purely from the means of photography itself. —LÁSZLÓ MOHOLY-NAGY

I use the legitimate controls of the medium only to augment the photographic effect. . . . As long as the final result of the procedure is photographic, it is entirely justified. —ANSEL ADAMS

THERE CAME TO BE a long agreement among modernists on both sides of the Atlantic, as well as on the Pacific coast—for example, Strand in the East, Moholy-Nagy in Germany, and Adams in the West—that the proper criterion for art photography was the *photographic purity of means*, without reference to other artistic media—no handworking of the print or negative, no obscuring of the sharpness of focus or the purely chemical nature of development. Such a stance, new in the twenties, was a rejection of pictorialism and an embrace, instead, of the mechanical, optical, and chemical nature of photography.

The fine-art photographers—those we might define as making pictures for aesthetic contemplation, not for some other, more practical purpose—thought more deeply, as was their nature, about the proper use of their medium than did the journalists or documentarians, who had a job to do and a message to deliver. The latter had used their cameras purely, as clarity and precision of information was always

FIGURE 3.1. Edward Weston, *Dancing Nude (Bertha Wardell)*, 1927. Collection, Center for Creative Photography. © 1981 Center for Creative Photography, Arizona Board of Regents.

their goal, but the artistically ambitious photographers had gone through a long period of imitation, of hoping their pictures would be considered works of art if they looked like the etchings or paintings they admired. The first two decades of the century, however, with their embrace of the machine and rejection of the old, touched the art photographers profoundly, and during the twenties and thirties many of them put away their soft-focus lenses and textured papers in favor of the precise look of the new photography.[1] Edward Weston described the new photography like this:

> It should be sharply focused, clearly defined from edge to edge—from the nearest object to most distant. It should have a smooth or gloss surface to better reveal the amazing textures and details to be found only in a photograph. Its values should be convincingly rendered; they should be clear-cut, subtle or brilliant—never veiled.[2]

If they agreed on purity of means, though, they disagreed on the limits of those means. Two very different new aesthetics developed in the 1920s: a broadly exper-

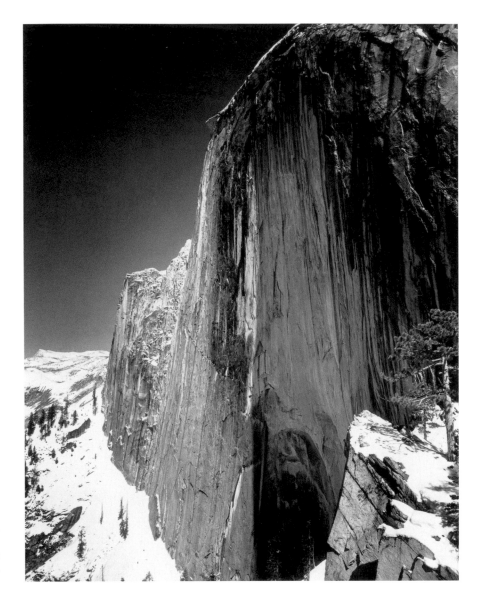

FIGURE 3.2. Ansel Adams, *Monolith, the Face of Half Dome*, 1927. © Ansel Adams Publishing Rights Trust/CORBIS.

imental approach in Europe, particularly at the German Bauhaus, following the theories of Moholy-Nagy, and a narrower American approach, for which the quotation by Weston can stand as a typical statement.

The West Coast aesthetic, which tended to dominate in the United States up to the 1960s, was institutionalized in the "f.64" group of photographers, who used large cameras and sharp lenses,[3] and was systematized by Ansel Adams in his phi-

losophy of previsualization (seeing all the colors in a scene translated into the black to white tones of a photograph before the shutter was tripped) and his methodical zone system for reading reflected light and translating it into black and white. The approach to the subject, as well, was one that glorified heightened description, often in extreme closeups, and abjured symbolic interpretation. As Weston put it,

> To see the *Thing itself* is essential: the quintessence revealed direct without the fog of impressionism. . . . This then: to photograph a rock, have it look like a rock, but be *more* than a rock. Significant presentation—not interpretation.[4]

On the East Coast, photographers like Strand, Charles Sheeler, Edward Steichen, Paul Outerbridge, Berenice Abbott, and Ralph Steiner took a similar approach, although their subjects were more likely to be architectural and mechanical, while the Westerners more often pictured nature.

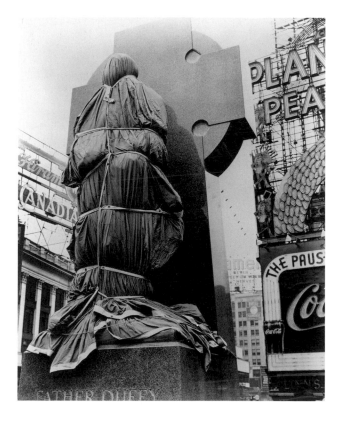

FIGURE 3.3. Berenice Abbott, *Father Duffy, Times Square,* 1937. © Museum of the City of New York, Federal Arts Project: Changing New York.

A similar crisp realism was practiced in Europe by photographers like August Sander, Albert Renger-Patsch, and Karl Blossfeldt. Echoing (or preceding) Weston's views about the "Thing itself," Hugo Sieker wrote that Renger-Patzsch's photography

> reveals nature more intensely than nature reveals herself—precisely because it offers a concentrated selection of what nature withholds by her very abundance. . . . for [the photographs'] essential quality is that they awaken in the viewer, quite forcefully at times, this extremely rare *amazement* at the *miraculousness of physical reality.*[5]

In Europe, however, the new art photography was full of creative options beyond sharp-focus realism. The broad spectrum of the New Vision, as the new aesthetic was called, encompassed at one end work as straightforward as the real-

FIGURE 3.4. Lucia Moholy, *László Moholy-Nagy,* 1925–1926. The Metropolitan Museum of Art, Ford Motor Company Collection, Gift of Ford Motor Company and John C. Waddell, 1987 (1987.1100.69).

ism of Blossfeldt or Renger-Patzsch, yet toward the other were a wild variety of techniques—photomontage, photograms, double exposure, negative prints and solarization, and photographs taken at dizzying angles.[6] In the more complex art culture in Europe, where the devastations of war had conspired to produce a cultural openness and where the cubists, futurists, constructivists, and dadaists had revolutionized modern art, all certainties were off and artists were encouraged to search for the most radical new solutions.

Nowhere was this radical thinking more developed than at the Bauhaus. This new German school of arts, architecture, and industrial design was established in 1919 in Weimar, and it survived at two other locations until it was closed by the Nazis in 1933 (after which many of its most important teachers emigrated to the United States to continue their teaching). Bauhaus thinking encouraged students to use technology and to consider both the usefulness and the beauty of objects simultaneously. It promoted photography both as a method of documentation and as a medium of illustration. The only Bauhaus photography class, taught by Walter Peterhans, was aimed at advertising, but the radical rethinking about the medium came from László Moholy-Nagy through his teaching at the Bauhaus (until 1928), his writings, and his own photography.

While the Americans seemed concerned with narrowing acceptable practice to a few "pure" techniques, Moholy-Nagy's thinking was expansive, typically listing *all* the possibilities of photography. The following list from 1936 gives one an idea of this expansiveness:

THE EIGHT VARIETIES OF PHOTOGRAPHIC VISION

1. Abstract seeing by means of direct records of forms produced by light: the photogram which captures the most delicate gradations of light values, both chiaroscuro and colored.

2. Exact seeing by means of the normal fixation of the appearance of things: reportage.

3. Rapid seeing by means of the fixation of movements in the shortest possible time: snapshots.

4. Slow seeing by means of fixation of movements spread over a period of time: e.g., the luminous tracks made by the headlights of motor cars passing along a road at night: prolonged time exposures.

5. Intensified seeing by means of:
 a) micro-photography;
 b) filter-photography, which, by variation of the chemical composition of the sensi-

tized surface, permits photographic potentialities to be augmented in various ways—ranging from the revelation of far-distant landscapes veiled in haze or fog to exposures in complete darkness: infra-red photography.

6. Penetrative seeing by means of X-rays: radiography.

7. Simultaneous seeing by means of transparent superimposition: the future process of automatic photomontage.

8. Distorted seeing: optical jokes than can be automatically produced by:

 a) exposure through a lens fitted with prisms, and the device of reflecting mirrors; or

 b) mechanical and chemical manipulation of the negative after exposure.[7]

European photographers did work in any number of the eight varieties, with multiple exposure, photogram, negative print, solarization, and photomontage being especially favored. Martin Munkacsi was a pioneer in photographing suspended motion even before the 35 mm camera was available, and many used the camera from odd up or down viewpoints.

Above all, Moholy-Nagy believed that photography should present something new not merely re-present something familiar, and for him "the photogram [(1) above], or camera-less record of forms produced by light, which embodies the unique nature of the photographic process, is the real key to photography."[8] Certainly, progressive Americans such as Strand, Weston, and Adams, with their devotion to sharpness and realistic detail, would not agree with his elevation of the photogram, yet they would agree with his statement that photography's "own basic laws, not the opinions of art critics, will provide the only valid measure of its future worth."[9] And I think they would have joined Moholy-Nagy in his most famous pronouncement of all, namely, that "a knowledge of photography is just as important as that of the alphabet. The illiterate of the future will be ignorant of the use of camera and pen alike."[10]

Onto this heady and wide-open photography scene in the 1930s came the early users of the Leica camera, and this little instrument had its own nature and basic laws beyond simply facilitating "rapid seeing" ([3] above). After using the 35 mm camera for two decades, Cartier-Bresson articulated its basic laws in his 1952 introduction to *The Decisive Moment*. Most important, it seems, was the possibility of shooting rapid-fire *sequences* from several perspectives on the long rolls of film.

Sometimes a single event can be so rich in itself and its facets that it is necessary to move all around it in your search for the solution to the problems it poses—for the

FIGURE 3.5. László Moholy-Nagy, *Photogram*, 1920s. The Metropolitan Museum of Art, Ford Motor Company Collection, Gift of Ford Motor Company and John C. Waddell, 1987 (1987.1100.158). © 2002 Artists Rights Society (ARS), New York/VG Bild-Kunst, Bonn.

world is movement, and you cannot be stationary in your attitude toward something that is moving.[11]

He encouraged a low-key unobtrusiveness as well, especially in making portraits: "Above all, the sitter must be made to forget about the camera and the man who is handling it. Complicated equipment and light reflectors and various other items of hardware are enough, to my mind, to prevent the birdie from coming out."[12] This, added to Cartier-Bresson's prejudice against flash, became popular as the cult of "available light" and "candid" photography, which was followed by 35 mm professionals and amateurs for decades.

A final rule from Cartier-Bresson had to do with composition, for him a delicate process of the greatest importance. A decisive moment was complete when the "geometry" of composition was correct, and within the photographed frame everything was sacred:

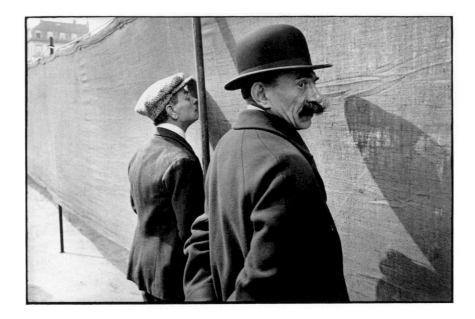

FIGURE 3.6. Henri Cartier-Bresson, *Brussels, Belgium*, 1932. © Henri Cartier-Bresson, Magnum Photos, Inc.

> If you start cutting or cropping a good photograph, it means death to the geometrically correct interplay of proportions. Besides, it very rarely happens that a photograph which was feebly composed can be saved by reconstruction of its composition under the darkroom's enlarger; the integrity of vision is no longer there. There is a lot of talk about camera angles; the only valid angles in existence are the angles of the geometry of composition and not the ones fabricated by the photographer who falls flat on his stomach or performs other antics to procure his effects.[13]

Besides being a sarcastic dig at the bird's-eye or worm's-eye views that had been popular with the Russians and the Germans, this anti-cropping stance became gospel for decades. It was the source of the black borders seen around the photographs of Cartier-Bresson and, indeed, a whole generation: when the frame edges are printed, the viewer knows the photograph has not been cropped.

With this devotion to photography's own basic laws, then, the modern art photographers produced pictures of contemporary life—its machines and buildings, its motion, its people, and its closeup details. In a number of ways all these photographers practiced spontaneous witness:

1. They responded to subjects and events in real time and space (*found* subjects, not *made* subjects).

2. They used their medium honestly, rejecting any conceit that would reduce the picture's precision, clarity, or purity as a photograph.

3. The moment of camera exposure was the most important moment in the creative process, much more important than any moment in the darkroom. This was as true for fast, 35 mm shooters, who would not later crop their images, as it was for slower, landscape photographers, who previsualized everything about the final result before making the exposure.

4. Their pictures were part information, part form, and always documents that could be shared with others and that embodied the energy of modern life.

5. For many, capturing a world in motion was an important inspiration and goal.

The romantic, ahistorical fantasies of the pictorialists were now relegated to the increasingly rule-bound salons run by the amateur camera clubs. The most progressive art photographers had left them behind. Fantasy did continue in the perennial genre of nude photography and in the surrealist creations of a few mod-

FIGURE 3.7. Minor White, *Ritual Branch*, 1958. Reproduction courtesy of The Art Museum, Princeton University, The Minor White Archive. Copyright © 1989 The Trustees of Princeton University.

FIGURE 3.8. Harry Callahan, *Chicago*, ca. 1950. © Harry Callahan, Courtesy Pace Wildenstein MacGill, New York; Collection of The Museum of Contemporary Photography, Columbia College Chicago.

FIGURE 3.9. Aaron Siskind, *Chicago, 1949*, 1949. Indiana University Art Museum: Henry Holmes Smith Archive.

ernist photographers, such as Man Ray, Clarence John Laughlin, and Hans Bellmer, but these were edgy, new, psychological fantasies, very much as modern as the most abstract closeups of machine parts.

In place by the 1930s, the modern art-photography aesthetic evolved but did not change radically until the 1960s. European artistic experimentation had been transplanted to American schools, where many of the Bauhaus masters taught after the war—Moholy-Nagy at the New Bauhaus (later the Institute of Design) in Chicago and Joseph Albers at Black Mountain College, for example. The West Coast school—Weston, Adams, Imogen Cunningham, and others—carried on, and Adams in particular continued to have followers, whose large-format cameras were sometimes set up in the same places where the pioneers had photographed.

The stark formalism of closeup abstractions also continued as a strong photographic genre throughout the period. Minor White, Harry Callahan, and Aaron Siskind were important new visionaries of abstraction in the 1950s. All three became influential educators, and White, as both teacher and longtime editor of *Aperture,* more than as a photographer, gained special prominence.[14] In the pages of *Aperture* White showcased art photographers who used the medium straightforwardly, while at the same time he gently reintroduced metaphor into fine photography, often in sequences of images that could be read as poems. He championed the ideas of Alfred Stieglitz, especially his notion of the "equivalent," another word for metaphor, or for the idea of translating one sensory experience into another (e.g., using photographs to evoke music). Added to those earlier ideas, White connected photography to many Eastern ideas from Hindu, Taoist, and Buddhist traditions. In the influential *Aperture,* "Spirit" became an essential element of fine-art photography, and photography itself became the "Way." As Jonathan Green has commented, White's view of interpretation was "not based on the European idea of active intelligence, but on the Oriental tradition of passive intuition."[15] (We will return to the importance of this spiritual approach for spontaneous witness in Chapter 6.)

Equally important, though operating more typically in the hurly-burly of the social landscape and the street, the tradition of small-camera photography first defined by Cartier-Bresson was developed by a number of photographers, such as Helen Levitt, Sid Grossman, Louis Faurer, Bruce Davidson, Robert Frank, and William Klein.[16] These photographers, increasingly showcased in galleries and avant-garde museum shows, began to expand the definitions of fine photography beyond notions of craft and precision.

The small camera found its most immediate use in documentary journalism, however. After World War II, with Robert Capa, David Seymour, George Rodger, and William Vandivert, Cartier-Bresson established the cooperative picture agency Magnum in 1947. Magnum aimed higher than to sell single photos of news events to picture magazines and newspapers. Instead, it marketed self-developed picture stories as visual essays, often unrelated to news events. Picture stories, or series on a particular facet of the social landscape, became a standard way of working for these photographers.

The Swiss immigrant Robert Frank pushed the small-camera style into a new kind of anti-narrative, personal territory in the 1950s. *The Americans,* his book of rough and grainy street photographs made on a 1955 trip across the United

FIGURE 3.10. Louis Faurer,
Philadelphia, Pa., 1937.
San Francisco Museum
of Modern Art.

FIGURE 3.11. Robert Frank, *Fourth of July—Jay, New York,* 1955. The Museum of Fine Arts, Houston; The Target Collection of American Photography, museum purchase with funds provided by Target Stores. © Robert Frank, Courtesy Pace Wildenstein MacGill, New York.

States—a book without text save for an introduction by Jack Kerouac—introduced a new, troubling voice into serious 35 mm photography when it was published in 1958–59.[17] Frank managed to break a number of the rules of the early modernists, particularly rules related to craftsmanship, yet he extended the equally important modernist impulse to social witness while at the same time creating a work that was profoundly personal. Frank's personal note is a turning point, marking the end of an outer-directed, sympathetic interest in the social scene and the beginning of seeing it as a projection or mirror of the self. Frank's impulse to release the shutter was driven by more than a simple desire to witness something outside himself; it was driven by a desire to see *himself* reflected there. In his words, it is the "instantaneous reaction to oneself that produces a photograph."[18] This personal note will be picked up in the radical work of the 1960s.

DOCUMENTARY

I think the best way to put it is that newspictures are the noun and the verb; our kind of photography is the adjective and adverb. The newspicture is a single frame; ours, a subject viewed in series. The newspicture is dramatic, all subject and action. Ours shows what's back of the action.
—ROY EMERSON STRYKER

To me documentary photography means making a picture so that the viewer doesn't think about the man who made the picture. —AARON SISKIND

Over three and a half million people have seen the exhibit; a million copies of the book, The Family of Man, have gone all over the world. . . . This is irrefutable proof that photography is a universal language; that it speaks to all people; that people are hungry for that kind of language. They are hungry for pictures that have meaning, a meaning they can understand.
—EDWARD STEICHEN

IT IS OFTEN SAID that *every* photograph is a document—of, at the very least, a decision by a photographer. Usually, though, some more important fact is documented. At one end of the scale are the evidence photographs taken by the police, by insurance adjusters, by witnesses to specific events, or by photojournalists. Somewhere in the middle are the landscapes, portraits, and more humble snapshots recording the particular look of things at a specific moment in time and space. Farthest from documentary seem to be the creations of the studio, but even these (fashion photographs especially) have a special relation to a particular time and later may seem to be almost intentionally documentary. Viewers looking for intentionality, of course, can concentrate on just what it was about a particular time

and place, a pose and framing, that triggered the photographer's decision to release the shutter. For those viewers, getting at the mind of the photographer is the game, and the putative content of a picture is almost irrelevant. Thus, all photographs document something, but that doesn't mean that every photograph is what we have agreed to call documentary.

Documentary instead is a particular kind of practice focused on social reality and on human life, informed by the strong feelings of the photographer. It is not simple reportage of objective fact or institutional recordkeeping: instead it is issue-driven, focused on a social issue about which the photographer cares strongly. While there is no one documentary style, there are parameters within which almost all documentarians have worked, namely, straightforward camera work and attention to the social environment. Going further, the historian Marianne Fulton has written, "Being there is important, being an eyewitness is significant, but the crux of the matter is *bearing witness*. To bear witness is to make known, to confirm, to give testimony to others."[1] Addressing the aesthetic side of documentary, Walker Evans said that the quality that "is really good in the so-called documentary approach is the addition of lyricism," but he didn't allow sentimental pathos: "The

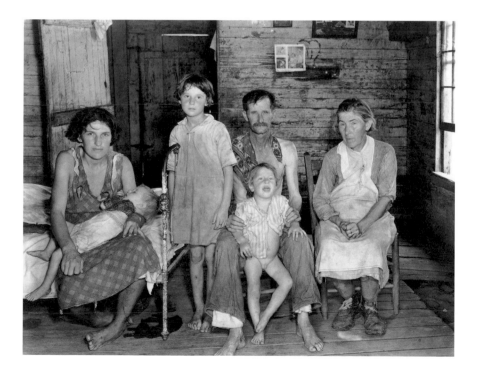

FIGURE 4.1. Walker Evans, *Sharecropper's Family, Hale County, Alabama*, 1936. Library of Congress.

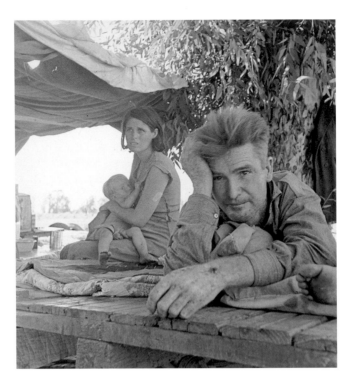

real thing that I'm talking about has purity and a certain severity, rigor, simplicity, directness, clarity, and it is without artistic pretension in a self-conscious sense of the word."[2]

If Evans was astringent and cool, especially in relation to his human subjects, his sometime colleague from the Farm Security Administration (FSA) team, Dorothea Lange, had a warmer approach. In an admiring 1934 essay her friend Willard Van Dyke wrote that "Miss Lange's real interest is in human beings and her urge to photograph is aroused only when values are concerned."[3] For both of these photographers, however, a scrupulous honesty was required: the photographs, even when posed or taken in several variations, had to bear a relation of truth to reality. For both Evans and Lange, as for scores of others before and after, documentary photographs bore a heavy responsibility to be true and unmanipulated, and when they have been discovered to be somewhat contrived—as when Arthur Rothstein planted the skull of a cow on a background of cracked, dried mud for one of his FSA photographs—the public has often been angry or distressed.[4]

The field of documentary, in fact, is where we see most fully the expression of

spontaneous witness. It is the genre of photography most dependent on pure attention to our fellow humans' lives, and the one from which we demand the most straightforward truth. Dorothea Lange's definition of documentary includes the elements most important to spontaneous witness:

> For me documentary photography is less a matter of subject and more a matter of *approach*. The important thing is not *what's* photographed but *how*. . . . My own approach is based on three considerations. First—hands off! Whatever I photograph, I do not molest or tamper with or arrange. Second—a sense of place. Whatever I photograph, I try to picture as part of its surroundings, as having roots. Third—a sense of time. Whatever I photograph, I try to show as having its position in the past or in the present.[5]

Documentary as a descriptive term was first used in 1926 by the filmmaker John Grierson to describe Robert Flaherty's film *Mouna*. As Anne Wilkes Tucker has written,

> In his writings and his own documentary films, Grierson declared a larger purpose than a simple recording of reality. He believed that documentaries should educate and persuade. He worked for "selective dramatization of facts in terms of their human consequences. . . . If facts are to be conveyed understandably and palatably to a lay audience, they must be expressed in terms of their human consequences. . . . [Documentary] is primarily not a fact-finding instrument, but a means of communicating conclusions about facts."[6]

So, communicating more than just facts, documentary nudges us in a particular direction by communicating *conclusions* about facts, even if those conclusions are mainly visual and sometimes hard to put into words (as in the work of Helen Levitt, for example). The psychiatrist Robert Coles, in his recent book about documentary work (within which category he includes photography, film, political work, anthropology, and a host of other activities), offers a more rapturous definition that focuses on the metaphysical benefits for the documentarian:

> Doing documentary work is a journey, and is a little more, too, a passage across boundaries (disciplines, occupational constraints, definitions, conventions all too influentially closed for traffic), a passage that can become a quest, even a pilgrimage, a movement toward the sacred truth enshrined not only on tablets of stone, but in the living hearts of those others whom we can hear, see, and get to understand. Thereby we hope

to be confirmed in our own humanity—the creature on this earth whose very nature it is to make just that kind of connection with others during the brief stay we are permitted here.[7]

If Coles's definition reaches the heart of the matter for those with profoundly sympathetic purposes, for others (such as the cooler Evans or the darker Bill Brandt, Bruce Davidson, or Larry Clark), it would be saying too much. Documentary can have a dark or angry side as well, and its conclusions may be open-ended or may even express a kind of nihilistic chaos as easily as a feel-good, we-are-one humanism. Evans suggested as much in writing about how some of his subway photographs, closeup faces recorded surreptitiously, were to be interpreted: "[Speculation] from such a page of . . . faces and hats remains then an open matter, the loose privilege of the reader, and whoever chooses to decide from it that people are wonderful or that what America needs is a political revolution is at liberty to do so."[8]

It would be better to pull back, I think, to the definition in our second paragraph since not all would agree with Coles nor even with Grierson's goal to "educate" the viewer. Given our definition—*practice focused on social reality and on human life, informed by the strong feelings of the photographer*—documentary may encompass work ranging from Jacob Riis's reformist photographs of New York tenement life at the end of the nineteenth century to Nan Goldin's photographs documenting her own sexual and social netherworld at the end of the twentieth century. The interesting question then becomes, what has happened? What in particular transformed the generally outgoing, sympathetic approach at the beginning of the documentary movement, often a sympathy that worked to effect real social change, into a narrow, fatalistic, personal approach at the end, the results of which rarely reach beyond a sophisticated gallery audience?

The rightness of doing documentary work at all has been questioned strongly in recent decades, perhaps first as a reflection of the struggles within the discipline of anthropology to deal with the issue of representing others.[9] At the same time the documentary subjects themselves, particularly indigenous or disenfranchised people in technological societies, have become more political, more resistant to being "taken" by the photographers. Documentary has lost its simplicity; in fact many people would say today that there *is* potential harm in the act of photographing people, as well as opportunity for all kinds of deception. The turning inward we see in recent work has occurred in part because with oneself or one's family at least no

violation is done to another's truth or image—or because, at the very least, one knows oneself best. Partly, though, it is also due to the psychological culture of the self of recent years, a culture in which the self has been the last frontier and also one's "material" in life. (We will return to this theme of the self in Chapter 11.)

Complicating all these issues is the existence of two subcategories of documentary: *street photography* and *documentary-style photography*. Although street photography is usually classified vaguely as documentary, it lacks the focused, content-driven purpose of most documentary projects and deals more often with the accidental and the absurd in the urban environment. "The hectic urbanism of the West could not fail to have been documented by the camera," according to critic Max Kozloff, who writes that street photography differs from planned documentary in that street photographers are

> committed to techniques of furtive and opportune surveillance whose goals cannot easily be rationalized. . . . If these street photographers certify that nothing more is seen or even meant than what is shown, they offer concrete findings without any journalistic pretext. More curious about the actual processes of the visual flux than in the debatable causes or outcomes of specific actions, they display a useless respect for their environment. . . . Afterward, the providential disorder of the images is structured and encompassed by the conscious sensibility of an individual. Instead of scenes rendered transparently by an impassive camera (for a known social purpose), we have a photographer's actively filtered world, or even an emphasis on how a pronounced *photographic* concern transforms the material of the world.[10]

Or as the photographer Garry Winogrand put it more concisely: "I don't have anything to say in any picture. . . . My only interest in photographing is photography."[11] The slippery thing about it is that when these photographers pull together a body of thematically related work—such as Winogrand's *Animals* or *Women Are Beautiful*—a strong point of view often unites the photographs, so that we might term the projects "documentary" even if there was no preconceived documentary plan.[12] It's the lack of an issue at the outset that creates the distinction.

Walker Evans, whose concerns were strongly aesthetic, preferred to describe his work as documentary-style photography:

> When you say "documentary," you have to have a sophisticated ear to receive that word. It should be documentary style, because documentary is police photography of a scene and a murder . . . that's a real document. You see, art is really useless, and a

document has use. And therefore, art is never a document, *but it can adopt that style. I do it. I'm called a documentary photographer. But that presupposes a quite subtle knowledge of this distinction.*[13]

Documentary style—straightforward camera recording of the social scene—has been used for many purposes besides classic documentary ones since the sixties, and we will look at this genre more carefully *as a style* in Chapter 8.

AN ACCOUNT of the high points of the documentary tradition may clarify this confusing picture and help to explain the change in documentary that has occurred. Almost as soon as cameras could be moved around, photographers were collecting pictures of exotic human others, just as European botanists collected the zinnias, red-hot pokers, and yuccas continents away from the Victorian gardens where they would end up. The motives were probably equally simple: specimen collection, a look at the strange.

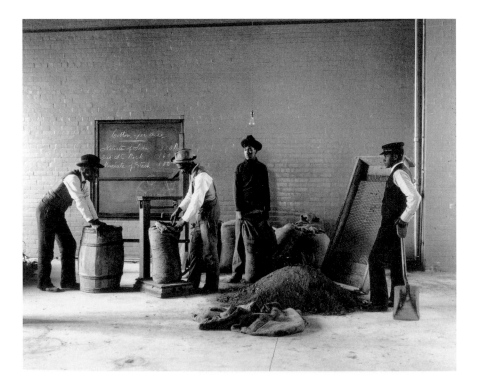

FIGURE 4.3. Frances Benjamin Johnston, *Agriculture, Mixing Fertilizer,* 1899–1900, from *The Hampton Album.* Courtesy of Hampton University Archives.

Soon enough, though, photographs taken closer to home began, through their wrenching subject matter, to inspire feelings of social conscience. After the casualties depicted by Roger Fenton in the Crimean War and by Mathew Brady and Alexander Gardner in the American Civil War, battle and its effects would never again be viewed as glorious. And John Thomson's photographs of poor Londoners, published in 1877 in *Street Life in London* (coauthored with Adolphe Smith), made a breakthrough in showing facts Victorians had preferred to ignore. The public's sympathy was actively engaged. To that end, Dr. Barnardo sold packets of before-and-after photographs of the homeless young waifs who came into Dr. Barnardo's Homes in England; photographs that not only aroused strong feelings but also were effective in public relations for fundraising.[14]

Similarly, in 1899 the noted American photographer Frances Benjamin Johnston was hired to do a public-relations job for the Hampton Institute, to demonstrate its success at teaching young black Americans the skills and the habits of white middle-class life. The photographs, which would be shown at the Paris Exposition of 1900, included convincing before-and-after contrasts, as well as beautifully composed group photographs of students at work.[15] It was a completely successful rhetoric and got the message across.

Other documentary projects were undertaken in the 1880s and '90s less to arouse conscience than to convey appreciation for marginalized, sometimes disappearing social groups, such as Frank Sutcliffe's views of English country folk and Emerson's *Life and Landscape of the Norfolk Broads* or, in the United States, Adam Clark Vroman's sustained documentary of the Hopi or Edward S. Curtis's mammoth effort, beginning in 1896 and lasting for decades, to photograph the many tribes of the North American Indian—"the vanishing race," as Curtis thought of them. Curtis has had his critical ups and downs, the latter primarily for faking costumes and removing signs of modern life, and yet *The North American Indian*, his twenty volumes of quite stunning images issued over the years 1907–30, is a monument for the ages.

A similar project, conceived after World War I, was the German photographer August Sander's "People of the Twentieth Century," which he intended to publish in a series of forty-five portfolios. Although he did not photograph the social scene itself, Sander believed in revelation through physiognomy and undertook a systematic portrait inventory of all strata of German society. "By sight and observation and thought, with the help of the camera, and the addition of the date of the year, we can hold fast the history of the world," he believed.[16] Hounded and cen-

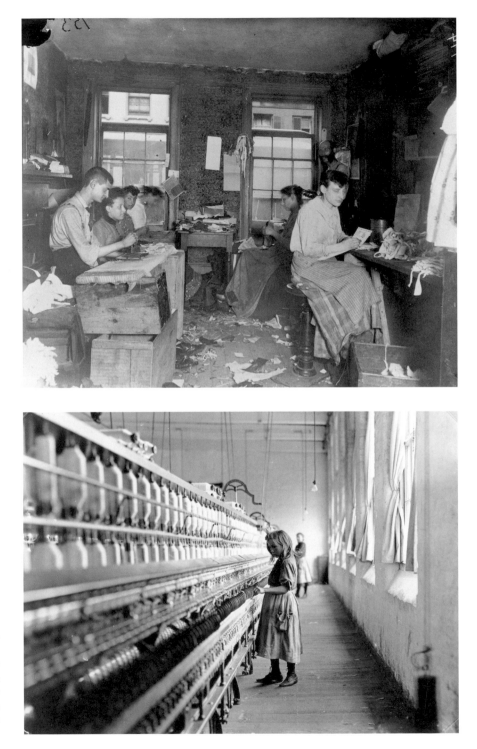

FIGURE 4.4. Jacob A. Riis, *Necktie Workshop in a Division Street Tenement,* ca. 1890. Museum of the City of New York, The Jacob A. Riis Collection.

FIGURE 4.5. Lewis Hine, *Spinner in a North Carolina Cotton Mill,* 1908. © The Art Institute of Chicago, acquired through exchange with the George Eastman House, all rights reserved.

sored by the Nazis, Sander's project was thwarted, but he was able to save his negatives, and a massive collection of his descriptive, dignified portraits was published as *August Sander: Citizens of the Twentieth Century* in 1986. A project smaller in scale but more gracefully romantic was undertaken by the serious American amateur Doris Ullman in the Appalachian South in the early 1930s.[17] Her subjects, obviously poor, were depicted not as objects of pity but as timeless, almost mythic individuals. Similarly, the Nebraska relatives whose lives Wright Morris indirectly evoked in his books *The Inhabitants* (1946) and *The Home Place* (1948) were never made to seem pathetic in any way.[18] Other photographers, though, by depicting the poor hoped to reform society.

The beginnings of what became the "eye of conscience" school of American documentary can be traced back to the work of a New York police reporter, Jacob Riis, who took up the camera (and flash) in the 1880s to document slum conditions of the largely immigrant tenement dwellers. An immigrant himself, Riis had the reformer's ardor and used his photographs, as well as his writings, to effectively arouse public indignation. Yet the photographs included in his *How the Other Half Lives* (1890) were reproduced so poorly that it was not until a 1947 exhibition of prints made from his original glass negatives at the Museum of the City of New York that Riis was recognized for the brilliance of his pictures.

Following Riis, Lewis Hine carried the reformer's standard in American photography. His early subjects (1905–14) ranged from immigrants at Ellis Island to tenement conditions to child laborers. His university training as a sociologist enabled Hine

> to comprehend instantly, and without effort, the background and its social implications. . . . When . . . he photographed children working in factories, he showed them at the machines, introducing a sense of scale which enabled the reader to grasp the fact that the workers were indeed small children.[19]

Hine's animus was trained on the employer of children, who "injures all of us because by forcing down wages he ruins the health and souls of future generations, and thus he weakens the nation."[20] After publication in *Charities and the Commons* and *The Survey*, his photographs were instrumental in the passing of child labor laws. His later work culminated in a paean to the construction workers who built the Empire State Building.[21] Hine might have seemed ideal for the team the economist Roy Stryker would soon put together for the Historical Section of the FSA, but Stryker would not hire him. According to the scholar Maren Stange,

Stryker seems to have regarded Hine as something of a has-been. . . . Stryker adamantly refused Hine work, becoming his open admirer only in 1938 when such support was . . . "one of the last things we can do for him." . . . "look[ing] back now . . . [I] realize that his photography made much more impression upon me than I had suspected at the time," . . . [and] led Stryker finally to conclude that Hine "had been doing the type of work which we [at the FSA] are now doing, back in 1908 and 1912."[22]

The glory and high point of American documentary was the work of the Historical Section—Photographic, of the Resettlement Administration, later called the Farm Security Administration (1935–43). The times were bitter. The country was in depression, and the South suffered from a terrible drought; great numbers of Dust Bowl tenant farmers became homeless refugees. As Roy Stryker said later,

> It was a trying time, a disturbed time. None of us [at the FSA] had suffered personally from the Depression, but all of us were living close to it, and when the photographers went out they saw a great deal of it. Curiously, though, the times did not depress us. On the contrary, there was an exhilaration in Washington, a feeling that things were being mended, that great wrongs were being corrected, that there were no problems so big they wouldn't yield to the application of good sense and hard work . . . not one of us has felt more purposeful, or had more fun, than when at F.S.A.[23]

Such "fun" as these photographers—a crack team that included Dorothea Lange, Walker Evans, Russell Lee, Ben Shahn, Arthur Rothstein, and Marion Post Wolcott, among others—had was in no sense frivolous entertainment.[24] Their work was hard and solitary, as the photographers were dispatched all over the country to record the dismal conditions of many rural citizens. But there was a hope and idealism about the effectiveness of their work in arousing the sympathy of their fellow Americans and persuading them of the rightness of the New Deal agricultural programs.

Much has been made of Stryker's scripting directions to the photographers, and at least three photographers left or were dismissed from the team over issues of control (or productivity). Yet there was little substantive disagreement on the team because for the most part Stryker let the photographers have their heads. Lange, who was eventually dismissed by Stryker, said of the working environment:

> I didn't find any organization. I didn't find any work plans. . . . The freedom that was there, where you found your own way without criticism from anyone, was special. That was germane to the project. That's the one thing that is almost impossible to du-

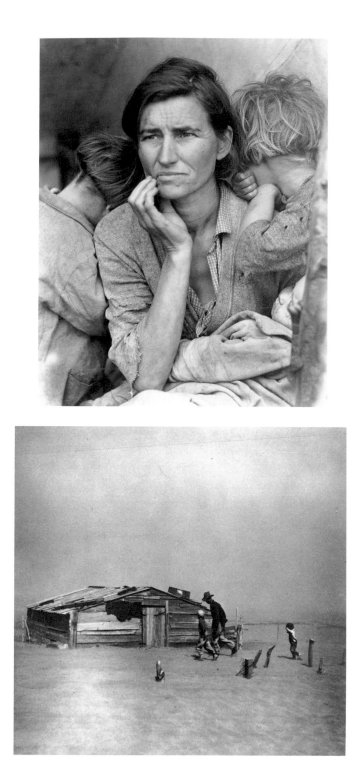

FIGURE 4.6. Dorothea Lange, *Migrant Mother, Nipomo, California*, 1936. Library of Congress.

FIGURE 4.7. Arthur Rothstein, *Dust Storm, Cimarron County, Oklahoma*, 1936. Library of Congress.

plicate or find. Stryker was a man with a hospitable mind, very hospitable. He has an instinct for what is important.[25]

In the tradition of Riis and Hine, the FSA photographers were making a difference, and the transparency of the "universal language" of the medium made photography central to the most important social work of the time. The photographs were used in exhibits, and they were also published in books[26] and in the big magazines like *Life*, where a huge weekly audience saw them:

> The first RA [Resettlement Administration, later FSA] photographs to appear outside a government publication were published in the January and March 1936 issues of *Survey Graphic* . . . they illustrated, in both cases, articles that dealt with the dire straits of southern sharecroppers and tenant farmers. . . . By the end of 1936, Stryker had placed photographs in *Time, Fortune, Today, Nation's Business,* and *Literary Digest*, and he had prepared twenty-three exhibits, including one at the Museum of Modern Art and another at the Democratic National Convention of 1936. . . . By 1938 . . . the newspapers and magazines that used F.S.A. photographs included not only *Look, Life,* and the *New York Times,* but also *Junior Scholastic,* the Lubbock (Texas) *Morning Avalanche* and the *Birth Control Review.*[27]

The FSA photographers were making history, that is, they were shaping the way an era would be remembered, but "no record of big people or big events in the collection . . . and absolutely no celebrities." Stryker's pride was that *"we introduced Americans to America."*[28]

Not only were the photographs useful in their own time but the vast archive (170,000 pictures now stored in the Library of Congress)[29] has become a defining historical document for the United States, and many of the photographs have become icons in our national consciousness. Dorothea Lange's *Migrant Mother, Tractored Out,* and *Desperation,* Arthur Rothstein's *Dust Storm,* Russell Lee's *Old Age* (also known as *Wife of a Homesteader, Woodbury, Iowa*), and Ben Shahn's *Destitute* are just a few of the photographs that seem burned into our minds.[30] *Migrant Mother,* perhaps the most famous, has become almost a religious icon—our modern madonna.[31]

World War II brought an end to the FSA project, and there has never been a sustained government photographic documentary project on the same scale since. Stryker went on to direct a vast public-relations project for the Standard Oil Company of New Jersey. Dorothea Lange, who felt that it was important that docu-

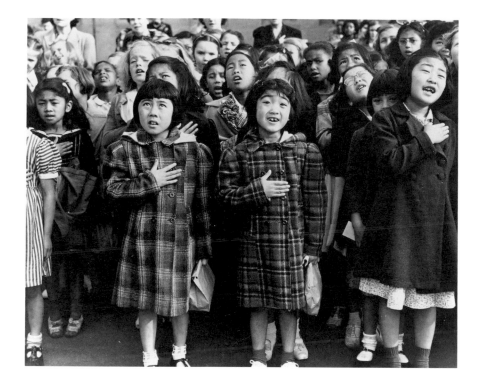

mentary work continue, was one who worked on a record for the War Relocation Authority (WRA) documenting the internment of Japanese Americans during the war. The moving photographs made by Lange and others of that shameful period in American life were not generally known until their 1972 publication by Maisie and Richard Conrat in *Executive Order 9066.*

Interestingly, although the WRA photographers worked much as they had at the FSA, the project itself documented not a New Deal for the poor but rather racial hatred and illegal discrimination—the uprooting, theft of property, and incarceration of innocent U.S. citizens—and the late publication had very much to do with the climate of racial tension that, along with McCarthyism and the Cold War fear of the bomb, became so much a part of the postwar atmosphere. The uplifting, unifying purpose that had marked the FSA was spent.

Not only was the documentary energy of the FSA gone but another important documentary organization, the Photo League, was actively persecuted and destroyed by the government during the witch-hunt years of the Cold War. The

Photo League was centered in New York but counted notable photographers all over the nation as either members or supporters.[32] Begun in 1936, when the Film and Photo League split into two divisions, the Photo League included a school of photography and interest groups that pursued various documentary projects, mostly in New York. It was a center of intellectual and social companionship for its photographer members. The Photo League bulletin, *Photo Notes*, included original articles as well as exhibition reviews. Notable members included Sol Libsohn, Walter Rosenblum, Sid Grossman, Jerome Liebling, Aaron Siskind, Ruth Orkin, Dan Weiner, Rosalie Gwathmey, and others. Grossman had a strong influence on younger photographers as the director of the Photo League School and through the impact of his unusually radical and aggressive shooting style.

In the paranoid postwar years of pervasive snooping by the Federal Bureau of Investigation (FBI), however, the Photo League was targeted as a "subversive organization" for its supposed, but never proven, Communist connections. On 5 December 1947 Attorney General Tom Clark included the Photo League on a list of "totalitarian, fascist, communist or subversive" organizations. Clark stated that the list of ninety organizations was the result of FBI investigations and the recommendations of the Department of Justice after President Truman's executive order creating a "loyalty board."

The Photo League tried to fight back, but the government was not required to provide any specific reason for the listing and did not. In a press release drafted the very day of the listing, member Walter Rosenblum boldly stated, "The Photo League repudiates this irresponsible and reckless smearing of its purposes and its membership. It regards itself as one more victim in the campaign, spearheaded by the Un-American Activities Committee, to stifle progressive thought in every walk of life, and to intimidate by threat cultural workers in every field." Despite these bold words, the blacklisting had the ultimate effect of instilling fear, doubt, and some repudiation of association among its members, and by 1951 the Photo League was dead.[33]

It is hard to overemphasize the chilling effect on documentary photography of the active and successful government persecution of the Photo League. Two paths for documentary would emerge as the fifties continued: a sanitized, sentimentalized kind of practice as published in the large-circulation magazines and in the popular exhibition *The Family of Man*, and a kind of inward-turning tendency toward personal documentary exemplified in the work of Robert Frank.

Despite the madness of House Un-American Activities Committee and govern-

ment blacklisting, most ordinary people seemed to crave commonality with others even during the suspicious era of the Cold War, and the magazines filled the bill. In 1947 John Morris, the dynamic picture editor for the *Ladies Home Journal*, the leading women's magazine at the time, conceived of a series of picture stories on farm families around the world, a series he called "People Are People the World Over." The first photographer to shoot one of these stories was Robert Capa, the charismatic cofounder (with Cartier-Bresson, George Rodger, David "Chim" Seymour, and Bill Vandivert) of the newly formed cooperative picture agency Magnum. Capa shot the Pratt family of Glidden, Iowa. Other stories, which ran as monthly features in 1948, were shot by Horace Bristol (China and Japan), Larry Burrows (England), Marie Hansen (Italy), George Rodger (Egypt, Pakistan, and Equatorial Africa), Phil Schultz (Mexico), and David Seymour (France and Germany).[34] The articles reached an audience of American families, emphasizing the similar patterns of family life around the world.

The stories were avidly consumed by *Ladies Home Journal* readers, and the continuing power of the theme was confirmed in the vastly popular 1955 photographic exhibition *The Family of Man*, curated by Edward Steichen at the Museum of Modern Art (and circulated all around the world to huge popular audiences). Steichen had directed photographic operations for the U.S. Navy during the war, and after the war he turned more to the pursuit of peace than to photography-as-art in his curatorial efforts. In that respect *The Family of Man* was his major project. About the theatrically designed exhibition, comprising 503 mostly documentary or journalistic photographs from sixty-eight countries by scores of photographers, Steichen wrote:

> To assemble this exhibition, my staff and myself went through over two million photographs to select the material. This two million was boiled down through our preliminary selection to ten thousand, and then I took over entirely. Boiling it down from ten thousand to five thousand was relatively simple; but from then on it was a heartbreaking struggle to reduce it to the final five-hundred odd prints that constituted the final choice.[35]

Because of its popularity and familiarity to most people even today,[36] I will not provide a detailed description of the themes (love, motherhood, children, families, work, play, learning, celebration, grief, hunger, justice, etc.). Suffice it to say the exhibition used photographs to demonstrate *Steichen's* strong convictions. He approached the show more as a picture editor than as a curator.

In the many calls for entries almost every photographer in America, as well as many in Europe, became aware of the project; photographers were asked to send unmounted contact prints or proof prints no larger than 8 × 10 inches, and political content was not wanted. There would be no prizes, and no prints would be returned. The final selections would be printed to Steichen's specifications and remain the property of the Museum of Modern Art. Many notable photographers, including Henri Cartier-Bresson, Dorothea Lange, Alfred Eisenstaedt, Margaret Bourke-White, and Robert Frank, among others, submitted their work and were well represented in *Family*, but not all photographers were eager to participate. As Walter Rosenblum said, "I'd never do anything where I gave up the right to the photograph, under any circumstances; it's my picture."[37]

Most viewers, to be sure, seemed to appreciate Steichen's goals: "to show the relationship of man to man; to demonstrate what a wonderfully effective language photography is in explaining man to man; and to express my own very firm belief that we are all alike on this earth, regardless of race or creed or color."[38]

Despite popular acclaim, the critical reception was mixed and has gained negative momentum since the time of the exhibition. As Lili Corbus Bezner has pointed out, in the criticisms of *The Family of Man* "readers can trace the decline of the intellectual left as it fell prey to elitist, aesthetic arguments which, in the end, silenced the voices of many documentary-oriented artists."[39] Steichen was seen as supporting a status-quo, Cold War American political view that erased difference or current political problems. Despite his well-meant attempt to end the show with a cathartic, universal image of horror—a large, backlit color transparency of the explosion of the first H-bomb—this image was *not* included in the catalog. Instead, the catalog ends with a softer image of photographer Gene Smith's little children walking out of the darkness into the light.

Criticisms have centered on these issues: *The Family of Man* was an *editorial* creation in which the points of view of individual photographers were lost; and it was a piece of persuasion and thus had no business being shown in the context of an art museum. Christopher Phillips pointed out in 1982 that Steichen's standard practice in the exhibitions he mounted at MoMA (beginning with *Road to Victory* in 1942 and ending with *The Family of Man* in 1955) had been "to prise photographs from their original contexts, to discard or alter their captions, to recrop their borders in the enforcement of a unitary meaning, to reprint them for dramatic impact, to redistribute them in new narrative chains consistent with a predetermined thesis."[40] The reasons for this practice had to do not just with Steichen's particular

sins; after all, other gurus, such as Stieglitz before him and Minor White after him, used other photographers' work to advance their own ideas. The picture is more complicated, having also to do with MoMA's goals to gain greater popular acceptance for its programming through photography and to identify with powerful governmental interests in the world at large.[41]

If Steichen's ideas themselves were comforting pabulum that didn't challenge any viewer with unacceptable "difference," nevertheless, the great success of the show and the book compels us to agree with him that people "are hungry for pictures that have meaning, a meaning they can understand."[42]

In 1955, at the very time that *The Family of Man* was beginning what would be an international tour sponsored by the U.S. Information Agency, a young Swiss immigrant photographer was traveling across the United States, supported by a grant from the Guggenheim Foundation, making the photographs that would end up in a challenging and very discomforting book, *The Americans*. Robert Frank's book, published first in France in 1958 and then in the United States the next year, stands firmly in the great tradition of documentary but just as firmly *outside* the tradition of confirming, respectful projects meant to raise social consciousness (see figs. 3.11 and 10.2).[43] Although his photographs pictured highly charged subjects such as racial segregation, juvenile delinquency, a rampant and deadly car culture, and—over and over—the American flag, he was not a political photographer. Viewers had no text to aid them in interpreting his grim visions and were left, not with their consciousness raised, but with a disquieting sense of unease. Lily Bezner has written,

> Frank might be called the perfect cold war photographer—his work walked the tightrope between social consciousness and political awareness while it remained invested with enough irony to obscure any didactic political clarity. No one named Frank in court, as they had [Sid] Grossman, for Frank's rebellion was one of spirit and personal alienation from contemporary society; there was no organizational or "communist" effort to his brand of disenchantment.[44]

Most disturbingly, Frank showed Americans to themselves not as the happy, smug citizens who deserved to run the free world and did. Far from it: Frank's Americans looked haunted, empty, all too human, living in a segregated society and in an environment of sad commercial icons. Jack Kerouac, who wrote the introduction to the American edition, credited Frank with

scenes that have never been seen before on film. For this he will definitely be hailed as a great artist in his field. After seeing these pictures you end up finally not knowing any more whether a jukebox is sadder than a coffin. . . .

What a poem this is . . . describing every gray mysterious detail, the gray film that caught the actual pink juice of human kind. . . .

Robert Frank, Swiss, unobtrusive . . . sucked a sad poem right out of America onto film, taking rank among the tragic poets of the world.[45]

If Kerouac was ecstatic, critical response was mixed. The book was reviewed in diverse publications, including the photography magazines as well as *Dissent*, the *New Yorker, Library Journal*, and the *New York Times Book Review*. Critics in the mainstream photography press either had reservations or were actively hostile toward the book.

Bruce Downes, editor of *Popular Photography*, dedicated space in the May 1960 issue for staff to comment on the book. Downes himself wrote that Frank was "a liar, perversely basking in the kind of world and the kind of misery he is perpetually seeking and persistently creating." Les Barry decried Frank's "warped objectivity," and John Durniak wrote that "Frank is a great photographer of single pictures but a poor essayist and no convincing story-teller at all." And Arthur Goldsmith, who acknowledged a strong personal vision, found "so many of the

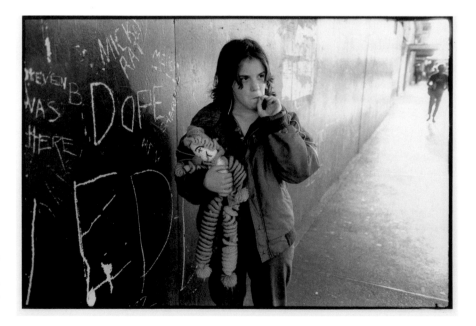

FIGURE 4.9. Mary Ellen Mark, *Lillie with Her Ragdoll, Seattle*, 1983, from *Streetwise*, 1988. Mary Ellen Mark / Library.

FIGURF 4.10. Bruce Davidson, *Young Man on the Subway, New York,* from *Subway,* 1986. © 1999 Bruce Davidson, Magnum Photos, Inc.

prints are flawed by meaningless blur, grain, muddy exposure, drunken horizons, and general sloppiness." H. M. Kinzer acknowledged that despite its negativity, "it is impossible to deny the sharp perception and the sheer power of most of the images in the book," and Charles Reynolds gave Frank credit for his "powerful and often moving photographic world. . . . an artist with a strong viewpoint, however limited, is better than one with no viewpoint at all." Perhaps most prescient was James M. Zanutto, who commented, "One wonders if his pictures contribute to our knowledge of anything other than the personality of Robert Frank."[46]

It is just this personally focused viewpoint that most characterizes Frank and marks his work as pivotal in the tradition of documentary. After Frank, documentary lost its outgoing innocence. His pictures somehow stripped away the illusions of Cold War America and at the same time pointed documentary in a profoundly inward, personal direction. Frank, the lonely stranger in America, became the life-story model for a whole generation of young Beats, then antiwar protesters and young radicals. The fifties were over.

What in fact has happened to documentary since the 1950s is a complicated story. The tradition of humanistic documentary *does* still continue—think of Sebastião Salgado, Eugene Richards, Mary Ellen Mark, and Donna Ferrato.[47] The social issues in their best work are the ones that are most troubling today: poverty, drugs, prostitution, homelessness, and domestic abuse. Bruce Davidson also created

I don't feel that Richie playing with guns will have a negative effect on his personality. (He already wants to be a policeman). His childhood gun-playing won't make him into a cop-shooter. By playing with guns he learns to socialize with other children. I find the neighbors who are offended by Richie's gun, either the father hunts or their kids are the first to take Richie's gun and go off and play with it.

FIGURE 4.11. Bill Owens, *Richie*, 1970, page from *Suburbia*, 1973. Bill Owens.

I have very clear ideas about what a man should be and I've tried to teach my son that; but the reason I didn't want a daughter was I didn't know what I wanted to teach her about being a woman.

I've told him he can be strong. He should be strong, and he should be smart. I don't know if she should be strong. I don't know if that's the right thing to tell her or not. Men tell me, "You're so strong." I think with my husband if I hadn't been so God damn strong, he would have been stronger.

FIGURE 4.12. Abigail Heyman, spread from *Growing Up Female*, 1974. Abigail Heyman.

an epic statement about urban poverty in his 1970 *East 100th Street,* as well as a searing look at the peculiar world of New York underground in his 1986 *Subway.* Fond, appreciative photographs of social others also continue in the work of Alex Harris and Norman Mauskopf and, less warmly, in Richard Avedon's portraits of American westerners.[48]

There is also a newer genre of affectionate but wry looks at the follies and folkways of one's own class or social group that owes something to the humorous work of Elliott Erwitt. Tony Ray-Jones's *A Day Off,* his brilliant, funny look at his fellow Englishmen at play, and Bill Owens's *Suburbia,* a similarly witty look at Owens's suburban neighbors in California, accompanied by their own words, are two examples from the early 1970s of a small genre that now includes Jim Goldberg, Larry Fink, Greta Pratt, Martin Parr, and a few others.[49]

And yet, even more personal projects—extended looks at one's own family or one's own life—seem to be the real rising tide in documentary. The enormous outpouring of personal work by women in the feminist art movement of the 1970s may have opened the floodgates. An important first book to mention is Abigail Heyman's *Growing Up Female* (1974), a book, as Heyman wrote, "about women, and their lives as women," but also "this book is about myself." A book about half the human race is an impossibly ambitious documentary, and of course Heyman was really focusing on her experiences and awakening to a feminist sense of self. Owing a bit of a debt to *The Family of Man,* Heyman brought together a wide variety of photographs of women, all, however, made by her, under a strong editorial theme. The photographs and personal, handwritten text made an engaging, effective, and utterly recognizable document for most American women.

In the next decade the British photographer Jo Spence made self-photography her project, in pointed reaction to the lies she felt were perpetrated by conventional photography. In *Putting Myself in the Picture: A Political, Personal, and Photographic Autobiography* (1988) Spence traced her gradual feminist, photographic, and political enlightenment in words and pictures and also, sadly, her affliction with the breast cancer that ultimately caused her death. (A huge outpouring of self-imagery *not* documentary in nature, and not all by women, was an important part of the 1970s and 1980s and will be considered in Chapter 11.)

Other recent photographic projects that have looked, sometimes rather darkly and always revealingly, at the photographers' own families include Emmet Gowin's intimate pictures of his wife and children, made continually since the late 1960s, Nicholas Nixon's *Family Pictures* (1991), Larry Sultan's *Pictures from Home*

(1992), Sally Mann's *Immediate Family* (1992), and Tina Barney's *Theater of Manners* (1997).[50] Even Eugene Richards, who has usually focused on social issues, produced a loving yet shockingly intimate documentary of his companion Dorothea Lynch's struggle with, and eventual defeat by, breast cancer.[51]

We should also consider as a sort of family documentaries a dark genre of insiders' views into subcultures of drugs and sexuality that began with Larry Clark's *Tulsa* (1971). Clark, an amphetamine user himself—"once the needle goes in, it never comes out"—photographed intimate and shocking scenes of his own young friends shooting up or high on drugs. In his later *Teenage Lust*, subtitled "An Autobiography by Larry Clark" (1983), he recorded his own peregrinations through backseats of cars, drug scenes, jail, and the world of street hustlers to give a frightening picture of self-destruction, sexual and drug obsession, and incest. It is doubtful that these books are in the collections of many libraries, but they achieved a wide circulation in the world of photography.

Clark opened the door for Nan Goldin's *Ballad of Sexual Dependency* (1986) and Robert Mapplethorpe's notorious *Portfolio X*, both of which managed to find a place in mainstream culture more secure than Clark's.[52] Both projects document, from the inside by insiders, the real and intimate activities of sexual subcultures, Goldin's quite similar to Clark's in many ways but including more homosexuality.

FIGURE 4.13. Larry Clark, *Untitled*, from *Tulsa*, 1971. Courtesy of the artist and Luhring Augustine Gallery, New York; University of New Mexico Art Museum, Gift of John T. Marvin.

Mapplethorpe's, on the other hand, was exclusively concerned with a tight culture within the male homosexual community, and the "presentational" style of the photographs has as much to do with that culture as with photographic style.

In these projects of the last thirty years we see the universalist and communitarian ideals of the high modernist period subverted or nearly abandoned. Many photographers have narrowed their range of concerns to their own experiences, and the tradition of sympathetic, discreet, and invisible witness has at the same time been transformed into self-conscious "exposure."

There is a final, rather simple reason why documentary has changed, and that is the image-saturating power of television. Documentary photography has always lived most vividly and been most effective on the printed page, particularly in the large-circulation magazines that dominated the media from the thirties through the fifties (the magazines are the subject of the next chapter). When both *Life* and *Look* folded in 1972, it was the end of an era for the big picture magazines.

More and more magazine photographers now aim to publish their work in books. An especially entrepreneurial photojournalist, Rick Smolan, for example, produced a series of books in the years 1981–88 on "a day in the life" of a particular country (the United States, Australia, Canada, Japan, the Soviet Union, etc.). With strong corporate backing, Smolan invited as many as one hundred photographers at a time to travel to the country in question; he gave them lots of film and a rough assignment but mainly asked them to photograph whatever they experienced on the one particular day. The oversize coffee-table books were quite popular, and the colorful, candid photography within them was focused on a particular point in time—the classic spontaneous-witness concern—although the projects as a whole might be said to be rather contrived around time more as a gimmick than anything. In the 1990s Smolan continued to use the many-photographers-in-one-place format but without the focus on a particular day (such as *Passage to Vietnam*, 1994). In any case, such projects can be seen as a valiant attempt to keep classic magazine documentary alive and spontaneous witness relevant.

Formerly vehicles for all kinds of social documentary, magazines now sell themselves mainly as purveyors of celebrity gossip and lifestyle-consumption fantasies. The photojournalist Gene Richards has written discouragingly about working in the new publishing climate:

Photojournalist? With a few exceptions, those of us working as photojournalists might now more appropriately call ourselves illustrators. For, unlike real reporters,

whose job it is to document what's going down, most of us go out in the world expecting to give form to the magazine, or to newspaper editor's ideas, using what's become over the years a pretty standardized visual language. So we search for what is instantly recognizable, supportive of the text, easiest to digest, or most marketable—more mundane realities be damned.[53]

Since the decline of the magazines, television has gradually taken their place, to the point now where a viewer at home (and nearly all homes have TV) can instantly and continually access news, travel and nature shows, or investigative reports from every corner of the world, not to mention more salacious or sensational material. The "armchair" distance between TV viewers and real experience (and sympathy to real others) can be seen also in prepackaged, sterilized, "Disney-style" cultural tourism.

Television has without a doubt the most cultural impact today, and people soak up plenty of it. The 1997 *Statistical Abstract* shows that the average person in the United States spends 4.4 hours a day watching TV but only 27 minutes reading newspapers and a mere 17 minutes reading books.[54] Still photography as a conveyor of information has lost its lead in the culture of television, and while this has freed documentary photography from the burden of communicating important public information, it has also marginalized it as a practice less vital now than before the 1950s.

THE MAGAZINES

There doesn't exist a picture magazine which transmits the vital rhythm of
everyday life: political events, scientific discoveries, disasters, exploration,
sports, theatre, film, art and fashion. *VU* is determined to fill this need.

— LUCIEN VOGEL, founder of *VU*

To see life; to see the world; to eyewitness great events; to watch the faces
of the poor and the gestures of the proud; to see strange things—machines,
armies, multitudes, shadows in the jungle and on the moon; to see man's
work—his paintings, towers and discoveries; to see things thousands of
miles away, things hidden behind walls and within rooms, things dangerous
to come to; the women that men love and many children; to see and to take
pleasure in seeing; to see and be amazed; to see and be instructed.

— Prospectus for *Life* magazine

Like most photographers of her time, Diane Arbus looked to magazines as
the sole means of earning a living taking pictures, which was not merely
gratifying but essential. They offered her an opportunity to work and have
her work seen, gave her access to people and events she might not have
been able to photograph otherwise, and, perhaps most important of all,
encouraged her to think of herself as a professional.

— DOON ARBUS and MARVIN ISRAEL

PHOTOGRAPHERS must find their viewers somehow (not to mention earn their
livings), and in the period we are discussing it has been primarily by way of the
printed page that they have found their audience. Newspapers had been printing
photographs since 1880, and early in the century a limited press had developed for
fine-art photography, notably Alfred Stieglitz's *Camera Work* (1903–17) in the
United States. However, the widespread publication of photographs for vast audi-

ences did not occur until the great popular magazines, particularly the picture magazines such as *Life* (founded in 1936) or its European predecessors, such as the *Berliner Illustrirte Zeitung* and *VU,* which were created in the 1920s as virtual showcases of photography. Older publications such as *Vanity Fair* (1914–36) or *National Geographic* (first published 1888), along with established fashion magazines like *Vogue,* were popular and heavy users of photography for more specialized purposes.[1]

As I have already noted, the role of informing and entertaining a mass audience now belongs to television, but earlier in the century it belonged to the magazines. In the households with subscriptions, the weekly arrival of *Life* or the monthly arrival of *National Geographic* signaled hours of absorbing distraction from everyday life for both adults and children in the pre-television years. Not only have the magazines been an important part of popular culture, they have also been the "canvas" for some of the most brilliant visual minds of the century—graphic designers, art directors, photographers—whose sensitive and daring ideas have changed our visual culture. Magazines continue to be the proving ground for new design and photographic ideas. The best ones today, though, are published for special interest audiences, not the vast general audience that once subscribed to *Life* or *Look.* That general-interest audience now turns to the so-called television magazines for the most part.

The American picture magazines were not the first on the field. That credit belongs to the *Illustrated London News.* In the twenties, however, the German picture magazines, particularly the *Berliner Illustrirte Zeitung (BIZ),* took the lead, paralleling the lead the German Bauhaus had taken in the development of art photography. Published since 1891, *BIZ* became a real photo magazine in the twenties under the editorship of Kurt Korff, and at its peak *BIZ* had a circulation of 2 million in a population of 40 million.[2] *BIZ* pioneered two kinds of photo innovations: "slice of life," or candid, photography, such as the pictures taken by Erich Salomon of unsuspecting statesmen; and the picture story, created by Martin Munkacsi, who would later perfect the form in his "How America Lives" stories for the *Ladies Home Journal* (1940–46).[3] Both of these were essentially spontaneous-witness efforts and furthermore had a leveling effect, as they allowed viewers intimate access both to the famous and to ordinary citizens.

Martin Munkacsi was the only staff photographer:

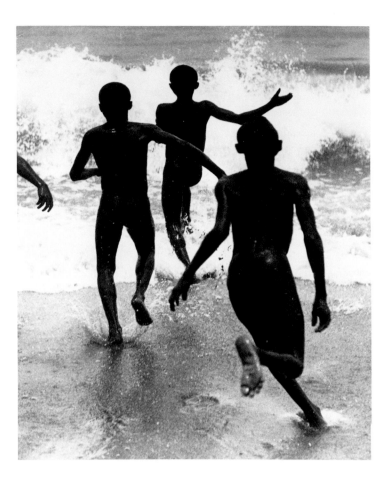

FIGURE 5.1. Martin Munkacsi, *Liberia*, 1931. The Metropolitan Museum of Art, Ford Motor Company Collection, Gift of the Ford Motor Company and John C. Waddell, 1987 *(1987.1110.35).*

Munkacsi was the real star of the *BIZ*. He had no particular specialty in subject matter but was a curious observer of human beings in all places. In Hungary he began as a sports photographer and thus was perfectly suited to expressing the fleeting movement of vivid and commonly experienced life. . . .

Munkacsi's perception of the peak moment of activity and his cropping of it to indicate its continuum were crucial when he came to the United States in 1934 to work as a fashion photographer. There he developed a style based on this same quality of vitality and natural activity.[4]

The rest of the photo coverage at *BIZ* was bought from freelancers like Salomon or agencies like Dephot, which employed a number of the pioneers in the use of the new miniature cameras. The photo agencies competed to sell their stories to editors,

and Simon Guttmann, of Dephot, was an innovative leader: he planned stories in advance, giving specific, detailed instructions to his photographers. According to Colin Osman and Sandra Phillips, "The photographers worked actively with Guttmann to produce informative captions, and they also worked with a reporter when possible. But the essential information had to be found in the pictures themselves, directed by the captions."[5]

In France Lucien Vogel founded *VU* in 1928, and like *BIZ*, *VU* used a lot of straight photography, as well as a great deal of photomontage, especially for its covers, under art director Alexander Liberman. (Liberman would later become a long-time art director of Condé Nast publications in the United States—one of a number of photographers and magazine people who would emigrate from Europe to the United States during the Nazi era.)[6] The sheer number of photographs used at *VU* was astonishing. "After the first year its editors reckoned up the number of photographs that had appeared: 3,324. No other magazine of that time even came close to publishing this quantity of photographs."[7]

When Kurt Korff arrived in America, he joined the Henry Luce organization, which already published *Time* and *Fortune* and was working on the prototype of *Life*. This American magazine was the product of a three-year study by a committee chaired by Luce. Luce already had gained some photo experience with *Fortune*, and he learned what he could from the Europeans.

> *Life* magazine was a product not only of the European refugees but of Luce's own experience. *Fortune*, founded in 1929, had used high-quality printing as befitted a magazine aimed at the heads of American industry and commerce. Good graphics and good photography were essential, and industrial photographer Margaret Bourke-White was the first of many photographers to work for that magazine. Her trip to Russia in 1930 was almost a forerunner of later photojournalism in *Life*. While on that trip she and Henry Luce visited many magazines, including the offices of *Weekly Illustrated* in London where they took away a complete run of the magazine to study.[8]

A large-format magazine crammed with photographs, *Life* was an immediate success when it hit the newsstands in November 1936, so much so that the costs of the huge production runs were not sufficiently supported by the initially low advertising rates or the single-issue price of ten cents. Not until January 1939 did it turn a profit.[9]

Several factors account for *Life*'s tremendous popularity. In its first decade Luce's strongly pro-Allied stance and the magazine's extensive, patriotic coverage

AN ACCIDENT INTERRUPTS HIS LEISURE

Dr. Ceriani's moments of relaxation are rare and brief. Last month, taking a chance that he would not be missed for three hours, he asked two employes of the Denver and Rio Grande to take him out on a railroad gasoline car to Gore Canyon. There he fished alone in the rapids of the Colorado, working expertly over the white water for almost 30 minutes. Suddenly he saw the car coming back up the canyon far ahead of time, and automatically he commenced to dismantle his fishing rod. Ceriani had no feeling of resentment at the quick end of his excursion; he merely stood still waiting for the car to reach him, wondering what had happened and hoping that it was not serious. When the car arrived Chancy Van

Pelt, the town marshal, hopped off and said, "Little girl at the Wheatly ranch got kicked in the head by a horse. Can you come now?"

Lee Marie Wheatly, aged 2½, was already in the hospital when Ceriani arrived. While her parents watched he looked for signs of a skull fracture, stitched up a great gash in her forehead and saw that her left eyeball was collapsed. Then he advised the Wheatlys to take their child to a specialist in Denver for consultation on removal of the eye. When they left Ceriani was haggard and profoundly tired. He did not remember that he had been fishing at all until, on his way out of the emergency room, he saw his rod and creel lying in the corner where he had thrown them.

AT 4:15 two friends start to give fisherman Ceriani a ride to Gore Canyon in a railroad motor car.

AT 5:00 Ceriani begins his day's fishing in the boiling, trout-filled rapids of Colorado River.

AT 5:30 Kremmling's town marshal has come after Ceriani and they start back to take care of an emergency case.

THE CHILD'S PARENTS watch in anguish (*left*) while Ceriani examines their daughter. The hospital's two nurses, one of whom is on duty in the hospital at all hours, had tried to check the flow of blood from her forehead and had given her a dose of phenobarbital while Ceriani was on his way back from fishing trip.

HAVING DONE HIS BEST for the child, Ceriani is worn out and tense as he completes the emergency treatment. He has stitched the wound in her forehead so that she will have only a slight scar, but already knows that nothing can be done to save her eye and tries to think of a way to soften the news for her parents.

FIGURE 5.2.
W. Eugene Smith, facsimile of spread from "Country Doctor," *Life*, 20 September 1948. W. Eugene Smith / TimePix, ©1948 Time Inc., reprinted by permission.

of World War II assured an avid readership, and indeed the war coverage was emotional and brilliant. Besides this, Luce understood that the magazine was *entertainment* above all, and from the beginning it featured plenty of attention to sports and to the "women men love," as the prospectus put it, and also plenty of visual humor. Covers usually featured a closeup portrait of a movie star or celebrity. A look at all classes of people, especially in the "*Life* Goes to a Party" stories and the classic photo essays of the forties and fifties, satisfied a voyeuristic curiosity on the part of the readership while at the same time defining contemporary American society. Features on art and science rounded out the coverage and provided the material by which the readers might "be instructed" as well as entertained.

Most critically, Luce understood the importance of photographs. In a memo written during the planning stages he stated: "Fifty or twenty years ago, people used to write 'essays' for magazines. . . . The essay is no longer a vital means of communication. But what is vital is *the photographic essay*." He noted that there was

> a new trick in the world which pleases people, namely, the strip of photographs in narrative sequence. One-two-three. One-two-three-four-five-six-seven-eight. We ought to make more use of this than we do. Almost as we say that every issue should have a few great photographs, so we should say that every issue should have at least two strip sequences.[10]

Both the sequence and the photo essay became staples of *Life* style, beginning with the first issue. In particular, the documentary photo essay became the vehicle for some of the best photography in the magazine. Perhaps the best-known, best-photographed essays were those of W. Eugene Smith, who shot many of them: "Folk Singers" (1947), "Trial by Jury" (1948), "Country Doctor" (1948), "Hard Times on Broadway" (1949), "Spanish Village" (1951), "Recording Artists" (1951), "Nurse-Midwife" (1951), "Chaplin at Work" (1952), "The Reign of Chemistry" (1953), "My Daughter Juanita" (1953), and "A Man of Mercy" (1954). The last story, about Albert Schweitzer, or more precisely, Smith's lack of complete control over the way the Schweitzer story would appear, provided the occasion of his resignation from the magazine; in fact it was his second resignation from *Life*, the first having occurred in 1941.[11] Although his stories as published are considered first-rate, Gene Smith struggled for full control of his published essays and was never fully satisfied.

The photo essay and the photograph were the heart and soul of *Life*, but the way stories were developed did not give the photographer primary decision-making

power. A story was first suggested by a writer who presented it for discussion and took the lead in planning, directing the research and then the photography. The picture editor and the designer laid out the story, and then the text was written.

> Though employed by the magazine, Gene Smith tried to distance himself from the *Life* approach. He made a distinction between a picture story and a photo essay, saying that the first was something a photo editor put together and the second was the work of the photographer. While this is a reasonable difference stressing the origin of the work, it cannot be used when discussing his work for *Life* magazine (much to his chagrin). "I just simply wanted to give the time and the effort to take the superficiality out of a story. After I did, *Life* often would bring back that superficiality."[12]

Nonetheless, it is Smith's work that best exemplifies the great *Life* photo essays, and in the best of them we have superb examples of spontaneous-witness photography. In "Country Doctor" or "Nurse-Midwife," for example, we are *there,* witnesses in the room. The naturalness of the activity and the lack of visible interaction between the subjects and the photographer suggest that the pictures are facts of nature, what we would have seen had we been there. But this transparency was the result of Smith's incredible skill and effort as a photographer: point of view, lighting, attention to expression, and seeing into his subjects' faces when their attention was on a task were handled so gracefully as to make his hand almost invisible. Only by trying to figure out how Smith got his shots does the viewer come to realize where he must have had to position himself. And we then realize that Smith showed more than we might ever have seen had we been there in person.

Smith was one of a great number of staff photographers directed by *Life*'s picture editor, Wilson Hicks, after he joined the staff in 1937. Hicks was respected by many staffers but not all. Robert Capa said that Hicks "was trying to hold him down with trivial assignments, was killing too many of his stories, and was constantly trying to cheat him."[13] Capa's remark is more than an opinion about his boss: it reveals the level of competition for ink within the magazine, the levels of decision making above the photographers, and the importance of the magazine as a venue for photographers. *Life* used many other sources for photographs as well: the photo agencies (Black Star was especially important), the Wirephoto services, the FSA, and international agencies like Keystone and Sovfoto.

Life thrived editorially through the sixties, although television had drawn advertisers away from its pages since the 1950s. Gradually the loss of advertising revenue became critical, and the giant Time, Inc., organization found that it could not

support its own staff of photographers posted overseas, which made room for new international photo agencies like Gamma and Sygma to rise to positions of prominence in the 1960s and 1970s. Weekly publication of *Life* was suspended in 1972 in favor of twice-yearly issues; in the eighties, the magazine was reinvented as a smaller-format monthly.

Life never regained its former position in the culture, but its authority as a *photographic* institution was confirmed in the hugely popular, multivolume series Life Library of Photography, issued between 1970 and 1972, with annual *Photography Year* volumes after that.[14] Lavish and handsome, the silver-covered books were collections of great images, as well as reliable sources of historical information and technical know-how for serious amateurs and professionals alike. Unlike *Life* the magazine, the books focused on the art and craft of photography itself, drawing more of their material, perhaps, from the fine-art sphere than from the commercial or editorial sphere, although all kinds of photography were included in the series. The clean, Swiss-style design echoed the serious, sophisticated tone. The Life Library of Photography was a great publishing success and deserves a large part of the credit for the growth of a knowledgeable, broad audience for serious photography in the 1970s.

If *Life* had become nearly extinct by the 1980s, another photo-based magazine, *National Geographic*, enjoyed tremendous growth during the same period. Its circulation grew from 2 million subscribers in the mid-1950s to 10 million in the 1980s.[15] Positioning itself never in topical, mass-culture journalism but rather as an educational journal of geography, the monthly *Geographic* managed to flourish as a less time-specific, booklike publication and therefore more properly as an object of study, while the more throwaway *Life* was finding it difficult to attract an audience. In addition, the *Geographic* has continually upgraded its printing techniques and the quality of its paper, using heavy, glossy paper, which gives it more the feel of a luxurious object than of a monthly magazine.

Publishing its first photographs as early as 1895, the *Geographic* recognized their potential impact on readership after the 1905 publication of a set of photographs of Lhasa, Tibet: circulation was 3,400 at the time the photographs of the "forbidden city" were published, but by the end of that year it had risen to 11,000.[16] From that time forward photography became the staple of the journal, and since then the pictures and their captions have always been considered more important than the text.

At the same time that Henry Luce was recognizing the impact of sequences and

essays of black-and-white photographs, Gilbert M. Grosvenor, editor of the *Geographic*, was pioneering with color photography. From 1921 to 1930 the magazine published more than 1,500 autochromes, an early type of color transparency.[17] And when the new Kodachrome film became available in 1936, staffers immediately experimented with it, and in two years it became the film of choice for the eventually all-color magazine. The social historians Catherine Lutz and Jane Collins point out that

> color photography began to differentiate the *Geographic* from a growing tradition of photojournalism that continued to rely on black-and-white photographs well into the 1950s. . . . The use of color photography also highlighted the magazine's similarity to museum exhibits—with their highly framed, aestheticized tidbits of traditional culture—rather than to starker news reportage or scientific documentation.[18]

Current printing technologies used by the magazine, they continue, "now allow ink to be laid down in such a way that color virtually hovers above the glossy page." Through these printing methods, which can pump up the intensity of the colors, and also through the expectations subtly created by advertising photography, which has been mainly color, "color has become the language of consumption and plenty" as well as the "vehicle of spectacle," say Lutz and Collins.[19] These factors, along with its heavy, shiny paper, make reading the *Geographic* a luxurious experience compared with reading other periodicals.[20] Back issues are kept around households as signs of middle-class respectability and also because it is hard to discard such lavishly beautiful albums of pictures.

Color and printing, of course, are not as important as the content of the *Geographic* and the way it has positioned itself as a somewhat scholarly, research-oriented rather than a profit-oriented enterprise, one that initially supported itself by subscriptions (called "memberships" in the National Geographic Society) rather than advertising. *National Geographic* readers become armchair explorers of every corner of the world, the depths of the sea, and the furthest reaches of outer space.

And readers are subtly assured that the rest of the world is a safe place for Americans, "that it is made up of people basically like us, that the people who are hungry and oppressed have meaningful lives, and that the conflicts and flare-ups we hear of in the news occur in a broader context of enduring values and everyday activities."[21] Because of its close historical ties to government leaders and its sensitivity to the political interests of the United States, the *Geographic*'s maps, research, and editorial coverage have enjoyed a quasi-official status. Its pages have never been the

FIGURE 5.3. Wilbur Garrett (for *National Geographic*), *Mekong Delta, South Vietnam*, 1968. "Desperate for medical help, a mother handed a sick child to a Vietnamese interpreter when a U.S. Navy patrol boat stopped her sampan in search of viet cong or contraband." WilburGarrett / NGS Image Collection.

site of radical political positions or, until recently, what insiders call "difficult" photographs. Rather, it has always tried to find "balance" in its coverage of the world—as much good as bad in every story, and plenty of smiling faces from the developing world—and to portray the government of the United States as a benevolent force in the world.

> After World War II and into the 1950s, the [National Geographic] society operated in a national context dominated by the expansion and consolidation of power. . . . Still, the United States public tenaciously held to a view of its presence in the newly independent nations as benevolent. . . . And the *Geographic* upheld this image with articles such as "The GI and the Kids of Korea: America's Fighting Men Share Their Food, Clothing and Shelter with Children of a War-torn Land" [1953].[22]

And when the world at home became torn by civil-rights struggles and antiwar conflicts in the 1960s, "*National Geographic* did not report on these issues."[23]

But under Grosvenor, who became editor in 1970, coverage became more controversial—Castro's Cuba, Harlem, separatist Quebec, South Africa—despite opposition from some board members, and when Wilbur Garrett became editor in 1980, his vision "was to keep the magazine moving in the present, but faster, and to lead it into the future."[24] Under Garrett (1980–90) more controversial subjects

were covered as coverage became more real-world, and the photographs became more sophisticated. The readership, which had been accustomed to the comforting, conservative position of the *Geographic,* declined somewhat. Yet beginning in the seventies, advertisements for upscale consumer goods have increased in the magazine, providing a level of financial support that cushions any minor loss of subscriptions, and the *Geographic* continues to enjoy its high-status position in American journalism.[25]

Garrett was one of a group of Young Turks brought into the organization in the 1960s. Not only were they interested in coverage of more controversial issues but they "advocated more use of natural lighting in photographs, more white space in layouts, and all-color issues."[26] The story of the photographs is one of gradual evolution to greater visual sophistication and professionalism.

Until World War II many of the photographs (and stories) came from diplomats, businessmen, explorers, and vacationing educators, and there were only two staff writer-photographers. By 1967, however, there were fifty writers and fifteen full-time photographers, many of whom had newspaper experience. And by 1987 there were sixty-seven photographers working for *National Geographic.*

> Seven of these were on staff, seventeen under long-term contract, twenty-nine operating on a free-lance basis (contracted for particular stories) and thirteen "others"— research grant recipients, expedition photographers and the like. The society sees this mix of relationships as important: the use of contract photographers allows the magazine to keep up with changing photographic styles, while a core of staff photographers lends continuity and preserves certain well-established values.[27]

As at *Life,* photographers at *National Geographic* are directed by others. The picture editors, according to Lutz and Collins, "see themselves as the brains behind the operation—the ones who give coherence to the photographic endeavor, the control nexus by which the creative work of the photographer is brought into line with the goals and policies of the organization."[28] According to Tom Kennedy, director of photography, "Our pictures have to be strong, but mainstream enough to be understood by our members."[29] Personal viewpoints are shunned, and Lutz and Collins report that "most *National Geographic* photographers . . . are uncomfortable with the idea that they are making a social statement with their photographs. Having too strong a social theory . . . makes you less objective."[30]

A photographer may return from an assignment with hundreds of rolls of exposed film. Photographers are given plenty of time and resources to make their sto-

ries right—1,408 pictures were published in the *Geographic* during 1993, chosen from more than *a thousand times* that many frames of film.[31] Selection from the plenitude of any shoot becomes the key step.

> At the *Geographic,* balance is pursued most assiduously in photo selection. This entails balancing focal lengths and subjects, making sure there is an adequate array of portraits, landscapes, and mid-range photographs. It involves balancing positive and negative, upbeat and gloomy, critical versus laudatory themes. As one editor put it, "It behooves us to show reality—and nothing is all bad or all good. If [the photographer] didn't find any happy people, I'd tell him to go back and find them." Photographers accommodate this attitude.[32]

If photographers accommodate the magazine's desire for balance, they still hold high standards of authenticity for their work and for opening the eyes of readers—"to make people care," said photographer Nick Nichols, "about the disappearing rain forest or great apes. I have a sense of mission."[33] Manipulating animals or provoking animal attacks for photographs has been problematic, and distress was great over the notorious digitized moving of the pyramids on a cover in 1982. "From that experience came a strict policy," according to Leah Bendavid-Val, "that says a pho-

FIGURE 5.4. Richard Avedon, *Suzy Parker and Robin Tattersall,* August 1957. Richard Avedon.

tograph cannot be altered by electronic or conventional photoengraving techniques."[34] With their human subjects, write Lutz and Collins, "photographers and editors believe that it is better to strive for candid shots. . . . Virtually all the photographers and picture editors we spoke with saw the return gaze as problematic and believed that such pictures ought to be used sparingly because they are clearly not candid, and potentially influenced by the photographer."[35]

Adherence to the tenets of real-time spontaneous witness, that is, avoidance of the contrived, manipulated, or stylized image, has been, in slightly different ways, a hallmark of reportage at both *Life* and *National Geographic*, but we might not expect to see it in fashion photographs in the pages of *Vogue* or *Harper's Bazaar*, the realm of ethereally beautiful women wearing outrageously expensive clothes. Nevertheless, even in these magazines an enormous change occurred over the same period, taking fashion from the fantastic lighting of Baron Adolf de Meyer in the twenties and the still, posed concoctions of Edward Steichen in the thirties to the lively street dramas of William Klein in the sixties.

Fashion photographs such as those taken by Norman Parkinson, Toni Frissell, Herman Landshoff, and especially Richard Avedon in the late forties and the fifties were made in the street, in natural light, and often in motion. Their models were fresh, modern women—strong, active, and happy. To be sure, such photographs were staged, yet the sense of real-world action was what gave them their freshness and appeal, and subsequent fashion work continued to be made in the street in the sixties and seventies, notably by William Klein, Helmut Newton, Guy Bourdin, and Deborah Turbeville, although with more contrived, fantastic (and darker) narrative implications.

The great shift to the active "Avedon style" began in the mid-forties, after the war, at the same time that the center of the fashion world was moving from Paris to New York, and the women readers' interest became excited more by comfortable American sportswear than by French haute couture, which earlier had been the magazines' staple. "The time was clearly right," as historian Nancy Hall-Duncan later wrote, "for 'honest' fashion photography."[36] Although it was very much an American vision, this style was brought into being by three notable European immigrants: Martin Munkacsi, Alexey Brodovitch, and Alexander Liberman. Munkacsi, already known as a great sports and action photographer for the *Berliner Illustrirte Zeitung*, immigrated to the United States to work for Carmel Snow, editor of *Harper's Bazaar*. In 1934 Snow hired the legendary Russian immigrant Alexey Brodovitch, who had been in the United States since 1930, as art director of

the magazine. Liberman, former art director at *VU*, also came to the United States in the early thirties and became art director for Condé Nast, publisher of *Vogue*.

Munkacsi created a new style, shooting fashion as if it were news or sports. According to Hall-Duncan, his photographs conveyed "an exuberant vitality and a natural informality which made them seem like mere snapshots. . . . Munkacsi's snapshot-like realism has vied with studio work as the second great mode of fashion photography."[37] A stylish, charming, and lively man (who boasted that he was the most highly paid photographer in New York), Munkacsi brought spontaneous witness to a realm that had not known it. In a column of photographic tips for *Harper's Bazaar* he advised: "Never pose your subjects. Let them move about naturally. . . . All great photographs today are snapshots."[38] Richard Avedon, who would later consciously work in the tradition of Munkacsi, said that "he brought a taste for happiness and honesty and a love of women to what was, before him, a joyless, lying art. He was the first."[39] Munkacsi's impact was broader than his effect on fashion, however. In particular, he had a strong influence on Cartier-Bresson:

> In 1932 I saw a photograph by Martin Munkacsi of three black children running into the sea, and I must say that it is that very photograph which was for me the spark that set fire to the fireworks . . . and made me suddenly realize that photography could reach eternity through the moment. It is only that one photograph which influenced me. There is in that image such intensity, spontaneity, such a joy of life, such a prodigy, that I am still dazzled by it even today.[40]

Both Alexey Brodovitch and Alexander Liberman, art directors who served lengthy terms at their respective magazines, stimulated and promoted the talents of a generation or more of young photographers. In particular Brodovitch at *Harper's Bazaar* was a mentor and provocateur who provided an "aesthetic protectorate in which the artists could maintain the highest standards. [He] championed the *avant-garde*, rejecting commonplace solutions and commonplace approaches."[41] Besides nurturing his staff photographers, Brodovitch expanded his influence by initiating a class in 1941 called "Art Applied to Graphic Journalism, Advertising, Design and Fashion" at New York's New School for Social Research. Brodovitch referred to the class, which in later years was held at Avedon's studio, as his design laboratory.[42] Every young photographer seems to have been affected by these classes, whether they attended or not. "You felt you were in his classes anyway, you heard so much about them," said one young assistant art director.[43] Brodovitch encouraged the use of blur and informal framing so that the energy on

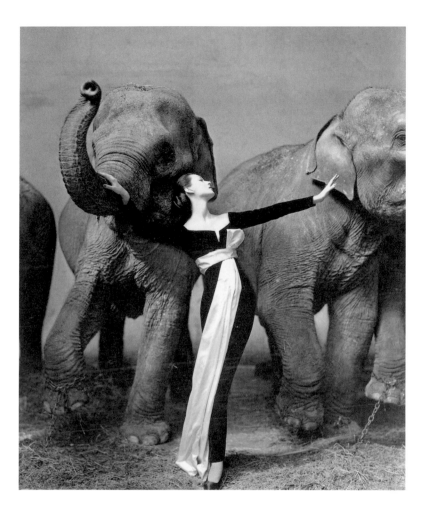

FIGURE 5.5. Richard Avedon (for *Harper's Bazaar*), *Dovima with Elephants*, September 1955. Richard Avedon.

the page came from the photograph and not just the layout. He was also passionately devoted to orchestrating the flow or pacing of the magazine, laying it out on the floor, spread after spread, so that he could construct the sequence as he wanted it. Brodovitch's own book of ballet photographs, *Ballet* (1945), published in a very small edition, was a legendary example of his theories of sequencing and full of blurry, evocative images that captured the spirit, if not the detail, of ballet performance.

Among the many who passed through his classes were Diane Arbus, Richard Avedon, Ted Croner, Bruce Davidson, Louis Faurer, Robert Frank, Saul Leiter, Leon Levinstein, Lisette Model, and David Vestal, all of whom absorbed his aesthetic thinking, some said "by osmosis." Not only that, but many were hired to shoot

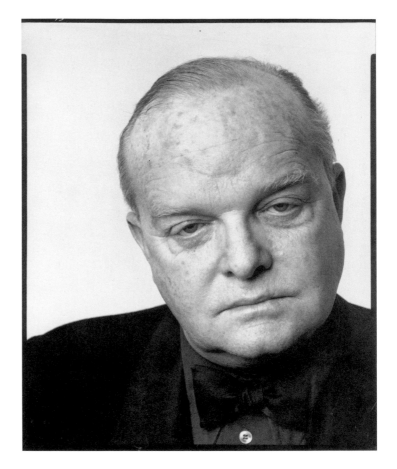

FIGURE 5.6. Richard Avedon, *Truman Capote, Writer, New York City,* 1974. Richard Avedon.

fashion. "One cannot say," writes Jane Livingston, "that Helen Levitt, Lisette Model, and Robert Frank ever were or even wanted to be 'fashion photographers' *per se;* yet their work appeared in *Harper's Bazaar,* as did the work of Brassaï, Cartier-Bresson, and Bill Brandt."[44] Other protégés of Brodovitch—Louis Faurer, Saul Leiter, Richard Avedon—did have a gift for it and found fashion to be a creative venue.

Art directors like Brodovitch at *Harper's Bazaar,* Liberman (who hired William Klein and Bruce Davidson to do fashion at *Vogue*), and Marvin Israel (who was especially encouraging to Diane Arbus at *Esquire*) understood that the new energy in photography was located on the street, in the real world. In the end, few of the essentially "street" photographers found their best home in the fashion pages, but

Richard Avedon was one who did. Avedon made his mark with his photographs in the fashion magazines, as arguably the greatest fashion and portrait photographer of the century, initially in his twenty-year tenure at *Harper's Bazaar* (1945–65) and later as a staff photographer for *Vogue* (1966–90) and the *New Yorker* (1992). Avedon has also prolifically generated books of his independent, mostly portrait projects.[45]

In 1944 Richard Avedon walked into the offices of *Harper's Bazaar* in his merchant marine uniform, and Brodovitch saw something worth developing in his portfolio. Carmel Snow agreed: "I knew that in Richard Avedon we had a new, contemporary Munkacsi."[46] After about six months his style emerged:

> Avedon's spontaneity is more orchestrated than Munkacsi's; it is a more complicated and sophisticated version of Munkacsi's innovations. Both share a mood of relaxed spontaneity. But while Munkacsi's origins as a sports photographer are always evident, for his women always remain sportswomen, Avedon's models are in motion in quite a different way. They are filled with carefree exuberance and joyous abandon, with a love of life.[47]

Beginning in 1945, Avedon, along with Herman Landshoff, created some of the most innocent and energetic photographs fashion was likely to see for a long time in the short-lived *Junior Bazaar,* modeled by pretty, smiling young women in motion and under the art direction of Brodovitch's assistant, Lillian Bassman. (Others, including Robert Frank and Louis Faurer, also worked for *Junior Bazaar.*) Later Avedon created intriguing "story" pictures by positioning his glamorous models in the street or in provocative settings like casinos or elephant barns! He would also move into the studio, pioneering the use of the plain white backdrop in fashion and yet retaining the high-energy action that was his hallmark on the street.

In his portrait work Avedon has used the plain backdrop and a trigger-finger sensitivity to what he calls "essential" moments. By their very nature these essential moments reveal, not the composed and public face, but something more vulnerable and private.

In both his fashion and his portrait photographs Avedon has taken the *style* of spontaneous witness into realms of artifice, glamour, and celebrity, and others have followed.[48] To be sure, these photographs have been staged, and yet they depict women who themselves are active and engaged with the world and far from the white-gloved, static beauties of earlier fashion illustration.

The magazines, then—both those that are now thriving, such as the fashion or

specialty magazines, and the nearly moribund general-interest picture magazines such as *Life*—were the locus for spontaneous-witness photography from the thirties through the sixties and in some cases still are. The camera as witness, real life as the subject, truth as the subtext—these were powerful ingredients in the glory days of twentieth-century editorial photography, reaching an audience of millions every week or month and providing a place where photographers could express their sense of contemporary life, push their own aesthetic boundaries, and earn their living.

SPIRIT IN PHOTOGRAPHY

Once it has selected a photographer spirit always stands still long enough
to be recorded. —MINOR WHITE

D URING THE YEARS we have been discussing, roughly from the 1920s to the
 1960s, photographers were motivated by many factors and were released, one
might say, to *be photographers,* in a more complete way than had ever been possi-
ble before, by an aesthetic that valued straightforward use of the medium and by
the remarkable technical advances that allowed photography under almost any cir-
cumstances. Photography was also honored not only as a reliable witness but also
as a universal language, and it had a social-political role of great importance. Pho-
tography had yet another dimension in this period, briefly touched upon in Chap-
ter 1, what might be called its spiritual base.

 This was not a theology that was illustrated, nor was it a uniform set of beliefs;
indeed if you looked into the lives of many of the photographers, you might find
no sign of anything that might be called religious practice. Yet the photographers
shared in the *Zeitgeist* and were often most sensitive to its spiritual dimensions.

 An important aspect to this worldview was a sense of the transcendence that
could emerge through the commonplace. William Carlos Williams's famous line
"No ideas but in things" might serve as a shorthand for a way of working shared
by many poets and photographers during the period. This was the idea of ground-
ing in the ordinary and transcendence *through* the ordinary. A man like Edward
Weston, for example, may not have been conventionally religious or interested in
decorum (in his *Daybooks* he wrote, "I find myself withdrawing from people who
are too nice"), yet he could reach a genuinely transcendent moment in photo-

graphing a green pepper, an eroded stump, a nude, a few water-sculpted rocks on a beach. "The camera should be used for a recording of *life*," he wrote, "for rendering the very substance of the *thing itself*, whether it be polished steel or palpitating flesh."[1] The almost quivering enthusiasm in these lines is a measure of his depth of feeling for this transformative power of photography. The art historian Wolfgang Born echoed the same sentiments in 1929, joining the rational with the spiritual, when he wrote that

> this new realism, which finds satisfaction in extreme precision of detail, is the expression of a rational *zeitgeist*. But this does not mean that it has to be banal and devoid of artistry. For no one can be truly moved by reality without a certain secular religiosity, a spiritual way of seeing that intuits a hidden meaning behind the appearance

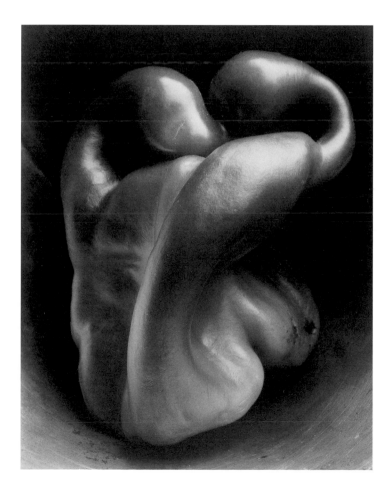

FIGURE 6.1. Edward Weston, *Pepper #30*, 1930. Collection, Center for Creative Photography. © 1981 Center for Creative Photography, Arizona Board of Regents.

of things. And it is this kind of emotion that is needed to produce a work of art; it is this that still distinguishes the artist from the engineer, who is merely concerned with the ultimate use of his work.[2]

Weston's *Daybooks* are a good source for another idea that gained hold in the photography of spontaneous witness, the idea that the photographer was not so much expressing him- or herself as identifying with his or her subject as a medium through which a higher truth might be revealed. He recorded in 1931:

> I am no longer trying to "express myself," to impose my own personality on nature, but without prejudice, without falsification, to become identified with nature, to see or *know* things as they are, their very essence, so that what I record is not an *interpretation—my idea* of what nature *should be*—but a *revelation,* a piercing of the smoke screen artificially cast over life by neurosis, into an absolute, impersonal recognition.[3]

Minor White touched on this same aspect of identification with nature and also alertness to and absorption in the world before his camera when he wrote that

> the state of mind of the photographer while creating is a blank. . . . The photographer projects himself into everything he sees, identifying himself with everything in order to know it and feel it better. To reach such a blank state of mind requires effort, perhaps discipline. . . . The feeling is akin to the mystic and to ecstasy; why deny it?[4]

Spirit in photography was not limited to the ideas of transcendence through the ordinary and alert presence in the real world. For the documentary photographers during this period, as well as curators and editors like Edward Steichen or Roy Stryker or even the staff of the *National Geographic,* there was a strong motivation to do good (or at least to do right) in the world, to change perceptions and even reality through their photographs. These photographers felt a mission to be the eyes of conscience, to rouse the public to a level of understanding and sympathy with others that would result in positive action to improve the plight of those neglected or damaged by circumstance or by society. Cornell Capa dedicated his book *The Concerned Photographer* to "photography which demands personal commitment and concern for mankind." And Milton Meltzer and Bernard Cole focused their book *The Eye of Conscience* on the work of photographers who

> have confronted the life around them and shared the truths they saw. Although they were often concerned to document a single event or condition of existence, their photographs remind us of our common humanity. Behind the lens was a personal vision

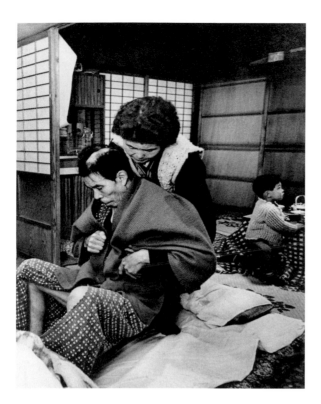

of what life is and what it could be. They hoped to make it better, to change the world by their exposure of the truth.[5]

Such concerns draw not only on a secular humanism but also on a tradition of care and responsibility for one's fellow humans that is deeply rooted in Western Judeo-Christian religious traditions. These photographers have also felt a kind of gift and burden to bear true witness to particular events or sights. Dorothea Lange wrote,

> You know there are moments such as these when time stands still and all you do is hold your breath and hope it will wait for you. And you just hope you will have time enough to get it organized in a fraction of a second on that tiny piece of sensitive film. Sometimes you have an inner sense that you have encompassed the thing generally. You know then that you are not taking anything away from anyone; their privacy, their dignity, their wholeness.[6]

The life of W. Eugene Smith offers an example of personal sacrifice in the service of documentary photography that goes beyond a simple commitment to help others. In 1971, toward the end of his long working life as a photographer, Smith, along with his wife, Aileen, dedicated himself to photographing and exposing the dire effects of the mercury poisoning from waste dumped into the bay of Minamata, Japan, by the Chisso Chemical Company. The community became poisoned by eating fish taken from the bay. Children born to sick parents had multiple congenital defects, and adults suffered crippling disabilities after a lifetime of eating the fish. As a result of this exposé he was beaten by thugs hired by the company, to the extent that his eyesight was damaged and he had to resort to using very wide-angle lenses (which have a great depth of focus) because he could no longer see well enough to focus his normal lenses. The work was published in *Life* in 1972 and was shown in an exhibition at the Seibu Department Store in Tokyo in 1973. It was an international wake-up call to devastating environmental pollution. In his portfolio *Minamata: Life—Sacred and Profane,* Smith explained his motivations:

> Photography is a small voice at best. . . . Photographs right no wrongs, they cure no illness.
>
> Then why photograph?
>
> Because sometimes—just sometimes—a photograph or photographs can strike our senses into greater awareness. . . . And as catalyst to emotions and to thinking, someone among us, or perhaps many among us may be influenced to give heed to reason and to understanding until a way will be found to right that which is wrong, to inspire a dedication for the search to cure an illness. For the rest of us it may perhaps give a greater sense of understanding and compassion for those who are alien to our own life.
>
> Photography is a small voice. . . .
>
> I believe in it.[7]

In the twentieth century the spiritual concepts of the West were enriched by knowledge of the traditions of the East—by Taoism, Buddhism, Hinduism—and many of them have found their way into the thinking of photographers through the work of Minor White. White was a photographer and, more importantly, an editor whose devotion to spiritual concerns in photography was most outspoken. Always the teacher, White used the pages of *Aperture* magazine not only to demonstrate or showcase his own beliefs but also to *teach others* methods by which they too could bring the spiritual dimension into their looking at and making photo-

graphs. White was firm in his commitment to transcendence through the ordinary, and further, he offered a kind of spiritual roadmap for achieving that transcendence.

As a longtime editor of *Aperture* from its beginnings in 1952, White used the magazine as a vehicle for reviving and modernizing Alfred Stieglitz's idea of the "equivalent," that is, consideration of a photograph not only for what it depicts but also for what associations it might arouse, for "what else it is." Although some realist photographers, such as Weston, abjured metaphor, White's mission was to revive it and to demonstrate how metaphor could live together with a commitment to straightforward camera work. *Aperture* was in many ways a reincarnation of Stieglitz's journal *Camera Work*, which had also been both a personal vehicle for the editor's ideas and a beautifully designed and printed publication that was enormously important for taking photographs seriously and for counteracting popular, conventional taste.[8]

Toward the end of his tenure as editor White created four theme-related issues, all of which had somewhat spiritual concepts at their center: *Light*[7] (14, no. 1, 1968), *Be-ing without Clothes* (15, no. 3, 1970), *Octave of Prayer* (17, no. 1, 1972), and *Celebrations* (18, no. 2, 1974). These issues were anthologies containing the works selected by White to illustrate his concepts (barely credited to the photographers in the first two efforts),[9] much in the same manner that Steichen used others' photographs to illustrate his own ideas in *The Family of Man*. Although these four big projects were the most extravagant efforts during White's tenure as editor, they were not his most important, and indeed they demonstrated a level of literal illustration in some of the photographs that showed a decline in White's taste and perspicacity.

Much more important had been the 1959 issue of *Aperture* entitled *The Way through Camera Work* (7, no. 2), in which White laid out his approach not only to making photographs but also to "reading" them, which was an important part of his philosophy. It was also the issue in which he applied and blended most directly the ideas he had picked up from various Eastern religious texts as well as from Western psychology. Drawing a comparison between the Tao of painting and the "Way" through camera work, the issue opened with the Chinese ideogram for *ch'i* (defined on a later page as "Breath of Heaven, Spirit, Vital Force"), and printed below it was a quote from Stieglitz: "In all of camera work the only freshness is spirit and spirit is the only quality in art that forever eludes imitation." The rest of the issue was a free-form collection of quotations from philosophers, photographers, and metaphysicians, photographs from a variety of makers (again, uncred-

ited except at the back), and White's own ruminations, some serious and others on the humorous side.

Emphasizing techniques of *contemplation* (for both the photographer and the "reader," or viewer, of photography), White suggested *projection* and *empathy* as ways to arouse what he called the *depth mind,* or spirit.

> Blobs for Rorschach tests and photographs for contemplation have a mirror action in common. Through the former a professional seeks a glimpse of a patient's psychological life; through the Equivalent a man may get a glimpse of the life of his own spirit.
>
> Let associations rise like a flock of birds from a field. What do various parts of the photograph remind you of—visually. What does the picture as a whole suggest, again visually. . . .
>
> What you find will be your own. The experience can not be compared to addition because that implies one right answer and many wrong ones. Instead the experience should be compared to an equation one factor of which is the viewer's depth mind. When so treated there are as many right answers as persons who contemplate the picture; and only one wrong answer—no experience.[10]

Other emphases in the issue were on the *moment,*

> If, in painting, spirit is present for the length of a brush stroke, in camera work it reveals itself at the moment of exposure.

FIGURE 6.3. Minor White, spread from *Aperture* 7, no. 2 (1959). Aperture.

accident,

> Camera work eliminates the "handwriting" or calligraphy characteristic of the hand arts. Hence in camera work the accidental thru which (according to the depth psychologist) the depth mind expresses itself comes, not from any calligraphy, but from those parts of the photograph which the photographer can not leave out. Camera work offers the accidents of existence for the accidents of calligraphy: the depth mind is hardly aware of the difference; and soul expresses itself with one as well as the other.

and the *ordinary.*

> A special contribution of Zen to Eastern thought was its recognition of the mundane as of equal importance with the spiritual. It held that in the great relation of things there was no distinction of small and great.[11]

White's emphasis on *anonymity* was supported by Edward Weston's idea against self-expression, quoted at the beginning of this chapter. In *The Way* White suggested that spirit has equal agency with the photographer ("Once it has selected a photographer spirit always stands still long enough to be recorded"), and more importantly the idea of anonymity was demonstrated by White's decision to credit the photographers in the issue only with a list in very small type at the back of the book.

Uniting traditional concepts of the soul with modern psychology, White wrote,

> If older generations located the soul in various parts of the body how can modern man help but locate it in the subconscious, preconscious, or depth mind? (These names are but a few in the swarm around the scientist as he pushes the boundaries of man's ultimate ignorance ever further into space.)[12]

One of the last quotations in the issue, of the photographer Syl Labrot, brings to mind the tradition of Alfred Stieglitz—his emphasis on photographs as works of art, freestanding experiences and not just references to something in the world (there is even a glimmer of Moholy-Nagy's dislike of "representation" here):

> In illustration the photograph abdicates its existence, or tries to, in favor of a realistic illusion. While in creative photography the photograph is the end in itself. . . . This kind of photograph does not leave any desire on the part of the viewer to view the scene in front of the camera, for the photograph is the full and separate experience rather than a facsimile of nature.[13]

The title of White's retrospective collection of photographs, *Mirrors Messages Manifestations,* would later encapsulate White's lifelong search to harmonize the self, spirit, and the world (i.e., psychology, metaphysics, and reality).[14] The critic Jonathan Green has pointed out that White's perspective and promotion of Eastern ideas derived from his life in San Francisco, where he had lived before moving to Rochester, New York.

> White's relationship to Stieglitz is always rightly emphasized. Yet his closest contemporary spiritual allies in the fifties were the same as Robert Frank's: the major Beat poets—Kerouac, Ginsberg, and Snyder—and the older members of the San Francisco and West Coast intellectual community—Kenneth Rexroth, Alan Watts, Gerald Heard, Christopher Isherwood, Aldous Huxley, Mark Tobey, and Morris Graves—who for years had been interested in Oriental religions and had been continually pursuing the contemplative life. Though *The Way Through Camera Work* appeared after White had left San Francisco for Rochester, its origins stem from the Oriental teachings that had long established themselves in California. . . .
>
> The sources to which *Aperture* and the Beats turned were identical. Kerouac read D.T. Suzuki's essays on Buddhism, Zen stories, *The Life of Buddha* by Ashvagosa, Dwight Goddard's *Buddhist Bible.* Ginsberg followed Buddhist Sutras, Yoga precepts, Vedic hymns, Chinese philosophy, and the Tao. Neal Cassady read Gurdjieff and Ouspensky.[15]

If such esoteric sources set the Beats and White somewhat against the grain of mainstream culture, still many elements of all kinds of spontaneous-witness photography were in perfect harmony with these metaphysical ideas: the alertness to the present moment, the humility in the knowledge that a photograph must be made in collaboration with the world, and the sense that the photographer was not so much in control but rather was a vehicle through which a truth might be made visible. In a 1995 interview the great Cartier-Bresson described his working attitude as essentially "the Buddhist idea." "We always want to work with our brains," he said, "but we must be available and let our sensitivity direct us . . . as if we're surfing on a wave. We must be open, open."[16]

It is clear that modernist photography was both grounded in and energized by ideas from Western spiritual traditions—speaking truth, bearing witness, human compassion, and personal humility—as well as Eastern spiritual ideas, such as living in the moment and quieting the mind to a state of contemplation in order to

identify with, and clearly see, the world around it.[17] If this harmonic integration of spiritual concepts with a remarkably modern technology didn't make saints of the photographers, and for the most part it did not, it still provided a deep, rich, often unspoken spiritual basis from which to work.

DISAPPEARING WITNESS

I believe in the imagination. What I cannot
see is infinitely more important than what I can see.

—DUANE MICHALS

Real Dreams

NEW PARADIGMS

Uelsmann, Michals, and Samaras

Photographers are always cast as spectators. They're always walking down the street responding to something they see on the street. They never make things happen themselves. Well, what I'm doing is really creating my own private world and making my own thing happen. I'm not relying on accidental events. —DUANE MICHALS

I should like to encourage more young photographers to get off the streets and back into the darkroom. It is my conviction that the darkroom is capable of being, in the truest sense, a visual research lab: a place for discovery, observation, and meditation. —JERRY UELSMANN

I have wanted to photographically explore my body for years and was going to have a professional photographer do it. But I have never been able to work well with others, and I was not going to go to a photography school and learn photography. Polaroid came in handy. —LUCAS SAMARAS

IN PART ONE we looked at many enormous changes that transpired in the 1920s. That was a decade of rapidly changing technology, of radical advances in communications and media. Artistically it was a decade that said farewell to the past. While not a neat parallel to the twenties either socially or technologically, the 1960s were also years of radical change, and years in which past aesthetic solutions—the ideas of modernism—began to seem irrelevant. Although no one used the term at the time, we could say that *postmodernism* began in the sixties. It was a time when classical modernist photography of witness suddenly didn't say enough and the most advanced practice in photography was turning inward—to the landscape of

the mind, to dream, to memory, to fantasy. Jerry Uelsmann, Duane Michals, and Lucas Samaras created powerful new paradigms during that decade that were hugely influential on the generation of the seventies and eighties and continue to be models for photographic practice today. Before examining their work and their new ideas in detail, some background on the times, particularly what it was about the sixties that provoked such radical change, may be useful.

Since the triumphant end of World War II and through the fifties the story of life in the United States had been one of increasing prosperity, increasing opportunities for higher education and homeownership (through the G.I. Bill), and finally a sense of consumerist complacency—for most Americans, that is. The structure of American society had its flaws, and these eventually presented cracks in the structure, which began literally to fall apart in the sixties. In the fifties, Cold War repression and paranoia had, as I have noted already, a chilling effect on documentary photography and on cultural work in general. Robert Frank's *The Americans*, published in 1959, proffered a rough, rude, and critical view of American society. Countering the mainstream American self-image of complacency, Frank's view suggested deep racism, vast differences between rich and poor, and a spiritual bleakness of the gravest kind.

Frank's was not the only critical voice to be raised at the end of the fifties. For example, in "Good-Bye to the 'Fifties—and Good Riddance" Eric Goldman wrote,

> We've grown unbelievably prosperous and we maunder along in a stupor of fat. We are badly scared by the Communists, so scared that we are leery of anybody who so much as twits our ideas, our customs, our leaders. We live in a heavy, humorless, sanctimonious, stultifying atmosphere, singularly lacking in the self-mockery that is self-criticism. Probably the climate of the late Fifties was the dullest and dreariest in our history.[1]

Such a state of affairs cried out for change, and the election in 1960 of the young John Fitzgerald Kennedy as president seemed to offer new hope, an open door bringing fresh air to a stale nation. The poet Robert Frost, in his inaugural poem for Kennedy, envisioned

> The glory of a next Augustan age
> Of a power leading from its strength and pride,
> Of young ambition eager to be tried,
> Firm in our free beliefs without dismay,

In any game the nations want to play.

A golden age of poetry and power

Of which this noonday's the beginning hour.[2]

The story that had such a bright beginning in January 1961 would, of course, play out tragically in less than three years. And President Kennedy's assassination in November 1963 would be echoed in the killings of three more leaders within the next five years: Malcolm X in 1965 and Martin Luther King Jr. and Robert F. Kennedy in 1968.

An early sign of trouble in the Kennedy presidency was the disastrous Bay of Pigs invasion in 1961 and the opening of the "credibility gap," the disparity between the truth and the official version of events as circulated by the U.S. government. Kennedy had greater success with his blockade of Cuba in the fall of 1962. The Soviet Union agreed to withdraw its missiles from Cuba, and the United States promised not to invade Cuba, but Kennedy's isolation of Castro undoubtedly drove Cuba even more firmly into the arms of the Soviet Union than would have occurred otherwise. What Kennedy would have done in Vietnam is open to speculation, but his hard line on Communism suggests that he might have continued a vigorous commitment to the war there (U.S. military advisers were in place in Vietnam in 1962).

In foreign relations, the Peace Corps, established in March 1961, was a popular achievement of the short Kennedy administration, but it was even more an indication of the desire of many young Americans to reject complacency and make a positive contribution to the world. With the Peace Corps Kennedy was perceived to be leading the way, but as Gerald Howard has written,

> The creation of the Peace Corps had much in common with various actions taken by the Kennedy Administration in the civil rights struggle. The Administration was often forced into reluctant action by initiatives on the part of activists that they (the activists) might not have taken had they not felt—feelings based more on faith than concrete evidence—that the Administration was irrevocably committed to their movement.[3]

In any case, there was soon a change in leadership, first to Lyndon Johnson and then to Richard Nixon, neither of whom proved equal to the issues of the sixties. As the decade unfolded, the country split apart in a kind of sputtering, slow-motion agony as the Vietnam War dragged on and race relations deteriorated to a model of

separatism, with the activities of the violent Black Panthers and the separatist Black Muslims replacing Martin Luther King Jr.'s nonviolent, integrationist approach.

The two great moral crises of the 1960s were the civil-rights struggle and the Vietnam War.[4] Both issues sundered families and communities—whites versus blacks, states' rights advocates versus federal lawmen, "patriots" versus war protesters, young men willing to serve versus those who fled the draft, old versus young. Millions of individual tragic stories could be told about these two great issues, which touched virtually every family. In the civil-rights struggle Americans were faced with parts of the nation being unwilling to live by its laws and ideals, and in the Vietnam War they were faced with a government that had become increasingly dishonest and impotent in a guerrilla war against a small nation of committed Communists. Faith in, even respect for, the government dwindled to nearly nothing.

This is not the place for a detailed account of the civil rights struggle or the Vietnam War, but some general observations about its effects can be made. First, the increasing duplicity of the government and the senseless violence and failure of the war created unbearable frustration on all sides. As well, the daily incredible body count deadened the nerves and allowed an increasing toleration for violence at home—in both antiwar protests and the civil-rights conflicts. In the civil-rights movement, the increasing violence and rioting during the sixties—King's nonviolent strategies had been largely abandoned by 1966—heightened the polarization of the races and even the demonizing of one race by the other and also raised the bar on tolerance for violence. In such an atmosphere the siren song of drug guru Timothy Leary's "Turn on, tune in, drop out" attracted many young Americans to drugs and to alternative, "drop-out" lifestyles. A powerful new drug, LSD, generated its own culture and even its own aesthetic style, "psychedelic art." Many others were involved in the student protests of the late 1960s, protests that literally shut down major universities. (It took another decade at least for gutted curricula in many institutions to be restored.) A huge youth culture was erupting, and young radicals declaimed, "Don't trust anyone over thirty!"

Violence, racial hatred, national tragedy, alienated youth, loss of belief in the government, and enormous losses of American (as well as Asian) lives in a war America couldn't win—in just a few years all this had replaced the "stultifying" and "dull" atmosphere of the fifties that Eric Goldman had railed against at the beginning of the decade. To be sure, this was a trade-off that had been hoped for by nobody.

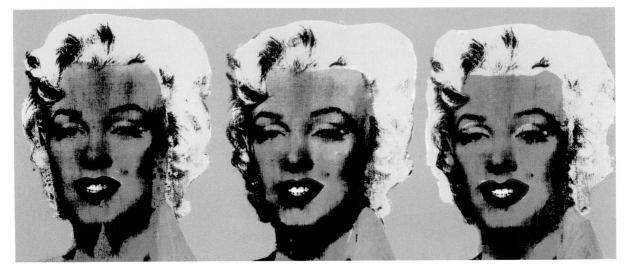

FIGURE 7.1. Andy Warhol, *Marilyn (Three Times)*, 1962 (synthetic polymer paint and photo-silkscreen on canvas, 14 × 33½ in.). The Andy Warhol Museum, Pittsburgh, Founding Collection, Contribution of The Andy Warhol Foundation for the Visual Arts, Inc. © Andy Warhol Foundation for the Visual Arts/ARS, New York.

In general, although there were committed idealists among the rebellious youth and disaffected minorities,[5] and although responsible critical voices like Rachel Carson's and Ralph Nader's entered public discourse,[6] an immense wave of anarchic cynicism swept over the nation in the sixties. At the same time, and very much a part of it, Hugh Hefner, the publisher of *Playboy*, was preaching his "Playboy Philosophy" of exploitative hedonism to men who may not have dropped out of mainstream capitalist society but surely had tuned out traditional values of male responsibility, a movement Barbara Ehrenreich would label "the male revolt."[7] By the end of the decade the best protection most Americans, young ones especially, could hope for was being "cool"—aloof, mocking, not drawn into enthusiasm for anything, and certainly withdrawn from public values, which seemed to lie in ruins.

"Cool" was the hallmark of the new art of the 1960s, embodied early and most clearly in the new pop art.[8] Artists like Roy Lichtenstein, Claes Oldenburg, Robert Rauschenberg, Tom Wesselman, James Rosenquist, and Andy Warhol (*especially* Andy Warhol) offered up art objects that undercut the heroic seriousness of the abstract expressionists who preceded them. Banal and common things—soup cans, hamburgers, comic book pages, newspaper photographs, advertisements—were made monumental subjects in pop art, and these creations mocked the earnest, spiritual ambitions of the fifties painters at the same time that they seemed to disregard the social issues of the day. Pop art seemed to locate American culture in its most menial, commonplace occurrences—maybe in fact the only place where any-

thing of value remained. Certainly pop art turned away from any shared public myths or values, except that most Americans were likely to share a taste for hamburgers, Campbell's soup, or Marilyn Monroe.

Besides pop art, the sixties was the decade of happenings, madcap performance pieces "which, in their improvisatory, participatory, transitory nature, were Pop in spirit."[9] The element of humor in happenings and in pop art was critical. It was a kind of humor called a "put-on"—aggressive, sly, subversive, and meant to make a fool of its target. To respond to a put-on, even for one who understood it, was to express little more than a bit of knowing, uneasy laughter. To ask what it meant was not cool.[10]

It comes as no surprise that in photography too the new sensibilities were turning away from shared public values during the sixties, and especially from the tradition of eye-of-conscience photojournalism. Idealistic visions of changing the world through photography seemed to evaporate (except on the part of photojournalists who continued to cover the war and the battles at home), and what documentary efforts were made were focused on increasingly shocking subject matter, such as drugs and sex (Larry Clark), freaks (Diane Arbus), abject urban poverty (Bruce Davidson), or outlaws and prisoners (Danny Lyon). As Jonathan Green has written,

> It was consistent with the social and psychological upheavals of the sixties that a documentary focus should emerge that looked at the less newsworthy, internal aspects of the new culture. . . .
>
> The obsessions of sixties photography were ruthless: alienation, deformity, sterility, insanity, sexuality, bestial and mechanical violence, and obscenity.[11]

Despite these changes in documentary—"The Sixties as Subject," as Green calls it—the really new energy in photography was directed at private, personal, or aesthetic issues and at making visible the landscape of the mind, not the real world. Because photography had been grounded in realistic witness for so many years, the new photography went in the *opposite* direction from that of pop art; that is, instead of moving toward newly banal subject matter (as in pop art), photography went from the banal to the *mysterious,* from everyday realism to *fantasy.*

Some of this new energy—private, personal, and aesthetic—came from the photography programs that began to emerge in colleges and universities across the country. While a few of the programs took photojournalism seriously, much more of the new college-level instruction in photography was oriented toward personal

or fine-art photography. Attention to the medium's history and encouragement to explore its limits were hallmarks of the best of these programs. Jerry Uelsmann was a product of this university-level training: he studied with Ralph Hattersley and Minor White at the Rochester Institute of Technology and with Henry Holmes Smith at Indiana University, receiving his M.F.A. degree in 1960.[12] After that he was on the faculty at the University of Florida for decades. When Uelsmann's work emerged on the scene in the sixties it was both technically dazzling and hyperconscious of photography's premodernist traditions.

Conscious as Uelsmann was of the past—he cast himself in a comic, dual self-portrait as both Robinson and Rejlander, two nineteenth-century masters of photomontage—his work was no rehash of Victorian ideas. Instead, and this was truly new, it was full of intuitive natural symbolism expressing the psychic topography of modern man. Despite its seemingly "archetypal" imagery,[13] the early work in the

sixties was thematically focused on contemporary issues: male-female relations; the multiple, continually unfolding aspects of the self; the conflation of woman with nature; and the political issues of the day—the threat of nuclear annihilation (*Apocalypse II*, 1967) and racism (*Massacre of the Innocents*, 1971).[14] About the last picture he has written, "I think *Massacre of the Innocents* deals with the South that is very much going through a painful transition. It was also done at the same time that three civil rights workers were killed in Mississippi."[15] That he chose to deal with such issues in large part symbolically (and then with symbols drawn from *nature*), and not descriptively, has masked for some viewers his contemporary point of view. Uelsmann has never allowed that he did not deal with reality; rather, "I am involved with a kind of reality that transcends surface reality. More than physical reality, it is emotional, irrational, intellectual, and psychological."[16]

Although all of Uelsmann's imagery has been conventionally photographed in the camera, his camera is more a collecting tool than anything. For him, camera work is neither the end point nor the most creative moment in the process. Instead, Uelsmann works on the theory of "post-visualization" (the title of his 1967 mani-

FIGURE 7.3.
Jerry N. Uelsmann,
Apocalypse II, 1967.
Jerry N. Uelsmann.

festo, meant to counter the Ansel Adams/f.64 theory of "pre-visualization").[17] Making use of his great archive of negatives, Uelsmann combines imagery in the darkroom, where his real creative work is done. His darkroom is a luxurious space, fitted out for comfort with multiple enlargers (each can hold a separate negative as he moves his light-sensitive paper from one image to the next). He works intuitively but also with great control and often repeats a motif from image to image. In 1970, assessing Uelsmann's work from the sixties, the photohistorian Peter Bunnell described Uelsmann's method thus:

> The excruciatingly complex techniques of photomontage are superbly suited to his effort. These techniques are Uelsmann's alchemy. His volatile photographic images, in which the dominant character is the dynamism of a psychic order, open to the world of magic. I do not believe he could ever satisfy himself with what is termed straight photography, because for him straight photography is not the resolution of a vision, but the beginning of a process. He takes pictures simply, rapidly, and straightforwardly, responding freely to the inspired revelation and recognition he achieves through the camera. With little or no preconceived notion of a finished photograph, he makes enormous numbers of negatives, stores them carefully, and in this way prepares his visual vocabulary for the next step.
>
> In the darkroom he progressively and additively compiles the visual equivalent of his inner vision. He consciously follows the dictates of his insight in the construction of an image. His work would not be as convincing if it were not totally drawn from himself, and this means working with the negatives of no other photographer. It is the intimacy of the personal, half-forgotten image or event, recorded perhaps years previously, which is drawn from the negative file and brought into the light of a new consciousness.[18]

As Uelsmann describes it,

> My contact sheets [containing small images of all his negatives] become a kind of visual diary of all the things I have seen and experienced with my camera. They contain the seeds from which my images grow. Before entering the darkroom, I ponder these sheets, seeking fresh and innovative juxtapositions that expand the possibilities of the initial subject matter. Ultimately my hope is to amaze myself.[19]

Of early critics who attacked his work as "not photographic" Uelsmann said in 1971,

That upset me a great deal because it seemed to me that if anything I was hyper-photographic. The out-of-focus image is a photographic phenomenon. The negative image is a photographic phenomenon. The multiple exposure is a natural aspect of photography. A lot of these phenomena have been more effectively exploited by people in other media but they belong naturally to photography and in my opinion should be very much a part of every photographer's vocabulary.[20]

The viewpoint of those critics, as the reader will recognize, had its origins in the American version of photographic purism that took hold in the twenties and thirties, not Moholy-Nagy's more expansive view, and its power as late as the 1960s is evidence of its continuing importance in American fine-art photography.

Among his many accomplishments, Uelsmann deserves credit for expanding the American understanding of the word *photographic*—he liberated future generations of young students. It is clear, though, that the critics were excited about something else: what he really violated was the ethos of *spontaneous witness*. As a "modern" photographer, he had dramatically discarded the role of witness-to-one-moment-in-time-and-space, which had quietly underlain modernist photography until then. Instead, he worked with a multivalent concept of time—as in a dream, when several events can occur impossibly at once—instead of linear time. Uelsmann's attitude toward combining many incompatible spaces (and scales) into one is very similar to his treatment of time, except that with a few early exceptions, he makes that "space" seem coherent. That he can concoct semilogical spaces (with perfect perspective and subtly blended tonalities) within which these impossible, layered events can occur is a major element in Uelsmann's magic. And, of course, that is what sets it apart from spontaneous witness.

Giving him rather grudging praise, John Szarkowski wrote in 1978 that

Jerry N. Uelsmann's fanciful, intricate, and technically brilliant montages have been broadly influential, but not widely followed. His pictures persuaded half the photography students of the sixties that manipulated photographs could be both philosophically acceptable and aesthetically rewarding, but few of those students adopted Uelsmann's fey, Edwardian surrealism, or his very demanding technical system.[21]

This judgment seems off the mark or at best premature for in fact Uelsmann has had followers. Even more to the point, today's students are avidly interested in his images, *but what Uelsmann did (and continues to do) in the darkroom, they are attempting on the computer.* The issue of Uelsmann's relation to computer-manip-

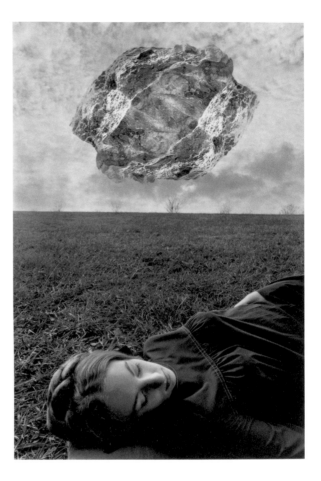

ulated imagery was considered from a nineties perspective by the critic A. D. Coleman:

> Works like Uelsmann's that, twenty years ago, had to fight for the right to be considered as part of the continuum of artistic/photographic activity now seem classic examples of a tradition—indeed, a tradition that, given the increasing presence of digitized photography, is unquestionably on the verge of technological obsolescence.
>
> . . . In fact, had the home computer been available to him when he started out, I suspect he might have bypassed silver-based photography entirely and avoided the decade of battle.[22]

Thus, if one said in 1978 that Uelsmann's example was "not widely followed," better to add the word *yet*. Reaching back into the nineteenth century for his in-

spiration, he was at the same time a photographer in advance of his time in the sixties, and computer programs like Photoshop, perhaps, will finally allow his vision to be broadly influential.

Duane Michals shares much with Jerry Uelsmann, although their work appears quite distinctive on first glance. They have in common an interest in spiritual or psychological experiences and at the same time a zany sense of humor. They are both somewhat manic enthusiasts, with humor of the "giggling mystic" variety, which emerges occasionally in their work (including wordplay in Michals's work) and always in their public lectures. "If you're serious it's important to be foolish," according to Michals.[23] Both men cite the painter René Magritte as an important influence. And most importantly, both pushed photography beyond its former limits. Uelsmann moved it into the area of complex combined imagery, and Michals found his métier in the late sixties, when he began to stage and photograph little sequences of action—made-up stories, fictions that unfolded in a few frames of film.

Not formally trained in photography—"Not having gone to photography school, I never learned the rules"[24]—Duane Michals began photographing as a tourist in Russia in 1958. His first photographs were portraits, and portraits have continued to be an important part of his work.[25] When he returned to the United States, he began seeking editorial portrait assignments, and he has done many for the fashion and lifestyle magazines. He has shot fashion as well, with available light. In this editorial work we might say he has been a photographer of witness, but in his personal work—the staged sequences—Michals parted company with that modernist tradition.[26]

If natural forms—rocks, water, trees, the sky—were the visual elements in Uelsmann's dreamlike visions, for Duane Michals's imaginary narratives the setting was the empty room or the city street. In fact, some of Michals's earliest published photographs were of unpeopled, empty rooms.[27] In hindsight these rooms look like stage settings awaiting the entrance of the actors.

Some of Michals's early sequences were little human dramas that were almost plausible (*Chance Meeting*, 1970), but more were of a fantastic turn, such as *The Fallen Angel* (1968), *Paradise Regained* (1968), *The Young Girl's Dream* (1969), or *The True Identity of Man* (1972). In many of them a mystical transformation related to death takes place, yet in the simplest of settings. In *The Spirit Leaves the Body* (1968) Michals suggests after-death transformation through double exposure, as the spirit gets up and walks toward the camera, leaving the body on the bed in an otherwise bare room. In *The Human Condition* (1969) a young man standing

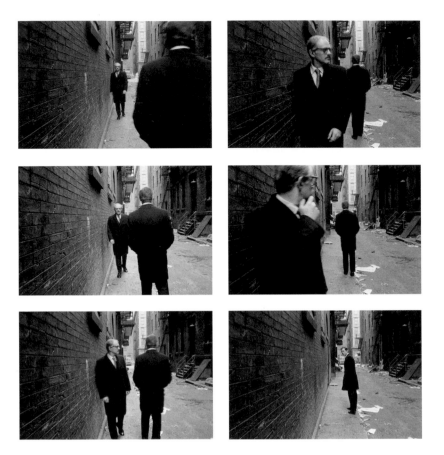

FIGURE 7.5. Duane Michals,
Chance Meeting, 1970.
Duane Michals.

on a subway platform is transformed, within six frames, into a galaxy of stars. In *Death Comes to the Old Lady* (1969) an old lady sits quietly in her dining room until a blurred, dark figure comes into the room, and then she rises in a blur and is gone.

Technically, Michals's photographic means were simple: black-and-white 35 mm shots printed full frame (with black borders). Sometimes he has used double exposure and sometimes dodging to hold light back on a print exposure, but more frequently Michals has used long exposure to create blur and to suggest the element of time passage. Time itself was usually linear even when the action was completely fantastic, except that a few sequences, such as *Things Are Queer* (1973) or *Alice's Mirror* (1974), suggested a kind of inside-out time-and-space. Michals's own childlike handwriting appeared at first in titles written on the first print of each se-

quence, and as the years have gone on, writing on his photographs has become more extensive and important.

"I began writing on photographs because of my frustration with the medium," Michals has said.[28] The writing expands possibilities—he can write about much more than he can picture with a camera—and it also lends a character of simple informality that has an unpretentious charm. "Always be a beginner," he tells students, "don't be cool or hip."[29] In his books, which are artistic vehicles for Michals and not just collections of pictures, extensive handwritten text appears. In *Real Dreams*, in particular, his handwritten introduction is a good statement of Michals's ideas. Here are a few of them:

I use photography to help me explain my experience to myself. . . .

I find the limits of still photography enormous. One must redefine photography, as it is necessary to redefine one's life in terms of one's own needs. . . .

When you look at my photographs, you are looking at my thoughts. . . .

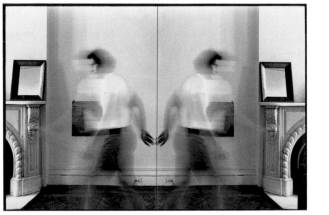

FIGURE 7.6. Duane Michals, *Now Becoming Then*, 1978. Duane Michals.

Everything is subject for photography, especially the difficult things of our lives: anxiety, childhood hurts, lust, nightmares. The things that cannot be seen are the most significant. They cannot be photographed, only suggested.[30]

A third photographer who broke dramatically with the past in the sixties could not offer a greater contrast to the personable photographers Uelsmann and Michals. For Lucas Samaras was first of all an artist (not a photographer), and an eccentric, reclusive artist at that. Although he had already used little pictures of himself inside his sculptural boxes and had collaborated with the filmmaker Kim Levin on a film called *Self,* his work was not known for its photographic content. Photography for Samaras became possible only when a new technology, the Polaroid instant print, became available. An inwardly focused, obsessively private misanthrope who has "never been able to work well with others," Samaras wanted nothing to do with the social exchange of the photographic moment. Furthermore, he wanted control.

Endlessly brooding on his particular history as a Greek immigrant and his distaste for most human interaction, Samaras wrote:

I have never been able to understand or accept my inability to permanently fuse with another person. Their individual quirks always got in the way. I thought about the possibility of having a brother, not a brother with independent will, a brother who felt and thought as I did.[31]

Tracing his story back to his childhood, he recalled the names by which he had been called:

"Sneaky, polite, frail, poetic, brutal, romantic, shy, lovable, snobbish, sensitive, proud, mama's boy, thoughtful, stupid, girl-like." The list of words that I can remember being soothed, stroked or pricked with is very long.[32]

In adulthood, living alone and mostly spending his time in his apartment/ studio, Samaras found some surcease from his discomfort:

My apartment is a reality that absorbs, challenges and soothes my mind. It is a springboard to my fantasies. It doesn't emote, it doesn't insult, it doesn't provoke those infancy-connected love-hate collisions, it doesn't talk about the weather. I can enjoy objects, surfaces, edges, metaphors, abstractions as I like. There is no competition.[33]

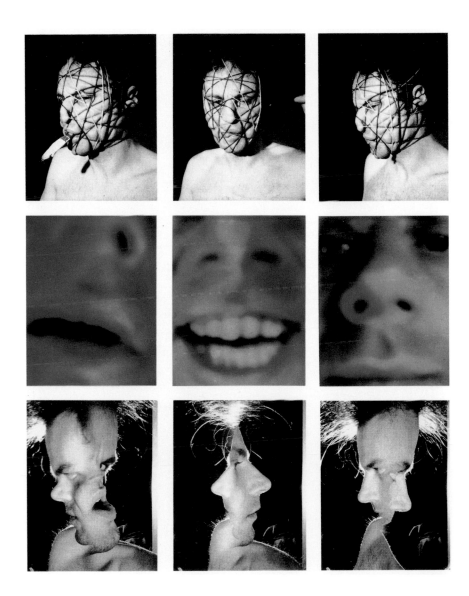

FIGURE 7.7. Lucas Samaras, *Autopolaroids,* page from *Art in America* 58, no. 6 (November/ December 1970). Lucas Samaras, Pace Wildenstein Gallery.

When the instant Polaroid process became available in both black-and-white and color versions in 1963,[34] the medium best suited to Lucas Samaras was an option.

He began producing his Autopolaroids, as he called them, in 1969 and published 106 of them in a big feature in *Art in America* in November–December 1970. In answer to a question he put to himself in an "autointerview" included in the article, Samaras said:

How did you stumble on the polaroid?

Martha Edelheit had taken some polaroids of me in 1968, and I liked the speed of the result. Also I wanted to show Kim Levin, who photographed the film we made of me called *Self* last year, that I was as good or better a photographer than she. It was a way of getting back some of the dignity that slipped out of me while she was manipulating the movie camera.[35]

The Autopolaroid pictures themselves were wildly various, but in none of them do we see what we might call a "normal" portrait. They were arranged in grids, usually in three rows of three. Samaras tried costumes, props, wigs, and makeup in some, intensely exaggerated facial expressions in others, long exposures with frantic motion of his head in some, and colored gels over his lights in many others, giving parts of his body a green, red, or yellow cast. Other shots were taken from the floor, giving a weird perspective to his nude body, and in still others he used double exposure, sometimes conflating his buttocks with his face and, more poignantly, sometimes showing him tenderly embracing himself.

He asked himself a number of other questions in the autointerview:

Is your work autobiographic?

Autobiographic, anthropomorphic, practical, abstract, realistic, mental, real, imagistic, fantasist—sure.

Why are you fascinated by your image?

Anything that anyone does is fascinating if you have the time. I am hooked on many things. You just happened to touch on this one.

Well?

My body is one of the materials I work with. I use myself and therefore I don't have to go through all the extraneous or other kinds of relationships like finding models and pretending artistic distance or finding workers or finding some symbol of geometry. I use myself also because it is still unorthodox to use one's self.

Is that narcissism?

Call it what you will, I get things done. The old notion of narcissism makes no provision for the audience. . . . Others talk about themselves when they talk about abstractions. I talk about others when I'm talking about myself.

Do you want to be a woman?

No, I wanted the pretense.

Is it significant that you took the polaroids yourself?

I suppose so. I was my own Peeping Tom. Because of the absence of people I could do anything, and if it wasn't good I could destroy it without damaging myself in the presence of others. In that sense I was my own clay. I formulated myself, I mated with myself, and I gave birth to myself. And my real self was the product—the polaroids.

What is this, creative psychodrama?

If it is, why not?

I thought art was . . .

Think again.[36]

A year later Samaras would get a big show of this work at the Whitney Museum of American Art, and in conjunction with the show a big publication, *Samaras Album*, filled with even more Autopolaroids and including three essays entitled "Autobiography" as well as a slightly altered version of the "Autointerview."

The next development of Polaroid material, the SX-70, offered Samaras even more possibilities:

Samaras's great opportunity to give the photographic image of his body the illusion of plasticity came in 1973 when John Holmes, an employee of Polaroid Corporation, gave Samaras and other artists the newly invented Polaroid SX-70 and asked them to experiment with it for an exhibition at the Light Gallery in New York. . . .

He discovered that while the image developed, the emulsion remained soft, and that it stayed soft for some time. By pressing and pushing it with a wooden stylus or the rounded end of a metal ruler he could elongate a body, split a chest, cover a wall with markings or a whole picture with the semblance of brushstrokes. Now the *image* of his body became a plastic material and gives the illusion that the body from which the image was taken is as plastic as the body in the photograph.[37]

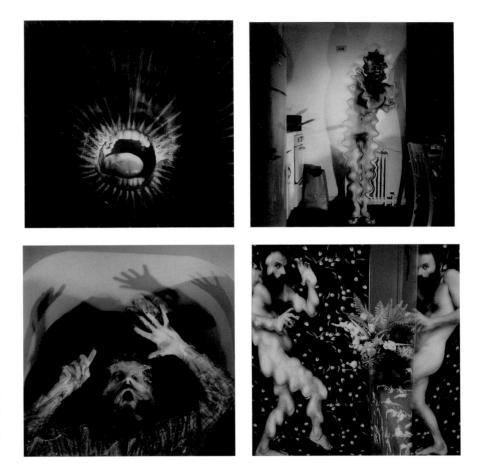

FIGURE 7.8. Lucas Samaras,
Photo-Transformations,
1973–1976 (four SX-70 Polaroids,
3 × 3 in. each). Lucas Samaras,
Pace Wildenstein Gallery.

These strangely distorted and expressionistic little images (SX-70 pictures are 3 × 3″) were named "photo-transformations" by Samaras, and they—like Uelsmann's combination prints and Michals's sequences—were, and continue to be, enormously influential on young photographers who followed. More than his Autopolaroids, the photo-transformations introduced a level of hallucinatory imagery and body obsession oddly in tune with the culture. The critic Ben Lifson described the points of similarity thus:

The artist . . . by picturing his kitchen nightmares in the terms of public, historical art, lets us understand his fears as versions of our own; and the eclecticism of his artistic allusions lets us see him as our contemporary. Contemporary, too, is Samaras's con-

fessional mode, which has its literary counterparts in the poetry of Robert Lowell, Sylvia Plath, John Berryman, Denise Levertov. And at the same time that Samaras made these photographs, younger Americans sought visions in hallucinatory drugs. They also ceremoniously exposed their nakedness in public and their sexuality in group lovemaking. Soft-core pornographic magazines, appearing at about the same time as Samaras's photographic work began, regularly featured snapshots of men and women in their homes, naked and spread-legged. Gay culture went public. . . . Samaras restores mythic dimensions to a cultural present in the process of detaching itself from history.[38]

How, then, did these three influential photographers, taken together, change the practice of photography at the end of the 1960s? The following summary, like the one in Chapter 3, lists the main points of change:

1. The moment of camera exposure is no longer the most significant step but simply one in a more lengthy process of creation.
2. The purist use of the medium has been extended or violated; prints are manipulated, written on, made from several negatives or multiple exposures.
3. The subject matter of the photographs has been *staged* and not found, as faith dissipates that the observable social scene contains meaning.
4. The idea that one print is a sufficient, stand-alone statement has been abandoned; work is done in combinations of several negatives in one print, sequences of prints, or series.
5. Internal, psychological, or dreamlike themes or the self—not ordinarily visible in the everyday world—have replaced the witnessing of events.
6. The practice of photography has been engaged by artists who don't care (or even know) about its traditions.

By singling out Uelsmann, Michals, and Samaras I don't mean to suggest that there were no photographic precedents for their bold, new approaches to photography. There were probably more for Uelsmann than for Michals and Samaras, not only Uelsmann's acknowledged nineteenth-century forbears but also, closer to his own time, Clarence John Laughlin, Frederick Sommer, Man Ray, Edmund Teske, his teacher Henry Holmes Smith, and the multiple-exposure work of Harry Callahan—all of them extending the medium, using more than one exposure to make a print, and basically approaching photography from an expressive rather than a realistic, descriptive sensibility. Nevertheless, Uelsmann's work was so fresh, so com-

pletely realized, emerging full blown as it did, that he had a greater impact than any of them.

Although one might cite as a precedent for Michals nineteenth-century "spirit photography"—those odd double exposures that claimed to picture ghosts—there are very few others. Indeed, his narrative impulse and combination of writing with photography were radical and went profoundly against the grain of modernist photography. (They were definitely not *Life* photo essays.)

Of the three, Samaras, in a sense, may have the most company in modernist art, because from Joseph Cornell to Robert Rauschenberg and Andy Warhol the photograph as raw material had been an important element of assemblage, collage, or other modern idioms. Samaras, however, took the bull by the horns—an artist making his *own* photographs—and furthermore pushed the medium of photography itself, in his manipulation of the emulsion, into new territory.

In the chapters that follow we will see how these changes were taken up in photographic education, in the art market, and in two major new genres, *self-imagery* and *directed arrangements,* which were, in Van Deren Coke's phrase, "fabricated to be photographed." In the next chapter we will examine how the changes impacted documentary practice.

DOCUMENTARY-STYLE AND
STREET PHOTOGRAPHY

In practice a photographer does not concern himself with philosophical issues while working; he makes photographs, working with subject matter that he thinks will make pictures. —JOHN SZARKOWSKI

A message picture is something that's simply too clear.

—ROBERT FRANK

I photograph to find out what something will look like photographed.

—GARRY WINOGRAND

The process itself has a kind of exactitude, a kind of scrutiny that we're not normally subject to. I mean that we don't subject each other to. We're nicer to each other than the intervention of the camera is going to make us. It's a little bit cold, a little bit harsh. —DIANE ARBUS

IF THE DISILLUSIONMENTS AND DISINTEGRATIONS of the sixties ripped apart the social fabric, they tore holes too in the tradition of documentary photography. The mixture of progressive politics and faith in the universal language of photography that had informed documentary practice seemed nearly impotent in the face of Cold War repression and then the "credibility gap," the drug culture, and a nightmarish war in Asia that was a bottomless pit of lives and ideals.

The young felt betrayed by the old, the old confused by official half-truths, and the escalating violence at home in political as well as race-related protests challenged the tradition of a peaceful domestic environment. In addition, in the world of photography the despairing or absurd images of Robert Frank, William Klein, and a few others of the New York school ripped away any notions of social agency

from photographers. Photographers felt as swallowed up as anyone by the times and retreated into a self-referential world of "photography" even as they continued to prowl the streets and obliquely bear witness to their times.

Interestingly, the sixties were the decade in which a deeply literate and thoughtful curator, John Szarkowski, came into great influence.[1] By interest as well as practice Szarkowski was clearly grounded in the documentary tradition. *The Face of Minnesota,* a centennial celebration of statehood in which both the text and the photographs were his, had been published in 1958, the same year that Robert Frank's *The Americans* was published in France. Szarkowski was a clear-eyed, unromantic chronicler of the state, but he had a sense of the limits to what any kind of documentary photography could do:

> I have tried to show the land and its people and their work, in such a way that the whole would fit together to give a lively and an honest sense of what the place is really like. But all the important facts could not be shown in a thousand books. It is necessary to select a few isolated images which seem to make sense together, so that one picture which is present will recall the many others which were never made, or which were made and discarded. The selected pictures are not necessarily of "important" subjects. (As when someone is trying to make you remember an old friend: he may tell you the old friend's height and weight and income and business and his wife's maiden name, but you will not remember him until you are reminded that he always looked at people over the top of his glasses.)
>
> There are many important Minnesota images which are not in this book—Lake Minnetonka on a Sunday in July, covered with white sails; or Paul Bunyan and Babe the Blue Ox, at Bemidji; or Mille Lacs in winter, covered with ice-fishing houses. But if those who know Minnesota will be reminded of these things, and if those who do not know it can imagine what these things might be like, then it is a good book.[2]

When Szarkowski became head of photography at MoMA in 1962, he brought these same intelligent reservations about photography to the job. In fact, his most important contribution was to define *just what is it about photography* that gives it both its limits and its power. What is the vocabulary? These issues were addressed first in his 1964 show *The Photographer's Eye* and in his 1966 book by the same name. In this important aesthetic treatise about photography he defined the important elements as "The Thing Itself," "The Detail," "The Frame," "Time," and "Vantage Point." Mention of print quality, previsualization, or postvisualization was conspicuous by its absence, as was any statement about photographs as agents

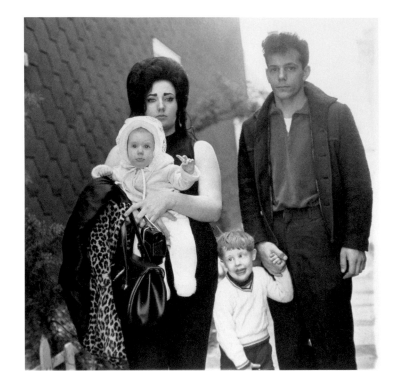

FIGURE 8.1. Diane Arbus, *A Young Brooklyn Family Going for a Sunday Outing, New York City*, 1966. The Beaumont Newhall Collection. Purchased with funds from the John D. and Catherine T. MacArthur Foundation, University of New Mexico Art Museum. © 1968 The Estate of Diane Arbus LLC.

of social change. Szarkowski was after something broader and at the same time more fundamental than art-photography or eye-of-conscience concepts. And, in fact, his illustrations bore this out, for they were drawn from newspapers, war photographs, anonymous historical sources, and conventional portrait studios, as well as art photography. In a later exhibition and book, *From the Picture Press* (1973), Szarkowski continued his aesthetic investigation, this time into the essentials of a newspaper photo. Again his interest was in the limits of the medium:

> A news photograph is a photograph before it is news; what it will tell us of the events of the world is limited ultimately by the medium of photography. Even a cursory investigation of photojournalism will demonstrate that there are many issues that photography has not, and probably cannot, deal with.[3]

In addition to the limits of the medium, there are limits to "news" itself as a real event:

> In the case of news photographs one should begin by recognizing that many of these

pictures are, in greater or lesser degree, set-ups. In a larger sense the news events that they report are themselves set up. With the exception of natural disasters, most news is and has long been managed news, to the degree that life arranges its schedules to make its climactic moments available to journalists.[4]

Szarkowski's reservations about the limits of photography, combined with his great attachment to the medium, predisposed him to savor the work of a new group of documentary-style photographers in the sixties, photographers who were trying, not to change the world, but rather to use the medium to its fullest. In 1967, a year after the publication of *The Photographer's Eye,* he mounted an important exhibition called "New Documents," which included Diane Arbus, Lee Friedlander, and Garry Winogrand, and through these three Szarkowski was able to see his own aesthetic ideas borne out. For the wall label to the exhibition he wrote:

> Most of those who were called documentary photographers a generation ago, when the label was new, made their pictures in the service of a social cause. It was their aim to show what was wrong with the world, and to persuade their fellows to take action and make it right.
>
> In the past decade a new generation of photographers has directed the documentary approach toward more personal ends. Their aim has been not to reform life, but to know it.[5]

Arbus showed thirty-two of her best-known pictures, such as *Exasperated Boy with Toy Hand Grenade* (1961), *Married Couple at Home, Nudist Camp, New Jersey* (1963), and *A Young Brooklyn Family Going for a Sunday Outing, New York City* (1966). Friedlander showed thirty pictures whose titles were mostly city names or else *Street Scene,* and Winogrand showed thirty-two whose titles also were mostly names of cities. Their styles were completely distinct, although both Friedlander and Winogrand used a 35 mm camera (Arbus used a square-format, waist-level camera).

Arbus pictured individuals, although not in the spirit of sympathetic portraits. Her subjects were centered and flash-frozen in the middle of the frame, like specimens in a collection of oddities. Often photographing what she called "freaks," Arbus could manage to make even the most commonplace, ordinary subject look freakish. She photographed outdoors on the street or indoors when she could insinuate herself into her subjects' homes. Winogrand too managed to find the moments of absurdity in ordinary life, but they were less likely to be centered on any

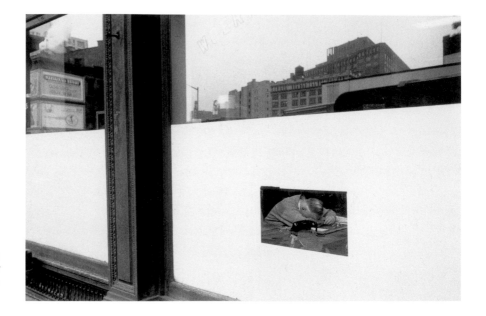

FIGURE 8.2. Lee Friedlander,
New York City, 1964. Courtesy
Fraenkel Gallery, San Francisco.

individual than on a particular moment in time. He shot in the street or in public places exclusively. Like Winogrand, Friedlander showed pictures taken in public places but not necessarily centered on human action. Friedlander was cooler and more aesthetic in his approach, interested in issues of framing, reflection and layering, accidental juxtaposition, and timing.

These three photographers went on to have prolific careers,[6] cut off only by death in the cases of Arbus (1971) and Winogrand (1984). Friedlander continues to produce and show his work. Supported most strongly by Szarkowski, their work was seen as important by other curators as well, such as Nathan Lyons,[7] and together they can be said to have influenced a generation of younger photographers seeking a kind of disengaged street imagery. In their work any sense of social usefulness or agency had been purged, although there were subjects that interested them. As Arbus said,

> I do feel I have some slight corner on something about the quality of things. I mean it's very subtle and a little embarrassing to me, but I really believe there are things which nobody would see unless I photographed them.[8]

But above all, it was the act of photography that was of greatest interest to them— as it was to Szarkowski.

We can call the practice of Arbus, Friedlander, and Winogrand *street photogra-*

phy, for they found their subjects only by discovering them on the prowl in public places. Street photography, of course, had a history before the 1960s. In *Bystander,* their exhaustive look at the genre, authors Joel Meyerowitz and Colin Westerbeck define the territory:

> The street as it is defined here might be a crowded boulevard or a country lane, a park in the city or a boardwalk at the beach, a lively café or a deserted hallway in a tenement, or even a subway car or the lobby of a theater. It is any public place where a photographer could take pictures of subjects who were unknown to him and, whenever possible, unconscious of his presence.[9]

And they define the type of photography like this:

> The moment truly typical of street photography, from John Thomson's work in the 1870s through Cartier-Bresson's more than a half century later, is the *in*decisive moment. . . . They are of events that are inchoate. Stopped at just this point by the photograph, they remain forever irresolvable, equivocal, ambivalent.[10]

This double definition is useful because while it emphasizes spontaneous witness, it has the seeds in it of being the absolutely ideal way to depict meaningless chaos—just what would become its task in the sixties. Earlier, the modernists who

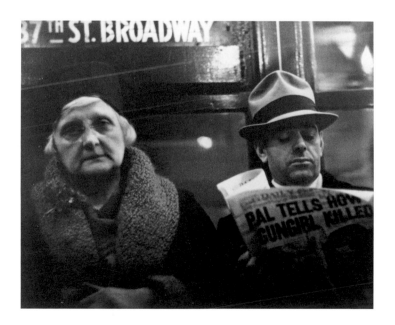

FIGURE 8.3. Walker Evans, *Subway Passengers, New York City,* 1938. Metropolitan Museum of Art, Gift of Arnold H. Crane, 1971 (1971.646.18). © Walker Evans Archive, The Metropolitan Museum of Art.

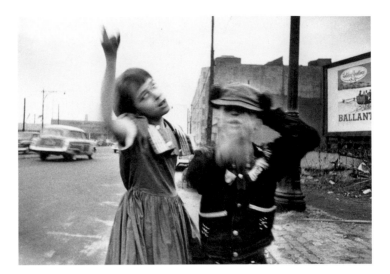

FIGURE 8.4. William Klein,
Dance in Brooklyn, 1954.
© William Klein.
Courtesy Howard
Greenberg Gallery, NYC.

FIGURE 8.5. Elliott Erwitt,
South Carolina, 1962. © Elliott
Erwitt/Magnum Photos, Inc.

practiced street photography included an international group: André Kertész, Brassaï, Bill Brandt, Manuel Alvarez Bravo, Robert Doisneau, and of course Cartier-Bresson. In the United States, many of Walker Evans's photographs were caught moments on the city street (or subway), and Helen Levitt's street pictures of the thirties and forties, particularly of children, were a testament to the serious pleasures and terrors of childhood, more poetry than document. In the forties and fifties Robert Frank, of course, continued street work, as did many others of the New York school—Sid Grossman, Louis Faurer, William Klein, Roy DeCarava, Lisette Model, and others.[11] And Elliott Erwitt applied his uncanny wit to found absurdities in the street.

By the time this tradition was in the hands of Arbus, Friedlander, and Winogrand, the sympathetic viewpoints of the earlier photographers had been replaced by a hardened, tough attitude committed to exploration of the absurd. In this, of course, it was of its time. Arbus seemed to show the public that everyone was stranger than anyone had dared to imagine, and Winogrand that the world was a comic or tragic stage setting for pointless activity, where the only goal was to see what the scene would look like photographed. Friedlander, cooler yet sadder, was a lone eye savoring disjointed visual scenes much as Winogrand did, for the effect they had when photographed (we will examine his impact on self-imagery in Chapter 11).

Younger photographers following these three on the street have continued to push the medium's particular quirks, for example, Larry Fink, with his weird chiaroscuro and time-stopping quality of electronic flash, and Mark Cohen, with his radical framing and his form-defining flash.

As for documentary projects themselves (where subject matter asserts some kind of precedence), since the 1960s many photographers have focused on subjects of greater sensationalism or else retreated to the family or the familiar social group. Sebastião Salgado, photographing developing-world workers, and Donna Ferrato, photographing the usually hidden scenes of domestic violence, along with others, continue to use the camera as a tool for social change. Yet neither they nor any contemporary photographer approaches a documentary project without a sense of limitations. And a greater proportion of newer documentary (for example, Bruce Davidson's work [see fig. 4.10]) depicts subjects looking directly into the camera, an approach that on the one hand honestly acknowledges the interaction with the photographer but on the other hand points up the absence of the "invisible truthful witness" of earlier documentary (for example, in W. Eugene Smith's work [see fig. 5.2]).

FIGURE 8.6. Mark Cohen, *Untitled*, 1975. © Mark Cohen.

And in other media, documentary has become simply a style to be adopted—as in a film like Larry Clark's sensational *Kids*, which was actually fiction, or Bruce Weber's extended documentary-style advertisement for Calvin Klein in the early 1990s. The furor surrounding both of these projects was over sexual explicitness, not the fact that each of them undermined documentary, although manipulation of the documentary "look" was their chief rhetorical device. Equally cynical was an advertising campaign of the early nineties by the clothing manufacturer Benetton. In this series of ads, *actual, authentic* photographs of recent disasters and misery were run full page and overprinted with Benetton's trademark, proving, it would seem, only that documentary was a "cool" style, and disallowing any old-fashioned, socially conscious response to the subjects of the photos.

Documentary, then, devolved into *documentary-style* and street photography for the most part after the sixties. The documentary genre, exclusively photographic, changed as a result of the changed *Zeitgeist*, from being centered on content, even social agency, to being centered on style. In the academy and in the art market too, as we will see in the next chapter, the greatest interest in photography centered on the medium itself, reviving historical practices and focusing attention on whatever was "peculiar to photography."[12]

PHOTOGRAPHY ABOUT PHOTOGRAPHY

The Academy and the Art World

Artists are interested in pictures as sources of ideas for their work. Where the pictures come from and how they are made are of little concern to them. —VAN DEREN COKE

I appeal for a critical re-evaluation of the discarded techniques of photography to enhance the images of the future. —ART SINSABAUGH

One of the more noticeable directions in photography today . . . is away from a primary emphasis on the craft for its own sake in favor of a re-examination of photography's ontological meaning, its syntax, what it is and does at its essential-most. —HENRI MAN BARENDSE

IF THE 1920S were a time when photography was rethought—both in Europe and America—another time of rethinking occurred in the 1960s and 1970s, particularly in the United States, where photography (and the *history* of photography) became a subject of in-depth study at colleges and universities,[1] and where photography also entered the art world as a serious player.

Besides the money changing hands in the art market for photographs, some photographers found an extraordinary patron in the National Endowment for the Arts (NEA), and a select group of academy-trained photographers found lucrative support through this agency. Founded in 1965, the NEA made its first grant to a photographer—to Bruce Davidson for his East 100th Street project—in 1968. A special category was established in 1971 for Photographer's Fellowships, which set a precedent for specific support to photography, and this was followed by the grant categories Photography Exhibitions and Photography Publications in 1973 and Photography Surveys in 1976. All of these categories were subsumed into other

programs in 1981. According to Charles Desmarais, some $6 million was specifically earmarked for photography between 1973 and 1980.[2]

It was also a time when serious scholarship was applied to the connections between photography and the other arts, particularly by Van Deren Coke and Aaron Scharf,[3] and when (as we have already seen, in the case of Samaras) some artists moved into photography as simply another medium of expression. It was also a time when thinkers with no previous connection to art or photography, such as Susan Sontag, became interested in the medium and wrote at length about it.[4]

The acceptance of photography within liberal-arts and fine-arts curricula brought photographers into communication with scholars and artists in every field, but at the same time, its sinecure in the academy allowed photography a place for content-free experimentation with the medium itself.

The most exciting and most advanced new work in the academy was being produced in the colleges and universities that had graduate programs in photography. These graduate programs, conferring the master of arts or the terminal master of fine arts in photography, were also where the faculty of the future were being trained. By 1982, according to the Society for Photographic Education (SPE), fifty-nine American institutions were offering graduate degrees in photography.[5] The SPE was founded in 1963 as a professional association of postsecondary teachers of photography. Through its conferences and its quarterly journal, *Exposure*, photo faculty, who often had no peers within their institutions, could stay abreast of activity in the field.

Early (pre-1960s) faculty may have been hired because of their professional expertise and established reputations, but by the seventies faculty had to have an M.F.A. degree to teach at the college level. And with the expansion of photography courses there was a need for more teachers, for a while. So the trade became brisk in turning out these degrees, and many degree holders found teaching jobs immediately. At the same time the gallery and museum system, not to mention the NEA, was sponsoring exhibitions and projects by very young photographers with just-minted M.F.A.'s. This led to a curious imbalance of many younger and far fewer seasoned photographers, particularly in teaching institutions. A. D. Coleman took notice of this in his 1973 plea, "Must They 'Progress' So Fast?":

> More and more, lately, I've seen shows—not just in galleries, but even in museums— by young photographers hot off the press whose bodies of work have little to say and lack any distinction beyond their statistically unique amalgamations of facets of their

mentors and other influences. In their early or middle twenties, they already have lists of exhibition and publication credits as long as your arm. Many of them have already been academically recycled and are actually teaching, thus perpetuating this syndrome.[6]

There were some active teachers who also curated exhibitions—Nathan Lyons, for example, curated shows for the George Eastman House; Van Deren Coke curated shows for the Art Museum of the University of New Mexico (and later for the San Francisco Museum of Modern Art); and, lest we forget, Minor White was still active, although near the end of his career, and his last three theme issues of *Aperture* were actually catalogues for shows he curated at the Hayden Gallery at MIT.[7] As might be expected, many younger photographers showed work in their exhibitions or played a part in curating them. Museum curators too were interested in the younger academic photographers and mounted shows including them, often shows based on media extensions. Two notable early examples were curated by Peter Bunnell at the Museum of Modern Art: *Photography as Printmaking* (1968) and *Photography into Sculpture* (1970).[8] At the Akron Art Institute, Tom Muir Wilson curated *Into the 70's* in 1970, and at the Hudson River Museum curator Donald L. Werner mounted *Light and Lens: Methods of Photography* in 1973. A few photographers appeared and reappeared regularly in these shows. All of them were pushing the medium beyond its conventional uses.

Light and Lens included a broad variety of media extensions by forty-three photographers and a four-page glossary of terms of the new extended photography.[9] This show was exemplary in bringing the younger photographers to light in the context of their media concerns, as well as in drawing connections to precedents in the work of eight older photographer-artists, who were also included in the show: Bill Brandt, Harry Callahan, Van Deren Coke, Joseph Cornell, Frederick Sommer, Naomi Savage, Barbara Morgan, and Oscar Bailey. As for the thirty-five remaining photographers in the show, they ranged in age from twenty to forty-two, the average age being thirty-two. Some of the artists' statements in this show were clear indicators of new concerns and abandonment of the role of witness:

Pictures should show more than the camera sees. FRED BURRELL

There are photographers by the thousands. I'm sort of curious to see if I can do something no one else has done. NAOMI SAVAGE

what makes people think

that one photograph

contains

one moment

did the trees

in a landscape

never grow

did the sun

in the sky

never rise and shine

and then

set NEAL SPITZER

Basically, I'm interested in symbolic imagery using photographic mark-making pos-
sibilities. These processes give me control over the color and tonal structure.

ROBERT FICHTER[10]

Despite (or possibly *because of*) the youth of the participants, the academic pho-
tography scene in the seventies was a hotbed of discovery and experimentation.
Like pulling back the lid of Pandora's box, historical researchers were uncovering
old texts, processes, and archives previously forgotten, and more experimental fac-
ulty were pushing the medium in new directions, combining it with other media,
especially printmaking. Still others were examining the ontology of photography,
its peculiar vocabulary and unique attributes, work that continued the ideas
Szarkowski had expressed in 1966 in *The Photographer's Eye*. In three directions,
then, academic photography was moving with great momentum: new histories, ex-
panded media, and conceptual and ontological thinking about photography.

NEW HISTORIES

For decades the standard American history of photography had been Beaumont
Newhall's *Photography: A Short Critical History*, first published in 1938, which
had its beginnings as an illustrated catalogue for his exhibition *Photography
1839–1937*, at the Museum of Modern Art.[11] Robert Taft published *Photography
and the American Scene: A Social History, 1839–1889* in 1938. Joseph Eder's *His-
tory of Photography* was published in 1945, and in 1955 Helmut and Alison Gern-

sheim published their *The History of Photography from the Earliest Use of the Camera Obscura in the Eleventh Century up to 1914*. Nevertheless, in the United States Newhall's history was the standard text until the 1960s. During the sixties and seventies many new general histories appeared, among them:

1964 Van Deren Coke, *The Painter and the Photograph: From Delacroix to Warhol* (University of New Mexico Press)

1965 Helmut and Alison Gernsheim, *A Concise History of Photography* (Thames & Hudson)

Aaron Scharf, *Creative Photography* (Studio Vista / Reinhold)

1966 Michel Braive, *The Photograph: A Social History* (McGraw-Hill)

1968 Aaron Scharf, *Art and Photography* (Penguin)

1969 Peter Pollack, *The Picture History of Photography* (Abrams)

1972 Arnold Gassan, *A Chronology of Photography* (Handbook Co.)

1974 Volker Kahmen, *Art History of Photography* (Viking)

1975 Cecil Beaton and Gail Buckland, *The Magic Image: the Genius of Photography from 1839 to the Present Day* (Little, Brown)

In addition to these broad histories, more specialized histories, as well as anthologies of writings about photography, began to appear in the sixties and seventies. Contemporary criticism became anthologized between book covers as well. Among these publications were:

1966 Nathan Lyons, ed., *Photographers on Photography* (Prentice-Hall)

1967 Beaumont Newhall, *Latent Image: The Discovery of Photography* (Anchor / Doubleday)

1970 Robert Sobieszek and André Jammes, *French Primitive Photography* (special issue of *Aperture*)

1971 Richard Rudisill, *Mirror Image: The Influence of the Daguerreotype on American Society* (University of New Mexico Press)

1972 F. Jack Hurley, *Portrait of a Decade: Roy Stryker and the Development of Documentary Photography in the Thirties* (Da Capo Press)

1973 Anne Tucker, *The Woman's Eye* (Knopf)

William Stott, *Documentary Expression and Thirties America* (Oxford University Press)

Jonathan Green, ed., *Camera Work: A Critical Anthology* (Aperture)

John L. Ward, *The Criticism of Photography as Art: The Photographs of Jerry Uelsmann* (University of Florida Press)

Michael Lesy, *Wisconsin Death Trip* (Pantheon)[12]

1975 Margery Mann and Anne Noggle, eds., *Women of Photography: An Historical Survey* (San Francisco Museum of Art)

Weston Naef, *Era of Exploration: The Rise of Landscape Photography in the American West, 1860–1885* (Metropolitan Museum of Art/Albright-Knox Art Gallery)

Van Deren Coke, ed., *One Hundred Years of Photographic History: Essays in Honor of Beaumont Newhall* (University of New Mexico Press)

1977 Eugenia Parry Janis and Wendy MacNeil, eds., *Photography within the Humanities* (Addison House)

Susan Sontag, *On Photography* (Farrar, Straus & Giroux)

1978 Jerome Liebling, ed., *Photography: Current Perspectives* (Massachusetts Review/Light Impressions)

William Welling, *Photography in America: The Formative Years* (Thomas Y. Crowell)

John Szarkowski, *Mirrors and Windows: American Photography since 1960* (Museum of Modern Art)

1979 A. D. Coleman, *Light Readings: A Photography Critic's Writings, 1968–1978* (Oxford University Press)

William Crawford, *The Keepers of Light: A History and Working Guide to Early Photographic Processes* (Morgan & Morgan)

Nancy Hall-Duncan, *The History of Fashion Photography* (Alpine Books/International Museum of Photography)

Peninah R. Petruck, ed., *The Camera Viewed: Writings on Twentieth Century Photography* (Dutton)

This list is meant to be illustrative, not exhaustive, and it is confined to the 1960s and 1970s (one could have gone on and on). Whatever its limitations, from the list the reader will get a sense of the explosion of historical and critical writing in the United States during this period, particularly during the seventies. Besides the books listed here, there were innumerable journal articles, monographs on photographers, exhibition catalogues, and critical pieces in newspapers and magazines. The

serious literature on the history of photography was clearly reaching critical mass, and some doctoral candidates in art history were beginning to write their dissertations on photographic subjects.

The new histories did far more than fill gaps in the older histories. Any one of them might explore relationships between photography and art, examine a particular period in great depth, restore the female practitioners to the history of the medium, examine a recent period of practice, or provide descriptions and formulas for forgotten antique processes. The critical anthologies were the beginning of a trend in publishing the writings of photographers themselves, as well as critics, and happily this trend has continued.

The effect this historical and critical activity had on the practice of photography would be hard to overestimate, at least for photographers trained in the academy who read the literature. No longer was it possible to think that there was one best way to photograph; all the options had opened up, and more surprising, all of them seemed to have a credible historical lineage. Nor was there a single canon of great photographs or a single aesthetic system for their creation or analysis after the 1970s. The situation was liberating for those who wanted practice to expand, but perhaps it was too much of an aesthetic candy store for a while: exciting new taste treats were to be found, but they were not always nourishing.

In the marketplace, photography went through something of a boom and bust in the 1970s. The bestselling contemporary photographer was Ansel Adams. At mid-decade the selling price of his famous *Moonrise, Hernandez, NM* (1941) climbed to a record $16,000 but then fell again before the end of the decade.[13] Photography galleries opened in several cities, but their success at selling contemporary material—despite the flurry of photographic activity in museums—was uneven at best. According to Charles Desmarais, "When the general recession of 1979–82 came, the precarious photography market began to fall apart, taking good galleries as well as bad along with it. Among the major galleries crippled or closed were Light (Los Angeles and New York), Harry Lunn, Robert Samuel, Photograph, Jeffrey Gilbert, Focus, Kiva, and David Mancini."[14]

The market for historical material was getting more sophisticated, yet newer collectors were able to amass valuable collections because a great deal of material was still available. The famous Gilman Paper Company collection, comprising more than five thousand images and given a major show and book by the Metropolitan Museum of Art in 1993, was not even *begun* until the mid-1970s.[15]

The rules of photography as articulated earlier by Edward Weston or Ansel Adams held fast for only a small (and diminishing) number of new practitioners in the 1970s. More and more, the attitude was that rules were meant to be broken, and new photographers found the expansive guidance they needed more in the spirit of Moholy-Nagy.

Media expanded both backward and forward, in the sense that new practitioners were trying antique processes like gum printing, cyanotype, and Van Dyke printing (all favorites in the pictorialist era but rejected by the classical modernists), as well as new processes combining black-and-white and color photography or utilizing any number of image-generating technologies that had proliferated in the postwar industrial environment. A number of photographic artists began experimenting with thermographic, electronic, and magnetic image generation, as well as video, facsimile (fax), and sound transmission possibilities for their imagery, along with the new three-dimensional process of holography.[16]

Some academic environments were particular centers of creative experimentation in the new technologies. One of them was the Department of Generative Sys-

FIGURE 9.1. Betty Hahn, *Road and Rainbow*, 1971 (gum bichromate on fabric with stitching). Courtesy Betty Hahn and Andrew Smith Gallery, Santa Fe.

FIGURE 9.2. Todd Walker, *Chris, Veiled*, 1970 (Sabattier solarization). Courtesy of the Todd Walker Estate. © Collection Center for Creative Photography, Arizona Board of Regents.

tems at the School of the Art Institute of Chicago. After a residency in the summer of 1970 at the Minnesota Mining & Manufacturing Company (3M), where she probed the potential for image making with the 3M copy systems, the artist Sonia Landy Sheridan established the Department of Generative Systems later that year. At that time copy machines were the most accessible means of altering images electronically, and as both teacher and artist Sheridan was one of the first to exploit their creative potential. But *generative systems* meant more than just using copy machines, as Sheridan explained in 1972: "Generative Systems refers primarily to the generation of ideas with the aid of current technology."[17] In the spirit of the Bauhaus, Sheridan eagerly and idealistically embraced technology. She taught her students to concentrate on process and experimentation, and not product. In time, Sheridan's students concentrated on work with computers and became influential in their turn.[18] One of them, John Dunn, who created the EASEL software (later

marketed as Lumena, a prominent microcomputer graphics program in the mid- to late eighties), described the generative systems department as "the difference between moving into the future and staying with the past."[19]

Particularly photographic phenomena such as solarization, double exposure, reticulation, and blur, discovered as accidents or mistakes in nineteenth-century photographs, were also used deliberately and creatively in the 1970s.[20] At the same time, a number of new photographers transformed photographically derived imagery into traditional printmaking media, such as lithography, etching, and serigraphy, and others began sewing on their photographs or applying paint or drawing directly on them.

Many of these experiments, whether the ones reviving antique processes or the ones that extended photography in new ways, have not stood the test of time, perhaps because of their emphasis on process and not product. However, there are several photographer-artists whose most significant work was done in the expanded-media days of the 1970s, most importantly Jerry Uelsmann and Lucas Samaras, who brilliantly extended the possibilities of the photographic medium, and also, for example, Betty Hahn, in her sewn-upon cloth images; Todd Walker, in his solarized or posterized silkscreen prints; Ellen Land-Weber, in her photocopier collages; Keith Smith, in his personal photolithographic and drawn images and books;

FIGURE 9.3. Keith A. Smith, *Moving Figure*, 1966 (photo-etching). Keith A. Smith.

FIGURE 9.4.
Chuck Close, *Nancy*,
1968 (acrylic on canvas,
108³/₈ × 82¹/₄ in.).
© Chuck Close, Milwaukee
Art Museum, Gift of
Herbert H. Kohl Charities, Inc.

Walter Chappell, in his luminous Kirlian high-voltage photograms; and Robert Heinecken, in his appropriated, combined imagery.

Also during the 1970s, Joel-Peter Witkin began to make his staged, marked and defaced images, which would become even more haunting and troubling in the eighties (see fig. 12.16). As Van Deren Coke wrote about Witkin, "He shows us little mercy as he torches us with the fire of taboos and horrors of madness." Aiding the effect of madness was Witkin's use of angry *drawn* marks on the prints. He said about these marks,

I've come to realize that the mark is the primal gesture, the internal connection of the caveman to the cosmos; an impossibility similar to an impulse in an insect's nervous system that it could somehow reduce the dust of a steel beam by endlessly crawling over it.[21]

Clearly, for Witkin and others the expressive possibilities of the traditional photograph by itself were inadequate.

In another direction—from art to photography—media were extended during the 1960s and 1970s as painters used photographs either as aids or as subjects themselves. I have already mentioned the role of photo-derived imagery in the work of pop artists like Warhol and Rosenquist. Of course, painting from photographs had a history, although not an acknowledged one in many cases. For the most part painters had kept very quiet about their use of photographs. Earlier in the century, however, Ben Shahn and Charles Sheeler, both of whom were active as painters *and* photographers, often painted openly from their own photographs, breaking down this taboo. In the sixties and seventies there was no hiding the clearly photographic source of many paintings.[22]

FIGURE 9.5. Audrey Flack, *World War II (Vanitas)*, 1976–1977 (oil over acrylic on canvas, 96 × 96 in., incorporating a portion of the Margaret Bourke-White photograph *Buchenwald, April 1945*, © Time, Inc.). Courtesy Louis K. Meisel Gallery, New York.

FIGURE 9.6. Sol Lewitt, cover for *Autobiography,* 1980. Marion Goodman Gallery.

Photorealist artists such as Richard Estes, Don Eddy, Robert Cottingham, and Ralph Goings painted the banal cityscape or street imitating the hyperdetailed accuracy of a photograph and, in the case of Cottingham especially, the fragmenting cropping of the camera. Photorealist artists such as Audrey Flack or Chuck Close meticulously and directly copied the detailed surface and varied focus of photographs made for the express purpose of being copied for paintings—Close by gridding them off and painting one small area after another in gargantuan size, and Flack by having her still-life setups photographed so that she could paint directly from their projections (also very large) on the wall.[23]

In a perceptive essay entitled "The Photo as Subject: The Paintings and Drawings of Chuck Close" the critic William Dyckes made the point that Close was using

the photograph not as a drawing aid but as a subject of interest in itself—for the phenomena of focus, compressed or expanded space due to focal length, and so on:

> Photo Realism is not only unconcerned with realism, it is actively involved with artificiality. Those artists who use the camera as something more than a translation device—and they are the only ones who may accurately be called Photo Realists—are aware of its shortcomings and gladly make use of them to expand the vocabulary of art.[24]

Dyckes also observed that photographic syntax had become truth for many viewers:

> The fact that so many persist in seeing these paintings as highly factual representations of people rather than as *photographic* representations of people is proof of the total assimilation of photographic syntax as visual fact. It is an easy enough matter to bypass the sensation of distortion in a family snapshot or a news-photo, but it requires a lifetime of training to screen so much out of a nine-foot-high painting.[25]

Other artists found the camera a useful tool for their conceptual ideas. Sol LeWitt, for example, catalogued his life in grids of photographs in his book without text, *Autobiography*,[26] and David Hockney, who had used photographs as aids in

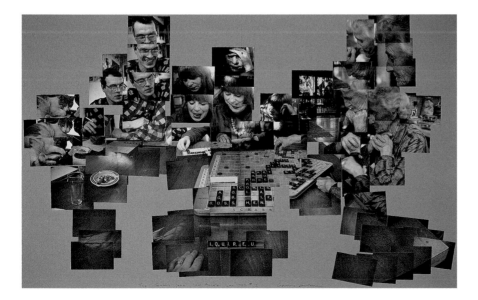

FIGURE 9.7. David Hockney, *The Scrabble Game, Jan. 1, 1983,* 1983 (photographic collage, 39 × 58 in.). © David Hockney.

painting for some time, began in the early eighties to make photocollages as serious, finished works of art, meant to explore spatial cubism and also to extend the time element in a photograph—a kind of multivalent "cubist" concept of both time and space.[27]

In the early 1970s the Dutch artist Jan Dibbets began to make serial environmental photographs that, put together as panoramas, brought to hyper-awareness the role of camera position in creating a sense of "natural" perspective and also the infinite variety of form and texture in the smallest patch of earth or water.[28]

Many international earthwork artists of the seventies—Ian Hamilton, Walter De Maria, Michael Heizer, Richard Long, Robert Smithson, Nancy Holt, and others—used the camera to document their quite inaccessible works in the landscape.[29] In terms of photography, the most remarkable earthwork artist has been Andy Goldsworthy, whose creations in the natural world are made entirely of natural materials—and ephemeral materials like leaves, icicles, flower petals, snow, and moving water. In the early 1980s this Scottish artist began creating his made-for-a-day-only works of earth sculpture and photographing them with exquisite effectiveness in color. Although this could not be argued for the earlier earthwork artists

FIGURE 9.8. Andy Goldsworthy, *Iris blades pinned together with thorns / Filled in five sections with rowan berries / Fish attaching from below / Difficult to keep all the berries in / Nibbled at by ducks / Yorkshire Sculpture Park, West Bretton, 29 August 1987*, 1987. Courtesy of the artist and Galerie Lelong, New York. © Andy Goldsworthy.

(one could actually visit the sites of De Maria, Holt, etc.), because of the ephemeral quality of his creations Goldsworthy's *photographs* are the originals that count in his art, and for most the only access to his creations.[30]

We see, then, that within the concept "expanded media" there was a rich cross-fertilization between photography, printmaking, painting, and sculpture, as well as between the present and the past, beginning in the late sixties and in the seventies. The "art-world" artists tended to use the camera for recording their earthworks in the field or, in the case of the photorealists, for its exquisite ability to render edge-to-edge detail, whereas the "photography-world" artists tended to push beyond those familiar roles of photography, often obscuring or manipulating the clearly photographic character of their work, in search of something new.

CONCEPTUAL AND ONTOLOGICAL IDEAS

When John Szarkowski wrote *The Photographer's Eye* in 1966 he was trying to define the unique concerns and essential aspects to all photography—those things of importance to newspaper, snapshot, and fine-art photographs—in other words, the *ontological* qualities of the medium. Earlier modernist analyses included, besides Moholy-Nagy's list of the eight kinds of photography (see Chapter 3), Edward Weston's 1943 article "Seeing Photographically," in which he distinguished as the inherently photographic characteristics an instantaneous recording process, "amazing precision of definition," and the nonlinear character of continuous tone.[31]

In 1960 the film theorist Siegfried Kracauer defined the essential affinities of still photography as follows:

- Photography has "an affinity for unstaged reality."
- Photography "tends to stress the fortuitous."
- "Photography tends to suggest endlessness . . . fragments rather than wholes."
- Photography has "an affinity for the indeterminate . . . surrounded with a fringe of indistinct multiple meanings."[32]

When Szarkowski put his mind to the task of defining the medium's essential features, they were:

- *the thing itself* (the right subject in the real world)
- *the detail* (the telling fragment)

- *the frame* (placement of the edges of the image—"the act of choosing and eliminating")
- *time* ("all photographs are time exposures, of shorter or longer duration")
- *vantage point* (the location of the camera "has shown us pictures that give the sense of the scene, while withholding its narrative meaning")[33]

In listing these five elements Szarkowski deemphasized others, and his list was extended by others working in the field during the seventies. Partly because its title provides such a good description of the project, a good example is an exhibition at the University of New Mexico Art Museum, *Peculiar to Photography*.[34] In his notes in the catalogue, Henri Man Barendse wrote:

This exhibit directs itself . . . away from a primary emphasis on the craft for its own sake in favor of a re-examination of photography's ontological meaning, its syntax, what it is and does at its essential-most. . . . The aesthetic to which *Peculiar to Pho-*

FIGURE 9.9. Ralph Eugene Meatyard, *Untitled*, 1960. Collection Walker Art Center, Minneapolis, John and Beverly Rollwagen, Cray Research Photography Fund, 1989.

FIGURE 9.10. John Pfahl, *Blue Right Angle, Albright-Knox Art Gallery, Buffalo*, 1978. Courtesy Janet Borden Gallery, New York.

tography addresses itself relies heavily on the quirky, the accidental, the fortuitous, the matter of fact but never the ingenuous. Perhaps more than to "art photography" in the main the photographers represented here look to the drugstore reject for inspiration. More than complying with a *de rigeur* art vernacular, they insist on allowing photography to find its own language. . . . such as the out of focus or blurred image, the tipped horizon and the truncated figure.[35]

Besides the out-of-focus image, the tipped horizon, and the truncated figure, the pictures in the show dealt with blur (long exposures with movement), vernacular reality, the effects of lenses with different focal lengths, the translations of reality into black and white, framing, point of view, and the effects of flash. This interest in peculiarly photographic effects did not begin, however, with the young photographers in the 1976 show. There were precedents.

In the sixties, blurred long exposures had been explored by Ralph Eugene Meatyard, who had created tableaux with children, family, and friends, often emphasiz-

FIGURE 9.11. Kenneth Josephson, *Wyoming*, from *History of Photography* series, 1971. © Kenneth Josephson.

ing the ghostly effects of movement.[36] The effects of movement blur and also flash were explored by the street photographer William Klein from the fifties forward,[37] and the out-of-focus blur was used creatively by Ray Metzker and Joe Jachna. Although it was not mentioned in the *Peculiar to Photography* catalogue, Harry Callahan, one of the included photographers, had been exploring double exposures, a uniquely photographic effect, since the fifties.[38]

Besides these effects and these photographers, there were others in the seventies who were exploring in a conceptual way the particular outcomes of the camera when picturing the world and were undermining those outcomes. One of the most salient of these effects is perfect one-point perspective, and John Pfahl, by adding

string, tape, and other materials to his "altered landscapes," was playing with the perspectival illusions created by the camera. Robert Cumming, with his elaborate setups photographed fore and aft, showed how a photograph might first show a "real" disaster and then, from a different point of view, show how that disaster had been set up and faked (see fig. 12.7).[39] The Canadian photographer Michael Snow used cameras and a variety of works of art to ask conceptual questions about photography. Is the photograph primarily a question of where one stands in relation to the subject? Can a photograph capture the flux that is life?

The Chicago photographer Ken Josephson's witty efforts were applied to undermine the too easy acceptance of a photograph for "truth." In many of his pictures-within-pictures the primacy of one over the other got very confused, and in his wry *History of Photography* series he poked fun at many icons of modernist photography.[40]

Other photographers used earlier historical photographs as subjects. In playful homage to Eadweard Muybridge's serial views of motion, *Animal Locomotion*, made in the 1880s, the photographers Marion Faller and Hollis Frampton created a series of spoofs called *Vegetable Locomotion* in 1975.[41] Mocking the seriousness with which Muybridge had analyzed all steps of the most ordinary motion, Faller and Frampton did the same with such improbable subjects as an apparently advancing apple, a cabbage flying, or tomatoes descending a ramp. Not quite in hom-

FIGURE 9.12. Marion Faller and Hollis Frampton, *Apple Advancing* (var. *Northern Spy*), from *Sixteen Studies from "Vegetable Locomotion,"* 1975. © Marion Faller.

age but rather from a critical, postmodern stance, in the eighties Sherrie Levine rephotographed pictures by Walker Evans and other well-known photographers and then, outrageously, presented the copies as her own. According to Christian Peterson, Levine's project asked,

> "What, exactly, is the original?" . . . Is it her print, Evans's print, or even Evans's subject matter? Where and when do art and authorship enter the picture. In Levine's view, photographers such as Walker Evans and Edward Weston stole as much from their subject in the real world as she takes from the objects of her desire—their images. Levine denies privileged status to any image and, further, rejects the whole concept of artistic self-expression. . . .
>
> Acting as a polemicist, Levine serves up a photographic pastiche for a postmodernist world. It is as if everything has been photographed. We can now either put down our cameras for good or follow Levine's lead, and in the ultimate act of image seizure, rephotograph the entire history of photography.[42]

In a multitude of ways, then, many new post-sixties photographers focused on their medium itself as their theme—extending its reach, identifying its traits, and critiquing its effects—particularly in academic settings. Traditional genres did, however, continue, and in Chapters 10 and 12 we will return to continuing, traditional subject-matter concerns (landscape, portrait, and still life), while in Chapter 11 we will explore an altogether new, post-sixties genre of photography, self-imagery.

TEN

NEW LANDSCAPES, NEW PORTRAITS

The Seventies and Eighties

I hope that these photographs are sterile, that there's no emotional content.

—LEWIS BALTZ

I don't try to overintellectualize my concepts of people. In fact, the ideas I
have, if you talk about them, they seem extremely corny and it's only in
their execution that people can enjoy them. . . . It's something I've learned
to trust: The stupider it is, the better it looks. —ANNIE LEIBOVITZ

BOTH LANDSCAPE PHOTOGRAPHS AND PORTRAITURE were touched by the
changes of the sixties. As the epigraphs to this chapter indicate, in the seven-
ties certain new photographers tried to purge their work of emotion on the one
hand and thought on the other. Such reactions, while not in fact anti-intellectual—
these photographers were too clever for that—did express a rejection of previous
earnestness, substituting instead a kind of "cool" that did not take its subject mat-
ter too seriously. Style, however, was something else—a serious matter indeed.

Nineteenth-century landscape painting had been the high point of American
art, but by the mid-twentieth century many painters had turned to abstraction, and
landscape, at least descriptive landscape, had diminished in importance. On the
other hand, it was practiced by modernist photographers with a passion. By mid-
century, landscape had come to belong to photography. The majestic views of Ansel
Adams (see figs. 1.5 and 3.2) and Eliot Porter had eclipsed painted landscapes in the
popular mind. Beginning in the twenties and thirties, Adams and Porter, along with
other photographers—Paul Strand, Edward Weston, Laura Gilpin, Minor White,
and legions of followers—were in the forefront of an aesthetic movement that
apotheosized the great glories of the American landscape, as well as its intimate
moments. Uninhabited, pristine, breathtaking views were the specialty of this

FIGURE 10.1. Eliot Porter, *Pool in Pond Brook, New Hampshire*, 1953. © 1990, Amon Carter Museum, Forth Worth, Texas, Bequest of Eliot Porter, Courtesy Scheinbaum & Russek Ltd., Santa Fe, New Mexico.

group, and purist photographic practice was their method. Sharp, perfectly exposed, with clearly separated tones (or colors, in the case of Porter), their pictures revealed the American landscape more clearly than an eyewitness could observe it.

Providing considerable aesthetic pleasure, the photographs of Adams and Porter also played a social role in awakening an appreciation of wilderness in the fledgling environmental movement. Both photographers published early and important books under the Sierra Club imprint: Adams (with Nancy Newhall) authored *This Is the American Earth* in 1960, and Porter's *In Wildness Is the Preservation of the World,* with text from Henry David Thoreau, was published in 1962. These books established a clearly activist role for landscape photography, while at the same time the photographs were very beautiful visual documents. In perfect spontaneous-

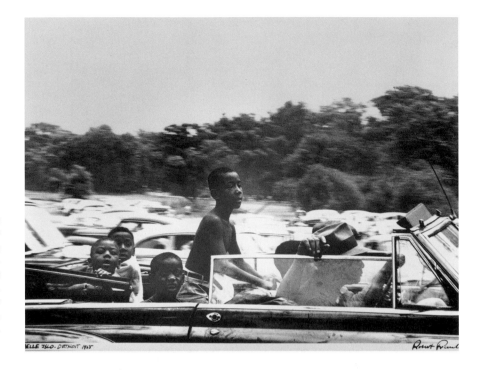

FIGURE 10.2. Robert Frank, *Belle Isle, Detroit,* 1955. The Museum of Fine Arts, Houston; The Target Collection of American Photography, museum purchase with funds provided by Target Stores. © Robert Frank, Courtesy Pace Wildenstein MacGill, New York.

witness fashion, the landscapists testified to an environment in great danger as the machine of consumption rolled across the land.

Despite a conservative, enduring industry of luxurious books and glossy calendars that continues to produce these familiar, majestic views to this day, landscape photography underwent profound changes during the later sixties. These changes affected the quality of high-culture landscape photographs, the kind that appear in museums, even if they did not impact the great popularity of the Adams-Porter school of beautiful pictures.

Some of the early stirrings of change can be seen in Robert Frank's *Americans,* of 1959. Although Frank's book made a bigger impact on documentary practice, his views of the American landscape were provocative and disturbing as well. Certainly they had nothing to do with the virgin nature shown so deliciously by Adams or Porter. Instead, Frank pictured gritty, mean cities or worn-out parks, where high-minded nature lovers were conspicuously absent but where the outdoors was the setting for a few small pleasures of life—a picnic, sleep, a bit of privacy, prayer, sex—or the setting for death.[1] Above all, the classic landscape for Frank was the open road, and the "man in the landscape" was driving a car.[2] In every sense, the

world Frank pictured was exactly the threat that Adams and Porter were trying to keep at bay in their landscape work. Frank was more of a sad poet than a critic; however, there were photographers who followed him, such as the "new topographers" discussed below, who pictured the same car culture and denatured world with a cool, critical eye.

Another important group of landscape photographers came out of the Institute of Design, Moholy-Nagy's "New Bauhaus" in Chicago. In the forties, fifties, and sixties the I.D., as it was called, was a premier training ground for young photographers, and a generation of important new ones emerged from its studios and darkrooms—among them Art Sinsabaugh, Ray Metzker, Joe Jachna, and Barbara Crane—students who had been taught for the most part by Arthur Siegel, Harry Callahan, and Aaron Siskind. Their new landscapes were strongly designed, and the photographers were self-conscious about using the peculiarly photographic vocabulary of forms, such as repeated frames, completely black shadows, the soft edges of out-of-focus forms, and solarization or high contrast. Callahan and Siskind, with their own rigorously designed and abstracted views of the world (see figs. 3.8 and 3.9), had a huge effect on these students, and the experimental approach to the medium that was the heritage of the Bauhaus had an equally strong impact.

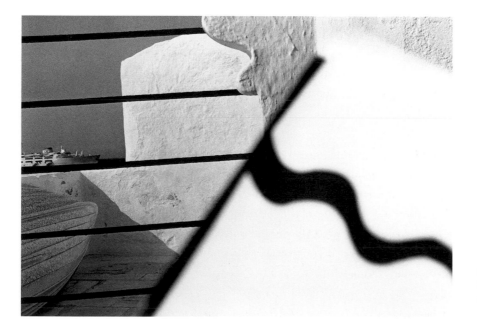

FIGURE 10.3. Ray K. Metzker, *Pictus Interruptus: Mykonos, Greece*, 1979. Ray K. Metzker.

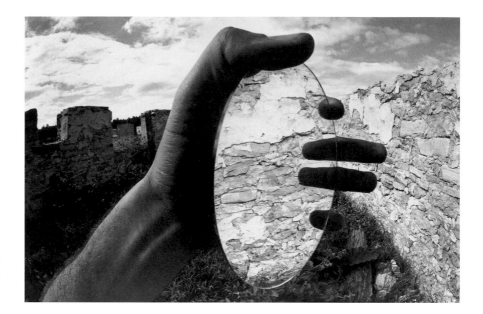

FIGURE 10.4. Joseph D. Jachna, *Door County, Wisconsin* (80370305IL3), 1970. Joseph D. Jachna.

Ray Metzker's mid-sixties *Double-Frames,* a series of photographs comprising two disjunctive views printed side by side with their seam masked by blackness, were followed by his huge composite prints, multiple images of a repeated motif in the urban landscape, often densely made from more than one layer of exposures. These were followed in turn by the radical *Pictus Interruptus* pictures of the late 1970s, in which an out-of-focus object was inserted by Metzker into the foreground. As landscapes, Metzker's work presented the man-made world as a kind of grid or graphic structure within which the human drama, itself a very delicate affair, might unfold.

Joe Jachna, like Metzker, used objects thrust into the picture space to interrupt it. Much more of a romantic than Metzker, though, he has been drawn to the natural landscape, to water, trees, rocks, but has approached them in the radical way of the I.D. Jachna's work came into its own with a 1970 series taken with a wide-angle lens in which he held a small oval mirror in the landscape. Sharply focused, with an exaggerated depth of space, the pictures were punctuated by his dark fingers, which seemed to appear out of nowhere. A later series in the mid-1970s pushed the idea further: mirrors or mirror fragments were held very close to the lens so that the edges of the hand and mirror dissolved into the softest foreground forms. At their most extreme, Jachna's photographs became almost completely abstract form.

Abstraction, along with repetition, has been at the heart of Barbara Crane's approach to the landscape (and to her other subjects as well). A small motif repeatedly photographed and then laid out in a kind of musical-score line or a grid achieves a totally new shape and form, derived from the landscape but not resembling it in the end. In Crane's *Repeats* series of 1974–79 and her *Whole Roll* series of 1968–78 she achieved rhythm and a kind of visual jazz in her composite images. Chance findings in the landscape, as well as delight in found form, give her work a playful and richly textured, mosaic character.

As graphic and fresh as they were, the photographs of Metzker, Jachna, and Crane were not widely followed *as landscapes*,[3] but interest in radical form seems to lie low for years and then emerge periodically, and I expect that we have not seen the last of it. Another photographer trained at the Institute of Design who did set a strong precedent for landscape work that would follow later in the 1970s was Art Sinsabaugh. In the early sixties Sinsabaugh married an old-fashioned panoramic camera to its perfect partner—the flat land of the Midwest—and created a series of perfectly descriptive, yet perfectly new landscapes in this unexpected, long horizontal format. Describing farmland, say, or a railroad crossing in a Midwest town, Sinsabaugh's landscapes were neither romantic reveries about lost nature nor critical documents of regret; rather they were deadpan descriptions of confident, visual wit.

Wit was also the fuel in the artistic engine of the Californian Edward Ruscha, who in the early 1960s began self-publishing little books like *Twenty-six Gasoline Stations* (1962), a catalogue of the palaces of petrol that regularly dot the landscape. Later he published *Some Los Angeles Apartments* (1965), *Every Building on Sunset Strip* (1966), *Thirty-four Parking Lots in Los Angeles* (1967), and *Nine Swimming Pools* (1968). Such deadpan cataloguing, using nondescript photos, of the built environment had a strong element of pop art spirit and, it turned out, would also be influential in turning other photographers toward the real new American landscape. Although the landscape changes I have sketched above don't fall into a single coherent style, in all of them *style* of some kind (including *style-lessness* in Ruscha's case) eclipsed content—much the same thing that happened to documentary—and something photographer John Schott said about Ruscha's pictures could apply to all of them: "They are not statements about the world through art, they are statements about art through the world."[4]

With a nod to Ruscha, the major goal of new landscape work of the 1970s was to represent the real America, uninflected by either remorse, outrage, or sentiment

FIGURE 10.5. Barbara Crane, *The Crust*, from *Repeats* series, 1975. Barbara Crane.

of any kind. This work went in two important directions: it looked at the contemporary, built landscape, or it looked back at (and rephotographed) the sites where the great survey photographers had recorded the nineteenth-century Western landscape. Deliberately skipping over the great modernist landscapists like Ansel Adams—whose overheated emphasis on beauty, and sometimes metaphor, seemed escapist to them—these photographers of the 1970s were sternly clear-eyed about the American landscape and looked back to cooler heads—the workmen-photographers who had recorded the geological and railway surveys to map the country—as their antecedents and models. Their work had a similar ambition, namely, to record without feeling the facts of the current landscape situation. Both Walker Evans and Robert Frank also served as exemplars to this group.

In 1975 the curator William Jenkins brought a group of these landscapists together at the International Museum of Photography in a show called *New Topographics: Photographs of a Man-Altered Landscape,* and this show, along with the phrase *new topographics,* became *the* new definition of landscape photography. The photographers in the group did not share the Institute of Design photographers' interest in radical form, but they did share Ed Ruscha's interest in "style-less" photography. Bernd and Hilla Becher, two Germans in the show, in fact took up Ruscha's cataloguing approach, but with a Teutonic grimness, in their groupings of types of industrial buildings. Lewis Baltz, who said that "the ideal photographic document would appear to be without author or art,"[5] documented the bleak landscape of new industrial parks in California. Several others—Frank Gohlke, Robert Adams, Henry Wessel Jr., John Schott, Joe Deal, Stephen Shore—presented plain pictures of plain American houses, new subdivisions, or roadside motels. "Pictures should look like they were easily taken,"[6] said Robert Adams, and Frank Gohlke deliberately put a passive, square frame around his centered subject matter, depriving it of any graphic tension or excitement. Only Nicholas Nixon's aerial views of

Boston had a celebratory, modernist spirit, an exception to the overall bleakness of the rest of the show.

This uninflected approach to the built landscape did not reach the broad public, who continued to enjoy pictures of colorful sunsets and spectacular waterfalls, but within the culture of photography it staked out some new territory. In many ways new topographics was as close as photography would come to the expressionless creations of pop art—Andy Warhol meets Main Street—although it never had quite the lightness of pop art. In another sense, within the photographic traditions new topographics made a strong break with the attachment to the sensual transcendence that had saturated the great modernist landscapes of Weston, Adams, White, and Porter.

Another way to break with the Adams-Porter tradition was to leapfrog over them back to nineteenth-century survey photographers such as Timothy O'Sullivan or William Henry Jackson.[7] Those heroic fellows had, under very difficult circumstances with heavy cameras and heavier glass plates, recorded the topography of the American West in the two decades after the Civil War. A group of enterprising young photographers led by Ellen Manchester, Mark Klett, and Joanne Verberg named themselves the Rephotographic Survey Project (RSP) and began in the summer of 1977 to re-record as many of the earlier views as exactly as possible. The RSP located eighty-five sites and recorded them not only from the same point of view but also at the same time and in the same season as the earlier photographs. As Jonathan Green has described their work,

> The early photographers of the land stood with the civilized world behind them and looked out toward the wilderness. In the latter half of the seventies the new breed of photographers reversed this orientation. They stood in the open land and pointed their cameras back toward the approaching civilization. Rather than explorers pushing into

FIGURE 10.6. Art Sinsabaugh, *Midwest Landscape #60,* 1961. Courtesy Elizabeth and Katherine Sinsabaugh; Indiana University Art Museum: Art Sinsabaugh Archive.

MOBIL, WILLIAMS, ARIZONA

STANDARD, WILLIAMS, ARIZONA

FIGURE 10.7. Edward Ruscha, spread from *Twenty-six Gas Stations,* 1962. Edward Ruscha.

the unknown, these new photographers were observers documenting the conflict taking place between man and nature on the new American frontier. They photographed that point in the landscape where the Old West was unceasingly and irreversibly dissolving into contemporary, homogenized America.[8]

Among the many observations one could make about the RSP is that their subject was not the world itself but rather *pictures* of the world were the subject—thus placing the project in classic postmodern territory. On the other hand, one could also say that the project represented a disciplined attempt to look at the reality of the current landscape. This last it shared, of course, with the new topographers, and both approaches spawned a number of additional projects, some of them "repho-

tography" of earlier sites and pictures, others simply clear-eyed views of the contemporary landscape.[9]

Despite the RSP's intention to be coolly descriptive, a romantic streak underlay the "rephotography" efforts, which can be seen as part of a romantic, backward-gazing approach to the landscape that reappeared in the late seventies. This romantic approach on the part of academic photographers frequently involved antique processes as a vehicle, as well as older landscape views or ancient prehistoric sites as inspiration. Linda Connor and Meridel Rubenstein were major figures in the new romanticism.[10] Connor saw the world as newly luminous and mysterious by way

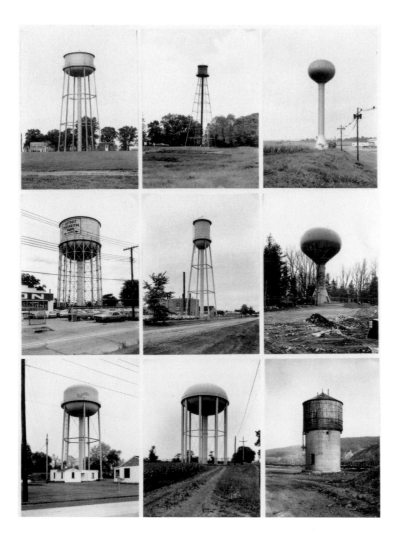

FIGURE 10.8. Bernd and Hilla Becher, *Water Towers*, 1974–1975. Courtesy Sonnabend Gallery.

of a nineteenth-century soft-focus lens, and Rubenstein made platinum, combination-print environmental portraits of her New Mexico neighbors, driven by an idealizing affection for them. Jerry Uelsmann's photographs of the sixties and seventies included many romantic, mythic landscapes, and his approach served as a useful precedent for Rubenstein's later composite pictures.

Color entered landscape photography in the late seventies as a serious medium for many younger fine-art photographers, such as Joel Meyerowitz, Richard Misrach, Joel Sternfeld, Arthur Ollman, Len Jenshel, John Pfahl, William Eggleston, and Jan Staller. This was news in the fine-art world, which tended to be conservatively attached to black and white for landscape even though much marvelous color landscape work had already been done by Eliot Porter, and published by the Sierra Club since 1962, as well as by Ernst Haas of Magnum, a postwar immigrant from Austria. Haas's color was given a spectacular publication in *Life* in 1953, and in his popular book *The Creation* in 1971 he found an even wider audience. His striking and sometimes abstract images were given the royal treatment in *Life*—twenty-four pages in two successive issues, compared with the eight pages usually allotted

to color—"establishing colour photography as the new mode of expression for photo-journalists," according to Russell Miller, "and helping to overcome widespread resistance to colour photography as an art form."[11]

Possibly because Haas and Porter had reached such a popular audience for their work, it may have continued to carry a slight stigma in the fine-art world despite its brilliance; in any case, by the seventies the younger photographers had embraced color in landscape photography with gusto. This embrace was encouraged also by the simplification of the color-printing process, now a three-step process easily performed even in a home darkroom. The new color photographers used color for its more complete descriptive powers and also for emotional effect; color could excite the viewers' *feelings*. As Meyerowitz said,

> A color photograph gives you a chance to study and remember how things look and
> feel in color. It enables you to have feelings along the full wavelength of the spectrum,

FIGURE 10.10. Jerry N. Uelsmann, *Untitled*, 1976. Jerry N. Uelsmann.

FIGURE 10.11. Joel Meyerowitz, *Bay, Morning Fog*, 1977. © 1977 Joel Meyerowitz.

to retrieve emotions that were perhaps bred in you from infancy—from the warmth and pinkness of your mother's breast, the loving brown of your puppy's face, and the friendly yellow of your pudding.[12]

What, then, distinguished Meyerowitz's approach from Porter's or Haas's? For Porter, subject matter tended to be pure nature or else agreeably picturesque architecture,[13] while Haas was intent on thematic or illustrative content. Yet both men used color in a modernist, abstract way, almost as if the existence of color in the world were adequate cause for the photograph. In Meyerowitz's *Cape Light* pictures subject matter was minimal and subtle at best—clothespins on a line, different colors of light falling on the same porch column, a gate in the fog—but color was never removed, through soft focus or other obscuring techniques, from its quo-

tidian locations. In general the new approach to color was close to the new topographers' approach. Color, however, gave it an additional emotional charge. In California, Arthur Ollman brought that emotionalism to his nighttime urban scenes of the late seventies and early eighties, using the color of existing artificial light, the ambient light of the sky, and his own contribution of flash during long exposures to create color that literally could not have been visible to the eyewitness. At the same time in New York, the photographer Jan Staller used the many sources of light in the city as his "available light" in (mostly) night pictures made at the rundown, abandoned edges of the city. Staller wrote about photographing a "neglected frontier abutting the functional metropolis," a possibly ironic reference to the re-photographers who were re-photographing the old Western frontier. About what was to him a newly romantic area of ruins, Staller wrote,

> It is to these areas that I have long been drawn, lingering there to meditate on a quality of light, space, and weather. In the decay and desertion of these run-down places, there is much for me to explore, and I find the atmosphere to be rich in mystery, reminiscent of a lost city.[14]

FIGURE 10.12. John Pfahl, *Rancho Seco Nuclear Plant, Sacramento County, California,* 1983. Courtesy Janet Borden Gallery, New York.

While more of a conceptual artist than a romantic landscapist, John Pfahl had an abiding respect for Ansel Adams and Eliot Porter, and the works in his witty *Altered Landscapes* series of the 1970s were often in affectionate homage to those earlier photographers.[15] Pfahl added objects—tape, string, rubber balls, etc.—to his scenes, and the way they were laid down created forms that contradicted the natural perspective of the pictures. Although he was self-consciously playing with the automatic illusions of the photograph (see fig. 9.10), Pfahl has always been interested in the landscape itself and in making a beautiful picture in color. Landscape has continued to be his subject for three decades, especially examination of our romantic

FIGURE 10.13.
Imogen Cunningham,
Martha Graham 2, 1931.
© 1978 The Imogen
Cunningham Trust.

FIGURE 10.14.
Henri Cartier-Bresson, *Gandhi after his last fast, with Prime Minister M. H. Srinivasan of Gwalior state,* 1948. © 1996 Henri Cartier-Bresson, Magnum Photos, Inc.

notions about it even in the face of nuclear power plants and air pollution, and most recently he has applied the computer to his landscapes of England, made in the spirit of the great watercolorists of the early nineteenth century.[16]

Broadly speaking, the new landscapes either pictured the vernacular, inhabited landscape or were engaged in a conversation of homage or rejection with the great photographic landscapes of the past. These pictures were still photographs of witness. Nevertheless, in all of the new landscapes, even the romantic ones, one is looking at the world through a screen of sophistication that knows the transparency and realism of photography to be a matter of artifice. The photographers were exploring the world with Szarkowski's reservations about the medium firmly planted in their minds, and with the altered social consciousness of the sixties internalized as well.

FIGURE 10.15. Alfred Eisenstaedt, *Arturo Toscanini, speaking with Richard Strauss* (left) *and Wieland Wagner, Bayreuth,* 1932. Alfred Eisenstaedt/TimePix.

A similar though not identical story can be told about the new portraits. The classic modernist portraits, many (but not all) of them made for the picture magazines, were documents of spontaneous witness. They were candid, made under available light and often in the subject's environment—a place of work, outdoors, or at home.[17] Imogen Cunningham, Henri Cartier-Bresson, Margaret Bourke-White, Alfred Eisenstaedt, Gjon Mili, Dennis Stock, and Elliott Erwitt were just a few of the many photographers who made candid, environmental portraits of celebrities on assignment for magazines like *Life, Look,* or *Vanity Fair.* In a world without television, magazines were the vehicle of access to the celebrated personalities of the day. Everyone, from presidents to movie stars to intellectual leaders, was pictured this way in the heyday of spontaneous witness.[18] Artists and writers were special favorites of the great portrait photographers; in France, Brassaï, and in England, Bill Brandt made portraits of many of them.[19] Cartier-Bresson shot portraits all over the world, many of writers and artists as well.[20] Eisenstaedt, who pic-

tured more than his share of famous people over a career that spanned sixty years, reflected on his method in 1985:

> My style hasn't changed much in all these sixty years. I still use, most of the time, existing light and try not to push people around. I have to be as much a diplomat as a photographer. People often don't take me seriously because I carry so little equipment and make so little fuss. . . . I never carried a lot of equipment. My motto has always been, "Keep it simple."[21]

The ease of using miniature cameras allowed many candid pictures to be made quickly in sequence, and often portraits were extended into picture stories or, sometimes, book-length documents. An extraordinary extended portrait of Pablo Picasso by the photographer David Douglas Duncan was published in book form in 1958. Duncan, who had been a war photographer in World War II as well as in Korea,

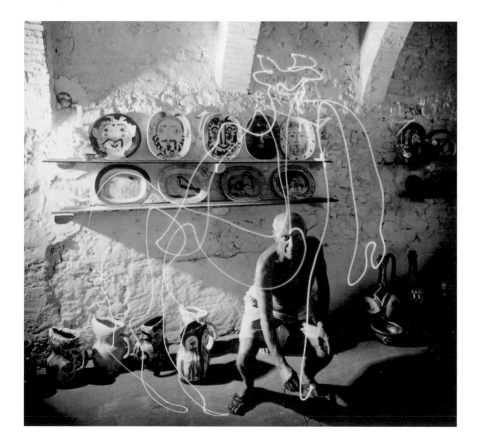

FIGURE 10.16. Gjon Mili, *Pablo Picasso drawing a centaur with a light,* 1949. Gjon Mili/TimePix.

spent three months with Picasso, photographing continually and ending up with an ebullient, revealing document of genuine intimacy. Duncan's comments about the project are almost a definition of spontaneous witness:

> This book was created by selecting a few hundred photographs from the more than 10,000 taken while I was Picasso's guest, during the seventy-fifth year of his life. I had cameras on him for more than three full months, literally for every waking hour of every day. No picture was ever arranged for my benefit, no hand ever raised to prevent my shooting. Each photograph was taken by existing light under precisely those conditions in which the Maestro works, and lives.[22]

In the same year another extended portrait was made by Wayne Miller and published by the same publisher.[23] Miller had been Edward Steichen's assistant on *The Family of Man,* and after that show and book he took on the project. *The World Is Young* was about childhood—"the most ambitious photographic exploration of childhood ever undertaken," according to a blurb on the back cover of the book— and to achieve this Miller focused on the daily lives of his own four children in their California suburban setting. The book is as much an extended portrait as it is a general look at American childhood, for the personalities of the individual children come through strongly and the pictures are supplemented by the children's own

FIGURE 10.17. Harry Callahan, *Eleanor,* 1948. © The Art Institute of Chicago, Reva and David Logan Foundation Fund, all rights reserved. Courtesy Pace Wildenstein MacGill, New York.

words. Again, the pictures are candid, taken by available light under every circumstance—at play, at school, and at home. Perhaps because it was published the same year as Frank's more challenging *The Americans*, and perhaps also because Miller was tainted by the sentimental reputation of *The Family of Man*, so far *The World Is Young*, a remarkable collection of 300 pictures (selected from 30,000), has not achieved the attention it merits in photographic history.

A separate, more private kind of extended portrait has been practiced within fine-art photography ever since Alfred Stieglitz made his many intimate views of his wife Georgia O'Keeffe early in the century. Like O'Keeffe, the wives of Harry Callahan and Emmet Gowin have become subjects of the somewhat obsessive photographic attentions of their husbands. Interestingly, while in his landscapes Callahan took the world as he found it, his portraits of Eleanor, made mostly in the 1950s, were arranged and always posed. They had a cool kind of mystery to them. Eleanor was usually photographed from the back or in silhouette, a perfectly stilled, quiet, nude figure. In other pictures Eleanor posed with their daughter Barbara, two small figures often isolated in a cold urban setting.[24]

Emmet Gowin, who studied with Callahan, began photographing his own wife, Edith, in the 1960s, and has continued to do so over the span of their marriage.[25] Edith is shown more revealingly, and in a less idealizing way, than Callahan depicted Eleanor, and yet the pictures have a strange, posed quality that suggests the mythic power Gowin seems to draw from his wife. In an image from 1986, in particular, he has double-exposed her seated, tired-looking nude figure with an image of root vegetables, suggesting the woman as made of the earth. These are reminiscent of pictures Callahan made in 1958 showing Eleanor double-exposed over lush summer fields, but Eleanor is shown only as a headless, anonymous ideal torso, whereas Edith is shown as a real woman whose flesh is beginning to bear time's marks. Other fine-art photographers dealing with the extended portrait in the last two decades include Wendy McNeil, Nicholas Nixon, Meridel Rubenstein, and Alex Traube. Much of their work has focused on family, not the public figures that are the more usual subjects of portraiture.

The master of environmental portraiture of public figures, with an active, successful career since the 1940s, has been Arnold Newman. Trained as an artist and grounded in his early experience in a portrait studio, Newman brought his intuitive, creative sensibility into collaboration with his subjects' work (whether the subjects were artists, politicians, actors, scientists), and the resulting portraits, besides being excellent likenesses, tell something about the life and work of the sub-

jects. Early on, his portraits of Max Ernst, Piet Mondrian (both 1942), and Igor Stravinsky (1946) established Newman as the premier portrayer of artists. Ernst, swathed in a fantastic swirl of smoke, looked "surreal"; Mondrian, set up in a gridded environment of easel and colored squares on the wall, looked "Mondrianesque"; and Stravinsky, radically off-center and dominated by the powerful abstract form of the piano lid, looked "modern." These portraits have continued until the present; Newman's archive is now definitive for American artists of the twentieth century. He has used environment to reveal the character of statesmen, actors, musicians, writers, and scholars as well. Managing to blend his style with the style or work of the sitter, Newman follows no formula, and each portrait is successful in its own way. In 1992 Newman described his method as follows:

> It has always been my need to photograph people with my own creative visual ideas, wedding them graphically and conceptually in order to make a statement about them and my work. . . . In general, I "build" rather than "take" a photograph, to differentiate it from the "candid" picture. . . . The subject's environment—its furniture, vistas,

and objects—provides not only the building blocks of design and composition but also the atmosphere created by the subject. These objects that surround the subject are *not* props, and should not be, but are *real*, integral parts of his life.[26]

Oddly, however, in his portraits of fellow photographers—Berenice Abbott (1986), Charles Sheeler (1942), Alfred Stieglitz, with O'Keeffe (1944), Man Ray (1948), and Paul Strand (1966)—Newman's backgrounds are curiously blank and expressionless. Only in his portrait of Eugene Smith (1977), sitting like the eye of the storm in his chaotic studio, do we get any sense of the subject photographer's work.[27] Perhaps because Newman considers himself something like a blank piece of film until that important interaction with his subjects, he has pictured other photographers in the same way.

Newman shot many of his portraits on assignment for *Life,* and his approach in many ways is classic photography of witness—including the environment and often even photographing outside. However, in other ways, hinted at in his statement above, his work points the way to post–witness photography. He *builds* a photograph, that is to say, he arranges what is before the camera—the subject, the background, the lighting—before making an exposure. He is not only the cameraman but also the *director* of an elaborate creation. To put it in the terms of this book, Newman's work is witness photography, but hardly *spontaneous* witness.

One might say the same thing about Jerry Uelsmann's occasional portraits, ex-

FIGURE 10.19. Arnold Newman, *Igor Stravinsky,* 1946. © Arnold Newman.

FIGURE 10.20. Duane Michals,
René Magritte, 1965.
Duane Michals.

cept that the arrangements of elements are made later, in the darkroom, and are likely to be whimsical and symbolic.[28] Duane Michals's portraits too partake in both *witness* and *direction*, but with a lighter touch than Newman's. Shooting his subjects in simple settings, either in his trademark empty rooms or in the street, and with available light and a small camera, Michals evokes a kind of new persona from his subjects through posing and sometimes through props. While Newman's effort is to bore deeply and realistically into the heart of the personality and then show its public face, Michals whimsically and obliquely suggests new or at least less public aspects of his sitters.[29]

Combining the playful approach of Michals with the more studied and elaborate setups of Newman, and pushing both approaches to new extremes, Annie Leibovitz became the foremost portrait photographer of the seventies and eighties. She began shooting rock stars for *Rolling Stone* in 1970, at first covering them in black and white as a photojournalist with a small camera. But as her work evolved, Leibovitz began shooting with larger cameras, elaborate artificial light setups, and color film. The first color work was for *Rolling Stone* covers. Her increasingly wild ideas were her trademark. As quoted above, she stated, "The stupider it is, the better it looks"—and remember, Leibovitz was shooting in a world already used to the

shocking strategems of Diane Arbus. What would she try next? She covered Bette Midler with roses (1979), bathed Lauren Hutton in mud (1981), put Woody Allen in a pink-tiled ladies' room (1981), painted Steve Martin to look like his Franz Kline painting (1981), posed John Irving in a wrestling suit (1982), backed Patti Smith with a wall of fire (1978), shot John Lennon nude, curled up and attached to Yoko Ono (1980) . . . and on and on. In the famous Lennon-Ono portrait Leibovitz realized her own best method:

> When I started to be published I thought about Margaret Bourke-White and that whole journalistic approach to things. I believed I was supposed to catch life going by me—that I wasn't to alter it or tamper with it—that I was just to watch what was going on and report it as best I could. This shoot with John was different. I got in-

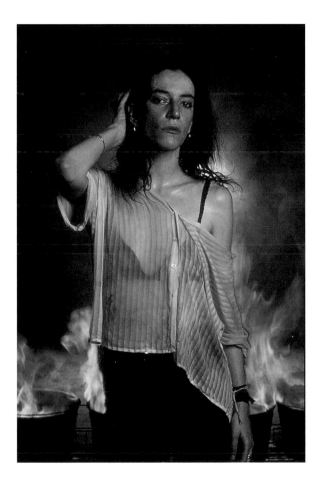

FIGURE 10.21. Annie Leibovitz, *Patti Smith, New Orleans*, 1978. Annie Leibovitz.

volved, and I realized that you can't help but be touched by what goes on in front of you. I no longer believe that there is such a thing as objectivity. Everyone has a point of view. Some people call it style, but what we're really talking about is the guts of a photograph. When you trust your point of view, that's when you start taking pictures.[30]

In 1983 Leibovitz became the first contributing photographer for the newly revived *Vanity Fair*, which gave her access to a broader range of celebrities, not only in show business but also in the arts and politics. Much of her *Vanity Fair* work, especially of entertainment personalities, continued to be outrageous, but other portraits of more serious characters seemed almost conventional, though always competent and stylish as well. Big advertising campaigns followed—for American Express and the Gap—and if a recent portrait photographer may be said to have become overexposed, it would be Leibovitz. This does not diminish, of course, her great contribution, which has been to extend the environmental portrait into new territory while at the same time pushing photography into a more artificial yet *revealing* style. Leibovitz realized that a hyped-up image, often focused on the body in some revealing way and with an element of humor, was the portrait for the times—especially, of course, if it was to sell magazines or clothes. Her humor tells you that a given portrait may be a send-up, but her skill and creativity make it compelling and "true" in some sense.

With portraits, then, as with landscapes, we see the new work of the seventies and eighties to be less candid and more controlled, less naïve and more self-conscious, less subtle and more bold. An innocent belief that a moment might reveal something without direction, and that photography might be a transparent, universal way to capture that revelation, has passed.

THE SUBJECT SELF

Question: What is this, creative psychodrama?

Answer: If it is, why not?

Question: I thought art was . . .

Answer: Think again.

—LUCAS SAMARAS

My photography is . . . a kind of autobiography relating to my explorations and absorption of new life experiences . . . a continual cataloguing of fresh understandings and perceptions. —ARTHUR TRESS

FROM THE EARLIEST DAYS of photography, fixing a human likeness has been one of its great marvels. Portraits are the visual lingua franca; they can be understood everywhere. As aids to memory, as stand-ins for missing loved ones, as fetishes of devotion, or for veneration of the famous, portraits are useful in every culture. Besides depicting others, photographers have portrayed themselves as well, although it is something of a trick to be both camera operator and subject. Most commonly, photographers have shown themselves with the tools of their trade or in a setting that is self-revelatory in some way, the point being both to *reveal* and to *define* themselves.

Since the 1970s, however, we find many photographers producing, not a definitive self-likeness, but multiple versions reflecting many personalities and possibilities. This photography of the self is not just a part of the changes in portraiture noted in Chapter 10, although it relates to the concept of an extended portrait; rather, it is a new genre, different from self-portraiture.

Traditional self-portraiture rests on the assumptions that an image can tell

about, or encapsulate, a personality and that there *is* a defined personality to be revealed. Such a self-portrait can be a kind of summative document. The new practice of self-imagery is based on the understanding that photography does not reveal truth but is often experienced as being in tension with reality, like the equivocal contemporary self. There is no definitive individual life to be revealed; rather, the effort is to discover or imagine as many alternative lives as possible.

There were early precedents for this work,[1] and there is hardly a photographer who has not at some time used the mirror as a pictorial device, but the great flood of such self-imagery poured forth after the radical changes of the 1960s. And once again we see the germinal influence of Jerry Uelsmann, Duane Michals, and Lucas Samaras. In elaborately set up self-images all three of these men explored *alternatives* or *extensions* of their "realistic" selves.

It is worth noting at the outset that the genre would be most fully developed by women photographers, who had a political, real-life stake in redefinition, and that for women Uelsmann and Michals in particular were sympathetic exemplars since both addressed gender identity in their self-imagery—Uelsmann as a man exploring his feminine side (e.g., in *Small Woods Where I Met Myself* [1967] and *Animus/Anima Self-Portrait* [1978]) and Michals as a homosexual man trying to imagine a fuller experience (as in *I Dreamed I saw the Face of My Unborn Son. He was Waiting for Me* [1974] or *Self-Portrait with Feminine Beard* [1982]). As for

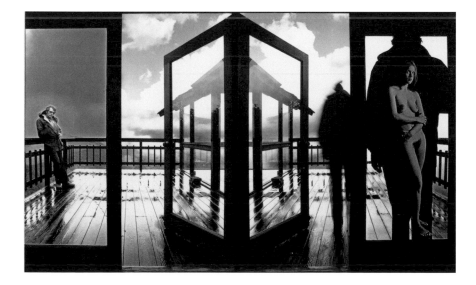

FIGURE 11.1. Jerry N. Uelsmann, *Animus/Anima Self-Portrait,* 1978. Jerry N. Uelsmann.

Samaras, in making his Autopolaroids he posed with makeup and wigs, appurtenances of femaleness, but that this had anything to do with empathy or developing his own feminine qualities is unlikely. It is more likely, as he said, that Samaras wanted the "pretense" of femaleness. But he did set the example of wildly aggressive gender change in his self-imagery, which has been followed most, I would say, by homosexual male photographers like Robert Mapplethorpe, although women like Judith Golden and Cindy Sherman come to mind as well.

In any case, these three photographers exploring a new kind of self-imagery were joined by another in 1970. In the same year that Samaras published his Autopolaroids in a major art magazine, Lee Friedlander published his brilliant *Self-Portrait* in quite another venue, the small-press book.[2] Friedlander's pictures in the book were his typical street photography (with the exception of a few taken in hotel rooms), and he wrote that the pictures had just gradually accumulated during the previous six years "as a peripheral extension of my work," suggesting in this offhand way that they had emerged almost without thought.

"I might call myself an intruder," he said about his own image in the pictures, and indeed in none of them do we see an assertion of belonging or solid character. Instead, Friedlander appears as a reflection, a shadow, or a lonely presence in a bleak

FIGURE 11.2. Duane Michals, *Self-Portrait with Feminine Beard*, 1982. Duane Michals.

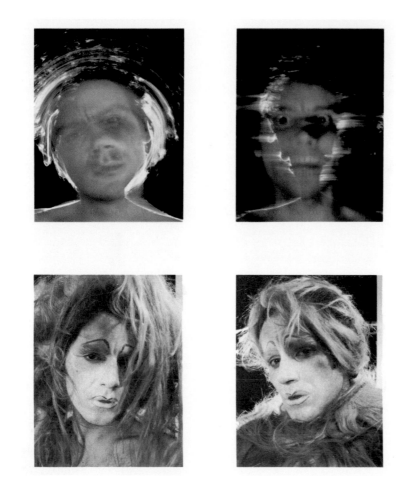

FIGURE 11.3. Lucas Samaras, *Autopolaroids*, page from *Art in America* 58, no. 6 (November/December 1970). Lucas Samaras, Pace Wildenstein Gallery.

and anonymous America. Friedlander's work comes out of the vision of Robert Frank, but his self-portraits are filled with concerns of the sixties—loneliness, desire, national tragedy, racism, a secondhand world full of images, and masculine doubt. The man who had dropped out of the mainstream, the insignificant, marginalized man, was Friedlander's pictured self/selves, for example, in the image that shows him reflected in a plate-glass window upon which is stenciled "American Temporaries—Male Division."

In the American photographic community Friedlander's book was very popular,

embodying the Frank aesthetic brought up to date—grainy, contrasty black-and-white photos suggesting regret, alienation, even dread. Samaras's Autopolaroids, on the other hand, made their appearance in a high-art setting and at first were not considered to be "part of photography" since the rather insular traditions of modernist photography had been built upon a rejection of and difference from other art media. In a way, however, the work of the two men was close: both pictured the solitary man, the marginalized man, the misfit. Where they parted company was in Samaras's rebellious individualism, which violated sexual and social taboos. Turning to himself in every way—sexually, socially, and creatively—Samaras dared to suggest that private performance with public documentation could be not only an art form but a life.

In the early seventies these photographers were joined in self-imagery by the feminist artist Mary Beth Edelson, who, like Samaras, came to photography from the world of art. In 1973 she created, through posing and handwork on the prints, a series of double self-images called *O'Kevelson,* three pictures showing her transformed into Georgia O'Keeffe and three showing her transformed into Louise Nevelson, two feminist-artist idols. In a series of photographs showing her towering nude figure rising above the camera, all made from the same negative but differing in the handwork done on the prints, with titles like *Trickster Body, Lightning Rod, Nobody Messes with Her, Strong Medicine,* and *Patriarchal Piss,* she pictured

herself as powerful, vengeful, and magical.[3] Edelson's use of her own figure in ritual performance augured the rise of a feminist tide of self-imagery, proclaiming a new kind of woman. With a strong interest in goddess spirituality, Edelson would continue to perform, sometimes as priestess and sometimes as goddess, asserting her figure as powerful in the natural environment. In long exposures, often involving moving lights, the ritual figure was recorded as a sometimes transparent blur in the landscape.[4]

At the same time, a follower of Duane Michals, Arthur Tress, published a narrative group of shadow images of himself imbued with myth, *Shadow: A Novel in Photographs* (1973).[5] During that period he was also focusing on the fantasies and dreams of both children and adults, resulting in a book published in 1976 called *Theater of the Mind.*[6] The pictures in *Shadow* follow a familiar mythic-quest format: the book divisions are titled "The Prisoner," "The Search," "The Journey," "The Town," "The Labyrinth," "The Valley of Marvels," "The Ancestors," "Initiations," "The Pilgrim," "Calls and Messages," "The Magic Flight," "Transformations," and "Illuminations."

The titles of the last two—"Transformations" and "Illuminations"—are a good summary of what the genre would become. Since 1970 an enormous amount of

FIGURE 11.5. Mary Beth Edelson, *Patriarchal Piss*, 1973 (ritual performance with China marker, ink, and oil on photograph). Mary Beth Edelson.

FIGURE 11.6. Arthur Tress,
The Ancestors, three images from
Shadow: A Novel in Photographs,
1973. Arthur Tress.

self-imagery has been created: photographs that have tried not so much to expli-cate character as to explore the possibilities of transformation, change and re-creation of the self, particularly the self in pain or in doubt. The personal voice in this work—the cry of the unique and often lonely individual—is the strongest thread, tying together photographs that range from social critique to private ob-session to slapstick exaggeration. Beyond the personal voice, a political element is embedded in the work as well, moving as it does away from gaze politics (the self as visible object, created by another's gaze) to projection politics (the self as activ-ity or imagination, creating oneself).

Why did this work emerge when it did? Obviously, the disruptions of the six-ties launched the new genre, but there was also a psychological sea change, shifting personal identifications and cultural roles for both men and women. Post–World War II conformity, cresting in the 1950s, created intolerable confinements for many, both men and women. The reactions against this conformity, in the forms both of feminism and of what Barbara Ehrenreich calls the "male revolt,"[7] were the yeast fermenting a cultural brew that would later express American individualism in a new way. Men in corporate lockstep, and women exiled in suburbia: both were conditions to be overcome, at least for middle-class whites. Self-imagery would later picture some ways out.

As Ehrenreich argues, preceding the feminist movement men had seized upon two models of revolt in the 1950s. One derived from the example of the Beats, whose rejection of bourgeois values spawned the hippie generation. The other in-fluence on men, according to Ehrenreich, was Hugh Hefner's *Playboy* magazine, with its "Playboy Philosophy," encouraging men to think of their own pleasure first and to commodify sex and life in general, while at the same time adhering to business-dominated values. Heeding Hefner's advice, consumption and commodi-fied sex replaced fifties-style commitment and duty for huge numbers of *Playboy* readers, more than were ever touched by the Beats or the hippies. Both movements, though, stressed in a newly hedonistic way the self as the center of men's lives, whether hippie or upwardly striving corporate man.

Beginning with the first issue of *Playboy* in 1953, men had a spokesman who told them it was OK to let go of the responsibilities that were not only spoiling the fun but even spoiling their health. The medical and psychological establishment it-self recognized "stress" as a killer of men and encouraged abandonment of the old-style masculine "maturity."[8] Instead, the new doctrine became "growth." Likewise, though somewhat later in 1973, the psychomedical establishment revised its for-

mer position and acknowledged homosexuality as a legitimate way of life, not a pathology, and gays pronounced themselves with new pride.[9]

For women, meanwhile, Betty Freidan articulated "the problem without a name," that vague sense of hopeless depression and confinement in a culture that didn't value women, and through reading her popular 1963 book, *The Feminine Mystique*, many women recognized their own oppression and determined to end it for themselves. *MS.* magazine was launched in 1972, providing the new woman with a monthly forum of her own. "The personal is the political," said the feminists, who began to re-create their lives according to their own values, and the inevitable cracks in the calcified state of gender relations appeared. Divorce rates began to soar, and the psychologist Fritz Perls's popular maxim suggested the breakup that was under way:

> I do my thing, and you do your thing.
> I am not in this world to live up to your expectations
> And you are not in this world to live up to mine.
> You are you, and I am I,
> And if by chance we find each other, it's beautiful.
> If not, it can't be helped.[10]

Adult lives for both men and women became a sequence of "passages," to quote the title of Gail Sheehy's popular 1974 book,[11] with the prospect of continual unfolding instead of boring sameness, or put another way, constant change instead of comforting certainty.

Private experience began to take precedence over shared culture and tradition. As an example, in their book *Telling Your Story: Who You Are and Who You Can Be,* Sam Keen and Anne Fox encouraged their readers to "find the unconscious and make it conscious, find an audience for untold tales, and you will discover you are already living a rich mythical life. . . . Each of us harbors the entire range of human possibilities . . . we can become authentically public only by first going to the depths of the private."[12]

Also, consumerism and increasing affluence promoted a continuing privatization of pleasure from the fifties forward—from television, the suburbs, and the automobile to the Polaroid camera, the personal radio headset, the hot tub, and recreational drugs. These newer pleasures were experienced alone even if one had companions.

And finally, the decline of traditional religions left a vacuum that was filled by

the myriad forms of the human potential movement.[13] Many others also explored the religions of the East.[14] For some women this was a time to reject patriarchal religious traditions.[15] God for them was not the Father, a vengeful player in history, but rather the spirit of life, seen as nurturing and female. The feminist theologians revealed the world as an interdependent organism instead of a machine or storehouse of raw materials to be consumed. Above all, this feminist religious practice was not rigidly institutionalized but open to self-definition for each practitioner. And so it was for participants in the human potential movement. "Do your own thing," said Fritz Perls, who, along with Abraham Maslow, was a chief leader of the movement. "Be here now!" was his gestalt slogan that called listeners to live their lives in a direct, noncognitive way.

In areas from gender relations to religion, then, the *self* was proclaimed as the new center and source of meaning and, when all else failed, the only true plastic material of human lives. The way out was the way in—into the self. In photography, as we have already seen, beginning with Robert Frank, photography began to turn inward to personal documentary in the late fifties. Eventually this turning inward would become—after Samaras, Uelsmann, Michals, and Friedlander—the self as subject and self-imagery as genre.

As we have observed in the cases of Samaras and Michals, picturing and redefining sexual roles has been one of the strongest threads in the fabric of self-imagery. Barbara DeGenevieve rejected both female and male stereotypes when she pictured herself in her *True Life Novelettes* series as a flagrantly sexual, albeit rather funny, presence; and she pictured men as both sexual objects and uncertain, indecisive individuals. And Arthur Tress, whose early self-images alluded to mythic alter egos, later used models to depict his homosexual fantasies in shockingly direct images. He wrote in 1978 about this series, called *Facing Up,*

> I believe it is the photographer's function to reveal that which is concealed, even if it be repugnant to the majority, not merely to record what we see around us.[16]

Other male photographers, while not dealing with homosexual themes, nevertheless have pictured themselves in new and revealing ways.

Arno Rafael Minkkinen, who began photographing in 1971, has been producing self-imagery exclusively since 1972. Never picturing quite the angst and alienation of Samaras, Michals, or Friedlander, though, Minkkinen's work is more humorous and exuberant. The Finnish-American artist's work reflects a Scandinavian affinity with nature and a strong sense of abstract design that may be cultural as well.

FIGURE 11.7.
Arno Rafael Minkkinen,
*Self-Portrait, Jamestown,
Rhode Island,* 1974, from
Frostbite, 1978. Courtesy
Barry Friedman Ltd.,
New York; Nathalie C.
Emprin, Paris.

Shock, surprise, and humor combine in works showing nudes of elegant design and acrobatics, free of masculine erotic posturing.[17]

An older man whose subject has been his own aging form, John Coplans has photographed his body in images that make visible and redefine the powerful physicality of age. The presentation is actually traditional—not unlike Edward Weston's nudes of about 1930, in fact—but it is the body of the photographer, every hair and bulge described, that the viewer must confront in the pictures. In a culture that has allowed visibility to young flesh only, Coplans has violated a taboo by the direct and forthright presentation in his self-images—an appropriate taboo to violate in a rapidly aging culture.

Anne Noggle too has forcefully confronted the taboos against picturing age in self-images and in portraits of others as well. Coming to photography in middle

age, she has photographed mostly older, sometimes dying subjects.[18] Her confrontational 1975 self-image made when she was recovering from a facelift, her eyes ringed with surgical sutures but a flower clenched between her teeth—quoting an old cliché of femininity—said plenty about the willingness of women to go through great pain to conform to a cultural ideal. Its frankness is partly a critique of that ideal, even though we know Noggle really had the facelift. By documenting it she pictured a method of remaking the self that is widely practiced by women (and more recently by men) in our culture. Along with her candor, Noggle also has a sense of humor, and we see both in her *Stonehenge Decoded*, of 1977, in which her stocky body and legs assume the strength of megaliths in the landscape. In the eighties Noggle created fantastic tableaux, using lighting and props and quoting photographic clichés to re-create, and not simply document, herself: as a teenager

FIGURE 11.8. John Coplans, *Self-Portrait (back with arms above)*, 1984. John Coplans.

(1984), an aging nymph (1985), and a man (*It is I, It Is He, It Is She* [1986]). The range of Noggle's self-imagery encompasses the diaristic as well as the fantastic.

Ritual made its appearance in the early seventies in the self-imagery of Mary Beth Edelson, and in all of her work of that decade—painting, photography, performance—a spiritual thrust was foremost. When she began creating rituals and photographing them, it was, as she says, "with Joseph Campbell's writings about myth ringing in my ears."[19] For her it was the feminist movement, and within it, the women's spirituality movement, that provided "that rare thing in our contemporary culture—a context in which the rituals, symbols, stories (myths) could be shared with a community." Edelson has participated in the revival, or perhaps we should say the reinvention, of a female- or goddess-centered spirituality, and siting her practice as she does in her own person is exemplary, not dogmatic. Her claims for it only go so far as its authenticity for herself. In 1978 she wrote,

> What I am most concerned with is spirituality as it manifests itself in our bodies/ minds and how this effects how we see/feel about our being, and as a feminist awakening to the *greater self* as female, as well as making a political statement for women that says *I am,* and *I am large,* and *I am my body,* and *I am not going away.*[20]

FIGURE 11.10. Mary Beth Edelson, *Fireflights in Deep Space, Chico Mountains, California,* 1977 (three images from a private ritual performance). Mary Beth Edelson.

Like Samaras, Edelson has never been exclusively a photographer, and like him, she freely manipulates and mixes photography with other media. But when she has used the camera, she felt that it was

far more revealing and private than the same type of act using a brush. . . . It captures the soul of the moment—there is no hiding from this exposure. These moments before the camera are beyond your absolute manipulation or control and therefore say how it is—reveal reality in ways that can surprise.[21]

This comment is interesting in that it shows that Edelson desires control yet appreciates the accidents of witness. As for the private nature of the process, although outdoors, she worked much like Samaras: "The camera is in fact usually the only witness to my private rituals—the best of them have been when I am alone."[22]

The Californian Eleanor Antin also used photography to document her performances in the seventies. Very much the actress, Antin pretended, tried on roles, acted out wildly varied characters and circumstances. One so-called performance, *Carving,* was actually the photographic record of Antin's weight loss over a period of weeks. Looking at her body in this deadpan way and making it public, she suggested that her flesh was her medium and that her purpose was transformation. In later performances she went beyond the limits of her body, and even of her histor-

FIGURE 11.11. Eleanor Antin,
The King of Solana Beach, 1974.
Courtesy Ronald Feldman
Fine Arts, New York.

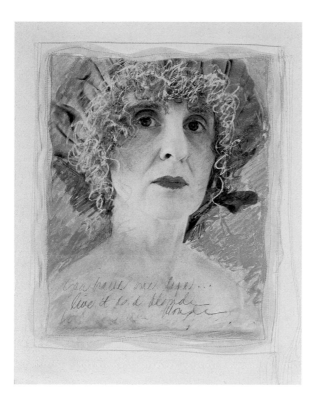

FIGURE 11.12. Judith Golden,
Live It as a Blonde (paint, pastel,
collage on photograph), from the
Chameleon series, 1975.
Courtesy of the artist.

ical time, to create fantastic other personalities—who entered the real world. One
might encounter her as the king of Solana Beach talking with some of his subjects
(1974–75), or as a nurse in the Crimean War in the trenches of Sebastopol (1977).
Later she created the character Eleanora Antinova, the "great black Russian balle-
rina," who had performances and gave lectures and gallery receptions. Antin's
witty creations expressed her impatience with her limits—in time, culture, and
gender. As she has said, "Why should I be limited by my own biography?"[23]

Judith Golden too was impatient—in her case with mass-media-created expec-
tations that women be young and beautiful. In her 1975 *Magazine* series she in-
serted her face into a torn magazine face, calling the stereotype it represented into
question. The rather coy self-pity of these first works became strong and amusing
as she went on to her *Chameleon* series, in which she created stereotypical person-
alities for herself, both male and female, with the strongly decorative manipulation
and color that have become her trademarks.[24] Sensitive to the objectifying gaze of
fashion and other stereotypical photography of women, Golden assumed control of

the camera gaze, thereby becoming author instead of object of her own image. She was in complete control of these photographs. This has been an important issue for many other women who have worked against stereotype and toward personal power through their self-imagery. Later Golden made a series of strong portraits of other women and a series of highly decorated emblematic photographs referring to the cycles of the seasons and to the natural elements. Hers is a feminist expression that has grown, as she says, from stereotype to archetype.

In the late seventies the young artist Cindy Sherman began photographing herself in a series she called *Untitled Film Stills.* This early work is highly appreciated now, but it was technically poor and not conceptually unique at the time, that is, compared with the work of Antin or Golden. In the context of the New York art world, however, Sherman was an early participant in the postmodernist recycling of images; her film stills would become what the critic Roberta Smith called "a cornerstone of post-modernism."[25] In the early eighties Sherman went beyond the film stills and came into her own with a series of big, horizontal self-images in color that took the art world by storm.[26] As much of her subsequent work would do, these made some viewers uncomfortable because her created personalities all seemed the subject of passive victimization: waiting for something to happen or else seemingly knocked to the floor by something that had happened. But, again, Sherman controlled the camera gaze, and she created the situations. Sherman's work has continued to evolve in interesting ways, suggesting at first more ambiguous and androgynous personalities and more recently, horrific and repulsive ones. If Golden and Noggle have explored more powerful and positive alter egos, Sherman's path seems to have gone in the other direction—toward the shadow, toward a negative kind of power.[27]

The idea of the double has been used by Eileen Cowin in her self-imagery. Cowin conveniently has an identical twin, who appeared with her in her *Docudrama* series beginning in the late seventies. Often including several other "family" figures as well, these pictures suggest stories of interpersonal relationships and domestic drama—sometimes a conflict between two women, sometimes a tension created by the needs of children and the desire for romance. Cowin used stills from plays and films, with their implied conflicts, as inspiration for the imagery in the elegant and open-ended photographs. She does not describe the work in terms of self-imagery but has said that she was "interested in using my twin sister as alter-ego or perhaps as an investigation of the concept of a *doppelganger.* . . . As I moved from issues of the family, I started using other models."[28]

FIGURE 11.13. Cindy Sherman, *Untitled #92*, 1981 (24 × 48 in.). Courtesy of the artist and Metro Pictures.

Although the phenomenon of self-imagery has been most strongly pursued in the United States, it has had its European practitioners, such as Arnulf Rainer and Gilbert and George. Another, less successful commercially but one of the most interesting, was the late British photographer Jo Spence. She followed the therapeutic implications of the genre to their furthest extremes as a vehicle of self-transformation and, she would say, psychological healing. A working-class woman who apprenticed herself as a portrait photographer, Spence recounted her life in photography in *Putting Myself in the Picture.*[29] In it she tells of her early complicity in portraits that told lies about the subject, reinforcing cultural stereotypes. As her political consciousness was raised, Spence tried to apply her new ideas to her photographic practice, which took many forms, many of them interpretations of her own image in photographs. In a 1979 Hayward Gallery exhibition called *Beyond the Family Album* she combined existing images of herself with a text that deconstructed them to tell a fuller story and, as she said, "to reclaim myself."

Spence also devised, with collaborator Rosy Martin, a practice called "phototherapy." In this nonhierarchical mutual therapy they used the portrait format, but in a subverted way. The subject acted out her material (usually from her personal past) for the camera, while the other played the role of photographer-therapist. According to Spence, their aim was "the demystification of photographic practice," and she described their understanding of a portrait as follows: "Instead of fixity, to us it represents a range of possibilities which can be brought into play at will, examined, questioned, accepted, transformed, discarded."[30]

The work of a younger British artist, Helen Chadwick, also deceased, suggested

multimedia installation possibilities for future practice of self-imagery. In sumptu-
ous and sophisticated installations informed by strong political and feminist the-
ory, Chadwick brought therapeutic psychodrama and art together in highly origi-
nal work in the eighties. Her themes were personal, ecological, and political, and her
means included photographs, lasers, slide projections, giant photocopies, and com-
puter-generated drawings. In the huge installation *Of Mutability* (1984–86) she
covered the floor with complex, life-size photocopies of her nude figure inter-
spersed with all manner of bird and beast. In the center of the room, five massive
golden balls focused the piece enigmatically, and around the walls were Bernini-
esque columns supporting arches of leaves with Chadwick's photocopied face as
keystones. *Of Mutability* created a sense of the interconnectedness of all life in a
metaphoric natural universe, in which, nevertheless, Chadwick's self-image is the
central motif.[31]

Attention to the self has a long history in Western culture. Its traditional em-
phasis, however, was self-mastery and control, not the self-transformative, expan-
sive thrust of the more recent culture of the self. As part of this new culture, self-
imagery stands as a rich and varied expression of the dominant experience of the
post-1960s culture. The new culture of the self, while turning radically inward and
away from the outside world, aims at discovery, growth, and continual transforma-
tion—witness, we might say, to the inner rather than the outer life.

ARRANGEMENT, INVENTION,
AND APPROPRIATION

To work in the directorial mode requires a photographer to violate more than a hundred years of trust in order to engage voluntarily in active deception. As a rule it involves an image-maker in a symbology that is not "found" but consciously chosen, imposed, and explored.

—A. D. COLEMAN

I am not a Historian, I create History. My images are antidecisive moment. It is possible to create any image one thinks of; the possibility, of course, is contingent on being able to think and create. The greatest potential source of photographic imagery is the mind.

—LES KRIMS

My practice has been to reject the role of witness or journalist, of "photographer," which in my view objectifies the subject of the picture by masking the impulses and feelings of the picture-maker. The poetics or the "productivity" of my work has been in the stagecraft and pictorial composition— what I call the "cinematography."

—JEFF WALL

I consider myself fortunate that photography exists, because otherwise I'd be stuck in the tragedy of ephemeralness that can come with installation art.

—SANDY SKOGLUND

I don't think of myself as a photographer. I've engaged questions regarding photography's role in culture . . . but it is an engagement with a problem rather than a medium.

—SARAH CHARLESWORTH

AFTER THE 1960S, if there was a genre of photography ripe for a revival, it was still life. This venerable form of art—arranged *objects* as subject matter, conveying either symbolic or formal meanings—had been largely neglected by most spontaneous-witness photographers, as still life hardly matched their excitement

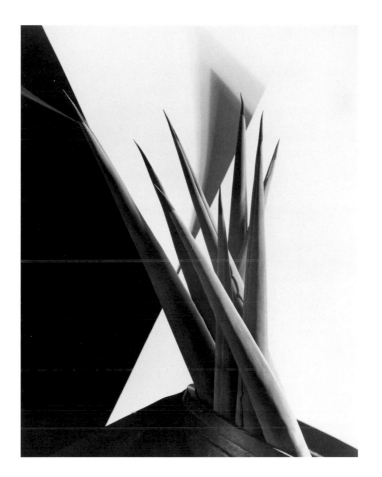

FIGURE 12.1. Imogen Cunningham, *Agave Design 1*, 1920s. © 1978 The Imogen Cunningham Trust.

FIGURE 12.2. Florence Henri, *Still Life*, 1929. The Metropolitan Museum of Art, Ford Motor Company Collection, Gift of Ford Motor Company and John C. Waddell, 1987 (1987.1100.63).

about catching life on the run. However, when Jerry Uelsmann, Duane Michals, and Lucas Samaras turned photography to a more controlled, contrived direction in the late 1960s, it was natural that interest in still-life photography would follow.

Not that it had been entirely neglected: Edward Steichen, Edward Weston, Imogen Cunningham, Charles Sheeler, Leslie Gill, Marie Cosindas, and Irving Penn in the United States produced many remarkable still lifes from the twenties to the sixties (Penn has continued to produce still lifes to the present day). Many more closeup fragments (such as Paul Strand's [see fig. 2.5]) or advertising pictures like those of Ralph Steiner or Paul Outerbridge also should be considered still lifes. In Europe, Man Ray, Walter Peterhans, Florence Henri, Hans Bellmer, and Josef Sudek had made exquisite still lifes during the reign of spontaneous witness as well. All of this was "studio practice," though, and, for the Americans at least (with the excep-

FIGURE 12.3. Man Ray, *Compass*, 1920. The Metropolitan Museum of Art, Ford Motor Company Collection, Gift of the Ford Motor Company and John C. Waddell, 1987 (1987.1100.40).

tion of the commercial photographers), just one part of a larger practice that included photography of witness outdoors. The Europeans were more likely to work exclusively in the studio (although Sudek would be the exception to that rule, as so many of his photographs were landscapes).

These classic modernist still lifes were not, for the most part, the traditional vase of flowers or *vanitas* symbolic arrangements.[1] They were modern, of their time, tending to be very sharp closeups of plants, simple geometric forms, machine parts, or ambiguous arrangements involving reflections or shadows. Old-fashioned humanistic references did, however, continue in some of Sudek's still-life work, but he was just as likely to attempt a surrealistic arrangement of objects—two embracing statues or an array of glass eyes, for example. Surrealism, of course, was Man Ray's tendency as well, such as in three still-life photographs from 1920: *Compass*, depicting a magnet hanging from a string with a handgun attached as the pointer; *La Femme*, of a hand-held eggbeater; and *L'enigme d'Isidore Ducasse*, picturing a sewing machine wrapped in an army blanket and tied with string (the last was published in the first issue of *La revolution surrealiste* in 1924).[2] Hans Bellmer, whose eccentric arrangements of a grotesque sexual doll were the subject of his still-life photographs (his major creative work was in printmaking), also made strongly surrealistic images, and these fetishistic pictures bear a close connection to the arranged, psychological tableaux of the 1980s.

Indeed, while documentary, landscape, portrait, and journalistic photography had gone strongly in the direction of spontaneous witness and a purely *photographic* aesthetic from the twenties to the sixties, still-life photography during the same period had kept a stronger connection to the major European art movements of the early twentieth century—dada, surrealism, cubism, and abstraction. In the seventies and eighties, a revived interest in still life, fabrication, and arrangement would reawaken this connection to modernist art movements as well as to other aspects of visual culture among photographers. In *Photography: A Facet of Modernism* Van Deren Coke observed,

> As the possibilities for straightforward photography seem to have become exhausted,
> it has been the photographers who know about the history of art, not simply the history of photography, who have shaped important directions for the future.[3]

Barbara Kasten, for example, looked back very specifically to Florence Henri and the Bauhaus as inspiration for her bold, colorful still-life photographs of the 1970s involving mirrors and abstracted, pure forms: "I have had a long standing interest

FIGURE 12.4. Barbara Kasten,
Construct NYC—17, 1984.
Courtesy of the artist.

FIGURE 12.5. Jan Groover,
Number 54–3 (Coleus), 1978
(chromogenic color print,
19 × 15 in.). Jan Groover;
The Art Institute of Chicago,
restricted gift of The Society for
Contemporary Art,
all rights reserved.

in the Bauhaus and through that investigation became aware of Henri's contribution."[4] And Jan Groover in her large still lifes of 1977–79, while picturing the traditional kitchen objects often found in still lifes, approached them with a radical, closeup eye and on a larger-than-life scale. Groover's precedents included Paul Strand's and Edward Weston's closeups, as well as cubist-inspired abstraction.[5] Olivia Parker's delicate still lifes of the seventies and eighties—at first split-toned black-and-white photographs and later Polacolor—incorporated the fresh and living (flowers, ripe fruit) with the antique (old documents, dolls, tools) in ambiguous, provocative arrangements that recalled the surrealistic microcosms of Joseph Cornell's boxes, as well as the ornate cases of old daguerreotypes.[6] In shallow, often compartmented spaces Parker created, in poet Mark Strand's words, "a remarkably suggestive world of particulars—so suggestive, in fact, that we are not sure if we are looking at strange extensions of reality or colorful projections of dream."[7] Betty Hahn's botanical still lifes of 1988, combining her drawings and fresh hothouse flowers and photographed in color, made witty reference to traditional botanical prints.[8] In all of these cases a fairly direct connection to earlier fine art or photography was important.

FIGURE 12.6. Olivia Parker, *Gravity,* 1982. Courtesy of the artist.

FIGURE 12.7. Robert Cumming,
*Two Views of a Mishap of Minor
Consequence,* 1973.
Courtesy of the artist.

Other still-life photographers used humor in their reference to tradition. Zeke Berman's most consistent theme since he began his still lifes in the mid-1980s has been a playful dialogue with perspective and other conventions of pictorial systems, contriving still lifes with suspended objects held together with strings that trace a kind of 3-D diagram. Berman's setups are witty references to past still-life tradition, from cubism to John Frederick Peto to Albrecht Dürer.

Robert Cumming, who, like Berman, became interested in the effects of illusion in the seventies, created humorous setups aping the trickery of Hollywood, then photographed each setup from a different angle to reveal the illusion. According to Jean Tucker,

> By the time we see [Cumming's] photographs, they have evolved from his sculptural constructions, his study of theatrical staging and lighting, model airplane building, architectural construction, and intense interest in movie stills, and an ongoing study of the physical forces of the universe.[9]

And Lucas Samaras's still lifes, begun in 1977—crammed with objects, pictures, and patterns—also make a kind of mad yet clever reference to other art, both high and low. Samaras himself is often included in the still lifes, though not always apparent at first glance. Unraveling them can be like the child's game of finding the hidden picture.[10]

Irving Penn, who depended for his livelihood on elegant color still lifes of seductive material objects—cosmetics, flowers, food, clothes[11]—turned in another direction for personal expression in the seventies and eighties. In these personal still lifes he pictured the detritus of the street or objects that intimated death and decay. His most notable series of this period was the 1972 cigarette butts printed in platinum at monumental scale. Other Penn platinum prints were arrangements of bones and bits of trash, which were just as elegant, nevertheless, as his shiny commercial still lifes. Other photographers, such as Frank Majore, looked to the seductions of advertising itself as a stylistic source and even subject matter: "I eliminate the products and push backgrounds forward. I'm asking, how does advertising stir up desire?"[12]

Kitsch, toys, and small objects of popular culture provided the objects and vocabulary for a group of still-life photographers working in a genre formerly reserved for hobbyists: the "tabletop," or miniature, still life. Ruth Thorne-Thomsen, Ellen Brooks, Laurie Simmons, James Casebere, David Levinthal, and others used dolls, knickknacks, ventriloquist dummies, cutouts, and figurines to create minia-

FIGURE 12.8. Lucas Samaras, *Kitchen Panorama*, 1986. Pace Wildenstein Gallery; Courtesy The Polaroid Collection.

ture tableaux that were sardonic or wistful efforts to address social, personal, domestic, or even mythic issues.

Ruth Thorne-Thomsen began in the late seventies to use a primitive pinhole camera to record the little tableaux she set up on the beach, pictures reminiscent of antique exploration photographs, and Casebere created his tabletop scenes by making all the objects himself, painting them white, then lighting them in a crepuscular, shadowy way. Drawing on the kitsch of American suburban lifestyles, Casebere "conjures up an uncanny, nocturnal world by mixing recollections of childhood buildings, film and television images, and architectural illustrations," according to Anne Hoy. Casebere has said, "Working small for me. . . . made objects anthropomorphic. . . . As you miniaturize, you identify with the child and imply childhood."[13] Just so, although for others the use of ready-made toys has been part of a

strategy of postmodern argument with the "truth" of documentary realist photography.

Brooks and Simmons used dolls to play out feminine psychodramas, and Levinthal photographed toy figures in vaguely focused tableaux about war, the Wild West, and even the Holocaust. Beginning with his book *Hitler Moves East* (1977),[14] Levinthal has tried to mimic documentary images in an effort to force the question what is "real" in photography. Despite their serious postmodern stance, and despite a certain poignancy that does attend these little tableaux, when history, anger, desire, or oppression is acted out in miniature settings the photographs have an oddly distanced sense of life at one remove.

Other photographers after the 1960s extended still-life photography by creating life-size tableaux, with human actors and sometimes elaborately created studio settings, though other times in natural or found environments; the work of both Michals and Samaras is, of course, in this category, and Uelsmann created tableaux in his combinations of negatives in the darkroom. Like still-life photography, this work had a history, and in an important 1976 article, "The Directorial Mode: Notes toward a Definition," the critic A. D. Coleman set out to recognize "directorial"

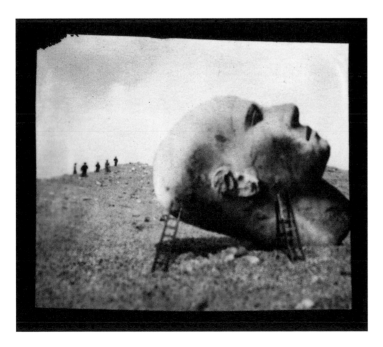

FIGURE 12.9. Ruth Thorne-Thomsen, *Head with Ladders*, from the *Expedition* series, 1979 (contact printed from a paper negative made in a hand-built pinhole camera). Courtesy of the artist.

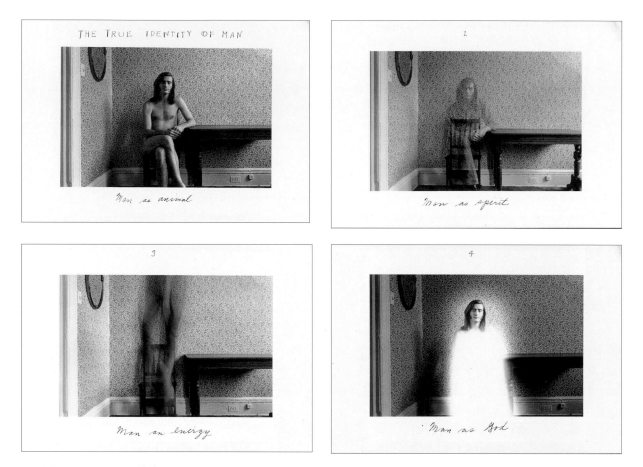

THE TRUE IDENTITY OF MAN

Man as animal

2

Man as spirit

3

Man as energy

4

Man as God

FIGURE 12.10. Duane Michals,
The True Identity of Man, 1972.
Duane Michals.

photography, as he named it, and also to make some corrections to the photohistorical record. Coleman defined the directorial mode as follows:

> Here the photographer consciously and intentionally *creates* events for the express purpose of making images thereof. This may be achieved by intervening in ongoing "real" events or by staging tableaux—in either case, by causing something to take place which would not have occurred had the photographer not made it happen. . . . Such images use photography's overt veracity against the viewer, exploiting that initial assumption of credibility by evoking it for events and relationships generated by the photographer's deliberate structuring of what takes place in front of the lens as well as of the resulting image.[15]

Coleman continued, italicizing the following for emphasis,

The substantial distinction, then, is between treating the external world as a given, to be altered only through photographic means (point of view, framing, printing, etc.) en route to the final image, or rather as raw material, to be itself manipulated as much as desired prior to the exposure of the negative.[16]

According to Coleman, the precedents for directorial work include *any instance* when the photographer intervened in the scene, but more specifically the work of these photographers: Oscar Rejlander, Henry Peach Robinson, Julia Margaret Cameron, Man Ray, William Mortensen, Clarence John Laughlin, Edmund Teske, and Ralph Eugene Meatyard. In addition, "erotic, fashion, and advertising photography . . . have been, by and large, explicitly directorial from their inception."[17] This would include the work of Avedon, Penn, George Platt Lynes,[18] and any number of advertising, "glamour," and editorial photographers. According to Coleman, most of this work had never been treated fairly in the standard histories:

FIGURE 12.11. Jerry N. Uelsmann, *Untitled*, 1978. Jerry N. Uelsmann.

It is apparent that, both inside and outside photographic circles, there is little recognition that there does exist a tradition of directorial photography. Certainly you would not know it from reading any of the existing histories of the medium. This widespread unawareness is traceable to two sources: the biases and politics of photographic historiography to date, and the ignorance about photography of most of the art critics who have dealt with the medium. The consequences have been that photographers with a predilection for this approach to image-making have had to undertake it in the face of outright hostility from a purist-oriented photography establishment, with no sense of precedent to sustain their endeavors; and the current crop of conceptual artists employing photography directorially are on the whole even less informed in this regard than their contemporaries in photography.[19]

Having thrown down the gauntlet in his lively, pugnacious way (to John Szarkowski, Beaumont Newhall, and various and sundry art critics), Coleman gave a new legitimacy to this work, which has flourished ever since. Soon after, in 1979, the curator Van Deren Coke mounted his exhibition *Fabricated to Be Photographed*

FIGURE 12.12. Clarence John Laughlin, *Light as Protagonist*, 1949. Collection Jack Woody.

at the San Francisco Museum of Modern Art, and the high profile of the genre was confirmed.

Tableau, or directorial photography, has indeed become a huge genre, and much of it has to do with self-definition, often in narrative form. With the possible exception of Friedlander's, all of the self-imagery discussed in Chapter 11 is directorial in mode—Duane Michals, Lucas Samaras, Jerry Uelsmann, Arthur Tress, Cindy Sherman, Mary Beth Edelson, Barbara DeGenevieve, Arno Rafael Minkkinen, John Coplans, Anne Noggle, Eleanor Antin, Eileen Cowin, Jo Spence, and Helen Chadwick have directed and determined the content of their photographs. In addition to extending the concepts of the self, tableau photography has been used to make visible the photographer's sense of psychological reality, sexual fantasy, and deep, often irrational, feeling.

This inner world—full of fear, desire, taboo, melancholy, and dream—was not, according to photographers of witness, available to the camera lens. Yet even before Uelsmann, Michals, and Samaras there had been a few rather isolated visionaries who made it their territory during the period of spontaneous witness. Prominent among them was Clarence John Laughlin, a New Orleans photographer with a Gothic, southern, literary mind. His photographs of the forties often featured a black-draped, veiled woman posed in a decaying southern mansion, and his lengthy caption to each picture directed the viewer to the often literary concept Laughlin was trying to make visible. George Platt Lynes in his mythology pictures and some of his sexual tableaux of the thirties and forties likewise evoked a state of mind beyond, and perhaps beneath, reason. The layered multiple exposures and solarized imagery of Val Telberg and Edmund Teske in the forties and fifties suggested the disjunctive quality of dreams. Ralph Eugene Meatyard, a southerner like Laughlin, used blur in the fifties and sixties to evoke a state of otherworldliness, as noted in Chapter 9 (see fig. 9.9). Later in his life, when he was dying of cancer, Meatyard created a series of photographs of figures in grotesque rubber masks called *The Family Album of Lucybelle Crater,* pictures that explained nothing but contained a feeling of quotidian horror.

Besides these Americans, a photographer from Japan, Eikoh Hosoe, produced tableau work in the 1960s that had a strong impact on American photographers. Although initially known only to the cognoscenti, Hosoe was the most active internationally of his generation of photographers in Japan, and his work, particularly three series—*Man and Woman* (1961), *Kamaitachi* (1969), and *Barakei* (Killed by roses, or Ordeal by Roses, published first in 1963 and again in 1971, then in an

FIGURE 12.13. George Platt Lynes,
Untitled, from the *Mythology*
series, ca. 1938.
Collection Jack Woody.

American edition published by Aperture in 1985)—eventually became well known in the United States and has been perennially influential, both for its darkly sensual quality and for its boldly imaginative, interpretive photographs. *Barakei* was the strongest and most unusual of Hosoe's works, a collaborative portrait with the novelist and cultural icon Yukio Mishima, made in the decade before Mishima's politicized ritual suicide in 1970.

The project began when a publisher assigned Hosoe to make a portrait of the writer—at Mishima's request, it turned out—in 1961. An admirer of Hosoe, Mishima wanted to collaborate with (or put himself at the mercy of) Hosoe. Over a number of photo sessions, at first at Mishima's Western-style Baroque house, then in Hosoe's studio, the photographer made a serial interpretation of the novelist in which several themes emerged: tortured sensuality, ambiguous sexuality, a pride in the physical body, and a mind conflicted between East and West. Mishima understood that this was a break in photographic tradition. In his own preface to the book he called it "testimony" photography, as opposed to "record" photography.[20] In ad-

dition to the photographs, *Barakei* was a gorgeously designed book.[21] As Hosoe's work became well known both through publication and through the portrait workshops he conducted in the United States beginning in 1972,[22] his imaginative approach to interpreting a human subject, particularly its dark side, made a strong impact on photographers in the West and encouraged the ripening movement toward arranged, tableau photography.

When Les Krims began publishing his staged photographs in the early seventies, he provoked shock and revulsion in many viewers for his focus on death and deformity and for his misogyny. His subjects included dwarfs and children with Down's syndrome (the latter wearing signs saying "Diane Arbus Lives in Us"), and two series were especially shocking in their treatment of women. One, called *Making Chicken Soup* (1972), showed his own mother clad only in underpants going through the process of making that staple of Jewish nurture, chicken soup. In poking fun at his culture, his mother, and "proper" nude photography his pictures broke several taboos. Another series, *The Incredible Case of the Stack-o-Wheats Murders* (1972), showed "murder scenes" of scantily clad young women sprawled in various domestic settings, blood oozing, always with an incongruous stack of pancakes nearby. These pictures not only spoofed "true crime" photos but also pic-

FIGURE 12.14. Eikoh Hosoe, *Yukio Mishima*, 1961, from *Barakei, Ordeal by Roses*, 1971. Eikoh Hosoe.

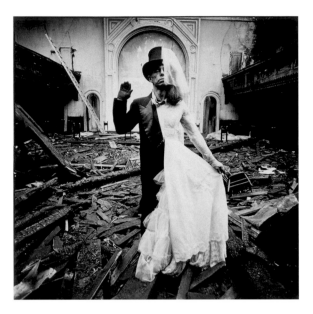

FIGURE 12.15. Arthur Tress,
*Stephan Brecht, Bride and Groom,
New York,* 1970, from *Theater of
the Mind,* 1976. Arthur Tress.

tured hostility toward women. Krims has continued to build on this oeuvre. As Jonathan Green has written,

> Krims's boisterous work brought him instant acclaim and undoubtedly helped liberalize the subject matter of photography. Some of the work is indeed funny, but most of it is more important for its gesture of defiance than its pictorial value. Krims's photographs become a theater of the ridiculous, employing an adolescent sexuality, burlesque slapstick, and scabrous comedy that shocks and entertains by the coarsest possible puns and situations. His photographs are more juvenile than perverse.[23]

Disturbing tableau photography by Arthur Tress (whose self-portraits in shadow I discussed in Chapter 11) included his series *Theater of the Mind* (published in 1976) and *Facing Up* (published in 1980). In staging the first, Tress engaged his subjects' cooperation, as he wrote,

> to create a photograph that will show the psychological spaces and relationships that exist between various members of a family group. . . . The photographer asks the individuals how they feel towards one another and gets them to act out that relationship in a physical way so that it can be caught by the camera. . . . not only to show us what families look like, which we already know, but to penetrate deeper into their thoughts and emotions.[24]

Facing Up was Tress's collection of acted-out "phallic phantasies," as he called them:

> The phallic archetype can be the fountainhead of religious experience or the rationale behind paternalistic exploitation. Within the homosexual world itself, the worship of the penis leads to many contradictions and hypocrisies. The "gay" life is filled with as much cruelty and loneliness as the heterosexual life. . . . I search into my dreams or desires and try to ask myself how these feelings can be made into concrete images. . . . Are they really abnormal, or are they trying to tell us something we have repressed about ourselves, something we don't want to see, something about the darker side of the human condition itself?[25]

If Hosoe, Krims, and Tress told us "something about the darker side of the human condition," a younger photographer, Joel-Peter Witkin, plumbed its murkiest depths in his staged and often defaced photographs of the 1980s, grotesque pictures that combined cadavers, hermaphroditism, deformities, and outré sexual practices with rather arcane art-historical references. The subjects of his photographs, which seem literally beyond belief, are presented as photographic fact, and Witkin has exploited the documentary aspect of photography to increase the discomfort of the viewer. His models are real human beings displaying practices or deformities one would never dare observe at length in everyday life, yet there they are, fixed in photographs made for contemplation. Van Deren Coke, who was Witkin's teacher

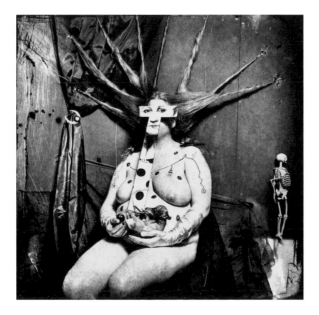

FIGURE 12.16. Joel-Peter Witkin, *Portrait of Nan, New Mexico,* 1984. Pace Wildenstein MacGill; Courtesy Fraenkel Gallery.

and early supporter, has written that Witkin "gives us an opportunity to infiltrate an alien land like an undercover agent."[26] As to the issue whether Witkin's pictures are pornographic, Coke continues,

> This question must be raised, but examination of his photographs leads to the answer that there is a mystical and even darkly spiritual quality to his pictures that is quite at odds with pornography. Pornography is intended to arouse lust immediately, not after contemplating a picture and thinking about its many implications. Pornography is a substitute for actual experience and tends to trivialize and focus narrowly the sexual urge. Witkin recognizes this strong universal urge and defines its manifestations in broad uninhibited ways, but the results have esthetic as well as emotional power.[27]

Witkin himself has claimed an ambitious, even spiritual goal for his work:

> In order to know if I were truly alive, I'd make the invisible visible! Photography would be the means to bring God down to earth—to exist for me in the photographic images I would create. I believe that all my photographs are incarnations, representing the form and substance of what my mind sees and attempts to understand.[28]

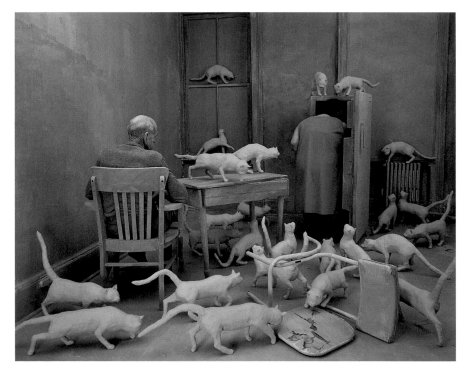

FIGURE 12.17.
Sandy Skoglund,
Radioactive Cats, 1980.
© 1980 Sandy Skoglund.

The darkness in the tableau photographs by these men reached a disturbing level that would be touched by very few women. The exception has been Cindy Sherman, whose work through most of the eighties was self-imagery—her photographs have gotten increasingly disturbing over time (she was, by the way, a student of Les Krims). Eventually abandoning herself as subject matter (after a series in which she deformed sections of her body with medical dummy parts), more recently Sherman has created still lifes of abominable, unthinkable subjects—blood and guts, excrement, trash. More commonly, however, women tableau photographers have tended to work more subtly, arranging theatrical pieces that have gender, race, or class as their theme or presenting scenes that suggest altered or dreamlike states of mind.

Related to the latter, for example, Sandy Skoglund has written about her tableaux, beginning with *Radioactive Cats* (1980),

> My work involves the physical manifestation of emotional reality. Thus, the invisible becomes visible; the normal, abnormal; and the familiar, unfamiliar. Ordinary life is an endless source of fascination to me in its ritualistic objects and behavior.[29]

Skoglund elaborately crafted installations usually depicting some kind of domestic space and each having two or three actors within them (as photographed, that is; in galleries the installations were shown unpeopled). In each scene, things were painted in strange combinations of strong colors having nothing to do with ordinary reality, and often there was a dominant motif—such as floating goldfish, clothes hangers, fluorescent-colored cats, or blowing leaves repeated ad infinitum in the tableau—resulting in a weird hybrid of familiar reality and nightmarish vision.

The California photographers Eileen Cowin and Jo Ann Callis both have created ambiguous theatrical tableaux of figures in domestic spaces. Cowin, as noted in Chapter 11, used herself as a model and domestic drama as a theme, and Callis used one or two figures, often blurred in some way, involved in ambiguous activities, such as *Man Doing Pushups* or *Man and Red Curtain* (both 1984). Callis, who has created many haunting and mysterious still lifes as well as these tableaux, through her models' unexplainable activities has created the aura of irrational dreams, and through the lush color of her photographs, a charged, sensual atmosphere.

Carrie Mae Weems, an African American artist, since 1977 has used photography with text to confront issues of identity, race, gender, and class. All of her work derives from, and centers on, what it means to be black—most of it a long, continuous, angry argument against stereotype. Her *Family Pictures and Stories*

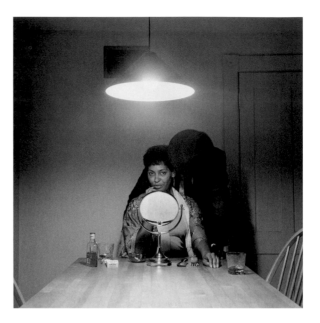

FIGURE 12.18.
Carrie Mae Weems,
Untitled, from *Kitchen
Table* series, 1990.
Courtesy of P.P.O.W.,
New York.

(1978–84) was a documentary about her own family, but in subsequent work, such as the *Ain't Jokin* series (1987–88) or the *Kitchen Table* series (1990), she used posed models, including herself, in carefully set up photographs. In the *Kitchen Table* series Weems and a man, child, or another woman act out little domestic scenes of male-female negotiation or tension, or women-child scenes of gender education, or woman-woman scenes of friendship, all accompanied by a bitter text commenting on the woman's life.

The curator Deborah Willis has pointed out that

> the narrative mode is a distinct tradition within African-American art. Story-telling is found in its folk art traditions as well as in its various contemporary genres of art making. One could even argue that within the African-American community, no art is developed without narrative, whether explicit or implied.[30]

Certainly this is true of Weems, and Willis suggests that it applies as well to Lorna Simpson, who has also dealt with issues of race and oppression through photographs and writing. Simpson has done this, however, in formally stylized, oblique presentations that puzzle the viewer—quite different from the straightforward narrative thrust of Weems. In her works dating from the early 1990s, Simpson has generally used several seemingly identical photographs (the repeats almost always

have subtle differences) of a woman in a plain dress, seen either from the back or from the neck down if frontal. The text that accompanies each piece is usually a kind of list of related words that are suggestive but not conclusive about an event or idea related to the woman's body. For example, the text accompanying the piece titled *Three Seated Figures* reads, "Prints, Signs of Entry, Marks, her story, each time they looked for proof." As Saidiya V. Hartman has pointed out,

> When examining Simpson's photographs, the viewer is confronted by the imperiousness of the gaze. . . . Simpson contends with this power by formally enumerating its strategies and shielding parts of the female body, most notably the face. The work endeavors to represent the female body while severing the connection between woman and the spectacle. Simpson undermines the viewer's mastery and disrupts the power of the normalizing gaze by employing segmented bodies, serial images, and aloof and anonymous figures with their backs turned toward the camera and the viewer. As a consequence, the viewer is not allowed to be a voyeur.[31]

Both Weems and Simpson have carefully staged their photographs and crafted provocative texts, yet the goal of their work is oddly reminiscent of that of earlier documentary photographers. Deborah Willis has said,

> Simpson's approach to photography is in one sense linked to the venerable traditions of the medium: like social-documentary photographers, "concerned" photographers and even environmental landscape photographers, she wants her work to change the world for the better, and she believes that photographs have a unique ability in this regard.[32]

Weems agrees:

> Photography can still be used to champion activism and change. I believe this, even while standing in the cool winds of postmodernism. In this regard, perhaps what is im-

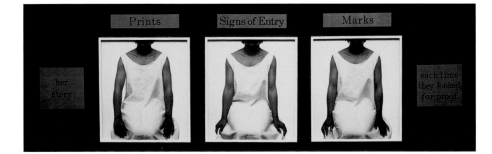

FIGURE 12.19. Lorna Simpson, *Three Seated Figures,* 1989 (three color Polaroid prints, three plastic plaques, 25 × 70 in.). Courtesy Sean Kelly Gallery, New York.

portant to consider is that our age necessarily demands, as Allan Sekula eloquently put it, "a new documentary," one that develops new forms, new visual possibilities. And one that still embraces a photography that is essentially humanist; a photography that encompasses the complexity of our diverse experiences and all the rest of it.[33]

Jeff Wall, a Canadian photographer, and Philip-Lorca diCorcia, an American, have both pursued what could be called "new documentary," or at least "new realism," within a highly stylized, staged kind of photography. DiCorcia's work since the late seventies has focused on scenes featuring real people in real, if unsettlingly ambiguous, settings—at first his family or friends in domestic scenes, later the hustlers and drifters of Los Angeles photographed on the street—but photographed as stilled, frozen figures in tableaux. In the earlier work we might see his brother staring into a brightly lit refrigerator, and later, a young hustler fixed and frozen on the street. Rather than the caught-in-the-moment 35 mm shooting of the documentarian or street photographer, though, diCorcia has used a medium-format camera, high-resolution color film, and most importantly, strategically and theatrically placed electronic flash. The lighting in particular gives his pictures a slightly eerie and very dramatic appearance—of the real world, yet not of it.

Jeff Wall's work takes diCorcia's direction to further extremes. Since the late seventies Wall has pursued ambitious, socially critical work depicting narrative scenes that are wholly staged and related to the social problems of the day. Trained in art history, Wall considers his practice an extension of Baudelaire's *peinture de la vie moderne*, except that his pictures are not paintings but photographs, and his modern-life scenes depict the end of the twentieth century rather than the middle of the nineteenth (though many of them refer strongly to earlier paintings, particularly from nineteenth-century France). Wall's method is to photograph in precise color with a very-large-format view camera, often using carefully placed flash, in settings often built in the studio, with actors or models enacting his narrative; and his method of presentation is to show the highly detailed color pictures as huge back-lit transparencies in galleries with low light, accentuating the theatricality of the images, as well as Wall's determination to present works in which "the construction contains everything, that there is no 'outside' to it the way there is with photography in general."[34] More of a painter with a camera than a photographer (he rejects traditional notions of witness), Wall has in his recent work used the computer to craft montages that begin to more closely approximate the condition of paintings:

One paradox I have found is that, the more you use computers in picture-making, the more "handmade" the picture becomes. Oddly, then, digital technology is leading, in my work at least, towards a greater reliance on handmaking because the assembly and montage of the various parts of the picture is done very carefully by hand.[35]

Which brings us to the idea of combining and appropriating existing imagery. Interestingly, the ambition to change conditions through photography that we have seen in the work of Weems and Simpson, or at least to raise consciousness, as in the work of Jeff Wall, is shared by another artist who has used wholly *appropriated* photographs, combined with text—Barbara Kruger.

Why certain artists (who may not actually be photographers) chose to appropriate existing photographs in their work became a critical issue in the 1980s. According to Joshua P. Smith,

This is because pictures rather than experience have defined the world for the artists of the eighties, who have turned to examining photographically derived imagery's preponderant role as the core and conduit of our culture and ideology. Mass media and popular culture—advertising, fashion, movies, television, video, and other electronic media—have made the world photographic, become the common language, and shaped a generation's visual and critical impact.

The use of already-existing images or image styles through appropriation, often accompanied by rephotography and pastiche, began as a primarily feminist critique of representation and of the commodity status of art objects. The works exposed the central role of photographically derived imagery in exploiting and culturally stereotyping women in society and art. For example, Barbara Kruger explored modes of institutional oppression in a patriarchal society; Sherrie Levine questioned the place of the male masters in art history in relation to their subjects, the viewer, and the female artist; and Sarah Charlesworth, Eileen Cowin, Sylvia Kolbowski, and Cindy Sherman examined women's entrapment in stereotyped roles.[36]

In a 1982 position paper entitled "Incorrect" Kruger laid out her manifesto, quoted here in its entirety:

Photography has saturated us as spectators from its inception amidst a mingling of laboratorial pursuits and magic acts to its current status as propagator of convention, cultural commodity, and global hobby. Images are made palpable, ironed flat by technology and, in turn, dictate the seemingly real through the representative. And it is this representative, through its appearance and cultural circulation, that detonates is-

sues and raises questions. Is it possible to construct a way of looking which welcomes the presence of pleasure and escapes the deceptions of desire? How do we, as women and as artists, navigate through the marketplace that constructs and contains us? I see my work as a series of attempts to ruin certain representations and to welcome a female spectator into the audience of men. If this work is considered "incorrect," all the better, for my attempts aim to undermine that singular pontificating male voice-over which "correctly" instructs our pleasures and histories or lack of them. I am wary of the seriousness and confidence of knowledge. I am concerned with who speaks and who is silent: with what is seen and what is not. I think about inclusions and multiplicities, not oppositions, binary indictments, and warfare. I'm not concerned with pitting morality against immorality, as "morality" can be seen as a compendium of allowances inscribed within patriarchy, within its repertoire of postures and legalities. But then, of course, there's really no "within" patriarchy because there's certainly no "without" patriarchy. I am interested in works that address these material conditions

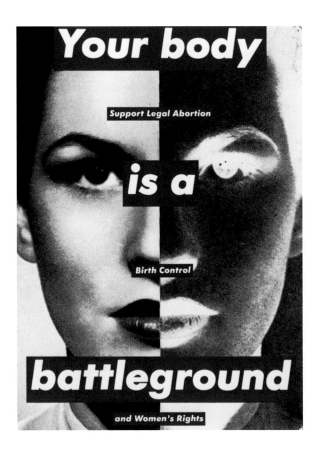

FIGURE 12.20. Barbara Kruger, *Your body is a battleground,* 1989 (postcard version). Barbara Kruger.

of our lives: that recognize the uses and abuses of power on both an intimate and global level. I want to speak, show, see, and hear outrageously astute questions and comments. I want to be on the sides of pleasure and laughter and to disrupt the dour certainties of pictures, property, and power.[37]

According to Kate Linker, "Kruger's art is inconceivable outside of the feminist movement and the complex of social issues in the 1970s that conferred new visibility on women artists." But feminism changed in the 1980s:

> Among Kruger's generation, gender was not regarded as an innate or "essential" condition, but rather as a construction produced through representation. Sexuality was regarded as the result of signification and semiotic effects, rather than of biology—a perspective that offers the possibility of changing our restrictive definitions of gender. Masculinity and femininity came to be seen as the products of adaptation to social standards of sexuality, in which the impact of signs play[s] a determining role. In a manner with radical implications for the visual arts, discussions converged on the politics of the image.[38]

Like others of her generation, Barbara Kruger has rejected the notion of artistic originality by appropriating images that already exist in the public culture. These photographs, of course, had makers, but they have been treated by Kruger as anonymous and therefore without authorship. As Linker has commented,

> Similarly, her use of mechanical reproduction contrasts the serial, or multiple, with the uniqueness associated with products of the hand. For Kruger refuses the mystique of the unique object: the hand in her work is never singular, always social.[39]

Interestingly, Kruger began her professional life in the 1960s working as a graphic designer and picture editor for one of the great magazine empires, Condé Nast. Linked to her growing interest in theories of semiotics and representation, her skill as a designer and her ability to use picture archives effectively armed her with the arsenal she needed for her increasingly political, polemical work of the 1980s. Although her bold, black-white-red picture-with-text panels have appeared in gallery and museum settings, they have also been plastered on walls as posters, displayed as giant billboards, and reproduced on such ordinary consumer items as matchbooks, T-shirts, refrigerator magnets, postcards, and shopping bags. Her targets have included big business, militarism, big science, consumerism, and patriarchal oppression of women. In addition to her personal work, she has created posters

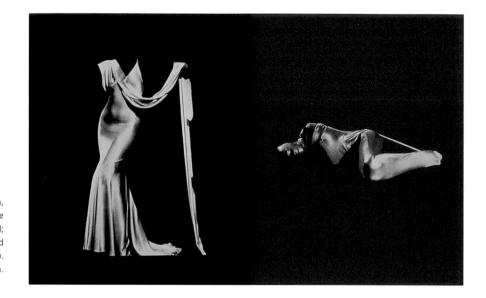

FIGURE 12.21. Sarah Charlesworth, *Figures*, 1983–1984 (Cibachrome prints, mounted and laminated; interlocking two-panel lacquered wood frame, 42 × 62 in.). Sarah Charlesworth.

for art events and for political activities, most notably her 1989 poster with the legend "Your body is a battleground" for a march on Washington in support of abortion rights.

Often mentioned in the same breath with Kruger—as feminist, image appropriator, and student of photography in popular culture—is her contemporary Sarah Charlesworth. Just as Kruger has understood and used the language of consumerist advertising in her big, bold, and graphic works, Charlesworth has understood the power of scale, brilliant color, and shiny surfaces in her creations. While Kruger assumed an active, polemical thrust with her work, however, Charlesworth took a more philosophical position, musing on the power of photographs in seductive and large-scale works. She said in 1983,

> To live in a world of photographs is to live in a world of substitutes . . . or so it seems, whose actual referent is always the other, the described, the reality of a world once removed. I prefer, on the other hand, to look at the photographs as something real and of my world, a strange and powerful thing . . . part of a language, a system of communication, an economy of signs.[40]

And in 1989 she defined her own work as follows,

> I don't think of myself as a photographer. I've engaged questions regarding photography's role in culture . . . but it is an engagement with a problem rather than a medium.

The creative part of the work is just as much like painting or design as it is like photography. I'm not using a camera and it's not based on recording a given world but on creating or structuring a given world.[41]

Several series of works used found photographs, including her lengthy *Objects of Desire* (1983–88), in which Charlesworth isolated cut-out photographs of objects ranging from a wedding dress to art objects to ritual religious objects in fields of gorgeous, saturated color. In this series, according to Lisa Phillips,

she asks the viewer to locate his or her own sources of sexual desire. Echoing Lacan's theory that desire is an instinct aroused by a gap or perceived absence—by something that is sensed but not seen—Charlesworth uses partial figures and fetish objects as her embodiments of social attitudes.[42]

Following this series, in *The Academy of Secrets* (1989) Charlesworth combined found images from art history in elaborate emblematic pictures that she characterized as portraits or self-portraits.

The avant-garde graphic designer Dan Friedman and the curator Jeffrey Deitch used appropriated imagery from popular photography, art history, and contemporary art in their book *Artificial Nature* (1990).[43] Friedman's purpose was classically modernist, that is, to use his design to express ideals:

"Embrace the richness of all culture; be inclusive instead of exclusive," advises Friedman. . . . "Live and work with passion, responsibility and a sense of humor. . . . Be radical."[44]

Artificial Nature was a curious, hybrid creation, part exhibition catalogue, part visual essay, and part written essay. The vivid pictures chosen and designed by Friedman in his bled-to-the-edges style, combined with his bold legends in black or red sans-serif type, created a hard-hitting, disjunctive, and very entertaining book. Drawing on stock photography, advertising pictures, fine art of the past, as well as the artworks included in the exhibition, the pictures in combination used humor and maximum design impact to make his point that "artificial nature" has become more familiar and comfortable to us than nature itself.

In the same year as *Artificial Nature* (1990) there appeared another curious book, *I'm So Happy*, by Marvin Heiferman and Carole Kismaric, longtime veterans of serious photographic enterprises.[45] They too used color stock photography, mostly from the Freelance Photographers Guild (FPG) agency, all undated but by

appearance mostly from the 1960s and 1970s—silly, too perfect scenes of smiling, affluent Americans. The text focused on all the permutations of middle-class contentment and bliss, making altogether a tongue-in-cheek spoof of the American right to the "pursuit of happiness," particularly as imagined by the affluent, apolitical Americans of the 1980s. Heiferman and Kismaric end their text as follows:

> You got it! The promotion, the raise, the partnership. You win the lottery. Big bucks. Money. Success. You invest. You reinvest. More. The kids grow up. They're well adjusted, drug-free. They leave home and you're free. And they call every week, like clockwork. Perfect. Your house triples in value, and the neighborhood is crime-free. Cities stay solvent. Taxes go down. You buy that second home. Relax. It's 2040, late in the evening, and you're having a glass of warm milk. The TV is on, you put down your favorite book, rest your head on the pillow, and fall comfortably into a very deep sleep with a smile on your face. Peace.[46]

Striking a light note, *I'm So Happy* was nevertheless part of a serious trend in the eighties to mine photographic archives as repositories of cultural values and fantasies, a trend that included the work of Barbara Kruger, Sarah Charlesworth, and Dan Friedman.[47]

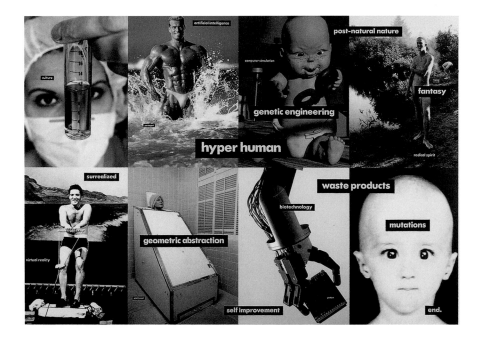

FIGURE 12.22. Dan Friedman, from *Artificial Nature*, 1990. Courtesy Deste Foundation, Athens, Greece, *top, left to right:* Dan MacCoy, Michael Neveaux, Pixar, Magnum Photos; *bottom, left to right:* Photofest, The Image Bank, Lou Jones, Nancy Burson.

All of the photography considered in this chapter—still lifes, tableaux, appropriations, and words with pictures—has been radically removed from classic photography of witness, even when it has had political aims, for example, the work Kruger or Friedman. The creators of this work have *invented* it, either from real objects or from existing representations. They have not *found* their pictures waiting for them in real time or real space. But this is not to say that the work has been removed from real-life concerns. As Joshua P. Smith put it,

> The new photography is not purposelessly inventive and detached from life, but rather in its own way is an authentic documentation of the live fictions and the genuine inauthenticity of our times.

Smith argues that if something seems to have been lost, expanded creative possibilities for photography now exist as a result of this work:

> In an ironic twist, photography can be seen as moving toward a detachment from its status and intrinsic nature as the supreme representational medium. It is asserting itself as an additional concrete reality, a part of life, not merely a representation of or comment on it. This switch in emphasis makes photography more like other art forms that are not dependent on an external source subject and thereby greatly expanded its creative possibilities.[48]

The photography of arrangement, invention, and appropriation is, it turns out, just a small step away from photographs manipulated by way of a computer. The reader may have noticed that the computer's "hand" can in fact be seen in images used in Friedman's *Artificial Nature.* In Chapter 13 we will look at digitized photography as the next logical step in "expanding its creative possibilities," although at the same time it is a step further away from the power of witness that photography embodied earlier in the century.

DIGITIZED PHOTOGRAPHY

I am not one of those who say: "that watering can is blue, that house is pink," or those who say: "nothing is beautiful but truth, only truth is pleasant." There are better things to do in life than copy. . . . Isn't it this perpetual mania of imitation that prevents man from being a god?

—MAN RAY

I mean, photography is all right if you don't mind looking at the world from the point of view of a paralysed cyclops—for a split second. But that's not what it's like to live in the world, or to convey the experience of living in the world.

—DAVID HOCKNEY

If you can *dream* it, you can *do* it.

—ADOBE PHOTOSHOP

As the two quotations from Man Ray and David Hockney attest—interestingly, both men painters as well as photographers—the limits of photography can be grating. For Man Ray in the 1920s the limit was the too-close adherence to perceptual "truth," and for Hockney in the 1980s the limit was the infinitesimal amount of time represented in a photograph and thus its failure to depict the reality of lived time. Both men found ways to overcome these limitations—Man Ray through sheer play and darkroom invention and Hockney through his elaborate collages photographed and assembled over an extended period of time. Nevertheless, photography was for them (and for many others considered in Chapters 7–12) not altogether perfect by itself. It needed assistance and improvement. A split-second mechanical witness was not enough for these imagemakers.

In many ways photography had been assisted, extended, and manipulated

throughout its history, even during the glory days of spontaneous witness. Some of the methods have been considered photographic, some have not. Darkroom techniques of dodging, burning, cropping, controlling focus, tone, and contrast, and choice of scale give the photographer (even the most conventional purist) several methods of translating a film negative into a finished print. When beginning photographers learn to do these things, they begin to understand the power of their possible mastery of the medium, and even before they enter the darkroom, of course, they learn that point of view, timing, lens and aperture choice, single or multiple exposure, and above all framing determine the look of the image on the film. Other printing techniques, less acceptable to photographic purists, have included hand-coloring, photomontage, painting or drawing on images, combining negatives in double-exposed prints, solarization, and printing with a variety of non-silver emulsions on special papers or other supports. As we have seen in Part Two, beginning in the 1960s photographers revived or reinvented many of these latter methods and began to stage and invent their images before the camera as well.

The time was ripe for a new technology. Just as the 35 mm camera, invented in the 1920s, made spontaneous witness possible, the digital revolution—and all the technology it touches, from camera to printed page—came along in the 1980s to reconfigure and provide a new level of control in photography. Before the digital revolution in the late 1980s, though, photographers explored a number of technological imaging systems developed in the industrial environment—thermographic, electronic, holographic, video-synthesizer—as avenues to manipulation of their imagery, and these experiments form a kind of prehistory to digital manipulation.[1]

When a photograph becomes a digital file, however, its physicality as a photograph is left behind. In essence, instead of being made up, as photographs are, of microscopic grains of silver and having continuous tone, digital images are made up of an extensive grid of tiny pixels, each one of which can be assigned any color or tonal value at will, or moved around within the image. When a photograph is scanned, it becomes a digital file that can be worked on, pixel by pixel, mouse in hand, on the monitor screen of a computer. Or it can be combined with another digital file. When the image is printed, the pixels remain on the printed image of the file. The finer the grid of pixels, the more the digital image will look like a photograph; the cruder the grid, the larger the pixels will appear, giving the image a potentially blocky, mosaiclike texture. This mosaiclike appearance can often be seen in newspaper photographs, now commonly digital files that have been beamed by satellite from the photographer in the field to the editorial desk.[2]

The watershed year was 1989. Just as that year marked the 150th anniversary of the invention of photography, it was also the year when John and Thomas Knoll wrote their program for Photoshop and sold it to Adobe Systems. Writing of that year, William J. Mitchell remarked, "From the moment of its sesquicentennial in 1989 photography was dead—or, more precisely, radically and permanently displaced—as was painting 150 years before."[3] Before Photoshop brought digital control to the personal computer station, however, the printing industry had been using digital correction throughout the preceding decade.[4]

According to Stewart Brand, in his *Media Lab: Inventing the Future at MIT,* written in 1987,

The technology for doing all this was pioneered at MIT by William Schreiber and Donald Troxel. . . . It began with a 1969–79 contract from Associated Press to solve AP's problems with the differing wirephoto standards between the U.S. and the rest of the world. Schreiber and Troxel invented a laser photo facsimile system and then an "Electronic Darkroom" for AP. Photographs and slides were read by a laser scanner in minute detail, translated into digital form, and stored in a computer, where the images could be reshaped and edited at convenience. Nearly every AP picture you see in newspapers is digital. So are all the photos in *Time* and *USA Today,* for the same reason: so they can be sent by satellite to distant printers for far quicker distribution than used to be possible.[5]

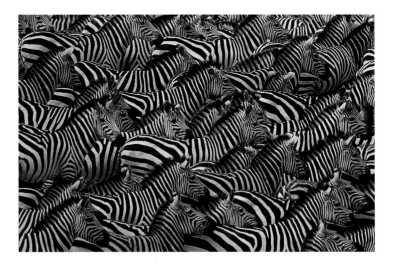

FIGURE 13.1. Art Wolfe, *Grant's Zebras, Kenya,* from *Migrations,* 1994 (digital composite). Art Wolfe/Stone.

Digital still-video cameras that captured information on magnetic disk or magnetic memory cards, laser scanners, and equipment that could "grab" parts of an image and move them around, in, or out of a picture or change colors, revolutionized newspaper and magazine picture publishing in the 1980s. Brand explains,

> The technology [of digital retouching] was refined subsequently for gravure printers. It is now common in "electronic color pre-press systems" used in most high-quality printing. The leading manufacturers of the equipment are Hell in West Germany and SciTex in Israel. It's so widespread that the kind of expensive retouching that used to be the sole province of advertisers and catalog makers is now a standard editorial tool.[6]

Some notorious examples of digital retouching in the eighties jolted sensibilities and raised some ethical issues related to the new technology. The *National Geographic* moved the pyramids of Giza closer to each other on computer in order to fit the vertical format of its February 1982 cover.[7] *Rolling Stone* removed a gun and holster via computer from Don Johnson's shoulder for the cover of its 28 March 1985 issue (the "college special"). And *Life* set up a photo titled *We Are the World*—intended to show the world's racial makeup—by photographing a dozen people in the studio and replicating them electronically in great numbers to make the point (the photographer was credited on the same page as the photo, while the digital work was credited on another page).[8]

More recently, digital replication was used by the nature photographer Art Wolfe in his 1994 book, *Migrations*. According to Kenneth Brower, "In about a third of the book's images the wildlife—caribou, zebra, geese, greater sandhill cranes—had been digitally enhanced, and some had been digitally cloned and multiplied."[9] Wolfe justified this "enhancement," saying that "art, as well as conservation" was a goal of the book:

> Over the years, as I reviewed the material, I often had to pass over photographs because in a picture of masses of animals invariably one would be wandering in the wrong direction, thereby disrupting the pattern I was trying to achieve. Today the ability to digitally alter this disruption is at hand. For the first time in *Migrations,* I have embraced this technology, taking the art of the camera to its limits. . . . I have enhanced the patterns of animals much as a painter would do on a canvas.[10]

Brower (son of the legendary David Brower, of the Sierra Club, under whose leadership the Sierra Club photo books were initiated) decries this practice in nature photography:

Photofakery is pernicious to conservation. Photographers—along with poets, painters, astronauts, reporters—are a sensing element for humanity. The public increasingly depends for much of its environmental awareness on photographic images from around the world. These images need to be true.[11]

A more sensational yet subtle example of digital retouching, *Time*'s darkening of O. J. Simpson's skin for its 27 June 1994 cover (whereas *Newsweek* used the same police photo, unretouched, on its cover), was interpreted by some as evidence of the magazine's intent to demonize Simpson and come to judgment on the famous athlete accused of murdering his wife. Interestingly, *Time*'s headline ("An American Tragedy") was much less incendiary than *Newsweek*'s ("Trail of Blood"); still, it was the darkening of the skin that seemed to send the loudest message. These and many other digital "cleanup" techniques (removing beverage cans, extending blue sky, removing wires) may seem harmless, but the ease with which almost anything can be done had made the industry sit up and take positions.

The National Press Photographers Association in 1991 developed a "Statement of Principle" on the ethics of digital manipulation of news photographs:

As journalists we believe the guiding principle of our profession is accuracy, therefore, we believe it is wrong to alter the content of a photograph in any way that deceives the public.

As journalists we have the responsibility to document society and to preserve its images as a matter of historical record. It is clear that the emerging electronic technologies provide new challenges to the integrity of photographic images. This technology enables the manipulation of the content of an image in such a way that the change is virtually undetectable. In light of this, we, the National Press Photographers Association (NPPA), reaffirm the basis of our ethics: accurate representation is the benchmark of our profession.

We believe photojournalistic guidelines for accuracy currently in use should be the criteria for judging what may be done electronically to a photograph. Altering the content of a photograph, in any degree, is a breach of the ethical standards recognized by the NPPA.[12]

John Long, a NPPA member and past president, developed a paper that fleshed out what was, and was not, acceptable according to the NPPA "Statement of Principle":

- Contrast control—acceptable
- Burn and dodge—acceptable
- Cropping—acceptable
- Cut and paste [moving things into, out of, or around in the picture]—not acceptable. "If you miss the picture, you miss the picture."
- Color correction—acceptable only to correct color temperature problems, but "unethical to change one color or one part of the picture all by itself since the eye does not work this way."
- Sharpening—it depends: "we have to ask two questions: 1. does the sharpening change the accuracy of the information in the image and 2. does the sharpening change the integrity of the moment? (is sharpness an essential part of the MOMENT or is it only an accident of the photographer's hand?)"
- Flopping [mirror-imaging]—not acceptable

Long concluded by saying,

> It is necessary for photographers to learn all there is to learn about electronic photojournalism and keep as much of the creative function in their own hands as they can. To do this they must be able to follow the process from camera to newsprint and they have to start thinking of the printed newspaper as the final product, not the photographic print itself.[13]

By calling on his fellow photographers to take responsibility for the picture all the way to the printed page, Long challenged the authority of editors to make the judgment calls regarding electronic manipulation. The editors of course disagreed. For example, in 1987 Robert F. Brandt, managing editor of *Newsday*, made a distinction between features, where manipulation is OK, and hard news, where, generally speaking, it is not. Above all, Brandt said that when in doubt, one should "show the page to the appropriate editor before it moves. . . . Smart editors, smart designers and smart Scitex operators will consult or bounce the toughest calls up to higher management."[14] Brandt and other editors feel that editorial decision making can be managed (by editors) on a case-by-case basis using journalistic common sense.

If newspapers must pay careful attention to credibility and avoid visual distortion of fact in the electronic age, magazines have become freer than ever from pictorial restrictions. The new magazines are narrower in scope, targeted at special au-

diences, and less carriers of hard information or explorers of the world than the classic general-interest magazines of the past—and the very place where electronic manipulation of photography has taken hold. Furthermore, the new photography has gradually usurped much of the formerly drawn or painted illustration in magazines, probably because of its new-found abilities to exaggerate and distort.

The story of how magazines narrowed their scope is neatly encapsulated in the tale of how *Life* was overtaken by *People,* followed by *Us* and finally *Self!*[15] Fred Ritchin, former picture editor of the *New York Times Magazine,* has described the phenomenon this way:

> In a new age of omnipresent market surveys and with the failures of mass magazines such as *Life, Look,* and *The Saturday Evening Post,* publishers began to prefer the known and controllable, in part to target specific audiences attractive to advertisers. Editorially, they chose the upbeat and upscale, confirming the reader's sense of optimism and reinforcing the consumer values of America. To this end pictures were used to create what one advertising director referred to as "a good environment for advertising."
>
> As a result of these trends today's pictures, particularly those in magazines, tend to overpower human vision rather than resemble it. They are more theatrical, better lit, sharper, and more highly colored than seeing itself—qualities well suited to the capabilities of electronic retouching systems.[16]

John Morris, another veteran picture editor—Morris has worked for *Life,* Magnum, the *New York Times,* and *National Geographic*—agrees:

> Unlike Henry R. Luce, who had the courage of his convictions, today's editors watch to see what sells, just as today's politicians adapt their policies to the polls. The line between journalism and entertainment is blurred. . . . Fewer than half the pages in most publications *inform* the reader; the majority are there to *sell* something. Only *National Geographic,* among major magazines, runs picture stories unbroken by advertising. No wonder serious photographers have turned to producing books and exhibitions.[17]

According to the magazine scholar Samir Husni, of the University of Mississippi, some "5,200 consumer magazines were distributed nationally [in 1997], up from just 2,500 in 1985. And the survival rate . . . is a respectable four of ten." If magazine publishing has entered a new golden age, it is with the concept of *me and my desires* at its center. "If I watch mud wrestling on ESPN and want to see more,"

Husni says, "I get a magazine. TV's fueling it all." An Associated Press story on Husni concludes by asking,

> Why is this happening? The Internet and cable television have driven a demand for more information on more obscure things. . . . While TV provides the viewership to feed the readership, the Internet—where niche marketing is far easier because distribution is cheap—is feeding a Balkanization of interests. And amateur 'zines, once almost guerrilla publications, are now entering the mainstream as desk-top publishing becomes easier.[18]

In an interview, the television humorist Bill Maher quipped about what has happened:

> There used to be magazines that everyone read—like *Life* or *Time*. Now there's *Gay Indian Biker* magazine. . . . Everyone has a magazine and a channel. There are 500 channels and 500 magazines, and we wonder why we're not united as a country.[19]

It goes almost without saying that most of the photographs in these magazines are setups or, lately, computer concoctions.

The fashion and celebrity photographer David LaChapelle, who digitally alters his images, has said, "People say photos don't lie. Mine do. I make mine lie." He makes a distinction between advertising work, "where I do execute other people's ideas," and editorial work: "Editorial is a laboratory. . . . I'm part of what I consider the entertainment industry. For my photos to be entertaining, they have to be provocative and new."[20] Man Ray would enjoy this new golden age.

There had been "paint" (picture manipulation) computer programs in existence since the early 1970s, but freelance photographers and designers suddenly had the electronic tools they needed when Photoshop was put on the market in 1989. The program could run on personal computers—Macintosh at first, and later PCs loaded with Windows, Silicon Graphics, or Sun software. Photoshop's authors, the brothers Knoll, were amateur photographers who had grown up with a darkroom in the basement, and as photographers they knew what they wanted to achieve: *easy and quick* contrast and tone control, solarization and posterization effects, color changes, combined imagery (or layering, probably the most popular effect of their program), sharpening and focus control, as well as the ability to erase, move, or insert visual elements in their pictures, all on their personal computers. "You can take things to a higher-level polish—more quickly and easily" with Photoshop, says John Knoll, and if the use of the program is "a bit gimmicky" right now, he be-

FIGURE 13.2.
Adobe Photoshop
advertisement,
early 1990s. Adobe.

lieves it will eventually become a tool with more sophisticated application.[21] Other "paint" programs have proliferated, but for manipulating photographs Photoshop is in the forefront.

"Divine Intervention," the headline reads. And under that, a photograph of a heavenly creature with billowy wings of chiffon, poised for a takeoff over what appear to be the Himalayas.[22] The text of the ad continues,

> The forces of nature are capricious. The sun, the moon, light and shadow don't always cooperate. Sometimes an image could use a few small miracles. In the digital world of Adobe Photoshop, photographers can achieve a level of control that's almost heavenly.

Advertisers are known to promise more than they can deliver, but in offering *mir-*

acles and heavenly control Adobe is reaching into transcendent territory. The implication is that photography has been an incomplete medium so far, awaiting more godlike powers to fix reality, and now they are available courtesy of Photoshop.

This ad, part of a series produced in the early nineties by Foote, Cone and Belding Technology, is—like many other ads—a cultural bellwether, and the FCB Photoshop campaign directed at serious photographers is fascinating. Other headlines announce "Strategic Alteration of Reality" or "A Camera for the Mind," again promoting the intellectual control now possible with photography in "a world beyond the lens. A place where a photographer's capabilities are not defined by budget, location, weather, or even time and space." The tag line in all the ads (it is a Photoshop trademark) reads, "If you can *dream* it, you can *do* it." Comparing this slogan with the one used by Ermanox in the twenties—"What you can *see*, you can *photograph*"—we can readily see that an enormous paradigm shift has taken place. Instead of a process demanding *presence* and *perception* in the real world, the process now requires *dreaming*. And whereas the earlier modernist photographers collaborated with the world and waited for special moments to photograph, the new manipulators don't depend on the weather or light (or even the presence of their subjects) to make their images.

As we saw in Chapter 6, the great modernist photographers in the earlier years of the twentieth century were supported by a largely unspoken metaphysical structure through which they felt empowered but never in "heavenly" control. The act of photography was cultivated by most of them as one of openness and alertness to chance, and hardly ever with a mind-set of directing the world or, most of the time, even directing the picture. Now Adobe suggests that photography will continue to have a transcendent aspect, but a very different metaphysics: we are seeing a change from a Zen-like philosophy of alert *presence* to a deistic theology of godlike *control* on the part of the picture-maker. A certain humility, as well as connectedness to real experience, is gone.

For many photographers who have embraced the computer, it offers great freedom, precision, and speed in handling imagery. The "digital darkroom," even for a traditional photographer, allows incredible control of color, value, and contrast, and new high-quality printers make output of the finest quality possible in the home studio. To an astonishing degree, not only professional but amateur photographers have embraced the digital processing of photographs. Whether the pictures are shot on a digital or film camera, output has become nearly effortless on the high-resolution color printers now available. Photographers have abandoned their darkroom

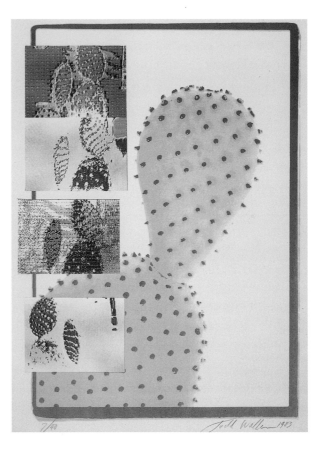

FIGURE 13.3. Todd Walker, *Opuntia, Digitized,* 1983 (photolithograph). Courtesy of the Todd Walker Estate, Collection Center for Creative Photography.

equipment and chemicals to work instead seated at their computers, and making all their corrections on the monitor.

Digitization also gives photographers a new way to work with their existing images. The photographer Todd Walker, well known for his pioneering work in the 1970s combining photography and printmaking, became a digitizer in the early eighties using a program he wrote himself. Typically for Walker, he took advantage of the abstract qualities of the pixellated image and also of its possibilities to distort color.[23] And the Mexican photographer Pedro Meyer, best known for his documentary work, said in 1995,

> I no longer have to stand for twelve hours at a time inevitably exposed to all those chemicals in the darkroom. As I grow older and my vision increasingly fails me, I can still make up with experience what I lack in agility out in the field. When geometry

and content miss their original appointment, I can try to make up for such a lost encounter. I can, like a gold miner, go back to all my old archives and find countless new veins and find new uses for my previous work.[24]

The moment of exposure is just one in a series of decisive moments as the ultimate image is crafted via computer. "I always wanted to be a painter, and I also love photography," says the commercial photographer John Lund, a prizewinner in *Photo District News*'s 1997 PIX Digital Annual, "So now I'm happy because I get to paint with images. Anything I can think up, I can create in a photographic reality. To me, that's the ultimate joy of being a photographer."[25]

Certain inherently "photographic" controls, such as separation of tones from white to black, are much improved by use of the computer. The digital photographer John Paul Caponigro (son of photographer Paul Caponigro) emphasizes the subtleties now possible with digital manipulation:

> Because the characteristic curve (the relative distribution of tones within the dynamic range of an image) is no longer tied to the response of specific materials (filtered light, paper, and chemistry) the range of manipulation of tone afforded is far greater. . . . Manipulation in selective areas has always been possible but never more easy. Masks that took hours, even days, to make can be made in minutes. . . . What is lost is a direct

FIGURE 13.4. Pedro Meyer, *The Temptation of the Angel,* 1991 (digital composite). Pedro Meyer.

FIGURE 13.5. John Lund, *Breaking Out*, ca. 1997 (digital composite). John Lund/Stone.

response to specific printmaking materials at the time of image resolution. This must be postponed until the separation process.

With a good understanding of the history of photography and its turn-of-the-century (pre–spontaneous witness) struggles to be accepted as a fine art, Caponigro continues:

> It is ironic that the very thing that validated photography as an art form, the ability to impress specific human intentions upon materials, is also the thing that threatens its authenticity today.... It is not the medium of photography which yields its "truth" value (a highly problematic but nonetheless useful concept), it is its ethical use by its practitioners. They are the witnesses, not the medium.[26]

Printing techniques that use digital scanning, with its subtle abilities to separate tones, yield reproductions that look better than the originals. The nature photographer Joseph Holmes has pointed out the advantages of digital separation even for photographs of the great master printer Ansel Adams:

> I don't know if you've ever gone back and looked at Ansel's stuff. At the Ansel Adams

Center, in San Francisco, they have a collection of his prints on permanent display, all dated from the early seventies. I looked at them recently, and I was shocked. They're miserable compared with recent reproductions, because the reproductions were done on a drum scanner that gave tonal control sufficient to add separation to the highlights and to the shadows. Photography has a terrible problem with highlights and shadows. It's one of the big reasons why photographs look like photographs. Highlights are washed out, usually, and shadows are black—"the soot and the chalk" that Ansel used to rail against. That's not the way the world really looks.[27]

Peter Campus uses the computer to provide emphasis to certain parts of his images, departing deliberately and radically from "the way the world really looks":

I began working with the computer about five years ago, and soon found that it allowed me to bring on the qualities of my pictures that I considered important. I could change color and texture, eliminate some parts and exaggerate others, distort, alter, or invert tonalities, merge images, and fabricate backgrounds. In this way I could make the contents of my pictures more apparent. I like to take objects (my subjects) out of context to reveal something about them, to make a larger point, or a more personal point.[28]

And Barbara Kasten, who formerly created similar effects in architectural sites

FIGURE 13.6. Peter Campus, *Stuff*, 1995 (digital composite). Peter Campus.

with projected colored lights and mirrors, now uses the computer to "deconstruct and distort the reality of the site."[29]

The pioneer Jerry Uelsmann, called elsewhere in this book a "proto-digitizer," has himself begun using Photoshop, at least selectively. Invited by Adobe Systems to create an image for a poster, Uelsmann was trained on the program and did produce the advertising poster. He says he is "convinced" that he *could* do anything he wanted to do on the computer but says that there are almost too many options, which can be "counterproductive to the creative process." Uelsmann still uses his own negatives exclusively and works for the most part in the darkroom ("it is so central to my way of working"). Where he is likely to make use of Photoshop is for a special effect, like adding a shadow to a scanned print, but after he has already done most of his manipulation in the darkroom. The darkroom for Uelsmann remains "a ritual important to my creative process."[30]

In at least one case digitized photography has brought unexpectedly direct social benefits. Nancy Burson, well known for work that has combined the features of various faces to produce works called *Mankind* (1983–84), a blend of Asian, Caucasian, and black features, weighted according to contemporary population statistics; *Warheads,* a series from the early eighties combining the facial features of several world leaders; and *Beauty Composites,* which did the same thing with

well-known female faces, has also written a software program used in law enforcement. At the MIT Media Lab in the late seventies, Burson created a computer program that simulated the aging process—the first of its kind—which has been used to update images of missing children and has aided in finding some of them. The FBI licensed the software in 1987.[31]

There are, however, serious drawbacks lurking in the shadows of the new possibilities. Besides the ones relative to truthful representation discussed above, there is the loss of reference to a specific moment in time, the ground zero of modernist photography. Also, there is a vexing cluster of problems having to do with authorship and originality. A digital file is easily replicated and does not deteriorate when copied (unlike all other types of photographic copying), and a digital file is literally never "closed." Mutant versions of computer files can circulate and proliferate rapidly and endlessly. How can copyright, protection of the creator's intellectual property, be enforced? And what is fair use of another's image? Given the ease of scanning and inserting fragments from others' images and texts into one's own, where does visual plagiarism begin? These questions are very much unanswered at present. They and other questions must be wrestled with in the new visual environment.[32]

Digitizers, consciously or not, are producing intellectual and creative work that directly subverts the beliefs of the great classical modernists, each of whom stood in unique, interpretive relation to the physical world. Yet as we have seen, digital control is clearly a logical step in the steady trend in photography since the 1960s toward a more controlled, imagination-based medium.

The new generation of digitizers may dimly realize that their authorial voice has been diminished once their images exist as digital files that can be replicated and manipulated ad infinitum in this postmodern world, and they may be aware that photography's special connection to time and place is gone, yet they seem to feel no sense of loss. The digitizers stand in a new place with a new creative vision that can literally see "out of this world," yet for those who have cherished photographs as revelatory moments in real time and space, witnessed by singular individuals, a certain poignancy accompanies the remarkable possibilities of digital photography.

CONCLUSION

Part one of this book begins with two lines from a 1937 poem by Wallace Stevens:

> It must be this rhapsody or none
> The rhapsody of things as they are.

The lines are plucked from *The Man with the Blue Guitar,* a long and evocative meditation on the role of the artist. The guitarist in the poem is asked by his audience to

> . . . play, you must,
> A tune beyond us, yet ourselves,
> A tune upon the blue guitar
> Of things exactly as they are.[1]

The guitarist must play a tune "beyond us" yet "of things exactly as they are"— imaginative yet realistic. The two lines chosen for the epigraph come down firmly on the side of realism, or witness, and succinctly define the philosophy of photographic witness described in Part One. The poem, though, doesn't draw such a neat conclusion. Its conflict between the need for a kind of transcendent creation and yet a realistic reflection of things as they are is left a problem at the end, though Stevens implies that the comforts of yesterday's dreams, "the rotted names," are pointless for the "time to come"—and this is exactly the struggle within photography that has been playing itself out over the last thirty years.

The new voices are calling, with photographer Duane Michals, for a kind of photography "beyond us"—

> I believe in the imagination. What I cannot see is infinitely more important than what I can see.[2]

Michals, with his simply staged photostories, created little dramas (through *purely optical, mechanical, and chemical means*—he was to that degree a modernist after all) that managed with simplicity to address themes of desire, spirit, fear, and death. Uelsmann created, in the darkroom, montages of highly charged, archetypally suggestive elements that can be read as dream or symbolic images. Samaras, by his iconoclastic focus on himself as a subject and his aggressive manipulation of the emulsion of the Polaroid pictures, managed to break patterns in several ways, opening the transformation of the self as a new photographic subject matter, violating the purity of the photographic means, and entering the arena of serious photography as an *artist*, not a photographer.

If these three planted the vines of the new paradigms, a generation of imaginative photographers has toiled since then in the vineyards creating astonishing photographs quite "beyond us." And yet many of these more recent photographers have managed to be witnesses of a kind to the realities of contemporary life as well. A number of the artist-photographers in Chapter 12—for example, Carrie Mae Weems, Jeff Wall, Sarah Charlesworth, and Barbara Kruger, among others—have used their artistry to address social issues with the aim of not only making visual statements but also making social change, or at least producing social enlightenment. Their method of bearing witness, though, differs radically from that of the pre-sixties photographers—they have directed their medium to make a statement that they have preconceived.

Earlier, social documentary photographers were looking for a moment in real time when events themselves, as caught by the sensitive photographer, were self-explanatory about the social reality in front of the camera. More recent photographers, whose environment has been more a world of images than a world of events, have responded in a sophisticated and layered fashion to their world, at a slight remove and from a position of control. Nevertheless, many are concerned about social and political issues.

Another stream of photographers—most of those considered in Chapters 7, 11, and 13, for example—have radically changed photographic practice by aiming to photograph the inner psychological landscape or the world of pure fantasy. In this, they too have changed ideas of "witness" to include personal testimony about truths available only to the photographer, truths that under normal circumstances would be unseen by others. In using the word *disappearing* in connection with witness in the title, then, I mean to indicate an ongoing process but not a disappearance altogether. For witness has not disappeared, though it most surely has

changed, and the magical moment in time and space that defined classical modernist photography—*spontaneous witness*—does seem marginal these days in a photographic environment that is more than anything about the photographer's *control*.

In the context of these changes toward photographic control, the arrival of computer programs for manipulation of photographs ("If you can *dream* it, you can *do* it") seems a natural next step. Nevertheless, digitized photography cannot ever replace the photography of spontaneous witness. We must cherish, and not forget, its special gifts and their crucial role in twentieth-century photography. For we still need photography to sing to us "the rhapsody of things as they are."

ONE | BEING THERE

EPIGRAPHS: Henri Cartier-Bresson, introduction to *The Decisive Moment* (New York: Simon & Schuster, 1952), reprinted in *The Camera Viewed: Writings on Twentieth-Century Photography*, ed. Peninah R. Petruck (New York: Dutton, 1979), 2:18; Alfred Eisenstaedt, *Eisenstaedt on Eisenstaedt* (New York: Abbeville, 1985), 102.

1. Cecil Beaton and Gail Buckland, *The Magic Image: The Genius of Photography from 1839 to the Present Day* (Boston: Little, Brown, 1975), 81.

2. In *After the Photo-Secession: American Pictorial Photography, 1910–1955* (Minneapolis: Minneapolis Institute of Arts; New York: Norton, 1997) Christian Peterson has demonstrated that the demise of pictorial photography was actually long and drawn out. Its salons and camera club activities continued, in fact, until midcentury. Nevertheless, although always aspiring to inclusion among the fine arts, most pictorial photography was ahistorical and decorative. This was so even when—and this happened frequently in the twenties—a bona fide modernist such as Edward Weston or Imogen Cunningham was involved.

3. John Szarkowski, *Looking at Photographs* (New York: Museum of Modern Art, 1973), 10.

4. Henri Cartier-Bresson, quoted in Peter Galassi, *Henri Cartier-Bresson: The Early Work* (New York: Museum of Modern Art, 1987), 12.

5. Galassi, *Henri Cartier-Bresson*, 15.

6. Cartier-Bresson, quoted in ibid., 16.

7. Galassi, *Henri Cartier-Bresson*, 21.

8. Henri Matisse, quoted in Peter Hamilton, *Robert Doisneau: A Photographer's Life* (New York: Abbeville, 1995), 36.

9. Ansel Adams, *Examples: The Making of Forty Photographs* (Boston: New York Graphic Society / Little, Brown, 1983), 79–80.

10. Harry Callahan, quoted in A. D. Coleman, "Harry Callahan: An Interview," *New York Photographer*, no. 4 (January 1972), 3–6.

11. Helen Levitt, quoted in *Photography Speaks: Sixty-six Photographers on Their Art*, ed. Brooks Johnson (New York: Aperture, 1989), 64.

12. Edward Weston, "Photography—Not Pictorial," *Camera Craft* 37, no. 7 (1930), quoted in *Photographers on Photography*, ed. Nathan Lyons (Englewood Cliffs, N.J.: Prentice-Hall, 1966), 156.

13. Edward Weston, from a 1934 leaflet for the Los Angeles Museum, reprinted in *Photography in Print: Writings from 1816 to the Present*, ed. Vicki Goldberg (New York: Touchstone, 1981), 318.

14. Willard Van Dyke, quoted in Robert Coles, *Doing Documentary Work* (New York: New York Public Library / Oxford University Press, 1997), 154.

15. Jerry Uelsmann, quoted in Johnson, *Photography Speaks*, 114.

16. Aaron Siskind, "The Drama of Objects," *Minicam Photography* 8, no. 9 (1945), quoted in Lyons, *Photographers on Photography*, 97.

17. Cartier-Bresson, introduction to *Decisive Moment*, reprinted in Petruck, *The Camera Viewed*, 2:18.

18. Minor White, "The Camera Mind and Eye," *Magazine of Art* 45, no. 1 (1952), quoted in Lyons, *Photographers on Photography*, 165–66.

19. Paul Caponigro, *The Wise Silence* (Boston: New York Graphic Society, 1983), 10.

20. Robert Frank, quoted in Johnson, *Photography Speaks*, 88.

TWO | SPEED AND THE MACHINE

EPIGRAPH: Albert Renger-Patzsch, "Aims" (1927), reprinted in *Photography in the Modern Era*, ed. Christopher Phillips (New York: Metropolitan Museum of Art / Aperture, 1989), 105.

1. The information in this paragraph is drawn from Bernard Grun, *The Timetables of History* (New York: Touchstone, 1991); and Beaumont Newhall, *The History of Photography: From 1839 to the Present Day* (New York: Museum of Modern Art / New York Graphic Society, 1964).

2. Grun, *Timetables of History*.

3. Marianne Fulton, *The Eyes of Time: Photojournalism in America* (Boston: New York Graphic Society / Little, Brown, 1988), 108.

4. Kent Cooper, *Kent Cooper and the Associated Press* (New York: Random House, 1959), 218.

5. Karen Tsujimoto, *Images of America: Precisionist Painting and Modern Photography* (Seattle: University of Washington Press / San Francisco Museum of Modern Art, 1982), 17–18.

6. Dorothy Norman, *Alfred Stieglitz: An American Seer* (New York: Random House / Aperture, 1973), 45.

7. Florent Fels, introduction to *Métal* (1927), reprinted in Phillips, *Photography in the Modern Era*, 14.

8. Grigory Shudakov, *Pioneers of Soviet Photography* (London: Thames & Hudson, 1983), 11.

9. Aleksandr Rodchenko, *Novyi Lef*, no. 11 (1928), quoted in ibid., 18.

10. Van Deren Coke, *Signs of the Times: Some Recurring Motifs in Twentieth-Century Photography* (San Francisco: San Francisco Museum of Modern Art, 1985), 5.

11. Grun, *Timetables of History.*

12. Newhall, *History of Photography,* 154.

13. Ibid., 155. The historian Marianne Fulton suggested that "perhaps too much" has been made of the Leica; in her opinion, the Contax was more useful. In any case, "the dominance of the Leica and Contax belonged to the early 1930s, not to the late 1920s" (Fulton, *Eyes of Time,* 84).

14. Fulton, *Eyes of Time,* 170.

15. Indeed, W. Eugene Smith was fired from *Newsweek* in 1938 for using a miniature camera—a Rolleiflex (which today is called a "medium-format" camera!).

16. Carlo Rim, "On the Snapshot" (1930), reprinted in Phillips, *Photography in the Modern Era,* 39.

17. Cartier-Bresson, introduction to *Decisive Moment,* reprinted in Petruck, *The Camera Viewed,* 2:12.

18. Louis Aragon, "The Quarrel over Realism," 1936, reprinted in Phillips, *Photography in the Modern Era,* 73.

19. Newhall, *History of Photography,* 158–59.

20. Cartier-Bresson, introduction to *Decisive Moment,* reprinted in Petruck, *The Camera Viewed,* 2:15.

THREE | FINE-ART PHOTOGRAPHY, REDEFINED

EPIGRAPHS: Paul Strand, "The Art Motive in Photography" (1923), reprinted in Goldberg, *Photography in Print,* 280; László Moholy-Nagy, "Unprecedented Photography" (1927), reprinted in Phillips, *Photography in the Modern Era,* 84; Ansel Adams, "A Personal Credo" (1943), reprinted in Goldberg, *Photography in Print,* 378.

1. The rejection of pictorial photography was not a simple or quick matter. Throughout the twenties, some modernist luminaries continued to be involved in the pictorial salons, and in fact sharp focus realism was only gradually accepted in these same salons. What finally separated pictorialism from the new art photography was the latter's tougher search for modern or at least fresh subject matter versus the rule-bound, amateur-club hobbyism of pictorialism. After Alfred Stieglitz abandoned pictorialism there was no comparable guru of serious amateur photography until Minor White came along as editor of *Aperture* in the 1950s. For more on this interesting and almost forgotten aspect of American photographic history, see Peterson, *After the Photo-Secession.*

2. Edward Weston, from 1934 leaflet for the Los Angeles Museum, reprinted in Goldberg, *Photography in Print,* 318.

3. An excellent summary of this group is Therese Thau Heyman, *Seeing Straight: The f.64 Revolution in Photography* (Oakland, Calif.: Oakland Museum, 1992).

4. Edward Weston, *Daybooks,* 24 April 1930, reprinted in Goldberg, *Photography in Print,* 311.

5. Hugo Sieker, "Absolute Realism: On the Photographs of Albert Renger-Patzsch" (1928), reprinted in Phillips, *Photography in the Modern Era,* 113.

6. For further reference, see Maria Morris Hambourg and Christopher Phillips, *The New Vision: Photography between the World Wars* (New York: Metropolitan Museum of

Art/Abrams, 1989), and its companion volume of texts edited by Phillips, *Photography in the Modern Era*. See also Van Deren Coke, *Avant-Garde Photography in Germany, 1919–1939* (San Francisco: San Francisco Museum of Modern Art, 1980).

7. László Moholy-Nagy, "From Pigment to Light" (1936), reprinted in Goldberg, *Photography in Print*, 346.

8. Ibid., 344.

9. Ibid., 347.

10. Ibid., 348.

11. Cartier-Bresson, introduction to *Decisive Moment*, reprinted in Petruck, *The Camera Viewed*, 2:13.

12. Ibid., 17.

13. Ibid., 19.

14. *Aperture* was first published in 1952 and continued under White's editorial guidance for two decades.

15. Jonathan Green, *American Photography: A Critical History* (New York: Abrams, 1984), 76.

16. See Jane Livingston, *The New York School: Photographs, 1936–1963* (New York: Stewart, Tabori, & Chang, 1992).

17. First published in France by Robert Delpire in 1958, the book was published in the United States by Grove Press in 1959.

18. Robert Frank, from a 1958 statement quoted in Johnson, *Photography Speaks*, 88.

FOUR | DOCUMENTARY

EPIGRAPHS: Roy Stryker, "The FSA Collection of Photographs" (1973), reprinted in Goldberg, *Photography in Print*, 353; Aaron Siskind, quoted in *Documentary Photography*, ed. Anne Horan, Life Library of Photography (New York: Time-Life, 1972), 102; Edward Steichen, "Photography: Witness and Recorder of Humanity" (1958), reprinted in Petruck, *The Camera Viewed*, 2:10.

1. Fulton, *Eyes of Time*, 107.

2. Walker Evans, quoted in Coles, *Doing Documentary Work*, 130, 125.

3. Willard Van Dyke, quoted in ibid., 153.

4. "On the morning of August 27, 1936 the [Fargo] *Forum* carried a front-page story branding Rothstein's skull photographs 'phony pictures.' Under a headline, 'It's a Fake,' the writer noted that Rothstein had moved the skull around the alkali flat and had shot it on both the parched earth and the grassy hillock. The article also insisted that the skull had obviously been bleaching for years and was not therefore a product of recent conditions. Finally, the article noted that the picture had been taken in the spring, before the actual drought conditions had occurred" (F. Jack Hurley, *Portrait of a Decade: Roy Stryker and the Development of Documentary Photography in the Thirties* [New York: Da Capo Press, 1972], 86–88).

5. Dorothea Lange, *Dorothea Lange: Photographs of a Lifetime* (New York: Aperture, 1982), 46.

6. Anne Wilkes Tucker, "Photographic Facts and Thirties America," in *Observations: Essays on Documentary Photography, Untitled* 35 (1984): 41–42.

7. Coles, *Doing Documentary Work*, 145.

8. Walker Evans, quoted in ibid., 128.

9. In "Representing the Colonized," *Critical Inquiry*, winter 1989, 205, Edward Said wrote that "it is now almost impossible, for example, to remember a time when people were *not* talking about a crisis in representation." A clearly developed recent work that painstakingly analyzes the effects of photography of a native people is James C. Faris, *Navajo and Photography: A Critical History of the Representation of an American People* (Albuquerque: University of New Mexico Press, 1996).

10. Max Kozloff, "A Way of Seeing and the Act of Touching," *Observations: Essays on Documentary Photography, Untitled* 35 (1984): 69–70.

11. Garry Winogrand, quoted in Dennis Longwell, "Monkeys Make the Problem More Difficult: Interview with Garry Winogrand" (1972), in Petruck, *The Camera Viewed*, 2:19–20.

12. See Garry Winogrand, *The Animals* (New York: Museum of Modern Art, 1969) and *Women Are Beautiful* (New York: Light Gallery Books, 1975).

13. Walker Evans, quoted in Coles, *Doing Documentary Work*, 130, emphasis added.

14. See Gail Buckland, *Reality Recorded: Early Documentary Photography* (Greenwich, N.Y.: New York Graphic Society, 1974), chap. 4.

15. Frances Benjamin Johnston, *The Hampton Album* (New York: Museum of Modern Art / Doubleday, 1966).

16. August Sander, "Photography as a Universal Language" (1931), reprinted in *Photography: Current Perspectives*, ed. Jerome Liebling (Rochester, N.Y.: Massachusetts Review / Light Impressions, 1978), 51.

17. Doris Ullman, *The Appalachian Photographs of Doris Ullman* (Penland, N.C.: The Jargon Society, 1971).

18. Mention of Morris's work, which seldom depicted people, but rather their artifacts and living spaces, brings up a vast genre of documentary of the human *environment:* Berenice Abbott, Walker Evans, Eugene Atget, David Plowden, Catherine Wagner, Michael Smith, Paula Chamlee, along with many others, have recorded human life indirectly in this way. For the purposes of this book, however, I have chosen to concentrate on those who documented human activity directly, as their work seems most relevant to the theme at hand.

19. Newhall, *History of Photography*, 142.

20. Lewis Hine, "The High Cost of Child Labor," *Child Labor Bulletin*, February 1915, 34.

21. Lewis Hine, *Men at Work* (1932; reprint, New York: Dover, 1977).

22. Maren Stange, *Symbols of Ideal Life: Social Documentary Photography in America, 1890–1950* (Cambridge: Cambridge University Press, 1989), 92.

23. Stryker, "FSA Collection of Photographs," in Goldberg, *Photography in Print*, 349.

24. For extensive treatment of the FSA project, see Hurley, *Portrait of a Decade;* and Stange, *Symbols of Ideal Life.*

25. Dorothea Lange, *Celebrating a Collection: The Work of Dorothea Lange, Documentary Photographer* (Oakland, Calif.: Oakland Museum, 1978), 69.

26. Some notable documentary photo-text books of the time, often incorporating FSA photographs, include: Archibald MacLeish, *The Land of the Free* (London: Boriswood, 1938); H. C. Nixon, *Forty Acres and Steel Mules* (Chapel Hill: University of North Carolina Press,

1938); Dorothea Lange and Paul Taylor, *An American Exodus* (New York: Reynal & Hitchcock, 1939); Richard Wright and Edwin Rosskam, *Twelve Million Black Voices* (New York: Viking, 1941); Margaret Bourke-White and Erskine Caldwell, *You Have Seen Their Faces* (New York: Viking, 1937), criticized for its manufactured quotations but nevertheless in the genre; and Walker Evans and James Agee, *Let Us Now Praise Famous Men* (Boston: Houghton Mifflin, 1941). Much could be written about each of these books, but for our purposes the list serves to demonstrate the penetration of documentary photographs of the Depression into the culture at large.

27. Stange, *Symbols of Ideal Life*, 108–9.

28. Stryker, "FSA Collection of Photographs," in Goldberg, *Photography in Print*, 353, Stryker's emphasis.

29. Stange, *Symbols of Ideal Life*, 107.

30. Reproduced in countless publications, all of the mentioned photographs may be found in Edward Steichen, ed., *The Bitter Years: 1935–1941* (New York: Museum of Modern Art, 1962).

31. Therese Thau Heyman, "Migrant Mother as an Icon," in Lange, *Celebrating a Collection*, 60–61.

32. Paul Strand, Berenice Abbott, and Margaret Bourke-White served on the Photo League's board of advisers, and others who were members for a time included Ansel Adams, Barbara Morgan, Beaumont and Nancy Newhall, W. Eugene Smith, and Edward Weston, among others (Lili Corbus Bezner, *Photography and Politics in America: From the New Deal into the Cold War* [Baltimore: Johns Hopkins University Press, 1999], 37).

33. For an excellent, detailed account of the trials and eventual death of the Photo League, see ibid., esp. the chapter "The Demise of the Photo League," 16–72.

34. John G. Morris, "A Photographic Memoir," *Exposure* 20, no. 2 (1982): 20–21.

35. Steichen, "Photography: Witness and Recorder," in Petruck, *The Camera Viewed*, 2:6.

36. See Edward Steichen, *The Family of Man* (1955; reprint, New York: Abrams, 1996), currently in print.

37. Bezner, *Photography and Politics*, 130–31.

38. Steichen, "Photography: Witness and Recorder," in Petruck, *The Camera Viewed*, 2:5.

39. Bezner, *Photography and Politics*, 169.

40. Christopher Phillips, "The Judgment Seat of Photography," *October* 22 (fall 1982): 46.

41. See Stange, *Symbols of Ideal Life*, 133–48.

42. Steichen, "Photography: Witness and Recorder," in Petruck, *The Camera Viewed*, 2:10.

43. Frank owed an aesthetic as well as a political debt to Walker Evans, whose careful sequencing of photographs in his *American Photographs* (New York: Museum of Modern Art, 1938) had a profound effect on the younger photographer, and Evans was helpful as well in being one of his supporters for the Guggenheim Fellowship.

44. Bezner, *Photography and Politics*, 191.

45. Jack Kerouac, introduction to Robert Frank's *The Americans* (New York: Grove Press, 1959), i–vi.

46. "An Off-Beat View of the U.S.A.," reprinted in Anne Tucker and Phillip Brookman,

Robert Frank: New York to Nova Scotia (Boston: New York Graphic Society / Little, Brown / Museum of Fine Arts, Houston, 1986), 36–37.

47. See, e.g., Salgado's *Workers: An Archaeology of the Industrial Age* (New York: Aperture, 1997); Richards's *Cocaine True, Cocaine Blue* (New York: Aperture, 1994); Mark's *Falkland Road* (New York: Knopf, 1981) and *Streetwise* (Philadelphia: University of Pennsylvania Press, 1988); or Ferrato's *Living with the Enemy* (New York: Aperture, 1991).

48. See Bruce Davidson, *East 100th Street* (Cambridge: Harvard University Press, 1970) and *Subway* (New York: Aperture, 1986); Alex Harris, *Red White Blue and God Bless You: A Portrait of Northern New Mexico* (Albuquerque: University of New Mexico Press, 1993); Norman Mauskopf, *Rodeo* (Pasadena, Calif.: Twelve Trees Press, 1985) and *A Time Not Here* (Santa Fe: Twin Palms Press, 1996); and Richard Avedon and Laura Wilson, *In the American West* (New York: Abrams, 1996).

49. See Tony Ray-Jones, *A Day Off* (Boston: New York Graphic Society, 1974), published posthumously; Jones died at age 31 in 1972; and Bill Owens, *Suburbia* (San Francisco: Straight Arrow Books, 1973), followed by his *Our Kind of People: American Groups and Rituals* (San Francisco: Straight Arrow Books, 1975) and *Working: I Do It for the Money* (New York: Simon & Schuster, Fireside, 1976). See also Jim Goldberg, *Rich and Poor* (New York: Random House, 1985); Larry Fink, *Social Graces* (Millerton, N.Y.: Aperture, 1984); Greta Pratt, *In Search of the Corn Queen* (Washington, D.C.: National Museum of American Art, Smithsonian Institution, 1994); and Martin Parr, *Home and Abroad* (London: Jonathan Cape, 1993).

50. Gowin's mythic photographs might seem anything but documentary, but I believe they set an important example for the subsequent genre of family documentary. See Emmet Gowin, *Photographs* (New York: Knopf, 1976).

51. Dorothea Lynch and Eugene Richards, *Exploding into Life* (New York: Aperture, 1986).

52. *Portfolio X* was shown at museums as staid as the Hartford Atheneum and was reproduced in the College Art Association's *Art Journal* 50, no. 3 (fall 1991). Goldin's work has been seen in countless museum and gallery shows and is anthologized regularly.

53. Eugene Richards, quoted in *Aperture* 129 (fall 1992): 9.

54. Randolph E. Schmid, "Census: We dine out more. . . ," *Albuquerque Journal*, 5 December 1997.

FIVE | THE MAGAZINES

EPIGRAPHS: Lucien Vogel (1928), quoted in Fulton, *Eyes of Time*, 95; prospectus for *Life* (1936), in Philip B. Kunhardt Jr., *Life, the First Fifty Years* (Boston: Little, Brown, 1986), 5; Doon Arbus and Marvin Israel, introduction to *Diane Arbus Magazine Work* (Millerton, N.Y.: Aperture, 1984), 5.

1. The great explosion of photography books did not really begin until the late sixties and seventies.

2. Colin Osman and Sandra Phillips, "European Visions: Magazine Photography in Europe between the Wars," in Fulton, *Eyes of Time*, 76.

3. Ibid., 79.

4. Ibid., 88–89.

5. Ibid., 83.

6. Others who emigrated to the United States during the Nazi era include Munkacsi and Korff, as well as Stefan Lorant, Tim Gidal, and Alfred Eisenstaedt, among others.

7. Osman and Phillips, "European Visions," in Fulton, *Eyes of Time,* 95.

8. Ibid., 101.

9. Fulton, *Eyes of Time,* 135.

10. Loudon Wainwright, *The Great American Magazine* (New York: Knopf, 1986), 16.

11. Smith would publish again in *Life,* his 1972 photographic essay on Minamata, Japan. About the Schweitzer story Ed Thompson, of *Life,* recalled that "none of the layouts we made satisfied Gene, so I decided we couldn't go on pasting up photostats forever. He later said 'I would have preferred silence to what appeared.' He did not demand silence at the time. I had told Smith that we would give the essay twelve pages. We didn't often have twelve pages of space available, though, and one week, when I was away, my deputy found ten pages and used them for the Schweitzer essay. The dropping of two pages was an insult to Smith and he resigned immediately" (quoted in Russell Miller, *Magnum: Fifty Years at the Frontline of History* [New York: Grove Press, 1997], 143).

12. Fulton, *Eyes of Time,* 181.

13. Richard Whelan, *Robert Capa: A Biography* (New York: Knopf, 1985), 174.

14. The volumes published in 1970 were *The Great Themes, The Print, Photography as a Tool, Color, Light and Film,* and *The Camera;* in 1971, *Great Photographers, Special Problems, The Studio, Photographing Children,* and *Photojournalism;* and in 1972, *Documentary Photography, Frontiers of Photography,* and *Travel Photography.*

15. Catherine A. Lutz and Jane L. Collins, *Reading National Geographic* (Chicago: University of Chicago Press, 1993), 4.

16. Ibid., 27.

17. Leah Bendavid-Val, *National Geographic: The Photographs* (Washington, D.C.: National Geographic Society, 1994), 40.

18. Lutz and Collins, *Reading National Geographic,* 32.

19. Ibid., 93.

20. Many photojournalists continue to prefer black and white for its clarity and impact, but editors (and evidently readers as well) seem to prefer color. One of the last holdouts for black and white was the *New York Times,* but that paper went to color in 1997 for even its hard news.

21. Lutz and Collins, *Reading National Geographic,* 280.

22. Ibid., 35.

23. Ibid., 40.

24. Bendavid-Val, *National Geographic,* 50.

25. The organization is now quite diversified, as are most publishing companies—producing books, TV shows, children's items, maps, videotapes, and the like—and seeks greater profits, according to Constance L. Hays, "Seeing Green in a Yellow Border," *New York Times,* 3 August 1997.

26. Lutz and Collins, *Reading National Geographic,* 41.

27. Ibid., 41, 57.

28. Ibid., 55.

29. Bendavid-Val, *National Geographic,* 52.

30. Lutz and Collins, *Reading National Geographic,* 60.

31. Cathy Newman, "Reel to Real," *National Geographic,* August 1995, 64.

32. Ibid., 65.

33. Ibid., 74.

34. Bendavid-Val, *National Geographic,* 153, 154.

35. Lutz and Collins, *Reading National Geographic,* 66, 198.

36. Nancy Hall-Duncan, *The History of Fashion Photography* (New York: Alpine Books / International Museum of Photography, 1979), 72.

37. Ibid., 68.

38. Martin Munkacsi, "Think While You Shoot," *Harper's Bazaar,* November 1935, quoted in Susan Morgan, *Martin Munkacsi* (New York: Aperture, 1992), 47.

39. Richard Avedon, quoted on dust jacket of Morgan, *Martin Munkacsi.*

40. Henri Cartier-Bresson, quoted in ibid., 74.

41. Hall-Duncan, *History of Fashion Photography,* 68.

42. Livingston, *New York School,* 291.

43. Bruce Knight, quoted in Martin Harrison, *Appearances: Fashion Photography since 1945* (New York: Rizzoli, 1991), 36.

44. Livingston, *New York School,* 291.

45. Avedon's books include *Observations,* text by Truman Capote (New York: Simon & Schuster, 1959); *Nothing Personal,* text by James Baldwin (New York: Atheneum, 1964), *Alice in Wonderland: The Forming of a Company, the Making of a Play,* text by Doon Arbus (New York: E. P. Dutton, 1973); *Portraits,* text by Harold Rosenberg (New York: Farrar, Straus & Giroux, 1976); *Avedon: Photographs, 1947–77,* essay by Harold Brodkey (New York: Farrar, Straus & Giroux, 1978); *In the American West,* coauthor Laura Wilson (1985; 2nd ed., New York: Abrams, 1996); *An Autobiography: Richard Avedon* (New York: Random House and Eastman Kodak, 1993); *Evidence: Richard Avedon, 1944–1994,* essays by Jane Livingston and Adam Gopnik (New York: Random House, 1994).

46. Carmel Snow, quoted in Harrison, *Appearances,* 26.

47. Hall-Duncan, *History of Fashion Photography,* 136.

48. For example, Annie Leibovitz in her lively celebrity portraits.

SIX | SPIRIT IN PHOTOGRAPHY

EPIGRAPH: Minor White, *The Way through Camera Work,* special issue of *Aperture* 7, no. 2 (1959): 65.

1. Edward Weston, *The Daybooks of Edward Weston,* ed. Nancy Newhall, 2 vols. (Millerton, N.Y.: Aperture, 1973).

2. Wolfgang Born, "Photographic Weltanschauung" (1929), quoted in Phillips, *Photography in the Modern Era,* 156.

3. Weston, *Daybooks,* 2:221.

4. White, "The Camera Mind and Eye," quoted in Lyons, *Photographers on Photography*, 165–66.

5. See Milton Meltzer and Bernard Cole, *The Eye of Conscience: Photographers and Social Change* (Chicago: Follett, 1974); and Cornell Capa, ed., *The Concerned Photographer* (New York: Grossman, 1968).

6. Dorothea Lange, *Dorothea Lange: Photographs of a Lifetime* (New York: Aperture, 1982), 72.

7. The quotation is from the text that accompanied the 1972 Japanese exhibition.

8. *Aperture* continues to publish as a journal (and also has become the major publisher of photographic books), but since his editorial direction ended in 1975 White's ideas no longer dominate, and under his successor, Michael E. Hoffman, the ideology is eclectic.

9. In *Light⁷* and in *Octave of Prayer* credits were not given on the same page as the photographs but in the back, and no dates or titles were provided. In *Be-ing without Clothes* photographers' names were printed beneath their photographs, and titles and dates were listed at the back. In *Celebrations* again no titles or dates were printed, although the photographers' names were printed under their pictures.

10. White, *Way through Camera Work*, 55–56.

11. Ibid., 63, 66, and, quoting the Japanese writer Okakuro Kakuzo, 75.

12. Ibid., 70.

13. Ibid., 83.

14. Minor White, *Mirrors Messages Manifestations* (Millerton, N.Y.: Aperture, 1969).

15. Green, *American Photography*, 76–77.

16. *New York Times*, 20 August 1995.

17. Compassion, of course, is fundamental to Buddhism as well.

SEVEN | NEW PARADIGMS

EPIGRAPHS: Duane Michals, "Interview with Professor Gassan and His Students" (1971), reprinted in Petruck, *The Camera Viewed*, 2:81; Jerry Uelsmann, "Post-Visualization" (1967), reprinted in ibid., 2:73; Lucas Samaras, "Autopolaroid," *Art in America* 58, no. 6 (November/December 1970): 66.

1. Eric Goldman, "Good-Bye to the 'Fifties—and Good Riddance," *Harper's*, January 1960, quoted in *The Sixties: Art, Politics, and Media of Our Most Explosive Decade*, ed. Gerald Howard (New York: Paragon House, 1991), 29–30.

2. Robert Frost, quoted in Howard, *The Sixties*, 28.

3. Howard, *The Sixties*, 31.

4. Feminism, including the struggle over abortion rights, would be a prominent and divisive issue in the 1970s. It began quietly, however, in the sixties, fueled in great part by the 1963 publication of Betty Freidan's *The Feminine Mystique* (New York: Norton) and the availability of the new birth-control pill in 1960.

5. Besides political and civil-rights protests, this was the decade of antimaterialism and communal living on the part of some.

6. Carson's *Silent Spring* was published in 1962, and Nader's *Unsafe at Any Speed*, in 1965.

7. Barbara Ehrenreich, *The Hearts of Men: American Dreams and the Flight from Commitment* (Garden City, N.Y.: Anchor Books/Doubleday, 1983), 42–51.

8. In 1963 the Guggenheim Museum in New York mounted a major exhibition of pop art, legitimizing it as a major art movement (and incidentally observing the fiftieth anniversary of the famous Armory Show, which had introduced advanced European art to America in 1913).

9. Howard, *The Sixties*, 267.

10. This is not to say that in hindsight it means nothing: pop art was a brilliant, surprising expression of the national mood of the fifties and sixties, particularly in its vacuity and its references to consumerism and the mass media.

11. Green, *American Photography*, 118–19.

12. Henry Holmes Smith, strongly influenced by the ideas of Moholy-Nagy, was a leader of the new breed of American photographic educators, first (1937–38) at Moholy-Nagy's New Bauhaus and later (from 1947) at Indiana University, where he established a new, very influential program in creative photography. Following in the footsteps of Moholy-Nagy, Smith specialized in camera-less images, or photograms. Made with viscous liquids and obeying the laws of chance, the unpredictable images sometimes took on the look of figures, and Smith sometimes pronounced them "archetypal" in the Jungian sense.

13. That the imagery was "archetypal" was the particular view of an early explicator of Uelsmann's work, William Parker, in "Uelsmann's Unitary Reality," *Aperture* 13, no. 3 (1967).

14. Themes that have emerged since the seventies include meditations on nature and culture, on history, and on the environment, but these were not dominant in the work of the sixties, which interests us here.

15. Jerry Uelsmann, statement in *Photographic Journal* (Royal Photographic Society, London) 3, no. 4 (April 1971): 178.

16. Jerry Uelsmann, "Random Thoughts on Photography" (1962), reprinted in James L. Enyeart, *Jerry N. Uelsmann: Twenty-five Years: A Retrospective* (Boston: New York Graphic Society/Little, Brown, 1982), 37.

17. Jerry Uelsmann, "Post-Visualization," *Florida Quarterly*, no. 1 (summer 1967): 82–89.

18. Peter Bunnell, introduction to *Jerry N. Uelsmann*, special issue of *Aperture* 15, no. 4 (1970), unpaginated.

19. Jerry Uelsmann, in Johnson, *Photography Speaks*, 114.

20. Jerry Uelsmann, "Some Humanistic Considerations of Photography" (1971), reprinted in Goldberg, *Photography in Print*, 446.

21. John Szarkowski, *Mirrors and Windows: American Photography since 1960* (New York: Museum of Modern Art/New York Graphic Society, 1978), 23.

22. A. D. Coleman, foreword to *Jerry Uelsmann: Photo Synthesis* (Gainesville: University Press of Florida, 1992), xiii–xiv.

23. Duane Michals, lecture at the University of Connecticut, Storrs, 20 April 1993.

24. Ibid.

25. Duane Michals, *Album: The Portraits of Duane Michals, 1958–1988* (Pasadena: Twelve Trees Press, 1988).

26. Minor White in his own photography, however, had created a genre of *sequences* that were poetic, nonlinear, non-narrative, and puzzling in the manner of a Zen koan. This poetic-sequence idea was taken up again in the late sixties and seventies by Ralph Gibson, who published a trilogy of book-length sequences in the early seventies: *The Somnambulist* (1970), *Deja-Vu* (1973), and *Days at Sea* (1974), all self-published by Gibson's Lustrum Press.

27. Michals was included in the 1967 collection *Toward a Social Landscape*, ed. Nathan Lyons (Rochester, N.Y.: George Eastman House / Horizon, 1967), along with Bruce Davidson, Lee Friedlander, Garry Winogrand, and Danny Lyon. The rest of these young photographers continued in the documentary-style, street-photography vein, but Michals's work took a turn—had already taken it by the time the book was published—toward contrived narratives. "I am a short story writer. Most other photographers are reporters," Michals would write in *Real Dreams* (Danbury, N.H.: Addison House, 1976).

28. Michals, lecture at University of Connecticut, 20 April 1993.

29. Ibid.

30. Michals, *Real Dreams*, 5–10.

31. Lucas Samaras, *Samaras Album* (New York: Whitney Museum of American Art, 1971), 50.

32. Ibid., 49.

33. Ibid., 14.

34. The instant-developing process was invented by Edwin H. Land in 1947; color Polaroid was introduced in 1963. After years of popularity, the Polaroid instant-imaging system lost ground to digital photography, and the company filed for Chapter 11 bankruptcy on 12 October 2001.

35. Samaras, "Autopolaroid" *Art in America*, 83.

36. Ibid.

37. Ben Lifson, essay, in *Samaras: The Photographs of Lucas Samaras* (New York: Aperture, 1987), 43.

38. Ibid., 45.

EIGHT | DOCUMENTARY-STYLE AND STREET PHOTOGRAPHY

EPIGRAPHS: John Szarkowski, *From the Picture Press* (New York: Museum of Modern Art, 1973), 5; Robert Frank, quoted in *The Pictures Are a Necessity: Robert Frank in Rochester, N.Y., November, 1988,* ed. William S. Johnson, Rochester Film and Photo Consortium Occasional Papers, No. 2 (Rochester, N.Y.: George Eastman House, 1989), 37; Winogrand, quoted in Longwell, "Monkeys Make the Problem More Difficult," in Petruck, *The Camera Viewed,* 2:27; Diane Arbus, *Diane Arbus* (Millerton, N.Y.: Aperture, 1972), 2.

1. Szarkowski, previously a photographer himself, became director of the Department of Photography at the Museum of Modern Art in 1962. In 1966 he published his important book *The Photographer's Eye* (New York: Museum of Modern Art), and in 1967 he showed the work of Lee Friedlander, Garry Winogrand, and Diane Arbus in a definitive show called "New Documents."

2. John Szarkowski, *The Face of Minnesota* (Minneapolis: University of Minnesota Press, 1958), vii.

3. John Szarkowski, *From the Picture Press*, 5.

4. Ibid., 4.

5. Wall label text courtesy of the Museum of Modern Art.

6. Arbus in particular did quite a bit of editorial work for *Esquire* and other clients. In fact, some of the pictures considered to be her "personal work" were actually done on assignment or on speculation for editorial publication. An example would be the photographs of the nudist colony. For more on this, see Arbus, *Diane Arbus Magazine Work*.

7. Lyons had included Winogrand and Friedlander, along with Bruce Davidson, Danny Lyon, and Duane Michals, in a 1966 show at the George Eastman House called "Toward a Social Landscape."

8. Arbus, *Diane Arbus*, 15.

9. Colin Westerbeck and Joel Meyerowitz, *Bystander: A History of Street Photography* (Boston: Bulfinch / Little, Brown, 1994), 35.

10. Ibid., 156.

11. See Livingston, *New York School;* and James Alinder, ed., *Roy DeCarava Photographs, Untitled* 27 (Carmel, Calif.: Friends of Photography, 1981).

12. *Peculiar to Photography* was the title of an influential exhibition curated by Van Deren Coke (with his graduate students) at the University of New Mexico Art Museum, Albuquerque, in 1976.

NINE | PHOTOGRAPHY ABOUT PHOTOGRAPHY

EPIGRAPHS: Professor of photography and history of photography at the University of New Mexico Van Deren Coke, *The Painter and the Photograph: From Delacroix to Warhol* (Albuquerque: University of New Mexico Press, 1964), preface; professor of photography at the University of Illinois Art Sinsabaugh, *Six Photographers* (Urbana: University of Illinois Museum, 1963), unpaginated; graduate assistant in the University of New Mexico department of art Henri Man Barendse, quoted in *Peculiar to Photography*, by Van Deren Coke and Thomas F. Barrow (Albuquerque: University of New Mexico Art Museum, 1976), 7.

1. There had long been technical schools of photography, as well as schools of commercial photography. New here were college and university settings where photography came to be studied either in its own department or else within an established art department.

2. Charles Desmarais, "From Social Criticism to Art World Cynicism: 1970–1980," in *Decade by Decade: Twentieth-Century American Photography*, ed. James Enyeart (Boston: Bulfinch / Little, Brown / Center for Creative Photography, University of Arizona, 1989), 98.

3. The two most important publications in this regard were Coke, *The Painter and the Photograph;* and Aaron Scharf, *Art and Photography* (Baltimore: Penguin, 1968).

4. In October 1973 Sontag published "Shooting America," the first of seven essays on photography, in the *New York Review of Books*. The essays were edited and published as *On Photography* (New York: Farrar, Straus & Giroux, 1977). Sontag's love/hate relationship with the medium in some senses demonized it but in other respects made it a serious arena of concern and study, and Sontag received a National Book Award for *On Photography*.

5. Gail Kaplan, "Survey of Schools with MFA/MA Programs in Photography," *Exposure* 20, no. 3 (1982): 11–29.

6. A. D. Coleman, "Must They 'Progress' So Fast?" *New York Times*, 26 August 1973, reprinted in A. D. Coleman, *Light Readings: A Photography Critic's Writings, 1968–1978* (New York: Oxford University Press, 1979), 155.

7. Notable exhibitions by these three included: by Nathan Lyons, *The Persistence of Vision* and *Toward a Social Landscape,* both at the George Eastman House, Rochester, in 1967; by Minor White, *Light[7]* (1968), *Octave of Prayer* (1972), and *Celebrations* (1974), all at the Hayden Gallery, MIT, Cambridge, Mass.; and by Van Deren Coke, *Light and Substance* (1974) and *Peculiar to Photography* (1976), both at the University of New Mexico Art Museum, Albuquerque, and *Fabricated to Be Photographed* (1979) and *The Markers* (1981), both at the San Francisco Museum of Modern Art.

8. At the same institution, in 1978 John Szarkowski mounted *Mirrors and Windows,* his survey of photography since 1960, and while few disputed his thesis (a general turning toward personal work), many were puzzled by the photographs he chose for (or left out of) the show. Never really sympathetic toward the kind of media extensions that were being created in the academy in the 1970s, although he did include some in the show, Szarkowski included mostly work that was, if not photography of witness, at least straightforward camera work.

9. The glossary contained terms such as *blueprint, gum printing, holography, line negative, liquid emulsion, pinhole,* and *solarization.*

10. Donald Werner, *Light and Lens: Methods of Photography* (Yonkers, N.Y.: Hudson River Museum, 1973).

11. Several revisions later Newhall's text is still in print as *The History of Photography: From 1839 to the Present Day,* the latest revision dated 1982.

12. Lesy's book is not a history of photography but rather a social history in which photographs are used as primary documents to reconstruct the past, but because it was notorious in terms of the liberties it took with the pictures I include it in this list. Much talked about at the time, it was influential in demonstrating expanded historical uses of photography, and Lesy would follow with another similar effort before the decade was out, *Real Life: Louisville in the Twenties* (New York: Pantheon, 1976).

13. Christian A. Peterson, *Photographs Beget Photographs* (Minneapolis: Minneapolis Institute of Arts, 1987), 9.

14. Desmarais, "From Social Criticism to Art World Cynicism," 98.

15. Maria Morris Hambourg, *The Waking Dream: Photography's First Century, Selections from the Gilman Paper Company Collection* (New York: Metropolitan Museum of Art/Abrams, 1993), xv.

16. Holography was discovered by Dennis Gabor in 1947, but not until the development of the laser did it prove to be of great fundamental and practical importance. For more about holography, as well as the other new technologies, see Catherine Reeve and Marilyn Sward, *The New Photography: A Guide to New Images, Processes, and Display Techniques for Photographers* (Englewood Cliffs, N.J.: Prentice-Hall, 1984), esp. the chapter "Photography of the Future."

17. Sonia Landy Sheridan, *Energized Artscience* (Saint Paul, Minn.: 3M Industrial Graphics Division, 1978), 17.

18. The Department of Generative Systems no longer exists at the School of the Art In-

stitute of Chicago. The department covering its functions is now called the Department of Art and Technology.

19. Personal communication to author, 15 May 2000.

20. A number of "cookbooks" of new, old, and combined processes were published, such as: *Creative Darkroom Techniques*, a Kodak handbook (Rochester, 1973); William Crawford, *The Keepers of Light: A History and Working Guide to Early Photographic Processes* (Dobbs Ferry, N.Y.: Morgan & Morgan, 1979); Jim Stone, *Darkroom Dynamics: A Guide to Creative Darkroom Techniques* (New York: Van Nostrand Reinhold, 1978); J. Seeley, *High Contrast* (New York: Van Nostrand Reinhold, 1980); Jan Arnow, *Handbook of Alternative Photographic Processes* (New York: Van Nostrand Reinhold, 1982); and Reeve and Sward, *The New Photography.*

21. Both quotations are from Van Deren Coke, *The Markers* (San Francisco: San Francisco Museum of Modern Art, 1981), 7. The show by the same name, one of Coke's most important during his tenure as photography curator at the San Francisco Museum of Modern Art, was typical of his extended-media interests and a good example of the counterpoint Coke's vision offered to the views and contemporaneous exhibitions of John Szarkowski at MoMA in New York. It is worth noting that of the ten contemporary photographers included in *The Markers* five were either graduates or members of the faculty of the University of New Mexico, where Coke had previously run the photography program (and presumably mentored these individuals): Tom Barrow, Rick Dingus, Bruce Patterson, Joel-Peter Witkin, and Steve Yates. To be sure, he did not always do this: two years earlier Coke had mounted an even more important show at the San Francisco Museum of Modern Art, *Fabricated to Be Photographed*, which included none of his former students. This show is discussed again in Chapter 12.

22. For an exhaustive treatment of the relationship between painting and photography, see Coke, *Painter and the Photograph.* A book bringing the story up to the eighties is Marina Vaizey, *The Artist as Photographer* (New York: Holt, Rinehart & Winston, 1982).

23. Jeanne Hamilton, "Drawing with the Camera," in *Audrey Flack on Painting*, by Audrey Flack (New York: Abrams, 1981), 96–105.

24. William Dyckes, "The Photo as Subject: The Paintings and Drawings of Chuck Close," *Arts Magazine*, February 1974, reprinted in *Super Realism: A Critical Anthology*, ed. Gregory Battcock (New York: Dutton, 1975), 152.

25. Ibid.

26. Sol LeWitt, *Autobiography* (New York: Multiples, 1980).

27. See David Hockney, *Cameraworks*, essay by Lawrence Weschler (New York: Knopf, 1984); and idem, *Photographs by David Hockney* (Washington, D.C.: International Exhibitions Foundation, 1986).

28. Jan Dibbets, *Jan Dibbets* (Minneapolis: Walker Art Center, 1987).

29. See John Beardsley, *Earthworks and Beyond: Contemporary Art in the Landscape* (New York: Abbeville, 1984).

30. Andy Goldsworthy, *Andy Goldsworthy: A Collaboration with Nature* (New York: Abrams, 1990).

31. Edward Weston, "Seeing Photographically," reprinted in *Classic Essays on Photography*, ed. Alan Trachtenberg (New Haven, Conn.: Leete's Island Books, 1980), 172.

32. Siegfried Kracauer, "Photography," reprinted in ibid., 263–65.

33. Szarkowski, *The Photographer's Eye*, 8–11.

34. See Coke and Barrow, *Peculiar to Photography*, which includes the work of Michael Becotte, Michael Bishop, Harry Callahan, Mark Cohen, Paul Diamond, Lee Friedlander, John R. Gossage, Gary Hallman, Anthony Hernandez, Richard P. Hume, Roger Mertin, Anne Noggle, Richard B. Reep, Richard Schaeffer, and Garry Winogrand.

35. Ibid., 7.

36. See Adam D. Weinberg, ed., *Vanishing Presence* (Minneapolis: Walker Art Center, 1989), 82–87.

37. Ibid., 75–81.

38. See Harry Callahan, *Harry Callahan* (New York: Museum of Modern Art, 1967), 12–66 passim.

39. See Van Deren Coke, *Fabricated to Be Photographed* (San Francisco: San Francisco Museum of Modern Art, 1979), 20–21 (Cumming), 26 (Pfahl).

40. See Kenneth Josephson, *Kenneth Josephson* (Chicago: Museum of Contemporary Art, 1983).

41. Peterson, *Photographs Beget Photographs*, 20–23.

42. Ibid., 37.

TEN | NEW LANDSCAPES, NEW PORTRAITS

EPIGRAPHS: Lewis Baltz quoted in Green, *American Photography*, 167; Annie Leibovitz, *Annie Leibovitz: Photographs* (New York: Pantheon/Rolling Stone, 1983), unpaginated interview.

1. From *The Americans* see, e.g., *Funeral—St. Helena, SC; Fourth of July—Jay, NY; View from Hotel Window—Butte, MT; Car Accident—U.S. 66 between Winslow and Flagstaff, AZ; Backyard—Venice West, CA; Mississippi River—Baton Rouge, LA; Crosses on the scene of highway accident—U.S. 91, ID; Beaufort, SC; Chinese Cemetery—San Francisco; Los Angeles; San Francisco; Belle Isle—Detroit; Public Park—Cleveland, OH; Picnic Ground—Glendale, CA;* and *Public Park—Ann Arbor, MI.*

2. Also from *The Americans* see *U.S. 285, NM; Butte, MT; Covered car—Long Beach, CA; Santa Fe, NM; Drive-in movie—Detroit; St. Francis, gas station,* and *City Hall—Los Angeles; Belle Isle, Detroit; Detroit;* and *U.S. 90, en route to Del Rio, TX,* a final poignant signature picture with the car Frank, his wife Mary, and their son Pablo traveled in visible through the windshield.

3. The influence of Metzker, Jachna, and Crane on a generation of students has been profound, but few have carried the experimental approach into the landscape.

4. John Schott, quoted in William Jenkins, *New Topographics: Photographs of a Man-Altered Landscape* (Rochester, N.Y.: International Museum of Photography/George Eastman House, 1975), 5.

5. Lewis Baltz, quoted in ibid., 6.

6. Adams followed this statement by saying, "Otherwise beauty in the world is made to

seem elusive and rare, which it is not" (ibid., 7), affirming his continuing belief in *beauty*; his pictures, however, were as bleak as any others in the show.

7. Uelsmann, of course, had chosen the same tactic, but his antecedents were the nineteenth-century photomontage artists.

8. Green, *American Photography*, 163–64.

9. See, e.g., Steve Fitch, *Diesels and Dinosaurs: Photographs from the American Highway* (Berkeley, Calif.: Long Run Press, 1976); Stephen Shore, *Uncommon Places* (Millerton, N.Y.: Aperture, 1982); Gretchen Garner, *An Art History of Ephemera: Gretchen Garner's Catalog* (Chicago: Tulip Press, 1982); Manfred Hamm and Rolf Steinberg, *Dead Tech: A Guide to the Archaeology of Tomorrow* (San Francisco: Sierra Club Books, 1982); Bill Ganzel, *Dust Bowl Descent* (Lincoln: University of Nebraska Press, 1984); Rick Dingus, ed., *Marks in Place: Contemporary Responses to Rock Art* (Albuquerque: University of New Mexico Press, 1988); and Richard Misrach, *Violent Legacies* (New York: Aperture, 1992).

10. In 1979 Connor published a book of the soft-focus images, *Solos* (Millerton, N.Y.: Apeiron Workshops). In addition to Connor and Rubenstein, a strong group of women landscape photographers emerged in the seventies and eighties. They were drawn to the inhabited landscape and the human figure (or signs of human presence) in the landscape, and their work was generally focused on a sense of numinosity, sometimes romantic and sometimes less so. Among them were Marion Faller, Linda Gammell, Lynn Geesaman, Gail Skoff, Mary Peck, Mary Beth Edelson, and Cynthia MacAdams. Several of them took a consciously feminist approach in their work (see Gretchen Garner, *Reclaiming Paradise: American Women Photograph the Land* [Duluth: Tweed Museum of Art, University of Minnesota, 1987]).

11. Miller, *Magnum*, 92.

12. Joel Meyerowitz, *Cape Light* (Boston: New York Graphic Society / Museum of Fine Arts Boston, 1978), unpaginated interview.

13. Although Porter's published books include several that emphasize architecture—on China, Egypt, the American Southwest, and Mexico—the architecture tends to be ancient, religious, or else old enough to be picturesque and not reminders of today's vernacular world (see the following by Porter: *Under Heaven: The Chinese World* [New York: Pantheon, 1983], *Eliot Porter's Southwest* [New York: Holt, Rinehart & Winston, 1985], and *Mexican Celebrations* and *Monuments of Egypt* [both Albuquerque: University of New Mexico Press, 1990]).

14. Jan Staller, *Frontier New York* (New York: Hudson Hills, 1988), 5.

15. Among his homages to Ansel Adams are *Wave, Lave, Lace, Pescadero Beach* (1978), *Canyon Point, Zion National Park* (1977), or *Moonrise over Pie Pan, Capitol Reef National Park* (1977) (see John Pfahl, *Altered Landscapes, Untitled* 26 [Carmel, Calif.: Friends of Photography, 1981]).

16. For a general survey of Pfahl's work, see John Pfahl, *A Distanced Land: The Photographs of John Pfahl* (Albuquerque: University of New Mexico Press / Albright Knox Art Gallery, 1990), and for the digital work, see his *Permutations on the Picturesque* (Syracuse, N.Y.: Robert Menschel Photography Gallery, 1997).

17. Once again, I must except the great number of studio portraits made for clients or for

fashion magazines. These generally were (and still are) posed in a studio setting. Richard Avedon, however, as I have already noted, injected a sense of action and decisive moment even in his portrait work.

18. See, e.g., the collection of portraits in David E. Scherman, ed., *The Best of Life* (New York: Time, 1973).

19. See Bill Brandt, *Bill Brandt: Photographs, 1928–1983* (London: Thames & Hudson, 1993); and Brassaï, *Brassaï: The Artists of My Life* (New York: Viking, 1982).

20. Henri Cartier-Bresson, *Henri Cartier-Bresson: Photoportraits* (London: Thames & Hudson, 1985).

21. Eisenstaedt, *Eisenstaedt on Eisenstaedt,* 116.

22. David Douglas Duncan, *The Private World of Pablo Picasso* (New York: Ridge Press, 1958), 7.

23. Wayne Miller, *The World Is Young* (New York: Ridge Press, 1958).

24. See Harry Callahan, *Eleanor, Untitled 36* (Carmel, Calif.: Friends of Photography; New York: Callaway Editions, 1984).

25. An interesting selection of the portraits, interspersed with Gowin's strange, often aerial landscapes, appears in Emmet Gowin, *Emmet Gowin Photographs* (Boston: Bulfinch / Philadelphia Museum of Art, 1990).

26. Arnold Newman, *Arnold Newman's Americans* (Boston: Bulfinch / National Portrait Gallery, 1992), 23.

27. All of these portraits are included in ibid.

28. See, e.g., Uelsmann's *Marilynn and the Sheep* (1964), *Romulus, Remus, and Peter* (1968), and *Aaron and Nathan* (1969), included in *Jerry N. Uelsmann, Aperture* 15, no. 4 (1970). See also *Aaron* (1973) and *Diane* (1978), included in Enyeart, *Jerry N. Uelsmann.*

29. See Michals, *Album.*

30. Annie Leibovitz, *Annie Leibovitz Photographs, 1970–1990* (New York: Harper Collins, 1991), 9.

ELEVEN | THE SUBJECT SELF

EPIGRAPHS: Lucas Samaras, "Autopolaroid," *Art in America* 58, no. 6 (November/ December 1970): 83; Arthur Tress, statement from 1968, reprinted in *Talisman,* incorporating *Shadow, Facing Up,* and *Theater of the Mind* (New York: Thames & Hudson, 1986), 147.

1. In the nineteenth and early twentieth centuries photographers sometimes donned exotic costumes or posed themselves in telling tableaux—Hippolyte Bayard, a neglected inventor of a type of photography, posing himself as a "drowned man," for example, or Frances Benjamin Johnston posing herself as a tough and vulgar female, smoking, drinking, her skirts hiked up to an unladylike altitude, or F. Holland Day posing himself as the crucified Christ— but I would suggest that most such pictures were made either in a sense of play or to convey a specific message, not to explore the limits of the self.

2. Lee Friedlander, *Self-Portrait* (New York: Haywire Press, 1970).

3. Mary Beth Edelson, *Photographs 1973–1993 and Shooter Series* (New York: privately printed, 1993), 5–7.

4. Mary Beth Edelson, *Seven Cycles: Public Rituals* (New York: privately printed, 1980).

5. Arthur Tress, *Shadow* (New York: Avon Books, 1973), included in Tress, *Talisman*.

6. Arthur Tress, *Theater of the Mind* (New York: Morgan & Morgan, 1976); a selection of the photographs is also included in Tress, *Talisman*.

7. Ehrenreich, *Hearts of Men*, 42–51.

8. In 1956 Dr. Hans Selye began publicizing the deleterious effects of "stress" on a man's heart. Also, a certain type of masculinity—hard-driving and aggressive—was dubbed "Type A" by the cardiologists Meyer Friedman and Ray Rosenman in the late fifties and found to be especially susceptible to heart disease.

9. Ehrenreich, *Hearts of Men*, 128–29.

10. Ibid., 94.

11. Gail Sheehy, *Passages: Predictable Crises of Adult Life* (New York: Dutton, 1974).

12. Sam Keen and Anne Fox, *Telling Your Story: A Guide to Who You Are and Who You Can Be* (New York: Doubleday, 1973).

13. "Human potential movement" was a general rubric for the psychological movement focused on personal growth rather than disease, the good news being that life was an adventure and not, as Freud had suggested, a tragedy. An important leader of the movement was Abraham Maslow, whose concept of the "self-actualizing person," whose life is created in a trajectory from one "peak experience" to the next, offered an approach radically different from past-determined, analytical, traditional psychology. The human potential movement became a kind of secular spiritual movement and eventually, at the many centers and encounter groups that sprung up everywhere, a big business (See Abraham Maslow, *Toward a Psychology of Being* [New York: Van Nostrand, 1968]).

14. Baba Ram Dass, guru (and formerly Dr. Richard Alpert, Harvard psychologist), offers an interesting model of the self-transformation, extending to religious affiliation and even name, that occurred in certain circles during the seventies, a transformation sometimes set in motion by an initial revelatory encounter with psychedelic drugs, followed by a trip to India.

15. See Merlin Stone, *When God Was a Woman* (New York: Dial Press, 1976); Mary Daly, *Beyond God the Father: Toward a Philosophy of Women's Liberation* (Boston: Beacon Press, 1978); Carol P. Christ and Judith Plaskow, eds., *Womanspirit Rising* (San Francisco: Harper & Row, 1979); and Starhawk, *The Spiral Dance: A Rebirth of the Ancient Religion of the Great Goddess* (San Francisco: Harper & Row, 1979).

16. Tress, *Talisman*, 57–68, 152.

17. Arno Rafael Minkkinen, *Frostbite* (Dobbs Ferry, N.Y.: Morgan & Morgan, 1978).

18. Jan Zita Grover, *Silver Lining: Photographs by Anne Noggle* (Albuquerque: University of New Mexico Press, 1983).

19. Mary Beth Edelson, letter to author, 1988.

20. Mary Beth Edelson, "Pilgrimage / See for Yourself: A Journey to a Neolithic Cave," *Great Goddess, Heresies*, no. 5 (1978): 96–99.

21. Edelson, letter to author, 1988.

22. Ibid.

23. In *Being Antinova* (Los Angeles: Astro Artz, 1983), Eleanor Antin published her journal of the week she spent in New York doing performances and receptions as Antinova. It is

worth noting that although she was the author of the self-images, another photographer operated the camera for Antin.

24. Judith Golden, *Cycles: A Decade of Photographs, Untitled* 45 (Carmel, Calif.: Friends of Photography, 1988).

25. In 1996 the Museum of Modern Art bought a complete set of the *Untitled Film Stills* by Sherman, marking in a dramatic way the changing direction of MoMA's Photography Department under its present director, Peter Galassi. Under previous directors—Edward Steichen and, even more so, John Szarkowski—MoMA had focused its curatorial attention almost entirely on spontaneous-witness photography (see Roberta Smith, "Modern Museum Buys Sherman Photo Series," *New York Times*, 23 January 1996).

26. The notoriety that Sherman and Samaras gained for their self-imagery had a lot to do with their positioning within the "art world" as compared with the "photography world," where Noggle and Golden were placed.

27. Francesca Woodman, a very young photographer whose 1981 suicide ended her life at age 22, produced a haunting group of anguished, blurred self-images in decaying buildings that also tell something of the shadow side (see Francesca Woodman, *Francesca Woodman: Photographic Work*, a posthumous catalogue published by Wellesley College Museum, Wellesley, Mass., in 1986).

28. Eileen Cowin, letter to author, 1990.

29. Jo Spence, *Putting Myself in the Picture: A Political, Personal, and Photographic Autobiography* (Seattle: Real Comet Press, 1988).

30. Ibid., 172.

31. Helen Chadwick, *Enfleshings* (New York: Aperture, 1989).

TWELVE | ARRANGEMENT, INVENTION, AND APPROPRIATION

EPIGRAPHS: A. D. Coleman, *The Grotesque in Photography* (New York: Ridge Press, 1977), 6; Les Krims, 1970 letter published in *Camera Mainichi*, quoted in Coleman, *Light Readings*, 252; Jeff Wall, interview by Arielle Pelenc, in *Jeff Wall*, by Jeff Wall (London: Phaidon, 1996), 17; Sandy Skoglund, "An Interview with Sandy Skoglund," interview by Robert Rosenblum, May 1996, in *Sandy Skoglund: Reality under Siege, a Retrospective* (New York: Smith College Museum of Art / Abrams, 1998), 12; Sarah Charlesworth, 1989, quoted in *Sarah Charlesworth: A Retrospective* (Santa Fe: Site Santa Fe, 1997), 43.

1. Marie Cosindas was a romantic throwback whose arrangements of flowers or moody, mannered portraits in color had an intensely painterly effect. However, and this was the new part, after 1963 she photographed exclusively with Polaroid color material, its first notable fine-art user.

2. Man Ray, *Man Ray Photographs* (New York: Thames & Hudson, 1982), 130.

3. Van Deren Coke, *Photography: A Facet of Modernism* (New York: Hudson Hills / San Francisco Museum of Modern Art, 1986), 23.

4. For Barbara Kasten the human connection was as vital as the aesthetic, and part of an effort among feminist artists to honor unappreciated women artists before them. In 1981 she wrote after a visit to Florence Henri, "I came away knowing that it was important for me and other women to know more than just the photographs of great women photographers. The

acknowledgement of their lives and being touched by their humanity are as important as the artifacts they create" (*Exposure* 19, no. 3 [1981]: 31). For a selection of Kasten's still lifes, see her *Constructs* (Boston: New York Graphic Society / Little, Brown, 1985).

5. See Jan Groover, *Jan Groover Photographs* (Boston: Bulfinch / Little, Brown, 1993), plates 10–17.

6. Olivia Parker's *Signs of Life* (Boston: David R. Godine, 1978) and *Weighing the Planets* (Boston: New York Graphic Society / Little, Brown, 1987) collect her black-and-white work; *Under the Looking Glass* (Boston: New York Graphic Society / Little, Brown, 1983) includes a collection of her Polacolor still lifes.

7. Mark Strand, introduction to Parker, *Under the Looking Glass*, unpaginated.

8. See Jean S. Tucker, *The Modernist Still-life—Photographed* (St. Louis: University of Missouri Press, 1989), 59.

9. Ibid., 24.

10. See Ben Lifson, essay in Samaras, *Samaras,* 69–91.

11. Penn's first *Vogue* cover, in October 1943, the first still-life cover the magazine had ever featured, was a color shot of a handbag, a belt, a glove, and a swatch of fabric, with a print of citrus fruit in the background (see Irving Penn, *Passage: A Work Record* (New York: Knopf / Callaway, 1991), 18. It might also be argued that Penn's fashion and portrait photographs, in their stilled perfection, were still lifes of a sort.

12. Frank Majore, quoted in Tucker, *The Modernist Still-Life,* 33.

13. Anne H. Hoy, *Fabrications: Staged, Altered, and Appropriated Photographs* (New York: Abbeville, 1987), 101; Casebere is quoted on the same page.

14. The book was co-authored by Garry Trudeau, who later created the comic strip "Doonesbury."

15. A. D. Coleman, "The Directorial Mode: Notes toward a Definition" (1976), reprinted in Coleman, *Light Readings,* 250–51.

16. Ibid., 251–52.

17. Ibid., 253.

18. Not only a portraitist and fashion photographer (for which he was best known in the histories until recently), Lynes was also a brilliant creator of erotic, mythological, and psychological tableaux, dramatically lighted and posed in the studio (see Jack Woody, *George Platt Lynes Photographs, 1931–1955* [Los Angeles: Twelve Trees Press, 1980]).

19. Coleman, "Directorial Mode," 250–51.

20. Yukio Mishima, unpaginated preface to *Barakei,* by Eikoh Hosoe (New York: Aperture, 1985).

21. The designer of the first and second editions was Tadanori Yokoo, and the designer of the third edition was Kiyoshi Awazu, who, according to Hosoe, "succeeded in bringing *Barakei* back to life, especially by the use of the bold colors, such as the combination of the imperial purple and the blood red" (see the unpaginated "publishing history" in ibid.).

22. See Eikoh Hosoe, *Eikoh Hosoe, Untitled* 42 (Carmel, Calif.: Friends of Photography, 1986).

23. Green, *American Photography,* 124.

24. Tress, *Talisman,* 151.

25. Ibid., 152.

26. Van Deren Coke, introduction to *Joel-Peter Witkin: Forty Photographs,* by Joel-Peter Witkin (San Francisco: San Francisco Museum of Modern Art, 1985), 6.

27. Ibid.

28. Joel-Peter Witkin, quoted in ibid., 9.

29. Sandy Skoglund, quoted in *Eight Visions: Works by Eight Contemporary American Women* (Tokyo: Parco, 1988), unpaginated.

30. Deborah Willis, "Eyes in the Back of Your Head: The Work of Lorna Simpson," in *Lorna Simpson,* by Lorna Simpson, *Untitled* 54 (Carmel, Calif.: Friends of Photography, 1992), 5.

31. Saidiya V. Hartman, "Excisions of the Flesh," in *Lorna Simpson: For the Sake of the Viewer,* by Lorna Simpson (Chicago: Museum of Contemporary Art, 1992), 56.

32. Willis, "Eyes in the Back of Your Head," 62.

33. Carrie Mae Weems, statement in *Aperture,* no. 129 (1992).

34. Wall, *Jeff Wall,* 9.

35. Ibid., 134.

36. Joshua P. Smith, *The Photography of Invention: American Pictures of the 1980s* (Washington, D.C.: National Museum of American Art; Cambridge: MIT Press, 1989), 12–13.

37. Barbara Kruger, "Incorrect" (1982), in *Remote Control: Power, Cultures, and the World of Appearances* (Cambridge: MIT Press, 1993), 220–21.

38. Kate Linker, *Love for Sale: The Words and Pictures of Barbara Kruger* (New York: Abrams, 1990), 59.

39. Ibid., 79. *Love for Sale* is an excellent compendium of Kruger's artwork. See also Kruger's *Remote Control* for a collection of her regular critical pieces for *Artforum* on television, film, and culture.

40. Charlesworth, *Sarah Charlesworth,* 74.

41. Sarah Charlesworth, quoted in Lisa Phillips, "Sarah Charlesworth: Rite of Passage," in ibid., 43. Interestingly, Charlesworth *would* become a photographer in her series *Natural Magic* (1992–93) and *Doubleworld* (beginning 1995), but at the time of this statement she was not making her own photographs.

42. Phillips, "Sarah Charlesworth," 80.

43. Dan Friedman and Jeffrey Deitch, curator, *Artificial Nature* (Athens, Greece: Deste Foundation for Contemporary Art, 1990).

44. Dan Friedman, quoted from an undated self-promotional piece.

45. Marvin Heiferman and Carole Kismaric, *I'm So Happy* (New York: Random House, Vintage Books, 1990).

46. Ibid., unpaginated.

47. Many more artists and photographers were involved in this movement. For a good compendium of this work, see Smith, *Photography of Invention;* and Hoy, *Fabrications.*

48. Smith, *Photography of Invention,* 27, 21.

THIRTEEN | DIGITIZED PHOTOGRAPHY

EPIGRAPHS: Man Ray, "Deceiving Appearances" (1926), reprinted in Phillips, *Photography in the Modern Era,* 11; Hockney, *Cameraworks,* 9; Adobe Photoshop, trademark

phrase and tag line for a number of ads created by Foote Cone and Belding Technology in the 1990s.

1. A 1998 exhibition, *Pioneers of Digital Photography*, curated by the digital artist Mary Ross at the Open Space Gallery in Allentown, Pennsylvania, showcased the work of eighteen leading digital artists from the 1970s and early 1980s: Peter Bode, Nancy Burson, Walter Chappell, Laurence M. Gartel, Carl Geiger, Robert Heinecken, William Larson, Graham Nash, Nam June Paik, Sheila Pinkel, Mary Ross, Sonia Landy Sheridan, Howard Sochurek, Mary Jo Toles, Woody Vasulka, Joan Truckenbrod, Julius Vitali, and Linda White. Their techniques included tomography, electro-carbon print created via FAX, digital dye-sublimation prints, high-voltage (Kirlian) photography, and digital ink-jet prints, among others.

2. An excellent description of the specifics of digital technology may be found in William J. Mitchell, *The Reconfigured Eye: Visual Truth in the Post-Photographic Era* (Cambridge: MIT Press, 1994).

3. Ibid., 20.

4. And even earlier, NASA had used digital imaging to create its synthetic "views" of outer space, and digital medical techniques such as magnetic resonance imaging were in use. These types of images were not created, however, from photographic (i.e., light-generated) information.

5. Stewart Brand, *The Media Lab: Inventing the Future at MIT*, 2nd ed. (New York: Penguin, 1988), 220.

6. Ibid., 221.

7. According to the photographer Galen Rowell, "Originally the cover was to be a picture of mine of a Tibetan boy. They kicked it off because the Chinese Embassy objected. The Chinese said they wouldn't let *National Geographic* writers and photographers into Tibet again if they ran that picture on the cover. It was already at the printer's. When they decided to yank mine out, they needed an instant replacement. They chose this picture, which was a horizontal. In making it a vertical, they reset the [camel] riders" (quoted in "Photography in the Age of Falsification," by Kenneth Brower, *Atlantic Monthly*, May 1998, 102).

8. These examples are discussed in the chapter "The Pixellated Press" in Fred Ritchin, *In Our Own Image: The Coming Revolution in Photography* (New York: Aperture, 1990), an excellent early discussion of the ethical implications of digitized photography, especially in photojournalism.

9. Brower, "Photography in the Age of Falsification," 95.

10. Art Wolfe and Barbara Sleeper, *Migrations* (Hillsboro, Oreg.: Beyond Words Press, 1994), v.

11. Brower, "Photography in the Age of Falsification," 109.

12. NPPA statement included in John Long, "The Ethics of Digital Manipulation, Areas for Discussion," an undated and unpublished paper, given to the author by Long in 1993.

13. Ibid.

14. Robert F. Brandt, "Technology Changes, Ethics Don't," *Presstime*, December 1987, quoted in Ritchin, *In Our Own Image*, 21.

15. To add insult to injury, the March 1998 *Photo District News* reported that "*Life* magazine fired a third of its staff and folded its photo department into its design department in mid-January as part of a plan to cut costs and reposition the magazine. . . . The events have

shocked and angered staff members. . . . A contributing photographer says, 'This means the photo department is now just a wallpaper supplier to the art director'" ("Publishing News," *Photo District News,* March 1998, 17).

16. Ritchin, *In Our Own Image,* 44.

17. John G. Morris, *Get the Picture: A Personal History of Photojournalism* (New York: Random House, 1998), 298.

18. "For Professor, a Magazine a Day Isn't Enough," *New Mexican,* 27 April 1998.

19. Bill Maher, quoted in *Mother Jones,* January/February 1998, 68.

20. David LaChapelle, quoted in Amy M. Spindler, "Making the Camera Lie, Digitally and Often," *New York Times,* 17 June 1997.

21. John Knoll, telephone interview by author, 23 April 1998. Knoll is currently the visual-effects supervisor at Industrial Light and Magic, working in the film industry.

22. The picture credit reads: "Photographed and digitally manipulated by Giles Hancock. Talent courtesy Stars/S.F."

23. See Todd Walker, *Todd Walker Photographs, Untitled* 38 (Carmel, Calif.: Friends of Photography, 1985), 13–14.

24. Pedro Meyer, *Truths and Fictions: A Journey from Documentary to Digital Photography* (New York: Aperture, 1995), 111. A fascinating section of Meyer's book describes exactly how nine of his best-known pictures were assembled on the computer.

25. John Lund, quoted in *Photo District News,* December 1997, 45.

26. John Paul Caponigro, letter to author, 12 May 1998.

27. Joseph Holmes, quoted in Brower, "Photography in the Age of Falsification," 97.

28. Peter Campus, quoted in *Metamorphoses: Photography in the Electronic Age,* ed. Michael E. Hoffman (New York: Aperture, 1994), 54.

29. Barbara Kasten, quoted in ibid., 57.

30. Jerry Uelsmann, telephone interview by author, 8 May 1998.

31. Hoffman, *Metamorphoses,* 73–74.

32. The move toward putting stock photography on the Internet is sending thousands of images into electronic orbit, and an agency like Bill Gates's Corbis is doing it on a gargantuan scale. On the other hand, encryption software such as PictureMarc aims to protect copyright, though only by bringing copyright notices up on the screen with the picture (see Russell Hart, "Encryption Solution," and David Roberts, "Corbis Unplugged," both in *American Photo,* November/December 1997).

CONCLUSION

1. Wallace Stevens, *The Collected Poems of Wallace Stevens* (New York: Random House, Vintage Books, 1954), 165.

2. Michals, *Real Dreams,* 4.

COLLECTIONS OF WRITINGS BY PHOTOGRAPHERS AND CRITICS

Battcock, Gregory, ed. *Super Realism: A Critical Anthology.* New York: Dutton, 1975.

Coke, Van Deren. *One Hundred Years of Photographic History: Essays in Honor of Beaumont Newhall.* Albuquerque: University of New Mexico Press, 1975.

Coleman, A. D. *Light Readings: A Photography Critic's Writings, 1968–1978.* New York: Oxford University Press, 1979.

Goldberg, Vicki, ed. *Photography in Print: Writings from 1816 to the Present.* New York: Touchstone, 1981.

Green, Jonathan, ed. *Camera Work: A Critical Anthology.* Millerton, N.Y.: Aperture, 1973.

Howard, Gerald, ed. *The Sixties: Art, Politics, and Media of Our Most Explosive Decade.* New York: Paragon House, 1991.

Johnson, Brooks, ed. *Photography Speaks: Sixty-six Photographers on Their Art.* New York: Aperture, 1989.

Kruger, Barbara. *Remote Control: Power, Cultures, and the World of Appearances.* Cambridge: MIT Press, 1993.

Liebling, Jerome, ed. *Photography: Current Perspectives.* Rochester, N.Y.: Massachusetts Review / Light Impressions, 1978.

Lyons, Nathan, ed. *Photographers on Photography.* Englewood Cliffs, N.J.: Prentice-Hall, 1966.

Petruck, Peninah R., ed. *The Camera Viewed: Writings on Twentieth-Century Photography.* 2 vols. New York: Dutton, 1979.

Phillips, Christopher, ed. *Photography in the Modern Era.* New York: Metropolitan Museum of Art / Aperture, 1989.

Trachtenberg, Alan, ed. *Classic Essays on Photography.* New Haven, Conn.: Leete's Island Books, 1980.

BOOKS BY OR ABOUT A SINGLE PHOTOGRAPHER

Adams, Ansel. *Examples: The Making of Forty Photographs.* Boston: New York Graphic Society / Little, Brown, 1983.

Adams, Ansel, and Nancy Newhall. *This Is the American Earth.* San Francisco: Sierra Club Books, 1960.

Antin, Eleanor. *Being Antinova*. Los Angeles: Astro Artz, 1983.

Arbus, Diane. *Diane Arbus*. Millerton, N.Y.: Aperture, 1972.

———. *Diane Arbus Magazine Work*. Millerton, N.Y.: Aperture, 1984.

Avedon, Richard. *Alice in Wonderland: The Forming of a Company, the Making of a Play*. Text by Doon Arbus. New York: E. P. Dutton, 1973.

———. *An Autobiography: Richard Avedon*. New York: Random House and Eastman Kodak, 1993.

———. *Avedon: Photographs, 1947–77*. Essay by Harold Brodkey. New York: Farrar, Straus & Giroux, 1978.

———. *Evidence: Richard Avedon, 1944–1994*. Essays by Jane Livingston and Adam Gopnik. New York: Random House, 1994.

———. *Nothing Personal*. Text by James Baldwin. New York: Atheneum, 1964.

———. *Observations*. Text by Truman Capote. New York: Simon & Schuster, 1959.

———. *Portraits*. Text by Harold Rosenberg. New York: Farrar, Straus & Giroux, 1976.

Avedon, Richard, and Laura Wilson. *In the American West*. 2nd ed. New York: Abrams, 1996.

Barney, Tina. *Theater of Manners*. New York: Scalo, 1997.

Bourke-White, Margaret, and Erskine Caldwell. *You Have Seen Their Faces*. New York: Viking, 1937.

Brandt, Bill. *Bill Brandt: Photographs, 1928–1983*. London: Thames & Hudson, 1993.

Brassaï. *Brassaï: The Artists of My Life*. New York: Viking, 1982.

Brodovitch, Alexey. *Ballet*. New York: J. J. Augustin, 1945.

Bunnell, Peter. Introduction to *Jerry N. Uelsmann*. Special issue of *Aperture* 15, no. 4 (1970).

Callahan, Harry. *Harry Callahan*. New York: Museum of Modern Art, 1967.

Caponigro, Paul. *The Wise Silence*. Boston: New York Graphic Society, 1983.

Cartier-Bresson, Henri. *The Decisive Moment*. New York: Simon & Schuster, 1952.

———. *Henri Cartier-Bresson: Photoportraits*. London: Thames & Hudson, 1985.

Chadwick, Helen. *Enfleshings*. New York: Aperture, 1989.

Charlesworth, Sarah. *Sarah Charlesworth: A Retrospective*. Santa Fe: Site Santa Fe, 1997.

Clark, Larry. *Teenage Lust: An Autobiography by Larry Clark*. New York: Lustrum, 1983.

———. *Tulsa*. New York: Lustrum, 1971.

Coke, Van Deren. Introduction to *Joel-Peter Witkin: Forty Photographs*, by Joel-Peter Witkin. San Francisco: San Francisco Museum of Modern Art, 1985.

Coleman, A. D. Foreword to *Jerry Uelsmann: Photo Synthesis*, by Jerry Uelsmann. Gainesville: University Press of Florida, 1992.

Connor, Linda. *Solos*. Millerton, N.Y.: Apeiron Workshops, 1979.

Crane, Barbara. *Barbara Crane: Photographs, 1948–1980*. Essays by Estelle Jussim and Paul Vanderbilt. Tucson, Ariz.: Center for Creative Photography, 1981.

Cunningham, Imogen. *Imogen Cunningham: Photographs*. Intro. Margery Mann. Seattle: University of Washington Press, 1971.

Davidson, Bruce. *East 100th Street*. Cambridge: Harvard University Press, 1970.

———. *Subway*. New York: Aperture, 1986.

DeCarava, Roy. *Roy DeCarava Photographs*. Ed. James Alinder. *Untitled* 27. Carmel, Calif.: Friends of Photography, 1981.

Dibbets, Jan. *Jan Dibbets*. Minneapolis: Walker Art Center, 1987.

Duncan, David Douglas. *The Private World of Pablo Picasso*. New York: Ridge Press, 1958.

Edelson, Mary Beth. *Photographs 1973–1993 and Shooter Series*. New York: privately printed, 1993.

————. *Seven Cycles: Public Rituals*. New York: privately printed, 1980.

Eggleston, William. *William Eggleston's Guide*. Ed. John Szarkowski. New York: Museum of Modern Art, 1976.

Eisenstaedt, Alfred. *Eisenstaedt on Eisenstaedt*. New York: Abbeville, 1985.

Enyeart, James L. *Jerry N. Uelsmann: Twenty-five Years: A Retrospective*. Boston: New York Graphic Society / Little, Brown, 1982.

Evans, Walker. *American Photographs*. New York: Museum of Modern Art, 1938.

Evans, Walker, and James Agee. *Let Us Now Praise Famous Men*. Boston: Houghton Mifflin, 1941.

Ferrato, Donna. *Living with the Enemy*. New York: Aperture, 1991.

Fink, Larry. *Social Graces*. Millerton, N.Y.: Aperture, 1984.

Fitch, Steve. *Diesels and Dinosaurs: Photographs from the American Highway*. Berkeley, Calif.: Long Run Press, 1976.

Flack, Audrey. *Audrey Flack on Painting*. New York: Abrams, 1981.

Frank, Robert. *The Americans*. New York: Grove Press, 1959. Originally published as *Les Americains* (Paris: Delpire, 1958).

Friedlander, Lee. *Self-Portrait*. New York: Haywire Press, 1970.

Galassi, Peter. *Henri Cartier-Bresson: The Early Work*. New York: Museum of Modern Art, 1987.

Garner, Gretchen. *An Art History of Ephemera: Gretchen Garner's Catalog*. Chicago: Tulip Press, 1982.

Gibson, Ralph. *Days at Sea*. New York: Lustrum Press, 1974.

————. *Deja-Vu*. New York: Lustrum Press, 1973.

————. *The Somnambulist*. New York: Lustrum Press, 1970.

Goldberg, Jim. *Rich and Poor*. New York: Random House, 1985.

Golden, Judith. *Cycles: A Decade of Photographs*. *Untitled* 45. Carmel, Calif.: Friends of Photography, 1988.

Goldin, Nan. *The Ballad of Sexual Dependency*. New York: Aperture, 1986.

Goldsworthy, Andy. *Andy Goldsworthy: A Collaboration with Nature*. New York: Abrams, 1990.

Gowin, Emmet. *Emmet Gowin Photographs*. Boston: Bulfinch / Philadelphia Museum of Art, 1990.

————. *Photographs*. New York: Knopf, 1976.

Groover, Jan. *Jan Groover Photographs*. Boston: Bulfinch / Little, Brown, 1993.

Grover, Jan Zita. *Silver Lining: Photographs by Anne Noggle*. Albuquerque: University of New Mexico Press, 1983.

Haas, Ernst. *The Creation*. New York: Viking, 1971.

Hamilton, Peter. *Robert Doisneau: A Photographer's Life*. New York: Abbeville, 1995.

Hamm, Manfred, and Rolf Steinberg. *Dead Tech: A Guide to the Archaeology of Tomorrow*. San Francisco: Sierra Club Books, 1982.

Harris, Alex. *Red White Blue and God Bless You: A Portrait of Northern New Mexico*. Albuquerque: University of New Mexico Press, 1993.

Heyman, Abigail. *Growing Up Female*. New York: Holt, Rinehart & Winston, 1974.

Hine, Lewis. *Men at Work*. 1932. Reprint. New York: Dover, 1977.

Hockney, David. *Cameraworks*. Essay by Lawrence Weschler. New York: Knopf, 1984.

———. *Photographs by David Hockney*. Washington, D.C.: International Exhibitions Foundation, 1986.

Hosoe, Eikoh. *Barakei*. Preface by Yukio Mishima. New York: Aperture, 1985.

———. *Eikoh Hosoe*. Untitled 42. Carmel, Calif.: Friends of Photography, 1986.

Jachna, Joseph D. *Light Touching Silver: Photographs by Joseph D. Jachna.* Intro. Steven Klindt. Chicago: Chicago Center for Contemporary Photography at Columbia College, 1980.

Johnson, William S., ed. *The Pictures Are a Necessity: Robert Frank in Rochester, N.Y., November, 1988*. Rochester Film and Photo Consortium Occasional Papers, No. 2. Rochester, N.Y.: George Eastman House, 1989.

Johnston, Frances Benjamin. *The Hampton Album*. New York: Museum of Modern Art / Doubleday, 1966.

Josephson, Kenneth. *Kenneth Josephson*. Chicago: Museum of Contemporary Art, 1983.

Kasten, Barbara. *Constructs*. Boston: New York Graphic Society / Little, Brown, 1985.

Klein, William. *Life Is Good and Good for You: Trance Witness Revels*. Paris: Editions du Seuil, 1956.

Krims, Les. *Fictocryptokrimsographs*. Buffalo, N.Y.: Humpty Press, 1975.

Lange, Dorothea. *Celebrating a Collection: The Work of Dorothea Lange, Documentary Photographer*. Oakland, Calif.: Oakland Museum, 1978.

———. *Dorothea Lange: Photographs of a Lifetime*. New York: Aperture, 1982.

Lange, Dorothea, and Paul Taylor. *An American Exodus*. New York: Reynal & Hitchcock, 1939.

Leibovitz, Annie. *Annie Leibovitz: Photographs*. New York: Pantheon / Rolling Stone, 1983.

———. *Annie Leibovitz Photographs, 1970–1990*. New York: Harper Collins, 1991.

Lewitt, Sol. *Autobiography*. New York: Multiples, 1980.

Linker, Kate. *Love for Sale: The Words and Pictures of Barbara Kruger*. New York: Abrams, 1990.

Lynch, Dorothea, and Eugene Richards. *Exploding into Life*. New York: Aperture, 1986.

Maddow, Ben. *Edward Weston: Fifty Years*. Millerton, N.Y.: Aperture, 1973.

Mann, Sally. *Immediate Family*. New York: Aperture, 1992.

Mark, Mary Ellen. *Falkland Road*. New York: Knopf, 1981.

———. *Streetwise*. Philadelphia: University of Pennsylvania Press, 1988.

Mauskopf, Norman. *Rodeo*. Pasadena, Calif.: Twelve Trees Press, 1985.

———. *A Time Not Here*. Santa Fe: Twin Palms Press, 1996.

Meatyard, Ralph Eugene. *The Family Album of Lucybelle Crater*. Text by Jonathan Williams et al. Louisville, Ky.: Jargon Society, 1974.

Meyer, Pedro. *Truths and Fictions: A Journey from Documentary to Digital Photography*. New York: Aperture, 1995.

Meyerowitz, Joel. *Cape Light.* Boston: New York Graphic Society / Museum of Fine Arts Boston, 1978.

Michals, Duane. *Album: The Portraits of Duane Michals, 1958–1988.* Pasadena, Calif.: Twelve Trees Press, 1988.

———. *Real Dreams.* Danbury, N.H.: Addison House, 1976.

———. *Sequences.* Garden City, N.Y.: Doubleday, 1970.

Miller, Wayne. *The World Is Young.* New York: Ridge Press, 1958.

Minkkinen, Arno Rafael. *Frostbite.* Dobbs Ferry, N.Y.: Morgan & Morgan, 1978.

Misrach, Richard. *Violent Legacies.* New York: Aperture, 1992.

Morgan, Susan. *Martin Munkacsi.* New York: Aperture, 1992.

Newman, Arnold. *Arnold Newman's Americans.* Boston: Bulfinch / National Portrait Gallery, 1992.

Nixon, Nicholas. *Family Pictures.* Washington, D.C.: Smithsonian Institution Press in association with Constance Sullivan Editions, 1991.

Norman, Dorothy. *Alfred Stieglitz: An American Seer.* New York: Random House / Aperture, 1973.

Owens, Bill. *Our Kind of People: American Groups and Rituals.* San Francisco: Straight Arrow Books, 1975.

———. *Suburbia.* San Francisco: Straight Arrow Books, 1973.

———. *Working: I Do It for the Money.* New York: Simon & Schuster, Fireside 1976.

Parker, Olivia. *Signs of Life.* Boston: David R. Godine, 1978.

———. *Under the Looking Glass.* Boston: New York Graphic Society / Little, Brown, 1983.

———. *Weighing the Planets.* Boston: New York Graphic Society / Little, Brown, 1987.

Parr, Martin. *Home and Abroad.* London: Jonathan Cape, 1993.

Penn, Irving. *Passage: A Work Record.* New York: Knopf / Callaway, 1991.

Pfahl, John. *Altered Landscapes. Untitled* 26. Carmel, Calif.: Friends of Photography, 1981.

———. *A Distanced Land: Photographs of John Pfahl.* Albuquerque: University of New Mexico Press / Albright Knox Art Gallery, 1990.

———. *Permutations on the Picturesque.* Syracuse, N.Y.: Robert Menschel Photography Gallery, 1997.

Porter, Eliot. *Eliot Porter's Southwest.* New York: Holt, Rinehart & Winston, 1985.

———. *In Wildness Is the Preservation of the World.* San Francisco: Sierra Club Books, 1962.

———. *Mexican Celebrations.* Albuquerque: University of New Mexico Press, 1990.

———. *Monuments of Egypt.* Albuquerque: University of New Mexico Press, 1990.

———. *Under Heaven: The Chinese World.* New York: Pantheon, 1983.

Pratt, Greta. *In Search of the Corn Queen.* Washington, D.C.: National Museum of American Art, Smithsonian Institution, 1994.

Ray, Man. *Man Ray Photographs.* New York: Thames & Hudson, 1982.

Ray-Jones, Tony. *A Day Off.* Boston: New York Graphic Society, 1974.

Richards, Eugene. *Cocaine True, Cocaine Blue.* New York: Aperture, 1994.

Rubenstein, Meridel. *La Gente de La Luz: Portraits from New Mexico.* Santa Fe: Museum of New Mexico, 1977.

Ruscha, Edward. *Twenty-six Gasoline Stations.* Alhambra, Calif.: Cunningham Press, 1962.

Salgado, Sebastião. *Workers: An Archaeology of the Industrial Age.* New York: Aperture, 1997.

Samaras, Lucas. *Samaras Album.* New York: Whitney Museum of American Art, 1971.

———, with an essay by Ben Lifson. *Samaras: The Photographs of Lucas Samaras.* New York: Aperture, 1987.

Sander, Gunther, ed. *August Sander: Citizens of the Twentieth Century.* Text by Ulrich Keller, trans. Linda Keller. Cambridge: MIT Press, 1986. Originally published as *August Sander: Menschen des 20. Jahrhunderts* (Munich: Schirmer/Mosel GmbH, 1980).

Sheridan, Sonia Landy. *Energized Artscience.* Saint Paul, Minn.: 3M Industrial Graphics Division, 1978.

Sherman, Cindy. *Cindy Sherman.* Intro. Peter Schjeldahl, afterword by I. Michael Danoff. New York: Pantheon, 1984.

Shore, Stephen. *Uncommon Places.* Millerton, N.Y.: Aperture, 1982.

Simpson, Lorna. *Lorna Simpson. Untitled* 54. Carmel, Calif.: Friends of Photography, 1992.

———. *Lorna Simpson: For the Sake of the Viewer.* Chicago: Museum of Contemporary Art, 1992.

Skoglund, Sandy. *Sandy Skoglund: Reality under Siege, a Retrospective.* New York: Smith College Museum of Art/Abrams, 1998.

Spence, Jo. *Putting Myself in the Picture: A Political, Personal, and Photographic Autobiography.* Seattle: Real Comet Press, 1988.

Staller, Jan. *Frontier New York.* New York: Hudson Hills, 1988.

Stevens, Wallace. *The Collected Poems of Wallace Stevens.* New York: Random House, Vintage Books, 1954.

Sultan, Larry. *Pictures from Home.* New York: Abrams, 1992.

Tress, Arthur. *Shadow.* New York: Avon Books, 1973.

———. *Talisman.* New York: Thames & Hudson, 1986.

———. *Theater of the Mind.* New York: Morgan & Morgan, 1976.

Tucker, Anne, and Phillip Brookman. *Robert Frank: New York to Nova Scotia.* Boston: New York Graphic Society/Little, Brown/Museum of Fine Arts, Houston, 1986.

Turner, Evan. *Ray K. Metzker: Landscapes.* New York: Aperture, 2000.

Ullman, Doris. *The Appalachian Photographs of Doris Ullman.* Penland, N.C.: The Jargon Society, 1971.

Walker, Todd. *Todd Walker Photographs. Untitled* 38. Carmel, Calif.: Friends of Photography, 1985.

Wall, Jeff. *Jeff Wall.* London: Phaidon, 1996.

Ward, John L. *The Criticism of Photography as Art: The Photographs of Jerry Uelsmann.* Gainesville: University of Florida Press, 1973.

Weston, Edward. *The Daybooks of Edward Weston.* Ed. Nancy Newhall. 2 vols. Millerton, N.Y.: Aperture, 1973.

Whelan, Richard. *Robert Capa: A Biography.* New York: Knopf, 1985.

White, Minor. *Mirrors Messages Manifestations.* Millerton, N.Y.: Aperture, 1969.

Winogrand, Garry. *The Animals.* New York: Museum of Modern Art, 1969.

———. *Women Are Beautiful.* New York: Light Gallery Books, 1975.

Wolfe, Art, and Barbara Sleeper. *Migrations*. Hillsboro, Oreg.: Beyond Words Press, 1994.

Woodman, Francesca. *Francesca Woodman: Photographic Work*. Wellesley, Mass.: Wellesley College Museum, 1986.

Woody, Jack. *George Platt Lynes Photographs, 1931–1955*. Los Angeles: Twelve Trees Press, 1980.

Wright, Richard, and Edwin Rosskam. *Twelve Million Black Voices*. New York: Viking, 1937.

OTHER BOOKS AND CATALOGUES

Arnow, Jan. *Handbook of Alternative Photographic Processes*. New York: Van Nostrand Reinhold, 1982.

Beardsley, John. *Earthworks and Beyond: Contemporary Art in the Landscape*. New York: Abbeville, 1984.

Beaton, Cecil, and Gail Buckland. *The Magic Image: The Genius of Photography from 1839 to the Present Day*. Boston: Little, Brown, 1975.

Bendavid-Val, Leah. *National Geographic: The Photographs*. Washington, D.C.: National Geographic Society, 1994.

Bezner, Lili Corbus. *Photography and Politics in America: From the New Deal into the Cold War*. Baltimore: Johns Hopkins University Press, 1999.

Braive, Michel. *The Photograph: A Social History*. New York: McGraw-Hill, 1966.

Brand, Stewart. *The Media Lab: Inventing the Future at MIT*. 2nd ed. New York: Penguin, 1988.

Buckland, Gail. *Reality Recorded: Early Documentary Photography*. Greenwich, N.Y.: New York Graphic Society, 1974.

Bunnell, Peter. *Photography as Printmaking*. New York: Museum of Modern Art, 1968.

———. *Photography into Sculpture*. New York: Museum of Modern Art, 1970.

Capa, Cornell, ed. *The Concerned Photographer*. New York: Grossman, 1968.

Christ, Carol P., and Judith Plaskow, eds. *Womanspirit Rising*. San Francisco: Harper & Row, 1979.

Coke, Van Deren. *Avant-Garde Photography in Germany, 1919–1939*. San Francisco: San Francisco Museum of Modern Art, 1980.

———. *Fabricated to Be Photographed*. San Francisco: San Francisco Museum of Modern Art, 1979.

———. *The Markers*. San Francisco: San Francisco Museum of Modern Art, 1981.

———. *The Painter and the Photograph: From Delacroix to Warhol*. Albuquerque: University of New Mexico Press, 1964.

———. *Photography: A Facet of Modernism*. New York: Hudson Hills / San Francisco Museum of Modern Art, 1986.

———. *Signs of the Times: Some Recurring Motifs in Twentieth-Century Photography*. San Francisco: San Francisco Museum of Modern Art, 1985.

Coke, Van Deren, and Thomas F. Barrow. *Peculiar to Photography*. Albuquerque: University of New Mexico Art Museum, 1976.

Coleman, A. D. *The Grotesque in Photography*. New York: Ridge Press, 1977.

Coles, Robert. *Doing Documentary Work.* New York: New York Public Library / Oxford University Press, 1997.

Conrat, Maisie, and Richard Conrat. *Executive Order 9066: The Internment of 110,000 Japanese Americans.* Los Angeles: California Historical Society, 1972; distributed by Scrimshaw Press, San Francisco.

Cooper, Kent. *Kent Cooper and the Associated Press.* New York: Random House, 1959.

Crawford, William. *The Keepers of Light: A History and Working Guide to Early Photographic Processes.* Dobbs Ferry, N.Y.: Morgan & Morgan, 1979.

Daly, Mary. *Beyond God the Father: Toward a Philosophy of Women's Liberation.* Boston: Beacon Press, 1978.

Dingus, Rick, ed. *Marks in Place: Contemporary Responses to Rock Art.* Albuquerque: University of New Mexico Press, 1988.

Eder, Joseph Maria. *History of Photography.* 1945. Reprint. New York: Dover, 1978.

Ehrenreich, Barbara. *The Hearts of Men: American Dreams and the Flight from Commitment.* Garden City, N.Y.: Anchor Books / Doubleday, 1983.

Eight Visions: Works by Eight Contemporary American Women. Tokyo: Parco, 1988.

Enyeart, James, ed. *Decade by Decade: Twentieth-Century American Photography.* Boston: Bulfinch / Little, Brown / Center for Creative Photography, University of Arizona, 1989.

Faris, James C. *Navajo and Photography: A Critical History of the Representation of an American People.* Albuquerque: University of New Mexico Press, 1996.

Freidan, Betty. *The Feminine Mystique.* New York: Norton, 1963.

Friedman, Dan, and Jeffrey Deitch, curator. *Artificial Nature.* Athens, Greece: Deste Foundation for Contemporary Art, 1990.

Fulton, Marianne. *The Eyes of Time: Photojournalism in America.* Boston: New York Graphic Society / Little, Brown, 1988.

Ganzel, Bill. *Dust Bowl Descent.* Lincoln: University of Nebraska Press, 1984.

Garner, Gretchen. *Reclaiming Paradise: American Women Photograph the Land.* Duluth: Tweed Museum of Art, University of Minnesota, 1987.

Gassan, Arnold. *A Chronology of Photography.* Athens, Ohio: Handbook Co., 1972.

Gernsheim, Helmut, and Alison Gernsheim. *A Concise History of Photography.* London: Thames & Hudson, 1965.

———. *The History of Photography from the Earliest Use of the Camera Obscura in the Eleventh Century up to 1914.* 1955. Reprint. New York: McGraw-Hill, 1969.

Green, Jonathan. *American Photography: A Critical History.* New York: Abrams, 1984.

Grun, Bernard. *The Timetables of History.* New York: Touchstone, 1991.

Hall-Duncan, Nancy. *The History of Fashion Photography.* New York: Alpine Books / International Museum of Photography, 1979.

Hambourg, Maria Morris. *The Waking Dream: Photography's First Century, Selections from the Gilman Paper Company Collection.* New York: Metropolitan Museum of Art / Abrams, 1993.

Hambourg, Maria Morris, and Christopher Phillips. *The New Vision: Photography between the World Wars.* New York: Metropolitan Museum of Art / Abrams, 1989.

Harrison, Martin. *Appearances: Fashion Photography since 1945.* New York: Rizzoli, 1991.

Heiferman, Marvin, and Carole Kismaric. *I'm So Happy*. New York: Random House, Vintage Books, 1990.

Heyman, Therese Thau. *Seeing Straight: The f.64 Revolution in Photography*. Oakland, Calif.: Oakland Museum, 1992.

Hoffman, Michael E., ed. *Metamorphoses: Photography in the Electronic Age*. New York: Aperture, 1994.

Horan, Anne, ed. *Documentary Photography*. Life Library of Photography. New York: Time-Life, 1972.

Hoy, Anne H. *Fabrications: Staged, Altered, and Appropriated Photographs*. New York: Abbeville, 1987.

Hurley, F. Jack. *Portrait of a Decade: Roy Stryker and the Development of Documentary Photography in the Thirties*. New York: Da Capo Press, 1972.

Jenkins, William. *New Topographics: Photographs of a Man-Altered Landscape*. Rochester, N.Y.: International Museum of Photography / George Eastman House, 1975.

Kahmen, Volker. *Art History of Photography*. New York: Viking, 1974.

Keen, Sam, and Anne Fox. *Telling Your Story: A Guide to Who You Are and Who You Can Be*. New York: Doubleday, 1973.

Kunhardt, Philip B., Jr. *Life, the First Fifty Years*. Boston: Little, Brown, 1986.

Lesy, Michael. *Real Life: Louisville in the Twenties*. New York: Pantheon, 1976.

———. *Wisconsin Death Trip*. New York: Pantheon, 1973.

Livingston, Jane. *The New York School: Photographs, 1936–1963*. New York: Stewart, Tabori, & Chang, 1992.

Lutz, Catherine A., and Jane L. Collins. *Reading National Geographic*. Chicago: University of Chicago Press, 1993.

Lyons, Nathan, ed. *The Persistence of Vision*. Rochester, N.Y.: George Eastman House, 1967.

———. *Toward a Social Landscape*. Rochester, N.Y.: George Eastman House / Horizon, 1967.

Macleish, Archibald. *The Land of the Free*. London: Boriswood, 1938.

Mann, Margery, and Anne Noggle, eds. *Women of Photography: An Historical Survey*. San Francisco: San Francisco Museum of Art, 1975.

Maslow, Abraham. *Toward a Psychology of Being*. New York: Van Nostrand, 1968.

Meltzer, Milton, and Bernard Cole. *The Eye of Conscience: Photographers and Social Change*. Chicago: Follett, 1974.

Miller, Russell. *Magnum: Fifty Years at the Frontline of History*. New York: Grove Press, 1997.

Mitchell, William J. *The Reconfigured Eye: Visual Truth in the Post-Photographic Era*. Cambridge: MIT Press, 1994.

Morris, John G. *Get the Picture: A Personal History of Photojournalism*. New York: Random House, 1998.

Naef, Weston. *Era of Exploration: The Rise of Landscape Photography in the American West, 1860–1885*. New York: Metropolitan Museum of Art / Albright Knox Art Gallery, 1975.

Newhall, Beaumont. *The History of Photography: From 1839 to the Present Day*. New York: Museum of Modern Art / New York Graphic Society, 1964.

———. *Latent Image: The Discovery of Photography*. Garden City, N.Y.: Anchor Books / Doubleday, 1967.

Nixon, H. C. *Forty Acres and Steel Mules*. Chapel Hill: University of North Carolina Press, 1938.

Parry Janis, Eugenia, and Wendy MacNeil, eds. *Photography within the Humanities*. Danbury, N.H.: Addison House, 1977.

Peterson, Christian. *After the Photo-Secession: American Pictorial Photography, 1910–1955*. Minneapolis: Minneapolis Institute of Arts; New York: Norton, 1997.

———. *Photographs Beget Photographs*. Minneapolis: Minneapolis Institute of Arts, 1987.

Pollack, Peter. *The Picture History of Photography*. New York: Abrams, 1969.

Reeve, Catherine, and Marilyn Sward. *The New Photography: A Guide to New Images, Processes, and Display Techniques for Photographers*. Englewood Cliffs, N.J.: Prentice-Hall, 1984.

Ritchin, Fred. *In Our Own Image: The Coming Revolution in Photography*. New York: Aperture, 1990.

Rudisill, Richard. *Mirror Image: The Influence of the Daguerreotype on American Society*. Albuquerque: University of New Mexico Press, 1971.

Scharf, Aaron. *Art and Photography*. Baltimore: Penguin, 1968.

———. *Creative Photography*. London: Studio Vista / Reinhold, 1965.

Scherman, David E., ed. *The Best of Life*. New York: Time, 1973.

Seeley, J. *High Contrast*. New York: Van Nostrand Reinhold, 1980.

Sheehy, Gail. *Passages: Predictable Crises of Adult Life*. New York: Dutton, 1974.

Shore, Stephen. *Uncommon Places*. Millerton, N.Y.: Aperture, 1982.

Shudakov, Grigory. *Pioneers of Soviet Photography*. London: Thames & Hudson, 1983.

Sinsabaugh, Art. *Six Photographers*. Urbana: University of Illinois Museum, 1963.

Smith, Joshua P. *The Photography of Invention: American Pictures of the 1980s*. Washington, D.C.: National Museum of American Art; Cambridge: MIT Press, 1989.

Sobieszek, Robert, and André Jammes. *French Primitive Photography*. Special issue of *Aperture* 15, no. 1 (1970).

Sontag, Susan. *Oh Photography*. New York: Farrar, Straus & Giroux, 1977.

Stange, Maren. *Symbols of Ideal Life: Social Documentary Photography in America, 1890–1950*. Cambridge: Cambridge University Press, 1989.

Starhawk. *The Spiral Dance: A Rebirth of the Ancient Religion of the Great Goddess*. San Francisco: Harper & Row, 1979.

Steichen, Edward. *The Family of Man*. 1955. Reprint. New York: Abrams, 1996.

———, ed. *The Bitter Years: 1935–1941*. New York: Museum of Modern Art, 1962.

Stone, Jim. *Darkroom Dynamics: A Guide to Creative Darkroom Techniques*. New York: Van Nostrand Reinhold, 1978.

Stone, Merlin. *When God Was a Woman*. New York: Dial Press, 1976.

Stott, William. *Documentary Expression and Thirties America*. New York: Oxford University Press, 1973.

Szarkowski, John. *The Face of Minnesota*. Minneapolis: University of Minnesota Press, 1958.

———. *From the Picture Press*. New York: Museum of Modern Art, 1973.

———. *Looking at Photographs*. New York: Museum of Modern Art, 1973.

———. *Mirrors and Windows: American Photography since 1960*. New York: Museum of Modern Art / New York Graphic Society, 1978.

————. *The Photographer's Eye*. New York: Museum of Modern Art, 1966.

Taft, Robert. *Photography and the American Scene: A Social History, 1839–1889*. 1938. Reprint. New York: Dover, 1964.

Tsujimoto, Karen. *Images of America: Precisionist Painting and Modern Photography*. Seattle: University of Washington Press / San Francisco Museum of Modern Art, 1982.

Tucker, Anne. *The Woman's Eye*. New York: Knopf, 1973.

Tucker, Jean S. *The Modernist Still-Life—Photographed*. St. Louis: University of Missouri Press, 1989.

Vaizey, Marina. *The Artist as Photographer*. New York: Holt, Rinehart & Winston, 1982.

Wainwright, Loudon. *The Great American Magazine*. New York: Knopf, 1986.

Weinberg, Adam D., ed. *Vanishing Presence*. Minneapolis: Walker Art Center, 1989.

Welling, William. *Photography in America: The Formative Years*. New York: Thomas Y. Crowell, 1978.

Werner, Donald. *Light and Lens: Methods of Photography*. Yonkers, N.Y.: Hudson River Museum, 1973.

Westerbeck, Colin, and Joel Meyerowitz. *Bystander: A History of Street Photography*. Boston: Bulfinch / Little, Brown, 1994.

White, Minor. *The Way through Camera Work*. Special issue of *Aperture* 7, no. 2 (1959).

Wilson, Tom Muir. *Into the 70's*. Akron, Ohio: Akron Art Institute, 1970.

PERIODICAL REFERENCES NOT ANTHOLOGIZED IN WORKS ABOVE

Arnheim, Rudolf. "On the Nature of Photography." *Critical Inquiry* 1, no. 1 (September 1974).

Brower, Kenneth. "Photography in the Age of Falsification." *Atlantic Monthly*, May 1998.

Coleman, A. D. "Harry Callahan: An Interview." *New York Photographer*, no. 4 (January 1972).

Edelson, Mary Beth. "Pilgrimage / See for Yourself: A Journey to a Neolithic Cave." *Great Goddess, Heresies*, no. 5 (1978).

"For Professor, a Magazine a Day Isn't Enough." *New Mexican*, 27 April 1998.

Goldman, Eric. "Good-Bye to the 'Fifties—and Good Riddance." *Harper's*, January 1960.

Hart, Russell. "Encryption Solution." *American Photo*, November/December 1997.

Hays, Constance L. "Seeing Green in a Yellow Border." *New York Times*, 3 August 1997.

Hine, Lewis. "The High Cost of Child Labor." *Child Labor Bulletin*, February 1915.

Kaplan, Gail. "Survey of Schools with MFA/MA Programs in Photography." *Exposure* 20, no. 3 (1982).

Kasten, Barbara. Statement in *Exposure* 19, no. 3 (1981): 31.

Kozloff, Max. "A Way of Seeing and the Act of Touching." *Observations: Essays on Documentary Photography. Untitled* 35 (1982).

Lund, John. Artist's statement. *Photo District News*, December 1997.

Maher, Bill. Quotation in *Mother Jones*, January/February 1998.

Mapplethorpe, Robert. "Portfolio X." *Art Journal* 50, no. 3 (fall 1991).

Morris, John G. "A Photographic Memoir." *Exposure* 20, no. 2 (1982).

Newman, Cathy. "Reel to Real." *National Geographic*, August 1995.

Parker, William. "Uelsmann's Unitary Reality." *Aperture* 13, no. 3 (1967).

Phillips, Christopher. "The Judgment Seat of Photography." *October* 22 (fall 1982).

"Publishing News." *Photo District News*, March 1998.

Roberts, David. "Corbis Unplugged." *American Photo*, November/December 1997.

Said, Edward. "Representing the Colonized." *Critical Inquiry*, winter 1989.

Samaras, Lucas. "Autopolaroid." *Art in America* 58, no. 6 (November/December 1970).

Schmid, Randolph E. "Census: We dine out more. . . ." *Albuquerque Journal*, 5 December 1997.

Smith, Roberta. "Modern Museum Buys Sherman Photo Series." *New York Times*, 23 January 1996.

Spindler, Amy M. "Making the Camera Lie, Digitally and Often." *New York Times*, 17 June 1997.

Tucker, Anne Wilkes. "Photographic Facts and Thirties America." *Observations: Essays on Documentary Photography. Untitled* 35 (1982).

Uelsmann, Jerry. "Post-Visualization." *Florida Quarterly*, no. 1 (summer 1967).

———. Artist's statement. *Photographic Journal* (Royal Photographic Society, London) 3, no. 4 (April 1971).

Weems, Carrie Mae. Artist's statement. *Aperture*, no. 129 (1992).

DISAPPEARING WITNESS

Change in Twentieth-Century American Photography

Gretchen Garner

Designed by Kathleen Szawiola,
typeset by the designer in
Aldus and Frutiger.
Separated and printed by
CS Graphics PTE Ltd.
in Singapore.